THE

UNIVERSITY OF

CALIFORNIA

A Pictorial History

THE
UNIVERSITY OF
CALIFORNIA

A Pictorial History

by Albert G. Pickerell and May Dornin

1868

U — C

1968

A CENTENNIAL PUBLICATION OF THE UNIVERSITY OF CALIFORNIA

Preface

This book is a pictorial record of the first hundred years of the University of California, published in commemoration of the University's centennial.

A century can be a relatively short time in the life of a university. The University of Bologna, considered the oldest in Europe, was established in the eleventh century. Oxford and Cambridge are approaching 800 years; and Harvard, the first university in the United States, already was 232 years old when the University of California was founded. It is noteworthy that the University of California has attained distinction so rapidly.

This volume attempts to convey an understanding of the forces that contributed to the growth of the University and to give an account of the achievements of its nine campuses. It honors the men and women who worked with dedication to achieve its distinction and pays tribute to the people of California for a century of support.

Arrangement of the volume is by campus, in order of the date established. University-wide programs, such as University Extension and Agricultural Extension, are integrated into campus sections rather than treated separately.

The authors are grateful to Centennial Editor Verne A. Stadtman, for helpful counsel throughout the project; to Carol Agee, coordinating editor; to Suzanne N. Mathison, designer; to Katherine Jacobs, secretary; and to Susan Howard, clerical assistant. The interest and advice of many other individuals and organizations are acknowledged on page 324.

Albert G. Pickerell
May Dornin

CONTENTS

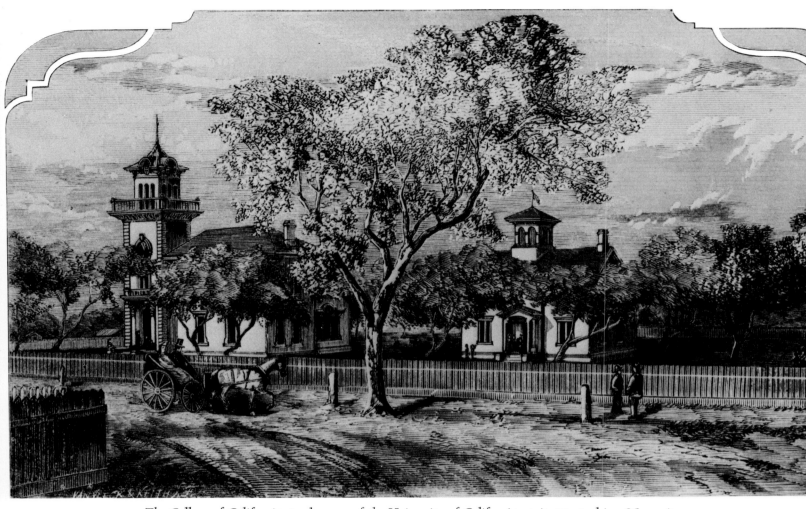

The College of California, predecessor of the University of California, as it appeared in 1865 on its downtown Oakland site, between Twelfth and Fourteenth Streets and Harrison and Franklin Streets.

The University of California

The men who prepared the first draft of the California state constitution, working at Monterey in 1849, provided for a state educational system and a university. California was admitted to the union the following year, but eighteen years were to pass before the University of California came into being.

In 1853, Henry Durant, a Congregational minister and Yale graduate, arrived in San Francisco with, as he later remarked, "college on the brain." One month after his arrival he opened the Contra Costa Academy, a private school for boys, in Oakland. Two years later, with the help of a group of educationally minded citizens, the school was incorporated as the College of California. Funds were scarce, but the trustees of the college persevered, and in 1860 the little institution opened its doors to a Freshman class of eight students. From its beginning, the College of California looked forward to becoming a university. The trustees purchased a tract of 160 acres for a campus in a tiny community four miles north of Oakland. In 1866, this community was named "Berkeley."

Meanwhile, agitation for a state university had been kept alive in the legislature. Funds from the sale of public lands and other sources were set aside, and in 1862 the legislature applied for the 150,000 acres of land which would be California's grant under the Morrill Act of Congress. Terms of the grant required the establishment of a college teaching agriculture and the mechanic arts. Accordingly, in 1866, provisions for an Agricultural, Mining, and Mechanical Arts College were adopted by the legislature.

This college was backed by state funds, but had no site. The College of California had a site, but inadequate finances. Generously, the trustees of the College of California offered to disincorporate and transfer their land in Berkeley and their land and buildings in Oakland (including a library of 1036 volumes) to the state —on condition that the act establishing the Agricultural, Mining, and Mechanical Arts College be repealed and a "complete university," teaching the humanities as well as agriculture and mechanics, be created. The legislature agreed, and on March 23, 1868, Governor Henry H. Haight signed the Organic Act, bringing the University of California into being.

The University opened in September 1869 with a faculty of ten and with forty students. For four years, until the first buildings could be completed on the Berkeley campus, instruction continued at the site of the former College of California in Oakland. In September 1873 the University moved to its permanent site with a registration of 199 students, of whom 26 were women.

The young institution was constantly hindered by uncertain financing dependent on the temper of successive legislatures, by political unrest, and by repeated attempts from without the University to establish the College of Agriculture as a separate institution. Six presidents came and went.

The nine-year presidency of Martin Kellogg (1890–99) was a period of calm during which definite progress was made, but it was not until the turn of the century that the University began making really large strides, both in size and distinction. New legislation made finances more stable; Regent Phoebe A. Hearst financed an international competition for an architectural plan that brought the University of California to the attention of the world; and in October 1899, President Benjamin Ide Wheeler began a twenty-year administration. Wheeler, who as professor of the Greek language and literature at Cornell was a recognized scholar, proved also to be an able administrator, especially skilled in pursuing funds for the University from both public and private sources. Handsome white granite buildings, distinguished new faculty members, library book funds, research grants, and scholarships all materialized steadily.

Soon demands began to be made for centers of higher education in other parts of the state, and in 1919, shortly before President Wheeler's retirement, the Regents agreed to the unique experiment of a second academic campus at Los Angeles. The following decade, under Presidents David Prescott Barrows and William Wallace Campbell, saw the emergence of the concept of a statewide university.

President Campbell retired in 1930, and for the first time a native Californian and graduate of the University was named president. In an administration that covered twenty-eight years, President Robert Gordon Sproul, '13, guided the University through an economic depression, World War II, and a tremendous postwar development in which Santa Barbara was added as a campus and facilities at Davis, Riverside, and La Jolla broadened their educational offerings.

As other campuses were established, they were administered locally by a "director," later "provost." In 1952, in a reorganization of the University administration, the office of chancellor was established at Berkeley and Los Angeles. Clark Kerr, first chancellor at Berkeley, succeeded Sproul as president in 1958 and served until January 1967, when the Regents voted to terminate his appointment.

By 1958 it was apparent that California—soon to become the most populous state—would need to triple its facilities for higher education by 1975. Early recognition of the need for planning permitted the development of a model for orderly growth. The state's Master Plan for Higher Education, adopted by the legislature in 1960, came to be emulated by other populous states and carefully studied by foreign educators seeking to modernize their educational systems.

Under President Kerr's administration, the programs of the campuses at Davis, Riverside, and Santa Barbara were enlarged, and they were designated as general campuses; in addition, new general campuses were established at San Diego,

Santa Cruz, and Irvine. President Kerr also continued the reorganization of the University administration, greatly increasing the local autonomy of the chancellors.

As the University observes its centennial year, there are nine campuses throughout the state, eight major research stations, and nearly two dozen other field and research stations. Broad programs also are offered by Agricultural Extension and University Extension. Total enrollment on the various campuses—exceeding 95,000 in 1967—is expected to increase by 1975 to 140,000. Enrollment of medical and health students is expected to double. Total expenditures for current operations, including Atomic Energy Commission laboratories and other federal projects, exceed seven hundred million dollars, of which approximately sixty-five per cent comes from non-state sources. Yet for all its campuses, colleges, schools, institutes, and research stations, it remains one University, under one Board of Regents and one president—the University of California.

Charles J. Hitch, the University's thirteenth president, was appointed in September 1967. He was serving at that time as vice-president of the University for administration.

The state constitution places administrative control of the University in a Board of Regents composed of sixteen members appointed by the governor and eight ex-officio members. The Regents meet ten times annually, rotating among the nine campuses of the University. This photograph was taken in July 1967 during sessions at Berkeley. Seated are Mrs. Edward H. Heller, Allan Grant, Mrs. Randolph A. Hearst, Edward W. Carter, DeWitt A. Higgs, John E. Canaday, Acting President Harry R. Wellman, Theodore R. Meyer, Edwin W. Pauley, William E. Forbes, Mrs. Dorothy B. Chandler, William U. Hudson, and Norton Simon. Standing are Laurence J. Kennedy, Jr., William K. Coblentz, William M. Roth, Philip L. Boyd, Frederick G. Dutton, and Roger C. Pettitt, Regent Designate. Not present when the photograph was taken were Governor Ronald Reagan, Lieutenant Governor Robert H. Finch, Speaker of the Assembly Jesse M. Unruh, Max Rafferty, Samuel B. Mosher, and Einar O. Mohn.

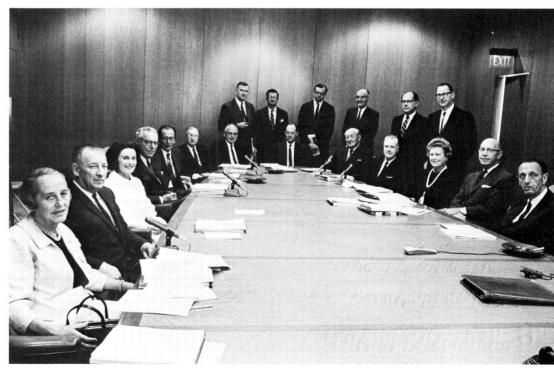

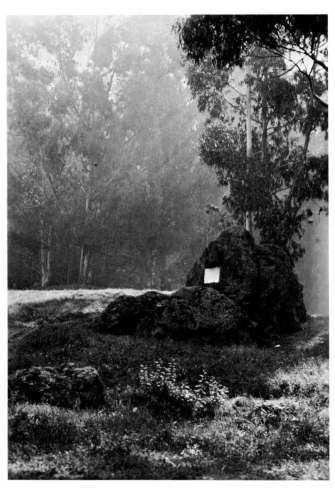

On April 16, 1860, "a clear and beautiful spring day" according
to Samuel H. Willey, secretary of the board, the trustees of
the College of California met at "the great rock or outcropping
ledge" near the upper boundary of the site they had purchased
for a future campus and dedicated it to the cause of learning
with the prayer "that it might ever remain a blessing to the
youth of the state and a center of usefulness to all this part
of the world." The commemorative plaque was set in "Founders'
Rock" in Charter Day exercises thirty-six years later,
by the class of 1896.

Berkeley

Lying against the Contra Costa hills at the head of a gently sloping plain, with a spectacular view of San Francisco Bay and the Golden Gate, the site chosen for the first campus of the University proved to be an ideal setting for development of an institution of higher education. Today the original 160-acre campus has been expanded, through purchase of adjoining land in the upper hill area, to a total of some 1,200 acres, and classroom buildings, offices, and research laboratories climb the steep slopes to the east above the busy main campus; but in the opening days the first buildings stood almost alone in the midst of orchards and wheat fields.

Also lonely were the early faculty, hundreds of miles and days of travel from their nearest colleagues. But this too proved fortunate, for the University developed uniquely, in response to the needs of the people of California, rather than as an imitation of another institution. A substantial academic reputation came quickly. The first faculty included such internationally distinguished men as physicist John LeConte and his brother Joseph, a natural scientist; Eugene W. Hilgard, soil scientist; and George W. Howison, philosopher.

As the only general campus of the University until 1919, Berkeley became a center of higher education that raised the standards of California's public schools and developed the concept of the junior college. Its faculties responded quickly to the state's need for applied research in the problems of western agriculture, engineering, and development of natural resources, as well as the need to know and communicate with other nations bordering the Pacific Ocean. Soon its resources spanned many fields of knowledge. The extension of its research and its international interests attracted noted scholars and teachers, who in turn added stature to the reputation of the University. (In a comparative study of graduate departments published in 1966, the American Council on Education called Berkeley the "best balanced distinguished university in the county.") Although challenged in size by the later campuses, Berkeley, the mother campus and seat of the University-wide administration, maintains its place in the forefront of international centers of learning.

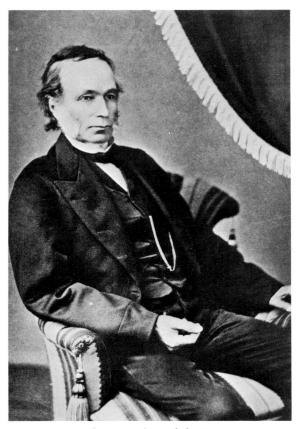

Henry Durant, first president of the University, served from 1870 to 1872.

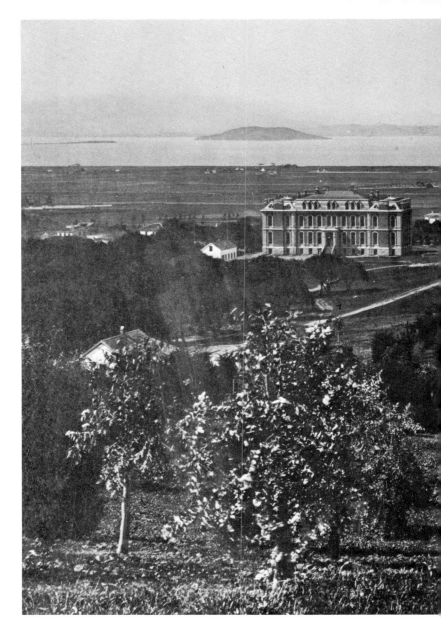

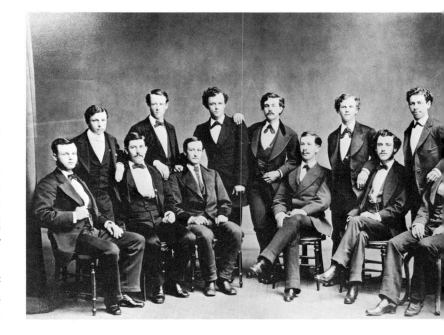

Of the twenty-four Freshmen who registered in Oakland during the opening days of the University, in 1869, twelve survived to graduate in 1873, in the not-quite-finished North Hall on the Berkeley campus. Here President Gilman addressed the candidates: "You are twelve in number; be jurors, sworn to declare the truth as you find it; be apostles bearing everywhere the Master's lesson." Known thereafter as the "twelve apostles," the class of '73, considering its size, was to produce a remarkable number of distinguished citizens and public servants, including a governor, three Regents of the University, a mayor, a prominent minister, a mathematics professor, and a noted attorney.

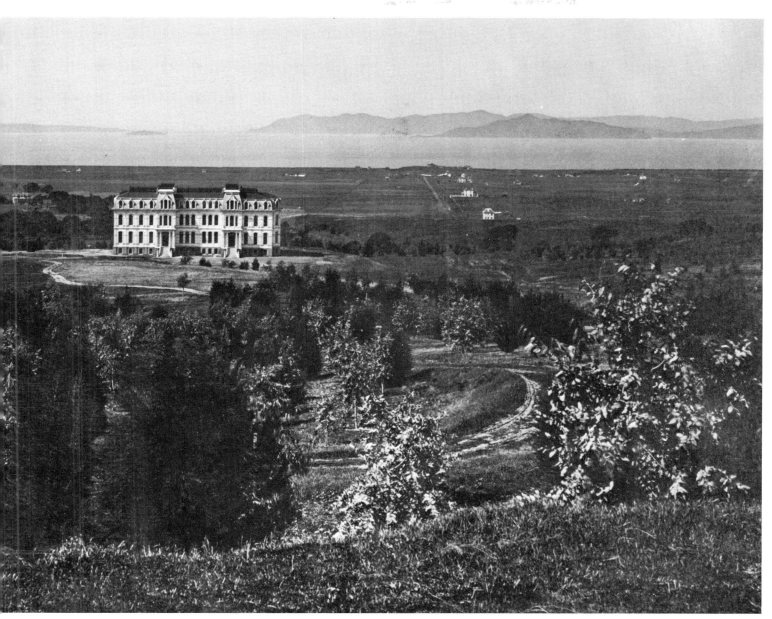

The University moved from Oakland to its permanent campus at Berkeley in the summer of 1873. The native oaks and bay trees, supplemented by plantings of eucalyptus, pine, and cedar, gave a park-like appearance to the grounds, and two buildings, South Hall and white-painted North Hall, stood alone against the farmlands, bay, and Golden Gate.

he "twelve apostles." Seated are George C. Edwards, Leander L. Hawkins,
ranklin Rhoda, Ebenezer Scott, George J. Ainsworth, and John M. Bolton;
anding are Jacob Reinstein, Frank Otis, James H. Budd, Thomas P.
oodward, Clarence J. Wetmore, and Nathan Newmark.

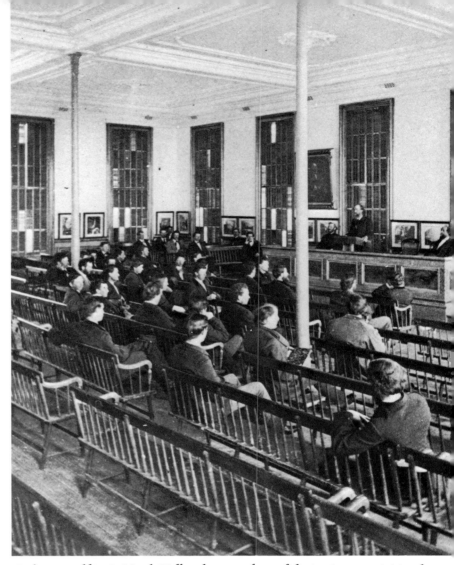

Daniel Coit Gilman, president of the University from 1872 to 1875.

Friday assemblies in North Hall to hear speakers of distinction were initiated by President Gilman. Martin Kellogg, dean of the Academic Senate, and Regent John B. Felton sit to the right and left of Gilman, who is presiding.
The framed pictures around the lower portion of the walls are the well-known photographs of Yosemite Valley taken by Carleton Emmons Watkins and given to the University in December 1873.

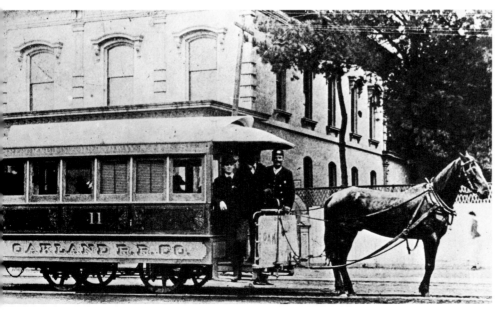

Early-day students could blame their tardiness on the breakdown of the one-horsepower public transportation, which required an hour and a quarter to travel the four miles between Oakland and Berkeley. According to the University Echo of November 1873, the faculty secured a special car for their use, and "woe to the benighted stranger who pollutes its sanctity as it slowly trundles along, seemingly conscious of the dignified body within." In 1878, the horse cars were replaced by a steam "dummy," which cut the running time in half.

One of the first agricultural experiment stations in the United States was established by Eugene W. Hilgard, first dean of the College of Agriculture. Between 1874 and 1900, it occupied forty acres in the northwest section of the campus, with plots "set apart for the culture of economic plants." The experimental eucalyptus grove, which also served as a windbreak for the athletic grounds beyond, has become a campus landmark, containing some of the tallest trees in California.

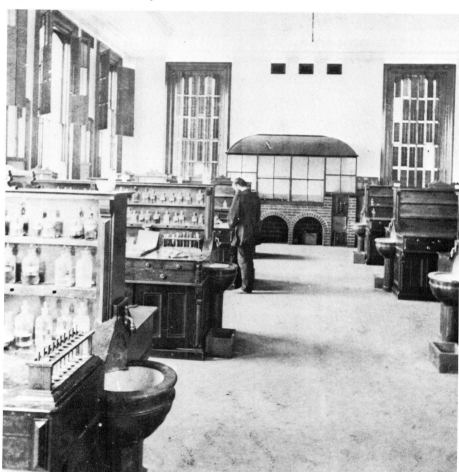

The chemical laboratory, at the south end of South Hall's main floor, was shared by the College of Agriculture and the College of Chemistry in 1874. Willard B. Rising, professor of chemistry and metallurgy, prepares a demonstration.

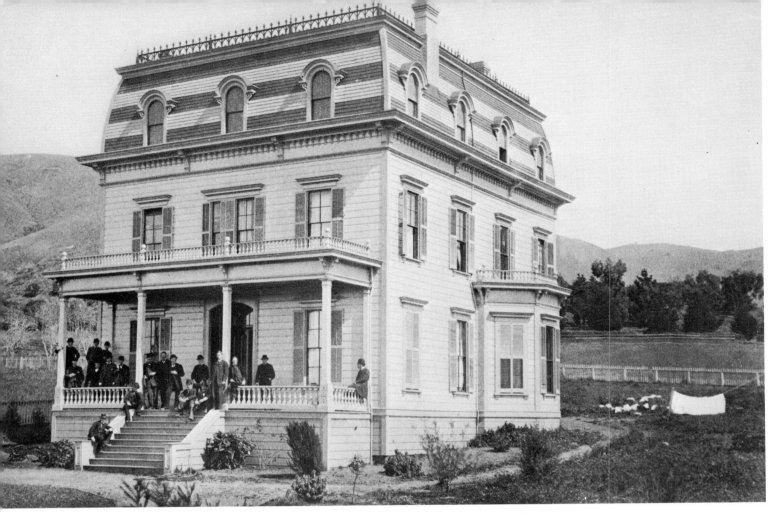

The first Greek-letter society established at the University was the Iota Chapter of Zeta Psi, chartered June 10, 1871. The chapter house, built in 1876 on Audubon Way (now College Avenue) north of Bancroft, is said to have been the first fraternity house erected on the Pacific Coast.

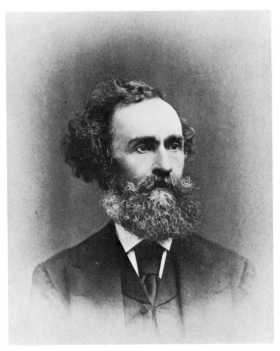

John LeConte, professor of physics, served as acting president of the University from 1875 to 1876 and as president from 1876 to 1881.

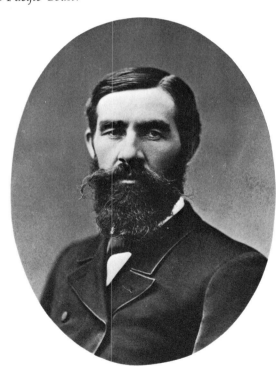

William Thomas Reid was president of the University from 1881 to 1885.

The original Harmon Gymnasium, the gift of A. K. P. Harmon of Oakland, was the fourth campus building (1879) and the first to be erected through a private gift. Aside from its basic function, it served as an auditorium for University meetings, a theater for music and drama, and a hall for dances and rallies. It was supplanted by the present Harmon Gymnasium in 1933 and razed as a fire hazard.

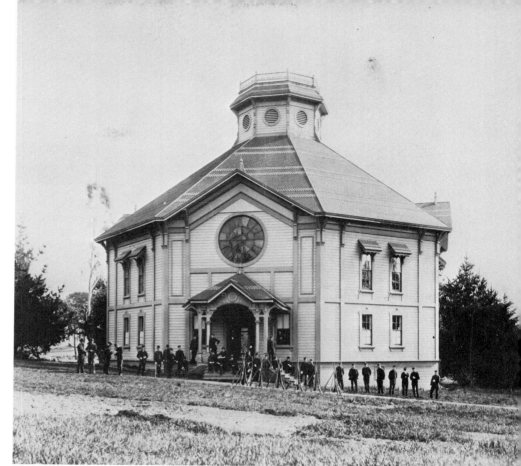

The Telegraph Avenue entrance in 1880; a picket fence marked the southern boundary of the campus. Through the trees to the left is Harmon Gymnasium.

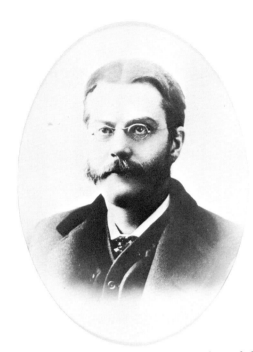

In 1875, James Lick, a pioneer citizen of San Francisco, founded the Lick Observatory, through a deed of trust that provided for the purchase of land and construction of a powerful telescope and "a suitable observatory connected therewith." When the project was completed, the land, building, and equipment were to be conveyed to the Regents, to be known as the Lick Astronomical Department of the University of California. Two months before his death in October 1875, Lick chose the summit of 4,209-foot Mount Hamilton, in Santa Clara County, as the site of the observatory. Building a road to the top, blasting a site from the rocky summit, and constructing the telescope and observatory took eight years. On June 1, 1888, the property was ceremoniously transferred from the Lick Trust to the Regents. Edward S. Holden, the first director, conducted research that rapidly brought the Lick Observatory into international prominence.

Edward Singleton Holden was president of the University from 1885 to 1888, when he resigned to become director of the Lick Observatory.

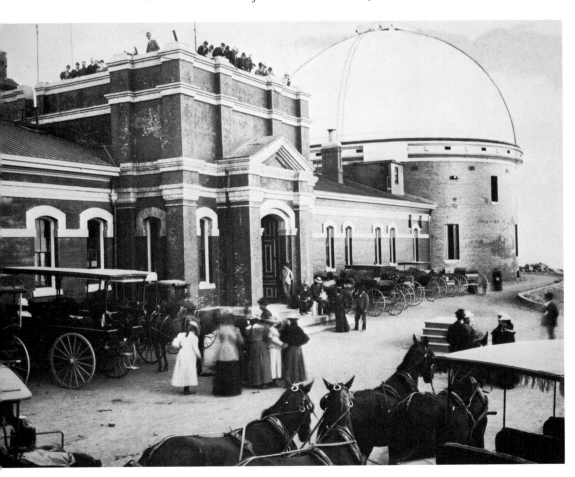

Although the trip from San Jose to the Lick Observatory took five hours by horse-drawn stage, some five thousand visitors came annually by 1896.

The campus of 1888, viewed from the roof of a private house. The five buildings are North Hall, the Mechanic Arts Building (whose one-story machine shop would become in 1931 the first Radiation Laboratory), the Bacon Art and Library Building, South Hall, and Harmon Gymnasium. The picket fence running along Allston Way enclosed the grounds to the Dana Street entrance at the lower left.

The University Avenue of 1888 gave little promise of its future importance as a busy four-lane boulevard reaching from the bay to the campus. Looking eastward from Louisa (now Bonita) Street, the Mechanics Building, North Hall, and the tower of the Bacon Library can be seen in the distance. The tower at left center marks the Shattuck Avenue crossing.

Horace Davis, president of the University from 1888 to 1890.

Martin Kellogg, professor of the Latin language and literature, served as acting president of the University from 1890 to 1893 and as president from 1893 to 1899.

Room 10, North Hall, familiar to all students of the first forty years as the Recorder's Office. James Sutton, '88 (at far left), recorder of the faculties from 1891 until his death in 1929, studies a report beneath a portrait of former President Henry Durant. Statistics of incoming students from 1890 to 1893, neatly displayed on the blackboard, show an increase from 170 to 303.

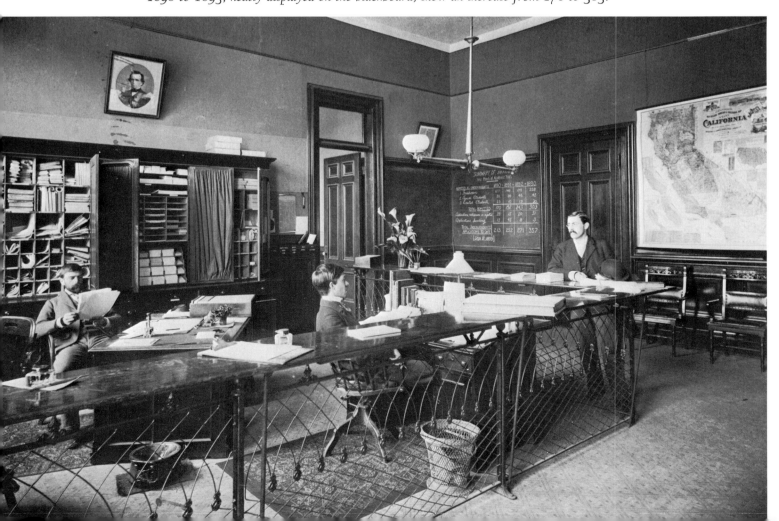

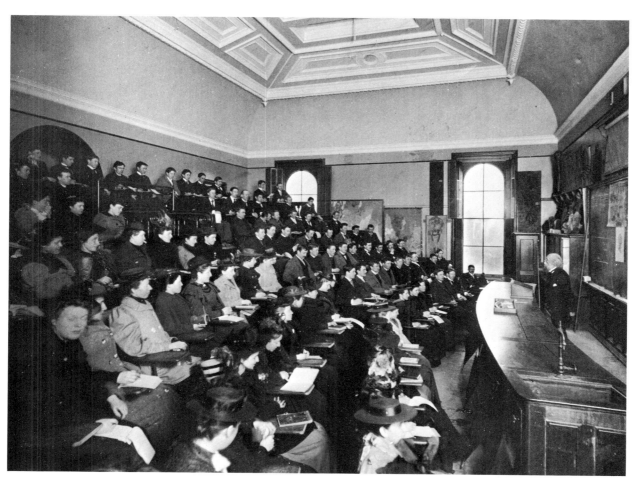

A class in the "grand lecture room" of South Hall, in 1898. The lecturer is Joseph LeConte, professor of geology and natural history, who at seventy-five was still attracting crowded classes. At his death in 1901, Dean Hilgard wrote, "It was LeConte through whom the University of California first became known to the outside world as a school and center of science on the western border of the continent."

The noblest of the California live oaks for which the early campus was noted was dedicated in honor of John and Joseph LeConte by the class of 1898, which placed a plaque in the crotch of the tree on their Class Day. Long a campus landmark, the original "LeConte Oak" finally succumbed to old age during a windstorm in 1939. A young tree planted at the site—next to Strawberry Creek on the west side of the campus—has now grown to considerable size, with the plaque mounted on a block of California granite at its base.

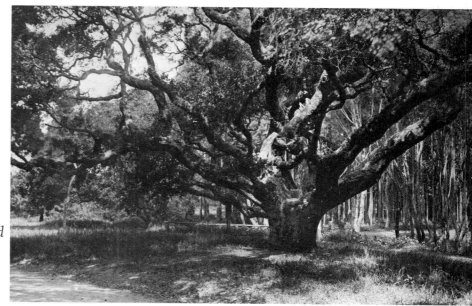

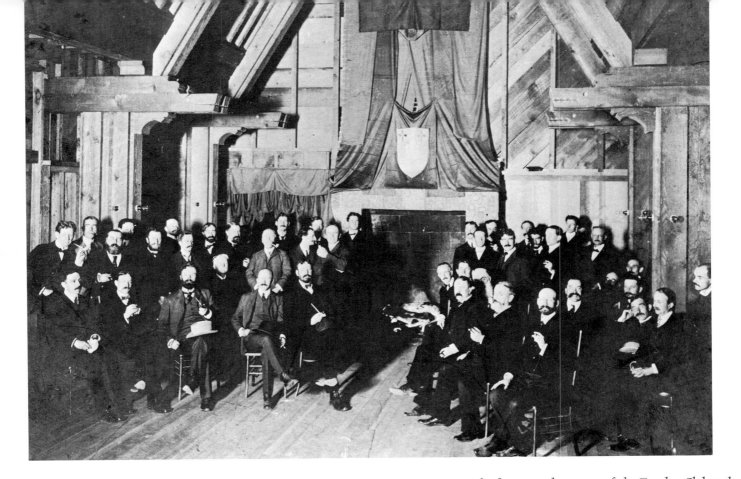

The first annual meeting of the Faculty Club and dedication of the clubhouse, on September 16, 1902, was photographed by Joseph N. "Little Joe" LeConte, '91, professor of mechanical engineering (standing at the extreme right). The Faculty Club had its beginning in a Dining Association formed in 1894, when restaurants were scarce in Berkeley; a University cottage was remodeled for the use of the association. In 1901, a formal Faculty Club was organized, funds were raised, and, with the permission of the Regents, a clubhouse designed by Bernard Maybeck was built, incorporating the former cottage as the kitchen. Through the years the clubhouse has been enlarged several times as the membership has increased from 25 to more than 1,60

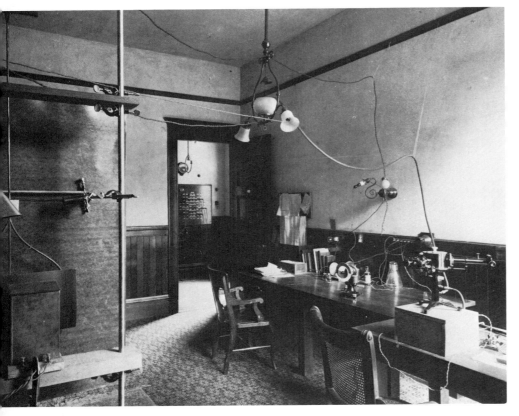

One of the first psychology laboratories in the United States was established in the Philosophy Building in 1899 by George M. Stratton, '88, after his doctoral study in European universities. The equipment has been preserved by the Department of Psychology.

The first home of Stiles Hall, the University YMCA, was erected opposite the Dana Street entrance to the campus in 1892, as a gift from Mrs. Anson G. Stiles in memory of her husband. From then until the late 1920's, when the building was purchased by the University and demolished to clear the site for the present Harmon Gymnasium, Stiles Hall served not only as a gathering place for students, but as a lecture and concert hall for the University. After a long period spent in temporary quarters, Stiles moved in 1951 to a new building of its own on the corner of Bancroft Way and Dana Street, where it continues to welcome student groups of every race, creed, and political belief.

"Ben Weed's Amphitheater," named for the student who discovered the acoustical properties of the hollow in the campus hills, was the setting for the Senior Class Day pageant of 1894. Some years later, at the suggestion of President Wheeler, the amphitheater became the site of the Greek Theatre.

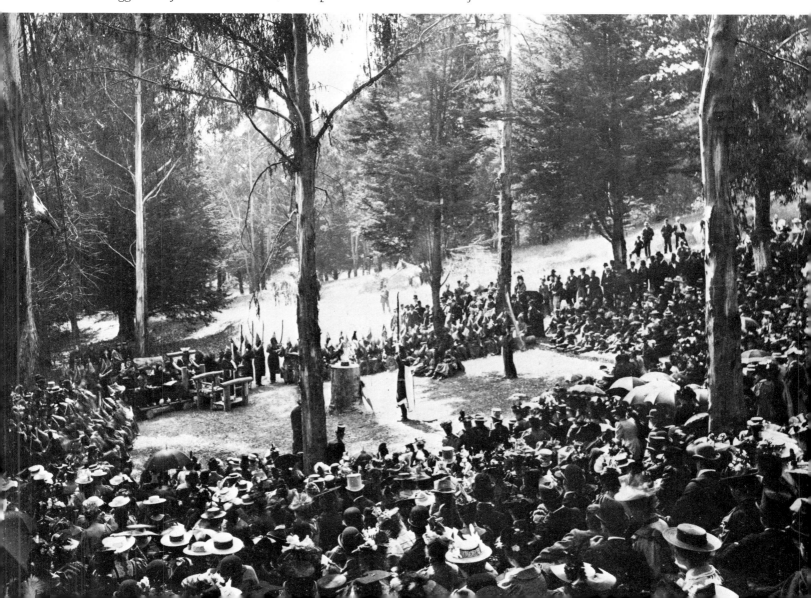

Plug hats distinguished the upperclassmen in the decades between 1880 and 1912. Junior plugs were gray, decorated to illustrate the owner's interests, then sat upon and kicked about until properly disreputable. Senior plugs were black, also crushed, but undecorated.

A Junior class in railway, highway, and canal engineering, in the field, accompanied by Frank Soulé, dean of the College of Civil Engineering.

The room of a student of the 1890's. His well-laden bookcase and large dictionary might proclaim him a "grind," but the faded black Senior plug on the gas fixture and the picture of his girl before him are reassuring.

In 1896, to dramatize the need for legislative funds for campus improvement, Regent Jacob B. Reinstein, '73, rallied the students to donate their labor on February 29 in landscaping the area around North and South Halls. So successful was the venture that it began the tradition of "Labor Day," a leap-year holiday on which the men students worked through the morning to better some part of the campus, the women prepared and served luncheon, and a dance closed the day.

Grading and finishing the paths around North Hall during the first Labor Day.

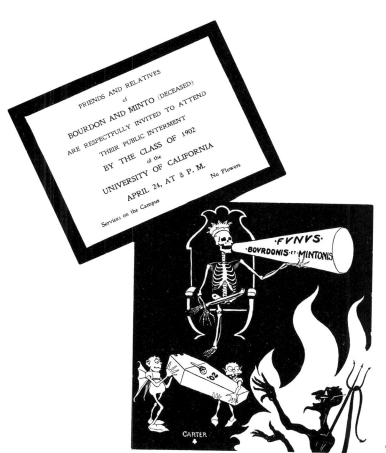

The burial of Bourdon and Minto, a ceremony conducted annually by the Freshmen between 1878 and 1903, celebrated the escape of the class at the end of the year from their bondage to Bourdon's *Elements of Algebra* and Minto's *Manual of English Prose Composition.* Copies of the textbooks were paraded about the campus in a coffin and then cremated in a roaring bonfire, after a funeral service which became more and more elaborate with the years. The resulting fracas, as the Sophomores sought to prevent the ceremony, became more and more rowdy. Serious injuries to participating students finally made it necessary for the University administration to forbid further celebration.

Formal invitations to the funeral ceremony were printed and mailed in black-edged envelopes.

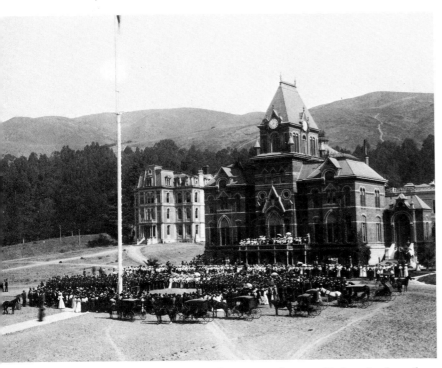

Faculty, students, and interested townspeople assembled at the flagpole before the Bacon Art and Library Building on October 3, 1899, to hear the first address of the University's new president, Benjamin Ide Wheeler. His concluding remark, "It has been good to be here," has become a byword in University history.

The Hearst Architectural Plan for the campus, adopted by the Regents in 1900, was one of the factors that turned the fortunes of the University decidedly upward at the beginning of the twentieth century. The need for a plan was suggested to Regent Reinstein by Bernard Maybeck, a young instructor in drawing at the University, later to become a famous architect. Reinstein talked in turn with Mrs. Phoebe A. Hearst, who had spoken of providing funds for a building in memory of her husband, Senator George Hearst.

In October 1896, Mrs. Hearst suggested to the Regents that she "be permitted to contribute the funds necessary to obtain by international competition plans for the fitting architectural improvement of the University grounds at Berkeley." The prospectus of the competition, published late in 1897, in English, French, and German, drew the attention of the world to the University. From 105 preliminary plans submitted at Antwerp, Belgium, 11 were chosen for the final competition in San Francisco. First prize went to Emile Bénard of Paris.

Modification and adaption of the Benard plan to the peculiarities of the campus site were made by John Galen Howard, who was appointed supervising architect of the University in 1903.

The Bénard plan. Note the architect's foresight as he extends the southern limits of the campus from curving Allston Way to Bancroft Way at Telegraph Avenue (center right), the northern limits across Hearst Avenue, and the eastern boundary into the hills.

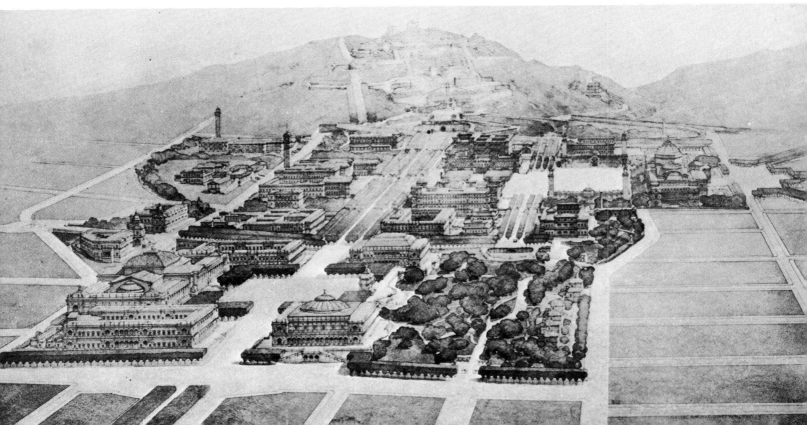

Ground was broken on May 12, 1900 for the President's House, first building to be started under the new architectural plan. At the ceremonies Mrs. Hearst, now a member of the Board of Regents, said, "It is particularly fitting that the first official act of helping toward the realization of our plan for a greater university should be the laying of a foundation for a home."

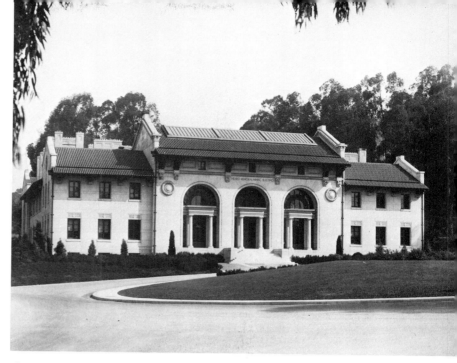

The Hearst Memorial Mining Building, a gift of Mrs. Hearst in memory of her husband, was the first academic building erected under the new architectural plan. It was completed in 1907.

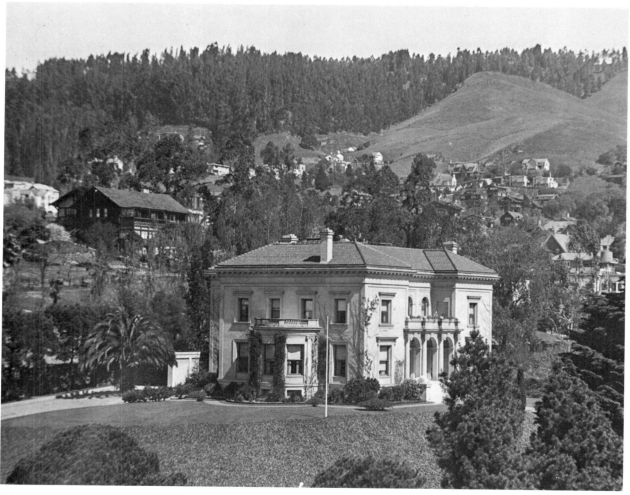

The President's House, renamed University House, is now the residence of the Berkeley chancellor.

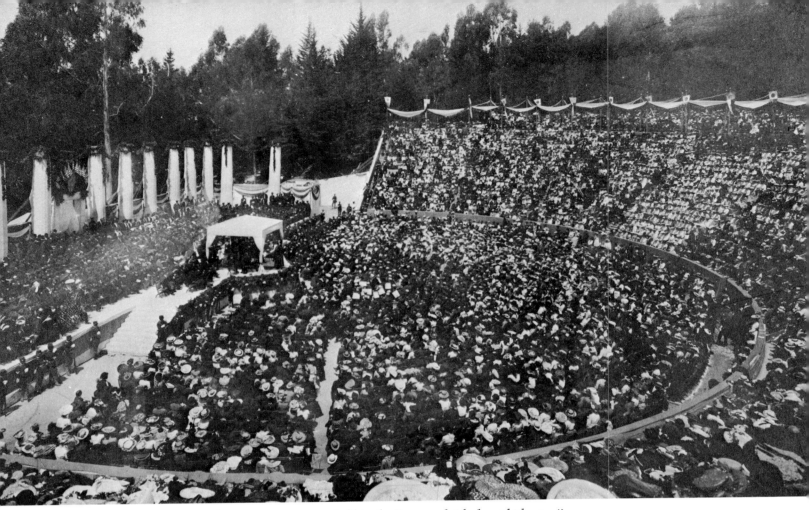

Commencement exercises of May 14, 1903 were held in the "new, unfinished amphitheatre."
Speaker of the day was Theodore Roosevelt, President of the United States.

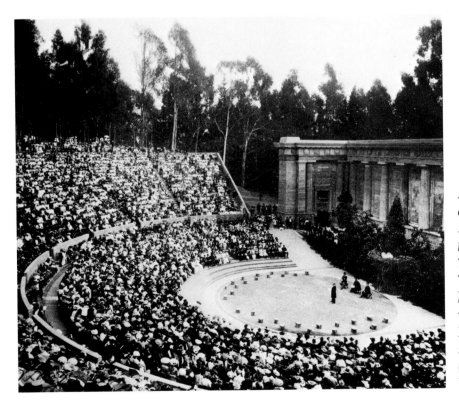

A dramatic festival lasting several days
dedicated the Greek Theatre in September 1903.
A gift of William Randolph Hearst, it was the
first structure completed under the Hearst Plan.
The opening performance of Aristophanes'
The Birds, presented in the original Greek
by a student cast directed by Professor James T. Allen
was preceded by dedicatory exercises at which
President Wheeler (seated center) presided;
speakers were architect John Galen Howard
(standing), Hearst (seated left), and Benjamin
Weed, '94, discoverer of the site (seated right).

The "golden age" of the Greek Theatre began in 1905, with the establishment of a Department of Music and the appointment of a Musical and Dramatic Committee chaired by William Dallam Armes, assistant professor of English literature. Armes brought to the Greek Theatre the foremost actors and musicians of the day—among them Sarah Bernhardt, Margaret Anglin, Maude Adams, Madame Schumann-Heink, Tetrazzini, and the New York Symphony Orchestra. Armes died in 1918, the year after he was appointed director of the Greek Theatre, and was succeeded by Samuel J. Hume, '07, assistant professor of dramatic art and literature. Beside carrying on the tradition of great professional performances in the Greek Theatre, Hume developed, together with Irving Pichel, the Greek Theatre Players, a student group that became noted for its performances on the Wheeler Hall stage as well as those out-of-doors. After Hume resigned in 1924, a change in administrative policy for the Greek Theatre brought about a decline in its use.

The English Club, which was founded in 1903 as a literary organization, began in 1906 the annual production in the Greek Theatre of a play of high literary merit. The play chosen in 1911 was Stephen Phillips' Paolo and Francesca. In the leading lady, Barbara Nachtrieb, '12, now Mrs. Barbara N. Armstrong, students of law since the 1930's will recognize their noted Morrison Professor of Municipal Law.

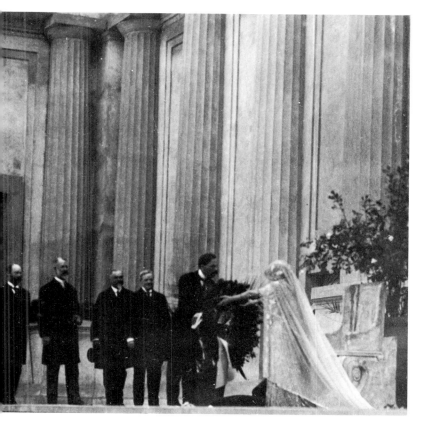

Following the performance of Racine's Phèdre in the Greek Theatre on May 8, 1911, Sarah Bernhardt received a laurel wreath from Henri Mérou, consul-general of France in San Francisco. With the consul were Professors William D. Armes (English), Melvin Haskell (mathematics), and Edmond O'Neill (chemistry) of the Musical and Dramatic Committee, and Professor Lucien Foulet of the French Department, who made an address of welcome.

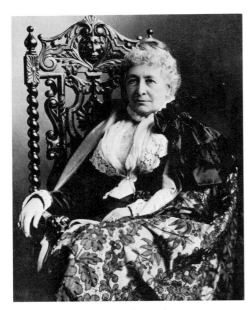

A generous donor of the early 1900's was Mrs. Jane Krom Sather, widow of Peder Sather, one of the first San Francisco bankers. Sather Gate and Sather Tower, or the Campanile, are the best known of her many gifts.

White granite blocks from California's Sierra Nevada lay about in confusion as Sather Gate, a gift of Mrs. Sather in memory of her husband, and the new Charles Franklin Doe Memorial Library began to take shape in the fall of 1909.

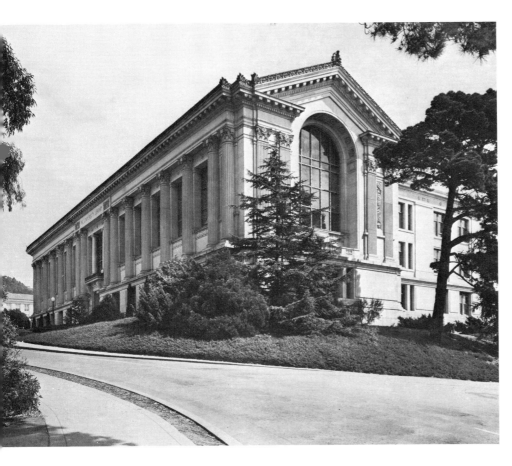

The Charles Franklin Doe Memorial Library, erected with funds from the estate of a San Francisco businessman, was occupied in the summer of 1911. It is the center of a library complex numbering some 3,300,000 volumes housed here and in twenty branch libraries about the campus.

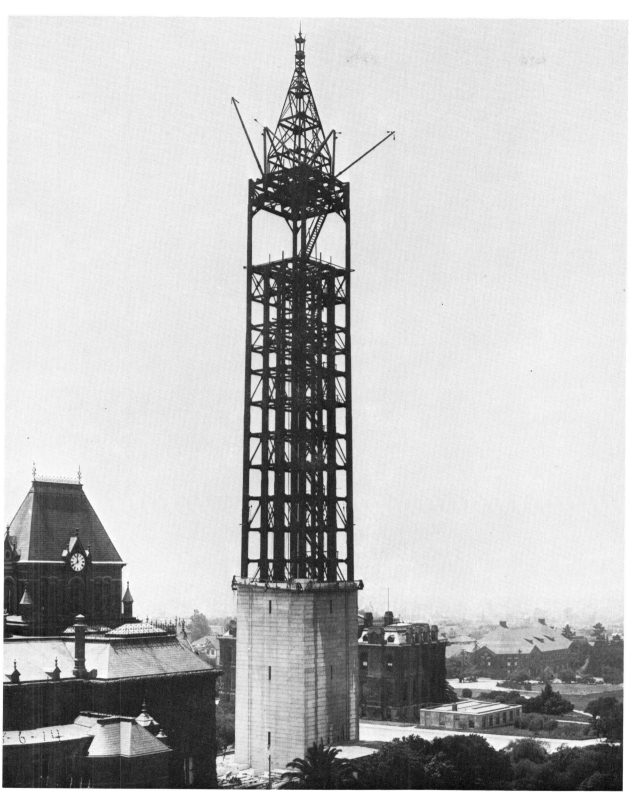

The Jane K. Sather Tower, known as the Campanile for its resemblance to the campanile of St. Mark's Plaza in Venice, took its place as Berkeley's chief landmark in 1914. In 1927, more than a decade later, two epochs of campus history were united when the tower of Bacon Hall (left), was removed and the mechanism of its clock was transferred to the Campanile, where it continues to strike the hours as it has since 1881.

The great distinction of the University in the chemical and physical sciences began with the appointment of Gilbert Newton Lewis as professor of chemistry and dean of the College of Chemistry in 1912. A brilliant scientist with a wide range of interests, encompassing mathematics and theoretical physics as well as chemistry, he recruited and led a faculty and attracted graduate students whose research laid many of the foundations for the advance into the atomic age. He was given numerous honors and awards, but perhaps would have been most gratified had he lived to see four of his graduate students—Harold Urey, Willard Libby, William Giauque and Glenn Seaborg—become Nobel laureates.

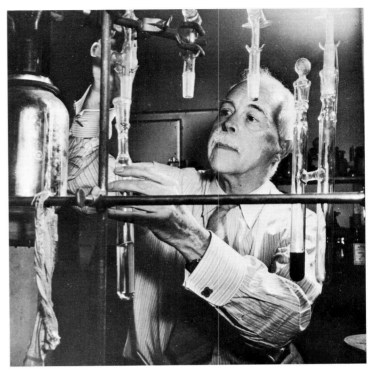

In 1941, Gilbert Lewis retired from the deanship of the College of Chemistry to devote more time to research.

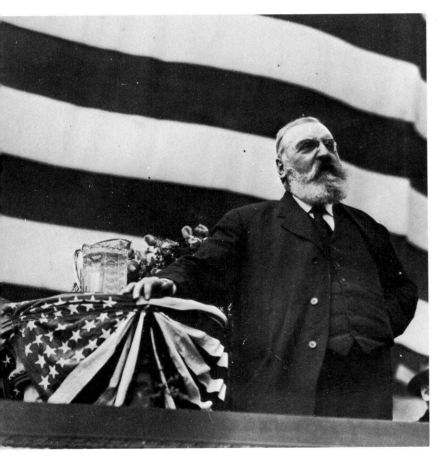

Few faculty members have been as widely known throughout the campus as Henry Morse Stephens, professor of history from 1902 until his death in 1919. First director of the Bancroft Library and a vigorous speaker who brought history to life for generations of Freshmen, he welcomed each incoming class at the Freshman Rally and bade it good-bye from South Hall steps on its Senior Pilgrimage

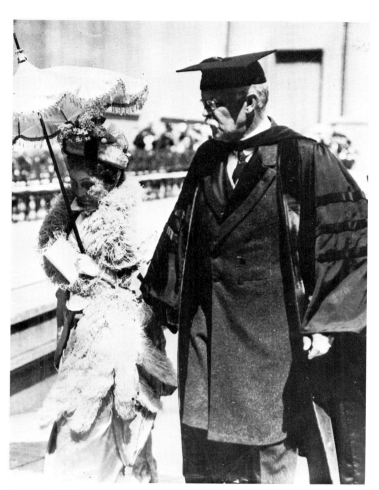

Women students had no gymnasium or recreational facilities until 1900, when Hearst Hall was completed. Designed by Bernard Maybeck, the building stood on the west side of College Avenue some two hundred feet north of Bancroft Way, on land now incorporated into the campus. An adjoining outdoor swimming pool and playing field were added in 1911. The destruction of Hearst Hall by fire in 1922 left a great void in campus life, for it had become a popular place for evening social events.

Undamaged by the fire, the swimming pool and playing field were used by women students until 1927, when William Randolph Hearst, in memory of his mother, built the Hearst Gymnasium for Women on another site. From 1934 until 1955, when the site was cleared for Wurster Hall, the former swimming pool was used as a hydraulic basin for engineering research in beach and harbor erosion.

Regent Phoebe A. Hearst and President Benjamin Ide Wheeler led the academic procession on commencement day, 1913.

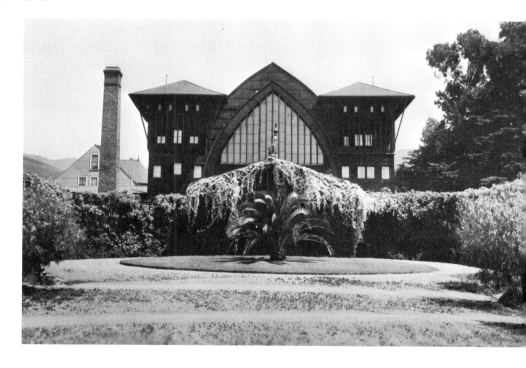

Hearst Hall about 1905, before the chimney was removed and an addition for showers and dressing rooms was built on the left.

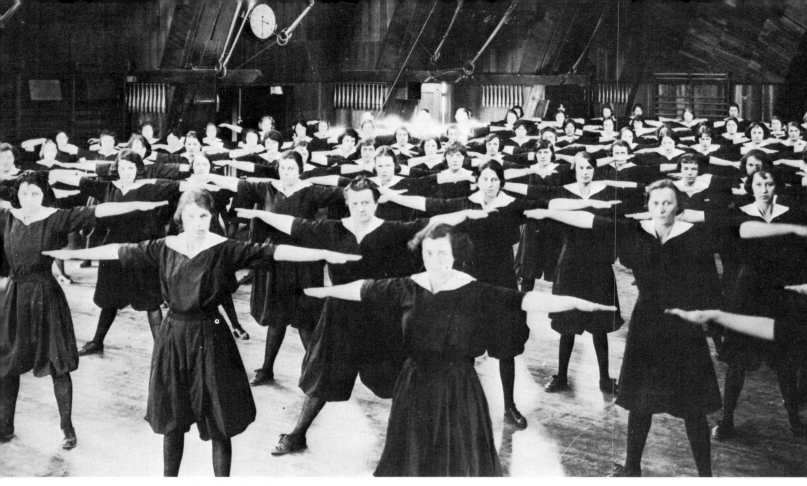

Physical education, which had long been required of Freshman and Sophomore men, became compulsory for lower-division women in 1901, and the sunlight filtered down on many a black-bloomered, Ground-Gripper-shod class like this before the gymnasium burned.

The Partheneia, a dramatic masque written and produced by four or five hundred women, was an outstanding tradition of the spring semester for twenty years. Miss Lucy Sprague, first dean of women, initiated the pageant in 1912 to give the girls the opportunity they then lacked for creative expression in student-sponsored productions. First held among the oaks near the eucalyptus grove, it was moved to Faculty Glade to allow for larger audiences. Like a number of other events, the Partheneia faded from the campus during the depression of the 1930's.

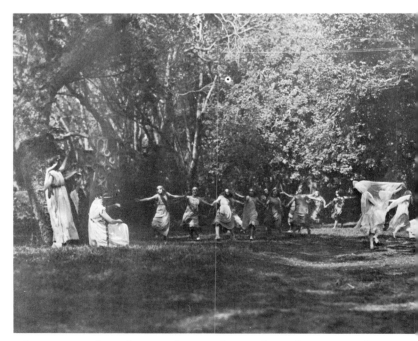

The Dream of Derdra, Partheneia *of 1914, by Helen M. Cornelius, '14.*

On the morning of February 29, 1916, some 2,500 students armed with picks and shovels spread along a prearranged route to the Big C, symbol of California's spirit built in 1905 by the Freshmen and Sophomores. Two hours later a trail six feet wide had been cut, leveled, paved with gravel, and provided with drains and bridges. Still in use today, it serves as a memorial to the vanished tradition of "Labor Day."

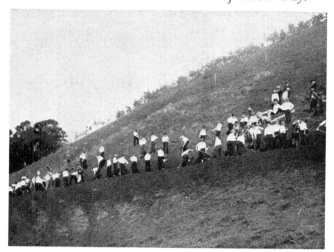

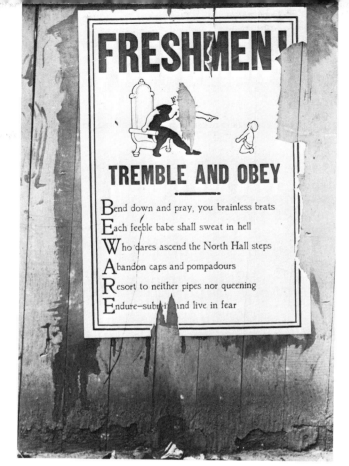

For many years the University was no exception to the time-honored collegiate tradition of hazing Freshmen. Sophomore posters outlining expected behavior greeted each incoming class from walls and telephone poles.

Looking north along Telegraph Avenue from Durant Avenue to Sather Gate in 1915. The block from Bancroft Way (marked by the hanging sign) to the gate is now part of the campus, covered by the Student Union, Sproul Plaza, and Sproul Hall.

During the first two decades of the University's existence, football was confined to inter-class matches and games with local athletic clubs. There was little excitement and scant notice in the press. All this changed radically with the establishment of Stanford University in 1891 and the holding of the first "Big Game" between Stanford and California on March 19, 1892. The game drew a record crowd to the field at Haight and Stanyan Streets in San Francisco. In the excitement, no one brought a football, and the game was delayed while someone went downtown to buy one.

In 1904, California dedicated her own on-campus California Field (now the site of Hearst Gymnasium and the women's playing fields). The Big Game that year, held at Berkeley, was rough, as was that of 1905, at Stanford. There were serious injuries, and Presidents Jordan and Wheeler decided to abolish the American game. From 1906 to 1914 the two universities played rugby instead.

Relations were broken with Stanford in 1915, when she objected to the rule barring Fresh-men from varsity games. California returned to American football, and from 1915 to 1917 the Big Game was played with the University of Washington.

Service teams on the two campuses, playing American football, brought Stanford and California together again in 1918, during World War I. The next year Stanford accepted the Freshman-eligibility rule and joined the Pacific Coast Conference. Except for an interruption during World War II, the long series of Big Games has remained unbroken since that time.

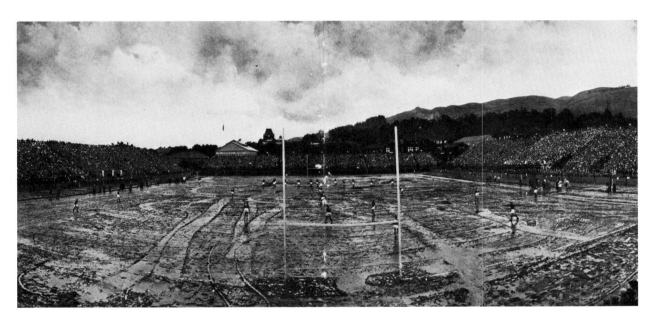

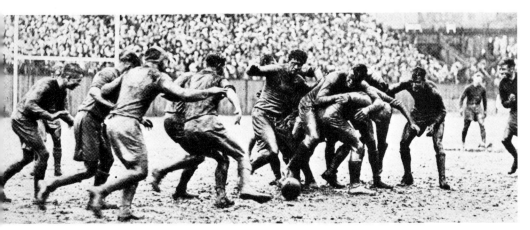

The Big Game of 1912—the famous mud game on California Field, ending in a 3–3 tie. It always remained a mystery how the officials or the players themselves knew one man from another after the first few minutes. Rains, which had lasted for several days, continued until an hour before kickoff. Those present would long remember the roar of laughter that greeted the first unfortunate player who slipped—in his crisp white rugby shorts.

The origin of card stunts between halves of a football game can be traced to the Big Game of 1908, when both rooting sections appeared in white shirts with rooter caps of one color on the outside and another color on the inside. By reversing the caps, simple designs such as block letters were displayed. At the Big Game of 1914, sets of stiff cards of varying colors were given to each Berkeley rooter, and the first effective, clear-cut patterns were produced.

The national flag waved in the rooting section between halves of the 1915 game against Washington, symbolizing the return to American football after nine years of rugby.

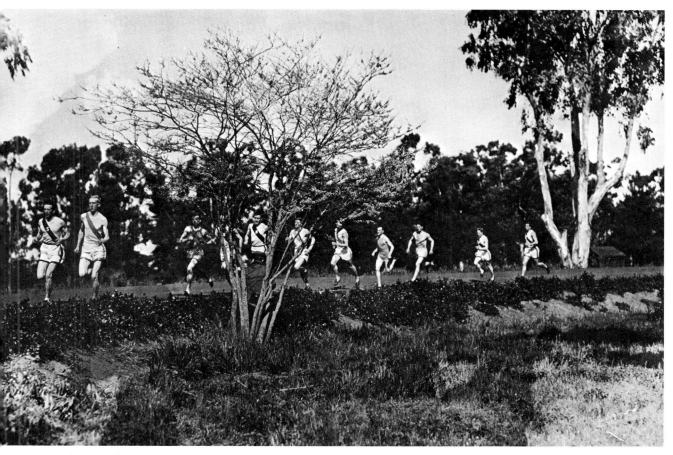

Matching strides with Stanford in the two-mile run is Robert Gordon Sproul (second from left), a member of the class of 1913 and a two-year letterman in track and field.

The tradition of the Golden Bear began in 1895, when the track team of that year invaded the East, becoming the first University of California athletes to compete outside the state. At each meet they displayed blue silk banners with the word "California" and a grizzly bear embroidered in gold thread. The team was spectacularly successful, and upon its return students, faculty, and townspeople gathered at the Berkeley train station for a jubilant welcome. Watching the team's banners, Charles Mills Gayley, professor of English, was moved to compose the lyrics of "Our Sturdy Golden Bear," with its concluding verse:

> Oh, have you seen our banner blue?
> The Golden Bear is on it too.
> A Californian through and through,
> Our totem he, the Golden Bear!

The symbolism caught on at once, and the Golden Bear became the guardian of the University of California and her athletic teams.

The track team of 1895.

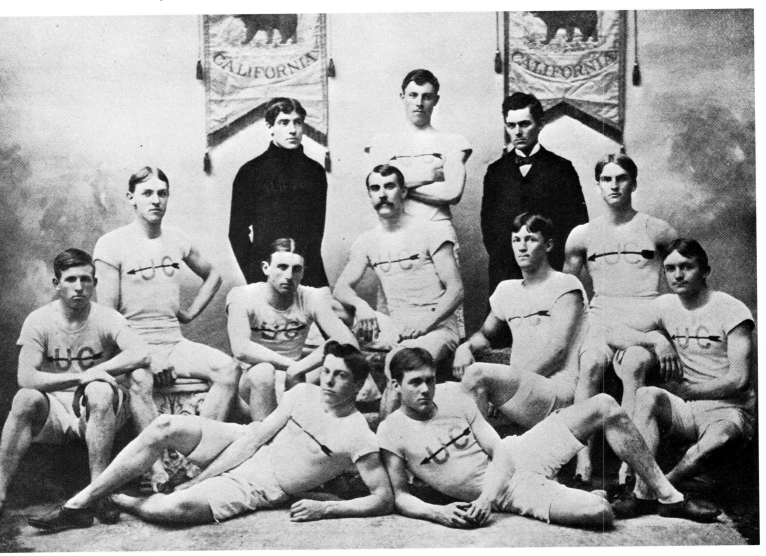

The Stanford Axe, a fifteen-inch steel blade mounted on a four-foot handle, made its first appearance in the Stanford rooting section during a baseball game in San Francisco on April 15, 1899. At the end of the game a group of Californians wrested the axe from its Stanford guardians and succeeded in outdistancing all pursuit. The handle was sawn off in a butcher shop and the blade, wrapped in butcher paper, was deposited near the solar plexus of one of the group who had managed to keep up even though he was wearing an overcoat.

Getting the axe onto a ferryboat, the only means of transportation across the bay, was a problem, since Stanford had enlisted the help of the San Francisco police in guarding the gates. It was solved when the bearer of the axe recognized a young woman acquaintance approaching the Ferry Building. As her escort, he walked peacefully past the guards and onto the boat.

The axe remained in a bank vault in Berkeley for thirty-one years. Stanford's attempts at rescue were unsuccessful until the evening of April 3, 1930, when the axe was being returned to the vault, under guard, after the annual Axe Rally. A Stanford student posing as a newspaper photographer ignited a quantity of flashlight powder; a companion tossed a tear-gas bomb among the California guardians; and still others of the group grabbed the axe and rushed it to a waiting car. In Stanford custody, the axe remained hidden in a bank vault until 1933, when cooler heads among the alumni of both institutions suggested the axe be made a football trophy to be awarded annually to the winner of the Big Game.

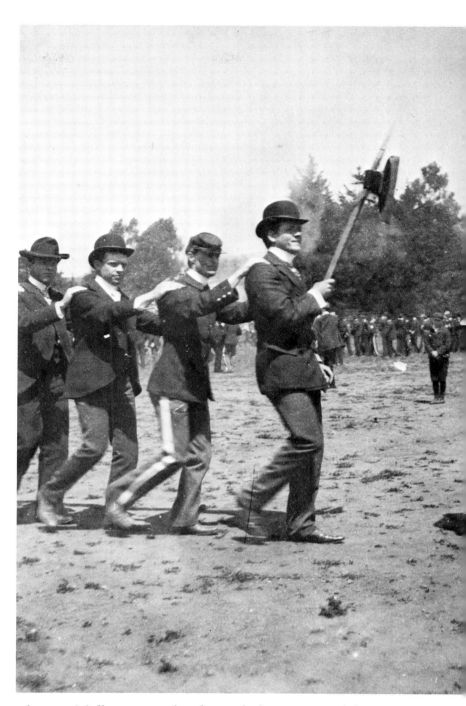

Classes and drill were ignored as the Stanford Axe was paraded about the campus April 17, 1899, the Monday following its capture. Holding it triumphantly aloft was Charles A. "Lol" Pringle, '01, football tackle and first custodian of the axe.

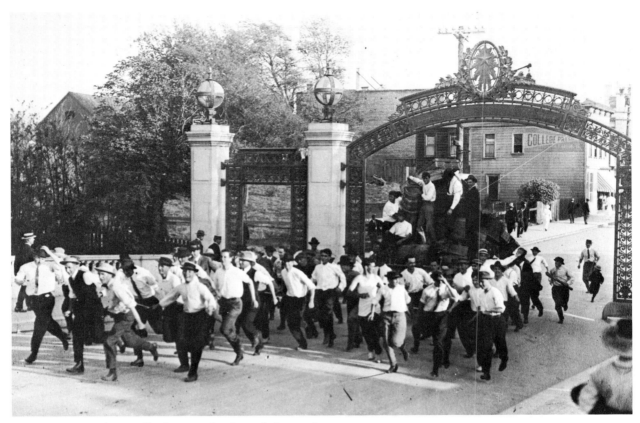

Gathering wood for a rally fire was the duty of the Freshmen, who in 1917 brought a big haul through Sather Gate.

Rallies on the eve of athletic events developed when intercollegiate competition, particularly with Stanford, began in 1892. Originally, bonfire rallies were held on the athletic field, a site now covered by the Life Sciences Building. Men's smoker rallies were held in the original Harmon Gymnasium; women held rallies in Hearst Hall. The bonfire rallies were moved to the Greek Theatre after its completion in 1903. Some of them, such as the Freshman Rally, the Pajamarino, and the Axe Rally, became annual events.

Before World War II, the bonfire rallies were masculine affairs. The men gathered by class outside the theater and serpentined into place about the fire. Women students sitting with the audience above the diazoma joined in singing California songs, but otherwise did not participate.

From its beginning in 1901 until World War II, the mid-October Pajamarino Rally featured a skit competition among classes. The pajama-clad men sat closely about the fire, with Sophomores to the north, Seniors next, then Juniors, and finally Freshmen opposite the Sophomores. The women cheered their favorites as each class performed.

Today, the form of the rally has changed. The Rally Committee arranges the entertainment, both men and women participate, and a mixed audience sits both at the fireside and on the steps above.

On the night of each Axe Rally, the Stanford Axe was brought from the bank under escort and displayed while alumni who had taken part in its capture retold the story. The rally was held before the Big Game until 1916. From then until 1930, when Stanford recovered the axe, the rally took place in the spring before the Stanford-California baseball series began. A rally continued to be held before each Big Game, however, and it now becomes the Axe Rally in years when California has the axe.

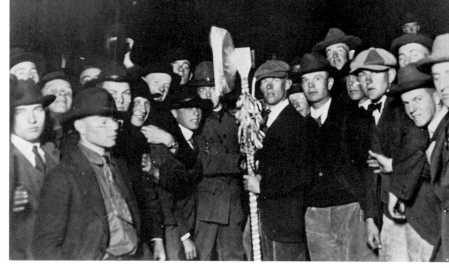

Escorted by a group of Freshmen, Bill Hudson, '19, baseball captain and custodian of the Stanford Axe, brought the trophy into the Greek Theatre for the Axe Rally, where guardianship was transferred to Harold Dexter, '20 (right of Hudson), baseball captain elect.

The Senior class of 1915 serpentines its way toward the stage for its skit.

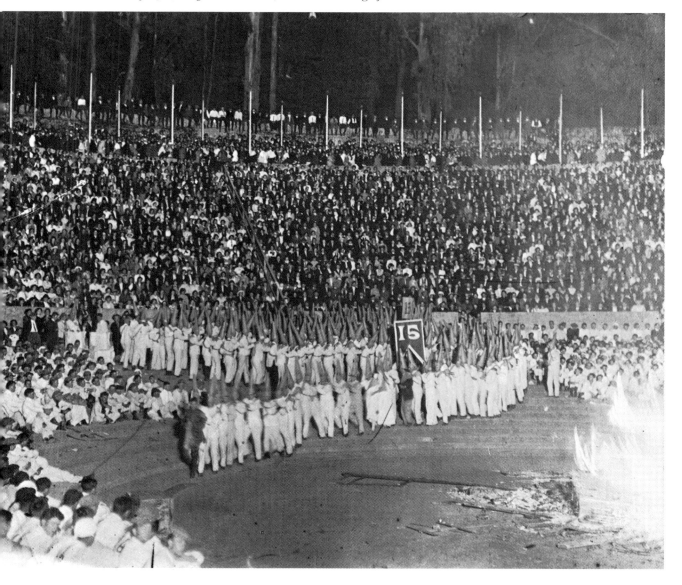

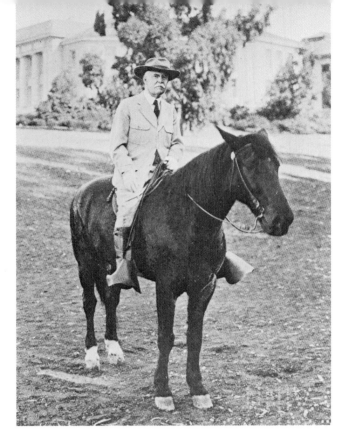

His desk cleared for the day, President Wheeler often mounted his horse and rode about the campus, stopping to watch athletic teams at practice or to chat with a student. Folklore claims the horse was white, but all extant photographs show a dark horse.

North Hall, second of the two first buildings, was the center of student life from its opening in 1873 until its condemnation as worn-out and unsafe in 1917. Home of the humanities, its basement floor contained the student store, the "joint" where the men could find refreshment (unneeded apparently by the women), the rooms of the student publications, and the student-body offices. The south stairs, sacred as the lounging place of the men of the three upper classes, overlooked the sheltered Senior Bench, where the lordly ones met to discuss campus affairs and to "pipe the flight" (watch the girls go by).

The advertisement for Candida *over the entrance to the student store dates this picture of North Hall as of February 1911. The mail truck with its white horse was as familiar a sight as the conservatory in the distance.*

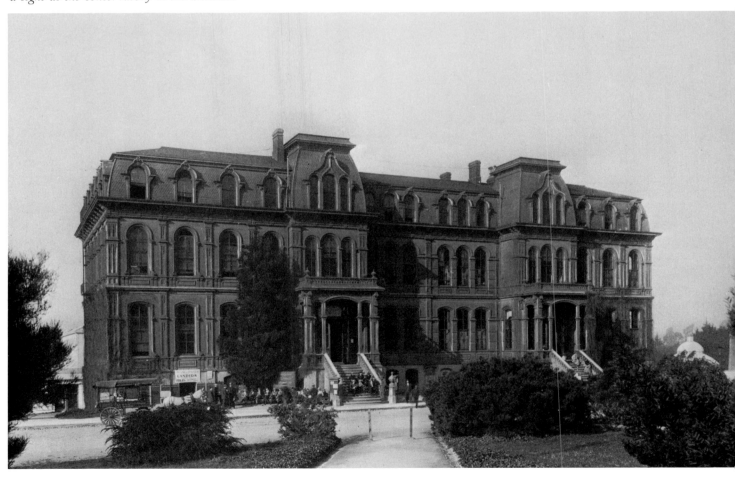

1869-1917
The Center of University Life for Fifty Years.

North Hall Farewell

Alumni, Faculty, Members of Graduating Class, and Friends
of the University of California will participate in
a Ceremonial Farewell to the Historic
Building following the

Commencement Luncheon

THE LUNCHEON WILL BE HELD IN THE FACULTY GLADE
IN STRAWBERRY CANYON AT 12:30 P.M.,
ON COMMENCEMENT DAY

Wednesday, May 16, 1917

The usual speakers' programme will be omitted. After the
annual business meeting of the California Alumni Association
the assemblage will form in procession, and led by the band,
will march through the Campus to North Hall Steps, where
the farewell ceremonies will be conducted. The wreckers will
begin the destruction and the pilgrimage will proceed to
Wheeler Hall where a reception and reunion will take place.

Annual Meeting of Alumni Association

which will take place at the luncheon will consist of the
election of officers and a review of the annual reports.

The enclosed luncheon ticket should be returned at once,
accompanied by check covering same, at price of 75 cents a plate.

*Special reunions will be held by the Classes of 1877, 1879, 1892,
1897, 1901, 1907, 1912.*

*North Hall is the only campus building to have been demolished with
ceremony. On May 16, 1917, some seven hundred alumni assembled to hear
farewell speeches and see President Wheeler strike the blow that
toppled the railing of the North Hall steps, "the shrine of
those who would loaf and invite their souls."*

*Uniformed students of World War I met for coffee
breaks in the roofed-over basement of North Hall,
which continued to house student activities until
the building of Stephens Memorial Union in 1923.
Later the Naval ROTC occupied the structure, until
the land was cleared in 1933. The University
library (background) was expanded in 1949 to occupy the
site. The wartime band in the foreground played for
parades of the School of Military Aeronautics (white
hatbands) and the Students' Army Training Corps.*

With the entrance of the United States into
World War I in April 1917, the campus was
almost completely taken over by the military.
On the open ground around the eucalyptus
grove, and on the swale opposite the University
Library, the male students lived in barracks
and tents under military discipline, in the uni-
forms of the School of Military Aeronautics,
the Students' Army Training Corps, and vari-
ous Navy units.

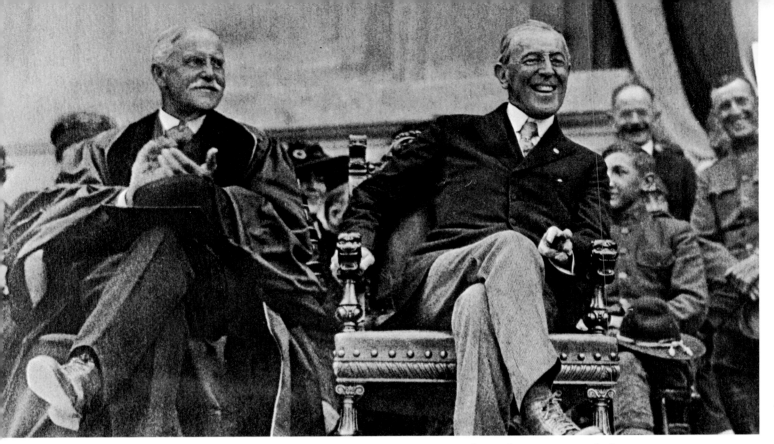

Woodrow Wilson, President of the United States, accepted the invitation of President Emeritus Wheeler to visit the University while touring the country on behalf of the League of Nations in September 1919. Hoarse and weary from speech-making, he had not planned to make an address, but the tumultuous welcome from the "little league of nations" filling the Greek Theatre moved him to respond briefly.

The first "Associated Students of the College of Letters and the Colleges of Science of the University of California," a title soon reduced to "Associated Students of the University of California," was formed in 1887 in response to the need for control over the conflicting interests of numerous independent student societies that had sprung up on the Berkeley campus. In 1905, with the encouragement of President Wheeler, a form of student self-government related more to self-discipline and control than to activities management was inaugurated. Senior committees of the ASUC determined rules for campus conduct and advised the president and faculty with regard to student discipline. This "Senior control" was successful for twenty years—until classes began to be too large for most of the members to know each other.

With the acquisition in 1923 of its first building, the Henry Morse Stephens Memorial Union, the ASUC reorganized and adopted a new constitution, which placed the business affairs of the association under a salaried general manager and created activities councils whose chairmen sat on an executive committee together with elected class representatives and ASUC officers. Essentially, this form of organization has been maintained since then, although there have been changes as the association has developed into a business with a revenue from all sources exceeding three million dollars annually.

The "Senior sombrero" marked the most active period of Senior control in student self-government. A stiff-brimmed felt hat of the sort worn by forest rangers, it was encircled with a leather band carved in a pattern of California poppies and bears, with the name "California" and the class year across the front. Initiated by the class of 1913, the sombrero was worn widely until the late 1920's, when it became fashionable for men to go hatless on informal occasions.

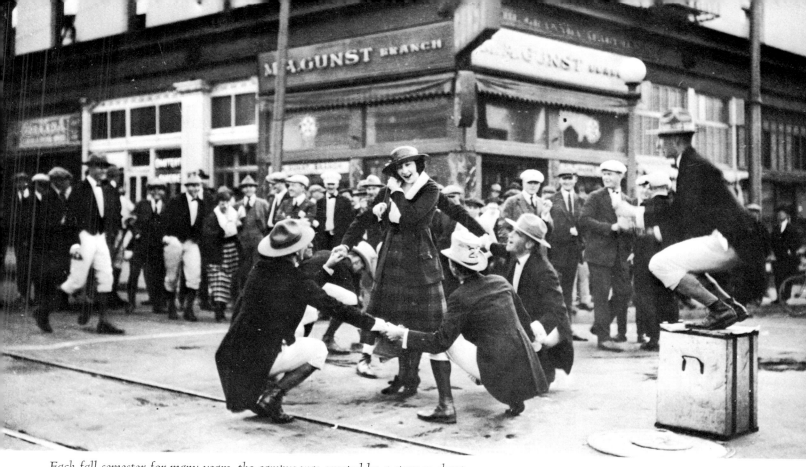

*Each fall semester for many years, the campus was greeted by a strange chant—
"Who—who—who are we? Loyal Skull and Key!"—recited by prominent
upperclassmen even more strangely clad in full dress coats, white trousers rolled to the
knee, and varicolored hose along with their Junior plugs and Senior sombreros.
Neophytes of the Skull and Keys Society, a men's upper-division social honor society
founded in 1892, they spent the morning playing children's circle games, diverting traffic
at Bancroft and Telegraph, and escorting apprehensive coeds along the city block from
Bancroft Way to Sather Gate, under the supervision of white-capped members of the
society. Although still in existence, the society no longer conducts a public initiation.*

Graduating classes from the 1890's onward
said farewell to well-known campus spots in
a colorful Senior Pilgrimage. The women dressed
in white and carried white parasols tied with
red or green ribbon, according as the class
year was even or odd; the men wore white
trousers, dark coats, and straw hats (later
Senior sombreros). The tradition began to fade
during the Depression, for many students could
not afford the special dress. Along with other
traditions, it faded still more during World
War II and the period of "GI" enrollment that
followed. Only a handful of Seniors, clad in
cap and gown, continue to make the Pilgrim-
age and gather at Sather Gate to sing "All
Hail."

*The Class of 1921 in front of Wheeler Hall
on its Pilgrimage.*

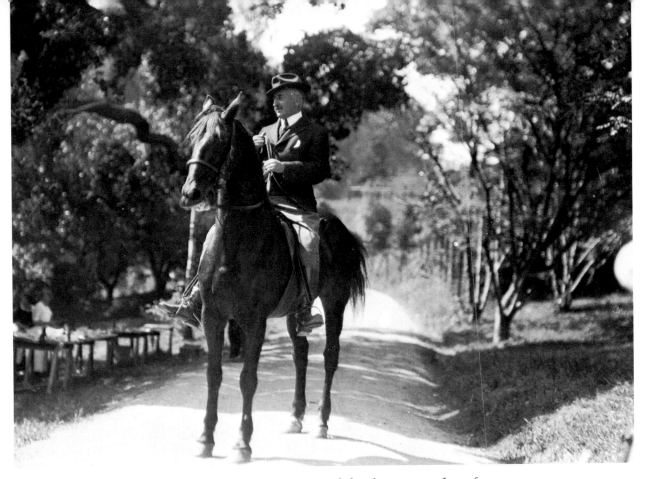

David Prescott Barrows, professor of political science at Berkeley, became president of the University in 1919 and served until 1923. A devoted horseback rider, as he appeared at the tenth reunion of the class of 1912 in the glade at the entrance to Strawberry Canyon.

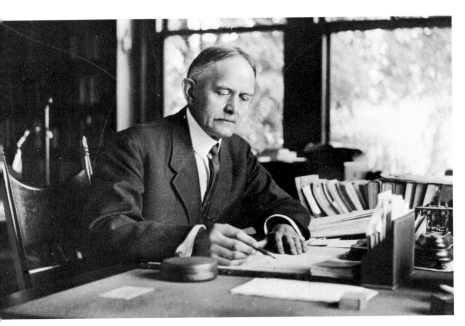

In 1923 William Wallace Campbell, director of the Lick Observatory since 1901, was elected president of the University. While retaining his directorship, he served as president for seven years, retiring in 1930.

Charles Mills Gayley, professor of the English language and literature from 1889 to 1923, was an able and inspiring teacher and a leader in academic affairs. The immensely popular literature classes that he conducted especially for the University's engineering students were one evidence of his belief in a rounded education for every student.

The first official division of the duties of the president was made in 1923, with the creation of the office of dean of the University. Walter Morris Hart, professor of English (right), standing with President Campbell, was appointed to the office. In 1925 two vice-presidencies were added. Dean Hart was given the additional title of vice-president in charge of academic matters; the title of vice-president in charge of business affairs was added to those of comptroller, secretary of the Regents, and land agent already held by Robert Gordon Sproul.

September 17, 1923 dawned unusually hot and dry, with the complication of a fierce north wind. During the morning a high-tension wire broke in the hills above the northern section of Berkeley, starting a grass fire. Driven by the wind, the fire quickly became a holocaust sweeping down upon the houses below. The wind shifted to the west in the late afternoon, blowing the fire back upon itself, but not until one third of the city lay in ashes. Although the campus itself (right) was untouched, faculty members living in the burned area lost not only their homes, but priceless collections of research materials and manuscripts still in process.

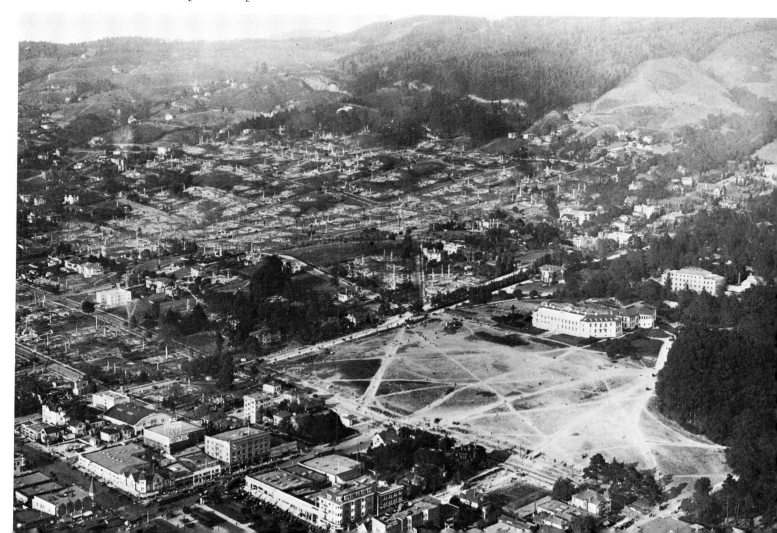

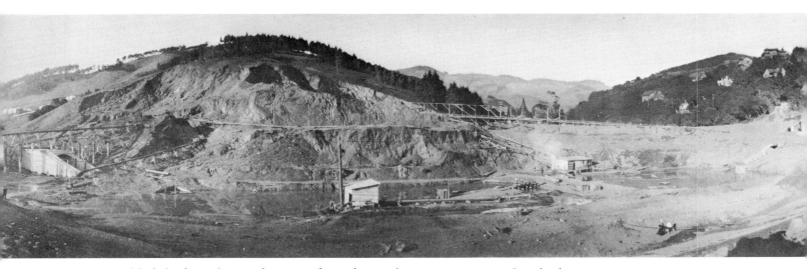

A beautiful glade alongside Strawberry Creek was lost to the campus in 1922, when the decision was made to locate the California Memorial Stadium at the entrance to Strawberry Canyon. The creek was diverted into a large culvert running diagonally northwest under the playing field, and the foundation embankment for the seats was formed with material excavated from the shoulder of Charter Hill.

The 1920 football team—the greatest college team of all time in the estimation of the Helms Athletic Foundation—just before its 38–0 Big Game victory. First and most famous of Coach Andy Smith's "wonder teams," this team scored 510 points for the season against 14 for its opponents, climaxing its record with a 28–0 victory over Ohio State in the Rose Bowl in January 1921. Left to right are Harold P. "Brick" Muller, Robert A. "Bob" Berkey, Jesse B. "Duke" Morrison, Charles F. "Charlie" Erb, Albert B. "Pesky" Sprott, Irving S. "Crip" Toomey, Dan A. McMillan, Stanley N. "Stan" Barnes, Lee D. Cranmer, George H. "Fat" Latham, and Captain Cort Majors.

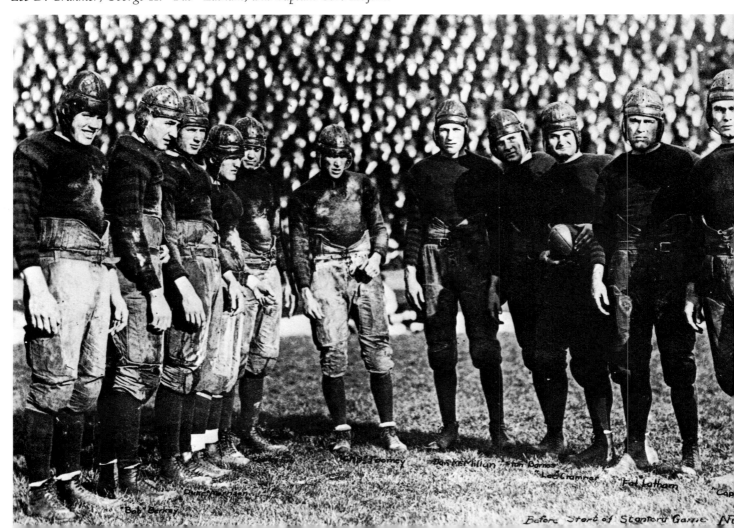

Coaches of the "wonder team" era in football, the five seasons
of 1920 to 1924, during which the Golden Bears, undefeated,
scored 1,564 points to their opponents' 146. Left to right are
Andrew L. "Andy" Smith, head coach, and Assistant Coaches
Clarence M. "Nibs" Price, '14; Walter A. Gordon, '18; and Albert
Boles. (Gordon, a tackle, was the first Californian to be
considered by Walter Camp for All-American rating; he was placed
on Camp's third team in 1918. Forty years later, Gordon was
appointed judge of the District Court of the Virgin Islands, after
serving three years, 1955–58, as governor there.)

"Brick" Muller, right end of the 1920 "wonder
team," was the first player west of the Missis-
sippi to be named a first-team All-American.
He and four other Golden Bear players and
coaches have been named to the National Foot-
ball Hall of Fame: Coaches Andy Smith (1916–
25) and Lynn O. "Pappy" Waldorf (1947–56);
Stanley N. Barnes, left tackle of the 1920 "won-
der team"; and Bob Herwig, All-American center
in 1936 and 1937.

The Helms Athletic Foundation Hall of Fame
has honored these five and four others: Vic
Bottari, All-American halfback in 1938; Rod
Franz, All-American guard in 1947, 1948, and
1949, the only three-year All-American from
the West Coast; Bob Reinhard, All-American
tackle in 1940 and 1941; and Joe Verducci, var-
sity quarterback in 1933, later coach and ath-
letic director at San Francisco State College,
who was selected for his contributions to inter-
collegiate football.

Between 1909 and 1936, three Berkeley coeds—
Hazel Hotchkiss, '11, Helen Wills, '27, and
Helen Jacobs, '30—first as students, then as
alumnae, won a long succession of tennis titles.
During her undergraduate years, 1909–11,
Hazel Hotchkiss held national championships
in singles, doubles, and mixed doubles. In
1924 Helen Wills, then a Freshman, won the
national and international singles titles, and
paired with Mrs. Hazel Hotchkiss Wightman,
by then the mother of four, to win both the
national and international doubles titles.
Finally they emerged from the 1924 Olympic
Games, held in Paris, as world champions,
Helen Wills in singles and doubles and Mrs.
Wightman in doubles. Helen Jacobs was run-
ner-up for the national singles title in 1928,
won the title in 1931, and held it through 1935.
In 1934 and 1935, she was also co-winner of
the national women's doubles, and in 1936 she
won the women's singles at Wimbledon.

Fine tennis players at Berkeley have not been

confined to women. Edward Chandler, '26,
brought the University its first national col-
legiate singles championship in 1925, and in
1926 he again won the singles title and teamed
with Tom Stow, '28, to capture the doubles
crown. More recently there have been others,
among them Tom Brown, '43, Bill Hoogs, '63,
and Jim McManus, '64.

Helen Wills in 1924.

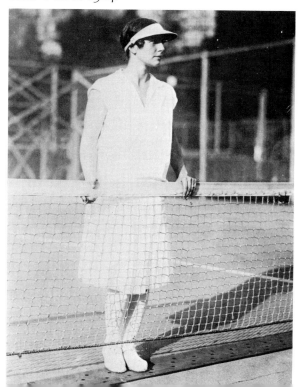

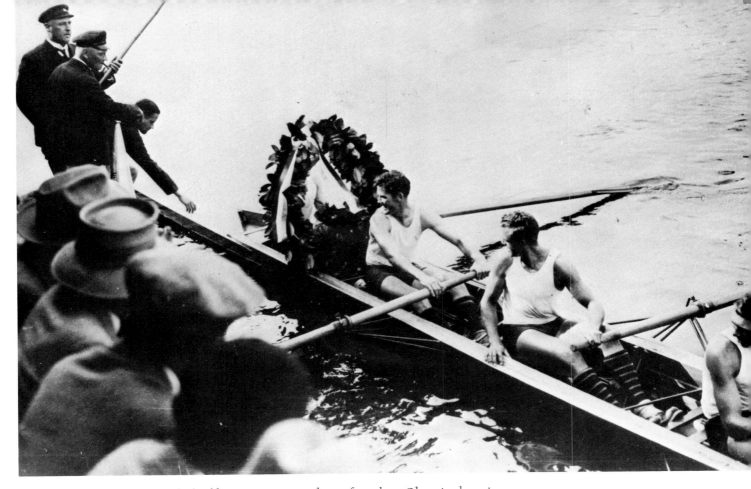

Among Berkeley's most cherished athletic victories are those of its three Olympic champion crews. Here the first receives the wreath of victory at Amsterdam, in 1928.

When the Olympic championship crew of 1928 returned to Berkeley, a holiday was declared, and a jubilant student body escorted its heroes to an overflow meeting of welcome in the Greek Theatre.

Carroll M. "Ky" Ebright, a Washington coxswain, came to Berkeley in 1924 and served as Golden Bear crew coach for twenty-five years. He is the only coach in the world whose crews have won more than one Olympic championship. Following Amsterdam in 1928, the Bears won again at Long Beach in 1932 and London in 1948. Ebright was named to the Helms Athletic Hall of Fame in 1956, and the crew boathouse on the Oakland estuary is named in his honor.

The victories of the 1895 track team were the first of many outstanding achievements by Golden Bear athletes in track and field: Eddie Beeson's high jump of six feet seven inches in 1913; the mile and two-mile relay teams of 1941; Grover Klemmer's world's record four hundred meters in 1941; Leamon King's hundred-yard and hundred-meter dashes in 1956; Don Bowden's four-minute mile in 1957; the two-mile relay team of 1958; Jack Yerman's four-hundred-meter run in 1960; and numerous others.

Walter Christie, track and field coach from 1900 to 1932. In Edwards Stadium in May 1963, members of teams he coached during three decades at Berkeley dedicated a stone bench in his memory. Engraved upon it are the words of his motto, "My heart and soul for California."

California's first individual gold-medal winner in Olympic track and field competition was Archie Williams, '40, who at Berlin in 1936 set a world record of 46.1 seconds in the four-hundred-meter run.

Brutus Hamilton succeeded Walter Christie in 1933 and, except for a two-year period during the war, served until 1965 as track and field coach. Hamilton, as a student at the University of Missouri, represented the United States in the decathlon at the 1920 and 1924 Olympics. In 1952 he returned to the Olympic games as head coach for the United States team that won more gold medals than any team in history. He also served as dean of men from 1942 to 1947, when he was appointed director of athletics. He resigned as athletic director in 1955 to devote full time to track and field. In 1927 Al Reagan (left) joined Christie as assistant coach and served in that capacity for 41 years (head coach 1943–45).

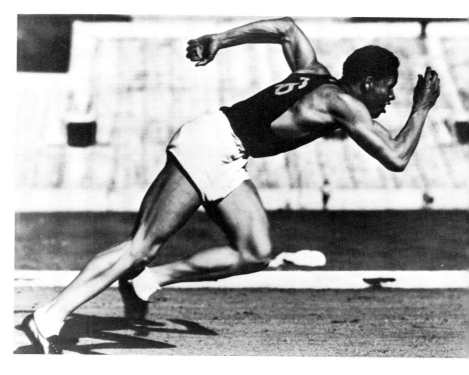

The Womens' Faculty Club is unique on university campuses. The clubhouse was built in 1923 through the sale of bonds by an organized group of women of the faculty and administration. Located on Strawberry Creek at the eastern end of Faculty Glade, it provides residence quarters for twenty-three women on the upper floors, with a members' lounge, dining rooms, and a kitchen on the main floor.

A unit of the Naval Reserve Officers Training Corps was organized at Berkeley in August 1926, under the command of Captain Chester W. Nimitz. Present at a year's-end review were President William Wallace Campbell (in top hat); two officers of the Twelfth Naval District (on either side of President Campbell); Colonel Robert O. Van Horn, in command of the Army ROTC; Commander Ernest L. Guenther, second-in-command to Captain Nimitz; and Captain Nimitz. In 1948 Nimitz, by then a fleet admiral, was appointed a Regent of the University; he served until 1958.

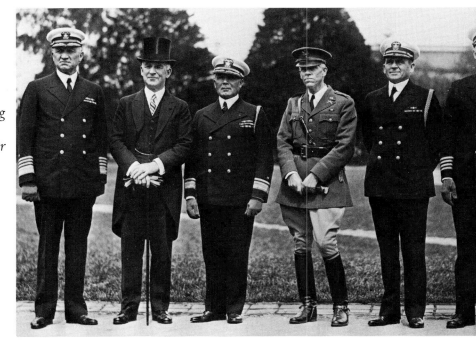

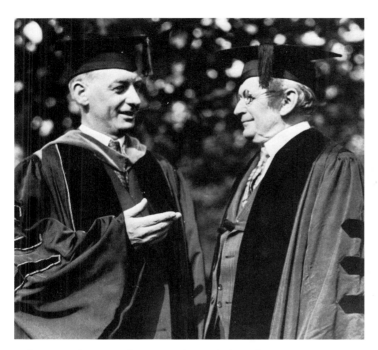

Robert Gordon Sproul, '13, exchanged the titles of vice-president, comptroller, secretary of the Regents, and land agent for that of president on July 1, 1930. On the day of his inauguration, October 22, 1930, he conferred with Governor Clement C. Young, '92.

The Bancroft Library is one of the world's outstanding collections of western Americana and Spanish-American historical source materials. Begun in 1859 by Hubert Howe Bancroft, in preparation for the writing of his thirty-nine-volume history of western North America, the collection was purchased from him by the University in 1905. Since then it has been greatly augmented and enriched through the directorships of Henry Morse Stephens (1905–19), Herbert Eugene Bolton (1919–40), and George Peter Hammond (1946–65).

The Bancroft Library's Director Bolton, who was a noted teacher of the history of the American West from 1911 until his retirement in 1940, examines the Drake Plate with Beryle Shinn, who discovered it. In 1579 the Explorer Sir Francis Drake fastened the brass plate, carved with a legend claiming the land in the name of Queen Elizabeth I of England, on a post somewhere in the vicinity of San Francisco Bay. The plate was lost during the centuries that followed, until Shinn turned it up accidentally in 1936, on a hillside near Greenbrae in Marin County. Tested with great care and considered authentic, the plate is now on display in the Bancroft Library.

Monroe E. Deutsch, '02, professor of Latin and dean of the college of letters and science, spoke at the presentation of the 1928 class gift, a bronze bust of Benjamin Ide Wheeler for the foyer of Wheeler Hall. In 1931 Deutsch became vice-president and provost of the University, and in 1944 he acquired additional authority as the first provost of the Berkeley campus. He held all three positions until his retirement in 1947.

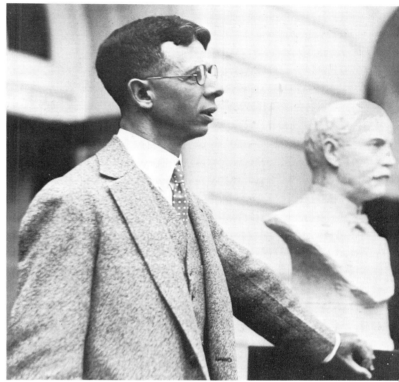

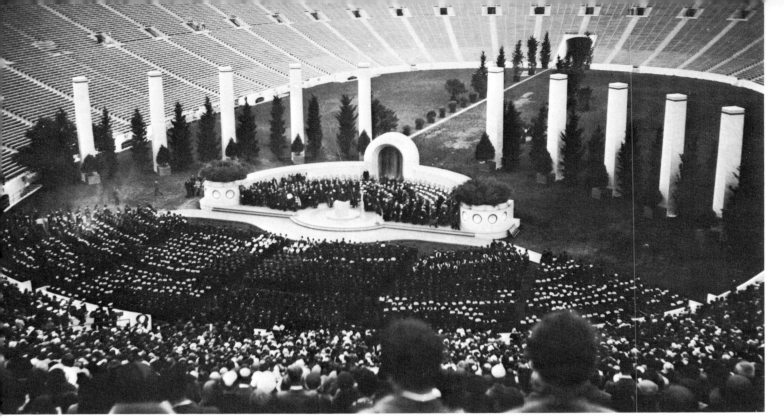

In the late 1920's, because of the increased size of graduating classes, commencement exercises were moved from the Greek Theatre to Memorial Stadium. Under the supervision of Michael A. Goodman, professor of architecture, various background motifs and platform arrangements have been used over the years—such as this of 1931.

After the removal of North Hall in 1917, the newly occupied Wheeler Hall became a favorite gathering place for the students. The men met and lounged on the western portion of the steps, while the women clustered at the eastern end under the shade of the Wheeler Oak. In 1934 the tree had to be removed because of great age, and a bronze plaque was placed on the site. When the road that ran in front of Wheeler Hall gave way to a plaza in 1952, the plaque disappeared. It was rescued by alumni interest and reset in 1954, with a new oak planted nearby.

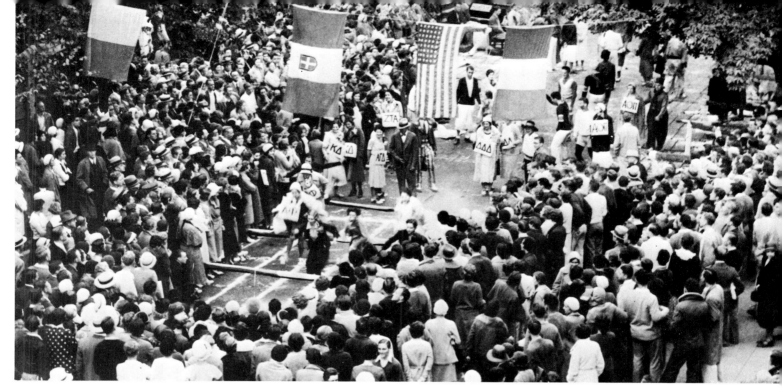

For twenty-five years, the Channing Way Derby introduced Freshman pledges to sorority life. The Derby began in 1916, when the Sigma Chi fraternity set up a tally board to record the number of pledges arriving for breakfast in the sororities along Channing Way; they bestowed a beer mug upon the house with the largest number. Through the years, the Derby expanded into an elaborate but mild form of hazing, such as this "try-out for the 1932 Olympic Games." Discontinued in 1942 because of the war, the tradition has not been revived.

The traditional collegiate "rush," which determined Freshman-Sophomore supremacy through a free-for-all wrestling and tie-up contest, was adopted on the campus very early. A unique form of it erupted in the 1890's, however, when the Freshmen began to celebrate Charter Day—March 23—by painting their class numerals on Charter Hill. The attempts of the Sophomores to prevent this developed into a prolonged battle, in which students were seriously injured and the noise interfered with the academic ceremonies held in celebration on the campus below. In 1904 it was determined that all rushing was too dangerous and had to be stopped. On Charter Day 1905, upon the advice of the Seniors, the classes of 1907 and 1908 "buried the rush" beneath a great concrete C that they built on Charter Hill.

In place of the tie-up rush, the Freshman-Sophomore Brawl was organized in 1907. Men of the two classes met on an athletic field for a push-ball contest, jousting and tying matches, and a tug-of-war. Members of the Big C Society (the athletic honor society) conducted the affair to prevent undue roughness. In recent years the turnout for the brawl has decreased markedly, and it is evident that the tradition is fading.

In the final event of the day, the class of 1941 out-tugged the exhausted class of 1940 to win the Freshman-Sophomore Brawl of 1937.

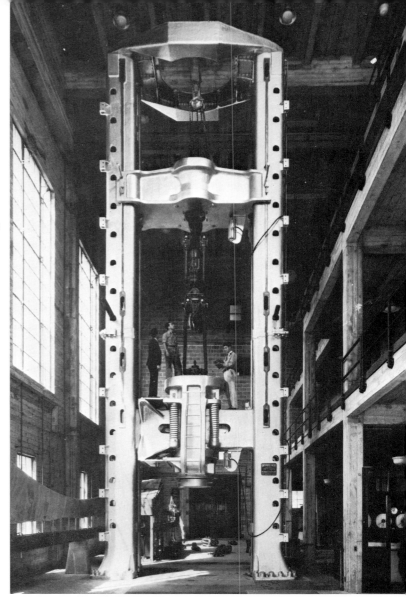

Before Hoover Dam and the San Francisco Bay Bridge were built, in the 1930's, large-scale tests of the materials to be used were made in the Engineering Materials Laboratory at Berkeley on this four-million-pound-capacity Southwark-Emery Testing Machine, the only one of its size on the West Coast. In 1966, the machine was moved to the Richmond Field Station, which was established in 1950 on a 160-acre site ten miles north of Berkeley for specialized research in engineering.

In solving the problems California faced, the Colleges of Mining, Mechanics, and Civil Engineering, led by Frank H. Probert, Clarence L. Cory, and Charles Derleth, made the field of engineering one of the earliest in which the University gained a wide and distinguished reputation. Speaking of the College of Mining, for example, a report issued in 1904 by the American Institute of Mining Engineers said, "The rapid development within the past twenty-five years of this mining college from a small beginning to a position not surpassed by any of its older colleagues in this work . . . presents the most extraordinary event in technical education."

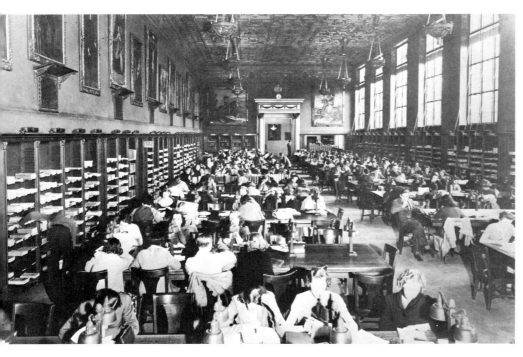

Overcrowding, particularly in the library, became critical during the latter half of the Depression era, as enrollment at Berkeley rose from 13,218 in 1935 to 17,285 in 1939, with no funds available for new buildings.

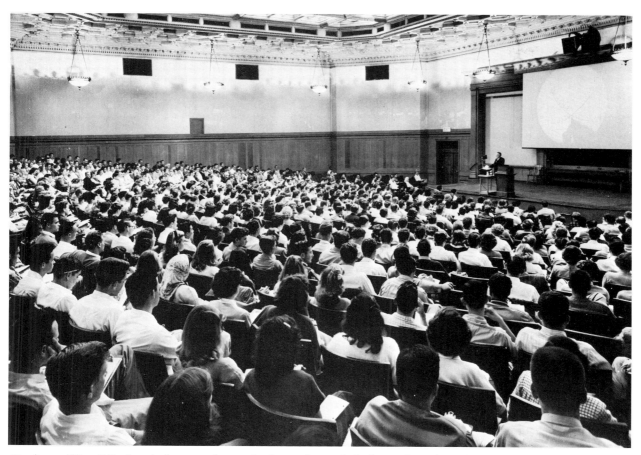

Freshmen filling Wheeler Auditorium during the forties learned the laws of supply and demand through the energetic lectures of Ira B. Cross, Flood Professor of Economics from 1914 until his retirement in 1951.

With the completion of Sather Gate in 1913, the wide public area before it at the meeting of Telegraph Avenue and Allston Way became a popular spot for impromptu student rallies. It took on added significance as a "Hyde Park" in the mid-1930's, when the rising tide of war in Europe and social unrest at home brought about gatherings with speakers of various political faiths. In September 1940, a Campus Committee to Fight Conscription announced a rally as "a democratic protest against the conscription bill." The crowd, estimated by the Daily Californian at 1,500, decided to send a telegram to President Franklin Roosevelt and Congress opposing the bill.

The Lawrence Radiation Laboratory, the University's world-renowned center for research in nuclear science, is named for Ernest Orlando Lawrence, who in 1929, as a young professor of physics in Berkeley, evolved the principle of the cyclotron and proved his theory with an operational model. The research space allotted Lawrence and his associates in an aging frame structure behind the Anthropological Museum (earlier the Mechanic Arts Building) soon became informally known as "the Radiation Laboratory." The research advanced so rapidly that in 1936 the Regents established an official Radiation Laboratory, with Lawrence as its director.

As the applications of nuclear energy to research in medicine became evident, Regent William H. Crocker, together with four medical and science research foundations, contributed funds for the construction of a laboratory housing a 60-inch cyclotron. The Crocker Radiation Laboratory, directly north of the "old Radiation Laboratory," was completed in 1939. That same year Lawrence received the Nobel Prize in physics, the first of a number awarded to University of California faculty members.

In 1940, the Rockefeller Foundation and others gave $1,500,000 for the construction and housing of a 184-inch cyclotron. Located over the brow of Charter Hill beyond the Big C, this was the beginning of the vast complex of variously named accelerators and nuclear equipment now occupying "the Hill." Here Lawrence, successfully merging basic research and practical engineering, developed the large-scale team-research programs now so generally used in laboratories around the world. Following Lawrence's untimely death in 1958, the Regents conferred his name upon the Radiation Laboratory and appointed the associate director and Nobel Laureate Edwin M. McMillan as director.

During the 1930's Lawrence and his associates continued to build accelerators of increasing size and energy. This 37-inch cyclotron, with Lawrence at the controls, was developed in the old Radiation Laboratory in 1938.

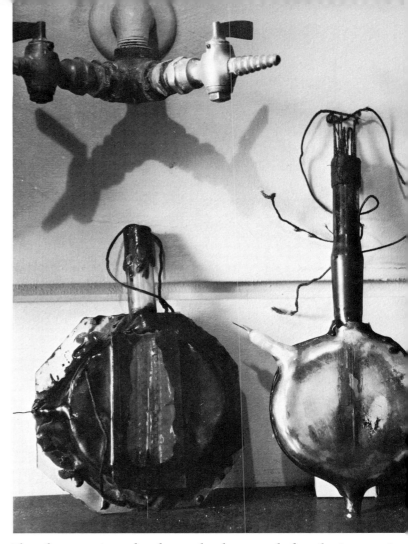

These first experimental cyclotron chambers were built under Lawrence's supervision by his student, Niels E. Edlefsen, in the basement of LeConte Hall. Lawrence made the first formal announcement of his principle in September 1930, at a meeting in Berkeley of the National Academy of Sciences—the first meeting of the academy on the Pacific Coast. On January 2, 1931, using a more sophisticated design with a 4.5-inch chamber made of brass and sealing wax, Lawrence and Stanley Livingston conducted the first successful operation of a cyclotron.

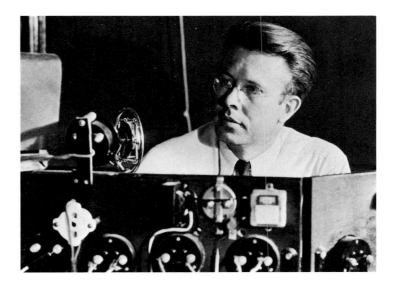

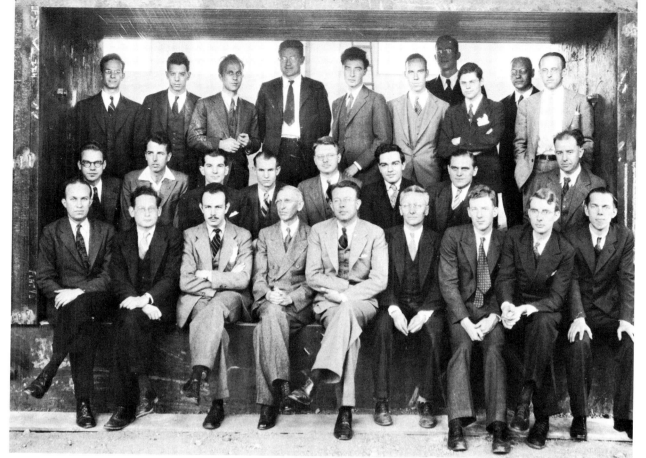

The scientific staff of the Radiation Laboratory in 1939, framed by the magnet of the unfinished 60-inch cyclotron. First row: J. H. Lawrence, R. Serber, F. N. D. Kurie, R. T. Birge, E. O. Lawrence, D. Cooksey, A. H. Snell, L. W. Alvarez, P. H. Abelson. Second row: J. Backus, W. B. Mann, P. C. Aebersold, E. M. McMillan, E. M. Lyman, M. D. Kamen, D. C. Kalbfell, W. W. Salisbury. Third row: A. S. Langsdorf, S. J. Simmons, J. G. Hamilton, D. H. Sloan, J. R. Oppenheimer, W. M. Brobeck, R. Cornog, R. R. Wilson, E. Viez, J. J. Livingood.

On January 1, 1943, the University of California was selected to operate a newly established government laboratory at Los Alamos, in northern New Mexico, for the immediate and sole object of making a nuclear weapon. J. Robert Oppenheimer, professor of physics at Berkeley, was named director, and continued in that position until the bomb was produced and the war ended in 1945. Since then the University has continued to operate the Los Alamos Scientific Laboratory, under the directorship of Norris E. Bradbury, through a series of five-year contracts with the Atomic Energy Commission. About four thousand persons are employed at the laboratory, which now devotes much of its effort toward the peaceful applications of nuclear energy—although it still maintains research on nuclear and thermonuclear weapons and weapon components.

The University of California and the Los Alamos Scientific Laboratory were awarded the Army and Navy "E" in October 1945 "for valuable services rendered to the Nation." Major General Leslie R. Groves, director of the Manhattan Project (code name for the project to develop the atomic bomb), presented the award to Director Oppenheimer as President Sproul stood by.

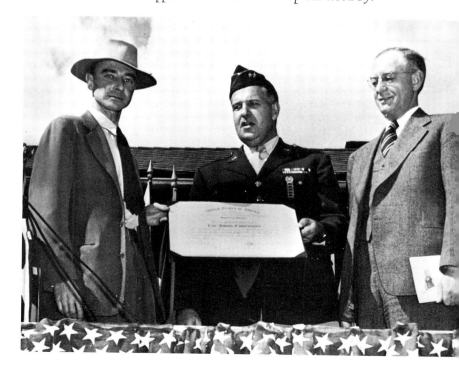

As early as 1927, ten percent of all foreign students in the United States were enrolled on the Berkeley campus. Because of its location as well as the stature of its faculty, Berkeley continues to lead all American institutions of higher education in the number of its foreign students, scholars and researchers.

International House was opened in 1930, one of four established in New York, Chicago, Berkeley, and Paris with funds donated by John D. Rockefeller. Slightly more than half of its five hundred residents are foreign students; the rest are Americans. With its attractive Great Hall, dining rooms, and auditorium, "I House" serves many purposes other than that of residence hall. Its staff gives counseling and help to anyone on campus from another country, whether student or visiting professor.

From the entrance to I House, students can look directly across San Francisco Bay to the Golden Gate.

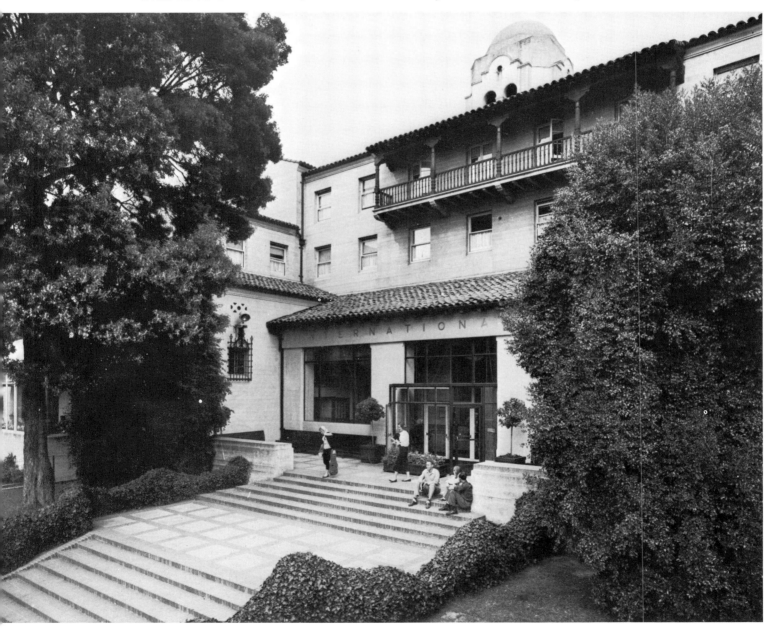

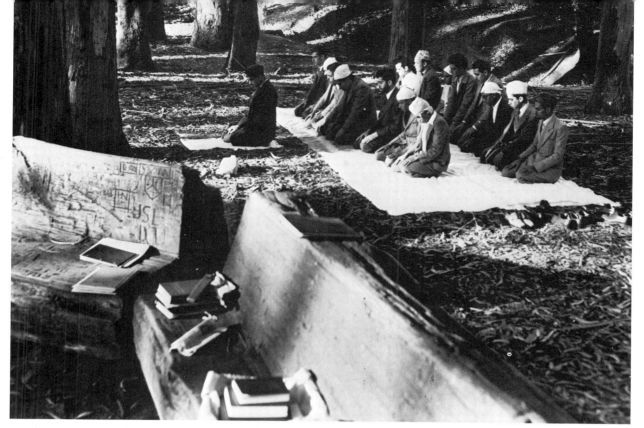

Moslem students on the campus in 1946 met for morning prayers in the eucalyptus grove.

At a special University convocation on May 4, 1945, statesmen of six of the nations writing the United Nations Charter in San Francisco received honorary degrees before a capacity audience in the Greek Theatre. With President Sproul are Ezequiel Padilla, secretary of foreign relations, Mexico; George Bidault, minister of foreign affairs, France; Edward R. Stettinius, secretary of state, the United States; Anthony Eden, foreign secretary, Great Britain; T. V. Soong, minister of foreign affairs and acting prime minister, China; and Field Marshal Jan Christian Smuts, prime minister, the Union of South Africa. Governor Earl Warren, '12; Lord Halifax, Great Britain's ambassador to the United States (far right); and Lady Halifax were honored guests.

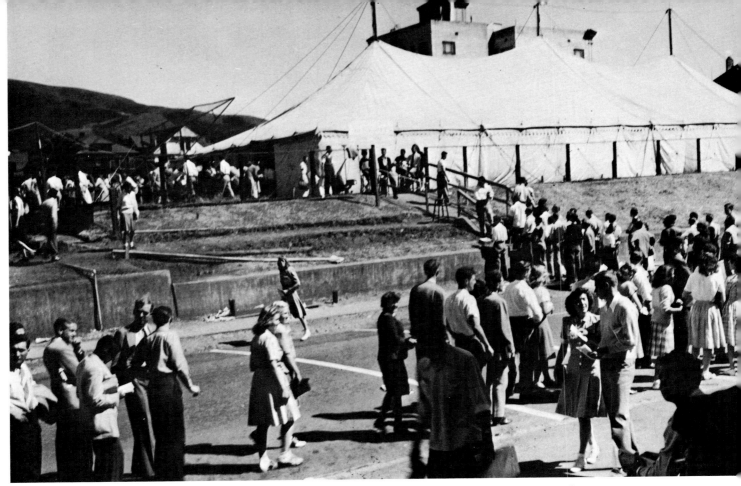

The end of World War II brought the GI enrollment boom and a doubling of student registration. More than 40,000 students flocked to the University's campuses in 1946—some 25,272 at Berkeley. Half were veterans, eager to make up for lost time. A circus tent erected opposite Harmon Gym during registration provided an effective and colorful solution to space problems.

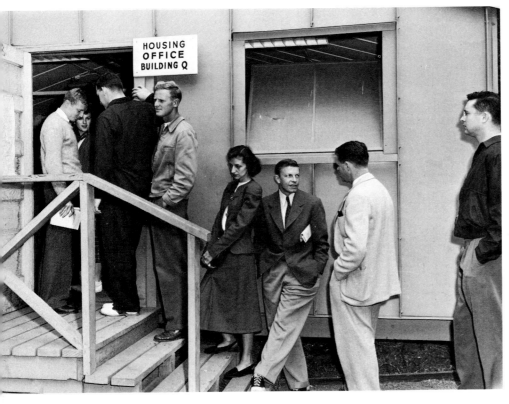

The problem of housing was an acute one for many of the veterans who flooded the campus in the years immediately following World War II. Long lines formed in front of Building Q, the housing office. First located on the present site of the Pelican building, it was later moved across to the north end of the women's playing field and finally demolished to make way for Barrows Hall.

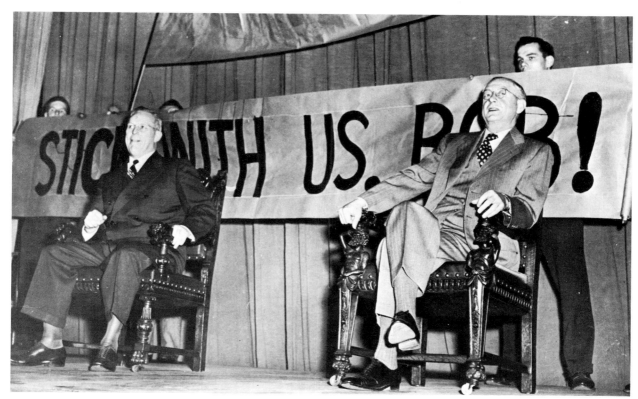

Governor Warren appeared ready to join the students who packed Harmon Gymnasium
for the University meeting of January 23, 1947, to roar approval of banners urging
President Sproul to decline the offer made him of the presidency of an eastern institution.

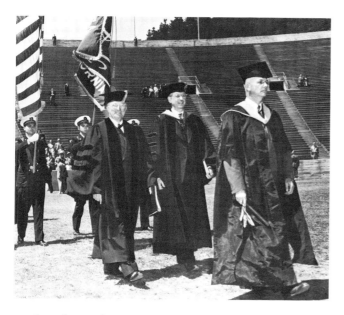

Leading the academic procession into California Memorial
Stadium for the commencement exercises of 1948 were
Edwin C. Voorhies, professor of agricultural economics and
University marshal; Harry Truman, President of the United
States (left); and President Sproul. Although Presidents
William Howard Taft and Woodrow Wilson had spoken
at University meetings previously, the class of 1948 was
the first graduating class since 1903 to be
addressed by a President of the United States.

At the conclusion of a meeting in his honor in the Greek Theatre on
October 31, 1949, Pandit Jawaharlal Nehru, prime minister of India
(second from left), received an ovation from the audience. With him on
the platform were President Sproul; Nehru's daughter, Indira; Madame
Vijaya Lakshmi Pandit, ambassadress from India to the United States
and Nehru's sister; Governor Earl Warren; Mrs. Warren; and Mrs. Sproul.

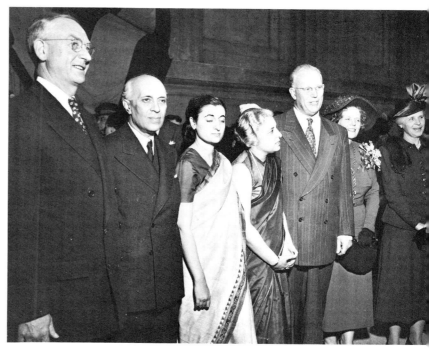

The wave of unrest and insecurity that swept the nation after World War II was reflected in the University of California by the "loyalty-oath" controversy of 1949–52. The dismissal of two tenured faculty members as Communists at another university, combined with an incident involving the use of University facilities at UCLA by a Communist speaker, convinced the Regents that they should strengthen the University's policy, made in 1940, against the employment of Communists. To do this, they amended the oath of allegiance to the United States, which was required of all state employees, to include a statement that the signer was not a member of the Communist party, nor under any commitment that was in conflict with the obligations of the oath of allegiance. This aroused a prolonged controversy which divided both the University and the Regents and finally resulted in the dismissal of thirty-one non-signing members of the faculty on August 25, 1950. A test case on the legality of the dismissal was begun in the courts. Meanwhile, an amendment to the state oath of allegiance, similar to that of the Regents but omitting specific reference to communism, was enacted by the legislature in October 1950. Two years later, the California Supreme Court decided that the state oath "occupied this particular field of legislation" and ordered the reinstatement of the non-signers. (In 1967, the amendment to the state oath was declared unconstitutional; the balance of the oath, declaring allegiance to the Constitution of the United States and the state constitution, remained.)

Spectators crowded every available space at critical meetings of the Board of Regents during the loyalty-oath controversy.

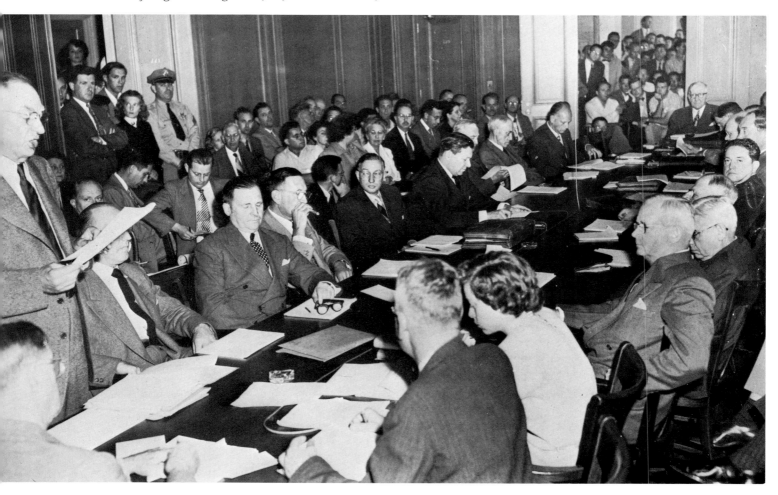

Before President Wheeler's administration, new students were very much on their own, for the University offered no advisory services. The position of advisor was first established in 1905 and that of dean of women in 1906. To Lucy Ward Stebbins, professor of social economics, assistant dean of women 1906–12, and dean of women 1912–40, the problems of satisfactory student housing and part-time employment were of great concern. Her office was made a clearing house of employment opportunities. Through her efforts, standards of housing were established, and regulations were passed requiring Freshmen women to live in University-approved housing.

During the Depression, a group of men formed the University Students' Cooperative Association, rented a house, and through judicious buying and doing their own work managed to live comfortably. Miss Stebbins encouraged the project and helped women students undertake a similar venture; the first women's cooperative house was named in her honor. The USCA now owns and operates eight residences. In its thirty-year history, it has housed and fed a membership of more than eighteen thousand students.

At Commencement 1953, President Sproul awarded Dean Emeritus Stebbins the honorary degree of LL.D., with the citation: "No single individual has contributed more to the personal and general welfare of the University's women, and few have touched helpfully so many phases of our University life."

Unlike the University's newer campuses, Berkeley, being the seat of the University, continued under the direct control of the president until 1945. That year a move toward campus autonomy began with the appointment of an administrative officer who held the positions of vice-president of the University and provost at Berkeley. Enlarged autonomy came in 1952, when the provosts at Berkeley and Los Angeles became "chancellors," with responsibility for all but University-wide policies, a pattern now followed on all the campuses.

Clark Kerr, professor of industrial relations and director of the Institute of Industrial Relations, became first chancellor in 1952.

For many years, Faculty Glade with its sloping lawns, sheltering trees, and views of Strawberry Creek has offered a welcome respite from classroom walls and laboratories.

"Free ink," a plank in the platform of every ASUC administration before the advent of the ball-point pen, was dispensed indoors until 1925, when this neat "fountain" was placed at the east entrance to the student store in Stephens Union.

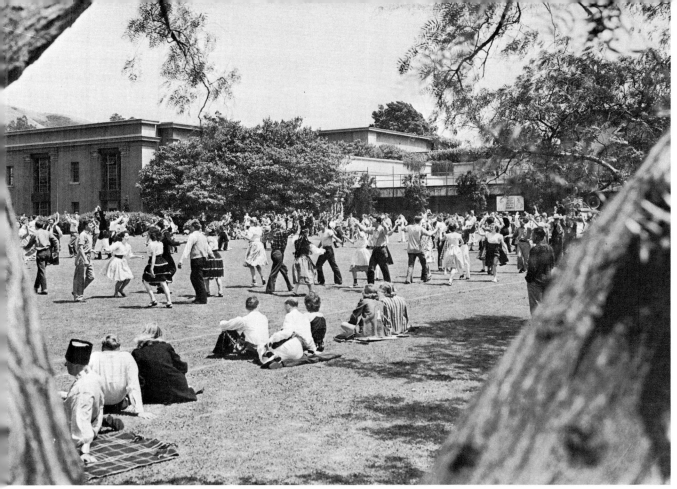

Serious research in the ethnic customs of man is combined with recreation and entertainment for hundreds of participants in the folk-dance and folk-music festivals held on the campus. Long a leader in the study of traditional dances, the Berkeley Square and Folk Dance Group, sponsored by the Department of Physical Education for Women, was host to the 1950 convention of the California Folk Dance Federation on the playing field north of Hearst Gymnasium.

An outstanding summer event is the Folk Music Festival, sponsored by the Associated Students and presented annually since 1958. Sam D. Hinton, marine zoologist on the San Diego campus, has been host artist of the festival since the beginning. Standing with him at the Sproul Plaza kiosk poster for 1963 is Jean Ritchie of Viper, Kentucky, a recognized scholar and performer of folk songs, who has appeared in five festivals.

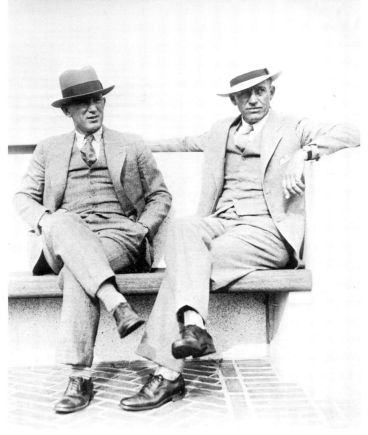

Clarence "Nibs" Price and Clinton Evans in the mid-1930's, when both were head coaches—Nibs in basketabll (1924–54) and Clint in baseball (1929–54). In the present-day era of specialization in coaching, Price seems truly remarkable in that at one time, 1926 through 1930, he was head coach of both basketball and football. In 1929 he attained one of the most remarkable coaching achievements in the history of collegiate athletics: In less than twelve months his Bear basketball and football teams both won Pacific Coast Conference championships, and his football team played in the Rose Bowl. Price was succeeded by William "Navy Bill" Ingram (1930-33) and Leonard B. "Stub" Allison (1935-44), whose "Thunder Teams" won or tied for three conference championships.

Twice national collegiate baseball champions—in 1947 and 1957—the Golden Bears have played intercollegiate baseball since 1892. Just as crew and "Ky" Ebright are synonymous, so are baseball and Clint Evans, '12, who for twenty-five years was a colorful, inspirational, winning coach. Evans was succeeded by George Wolfman, who had played under Evans. Between 1930 and 1967, the Bears compiled the best record in California Intercollegiate Baseball Association history: They won or tied for twelve titles and were runners-up eleven times.

Clint Evans' Golden Bear baseball squad of 1947, which defeated Yale to capture the first College World Series championship—an honor Wolfman's team was to receive exactly ten years later.

*Jubilant Bears and Coach Newell hold their 1959 National
Collegiate Athletic Association trophy.*

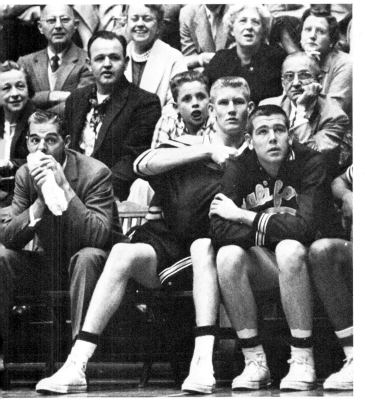

*A familiar scene in Harmon Gymnasium from 1955 to 1960—
basket ball coach Pete Newell chewing on a folded towel to relieve
tension during difficult moments. Darrell Imhoff and Dick
Doughty of the 1957–58 team worry with him. In six years
at Berkeley, Newell coached the Golden Bears to four
straight conference titles, culminating in a national
championship in 1959 and a national runner-up in 1960.*

*When he captured the world trampoline title in
1964, Freshman Dan Millman became the first
American in several years to win an international
gymnastic championship. Berkeley has been
consistently strong in gymnastic competition
since Hal Frey became coach in 1958.*

BERKELEY 71

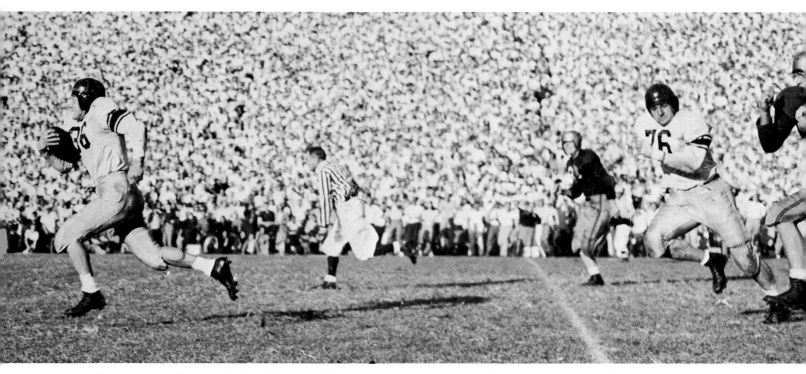

Jackie Jensen streaks into the clear for a touchdown against Navy on September 27, 1947, giving the Bears a 14–7 victory—a win that marked the beginning of the Waldorf coaching era. Under Coach Lynn "Pappy" Waldorf, in the next four seasons the Bears lost only one regular season game and captured three consecutive conference championships. The game was witnessed by eighty-three thousand persons, the largest crowd ever to attend a football game in California Stadium.

Pappy Waldorf and the football coaching staff of 1951: Harold "Hal" Grant, Zeb D. Chaney, Nibs Price, Edgar "Eggs" Manske, Herman Meister, and Wesley L. Fry.

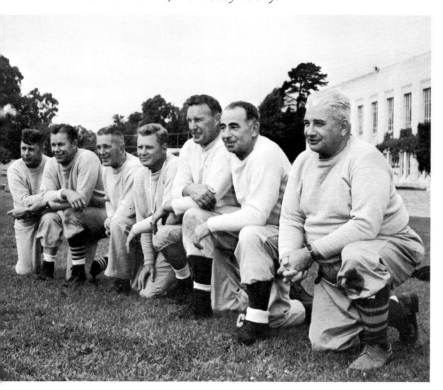

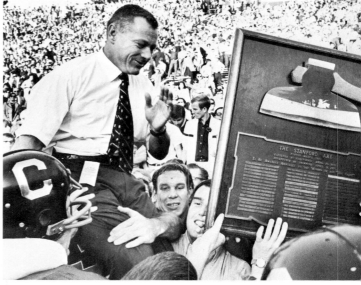

At the conclusion of the Big Game of 1967 in Stanford Stadium, the score was California 26, Stanford 3. Jubilant Californians hoisted Coach Ray Willsey and the Stanford Axe high on their shoulders. Since the axe became a trophy in 1933, California has won it sixteen times, Stanford fourteen times, and two games have been ties. The Big Game was not held during the war years of 1943–45.

Between halves, the California Marching Band takes a bow after forming the familiar "Cal" signature.

The Straw Hat Band, a living symbol of "Cal spirit," began when an informal group from the marching band started playing at basketball games during the 1949–50 season. The group acquired its name when its members started wearing straw hats picked up at a bargain at the Sacramento State Fair in 1951. With the hats there developed a joyous personality and a unique musical style.

The Straw Hat Band of 1965.

Since live bear cubs inevitably became too large and dangerous to be kept as mascots, "Oski," the inspiration of William Rockwell, '43, appeared to take a place in the traditions of the campus. His name taken from the "Oski wow wow" cheer, Oski took his first bow at the 1941 Freshman Rally. Since 1946 he has been the charge of a special committee whose members, between 5'2" and 5'4" in height and possessed of considerable gymnastic ability, determine his schedule, plan his stunts, and take turns assuming his character. The names of the committee are not listed, and the identity of Oski on any given occasion is kept strictly secret.

From the crossbar of the goal, Oski signals the approach of the football varsity.

Closing each Big Game Rally is the Andy Smith eulogy. The philosophies of clean living and good sportsmanship taught by Andrew L. Smith, football coach from 1916 until his death in 1926, were recounted at the rally of 1948 by the radio announcer Mel Venter. The following year Garff Wilson, professor of speech and dramatic art, was asked to prepare a eulogy which was read at the rally by the ASUC president. Since then Wilson himself has read the eulogy to a darkened Greek Theatre, illuminated only by the dying embers of the bonfire and the flickering lights of candles held by students in the amphitheater above.

The first University Alumni Association was formed in 1872. It was named the Alumni Association of the University of California in 1874, and continued under that title until 1917, when it became the California Alumni Association. The association supports scholarships, opportunity programs, cultural resources, and research at Berkeley, maintains two alumni summer camps and a year-round conference and recreational center in the Sierra Nevada, and publishes the *California Monthly.*

In 1918, a state constitutional amendment named the president of the California Alumni Association a Regent ex officio; with the growth of the autonomous UCLA Alumni Association, formed in 1934, a system was provided in 1947 whereby the presidents of the Berkeley and Los Angeles associations serve on the Board of Regents in alternate years.

Two alumni, who had known the University from the beginning and served it from graduation to retirement and afterward, led the commencement procession of 1929. George C. Edwards, '73, professor of mathematics from 1874 to 1918, holds his class banner, while next in line stands Joseph C. Rowell, '74, University librarian from 1875 to 1919. With them is Robert Sibley, '03, executive director of the California Alumni Association from 1923 to 1949. Edwards Fields and Stadium are named in honor of "Colonel" Edwards, who continued an active interest in sports, especially track and field, until his death in 1930.

Each year on commencement day, members of the California Alumni Association meet with the president of the University and the Berkeley chancellor for luncheon in Faculty Glade, to honor the fifty-year class and retiring faculty.

Inaugurated as the twelfth president of the University
in September 1958, Clark Kerr dons the historic
inaugural robe first worn by President Wheeler and
awaits the start of the ceremonial procession to
the Greek Theatre. He was succeeded as chancellor
by Glenn T. Seaborg, associate director of the
Lawrence Radiation Laboratory.

Professional instruction in law at Berkeley
dates from 1894, when the Department of Juris-
prudence was established—although William
Carey Jones, first head of the department, had
taught Roman and constitutional law courses
on the campus since 1882. By 1903 a complete
curriculum in professional law was offered,
and that year three students received the first
bachelor of laws degrees conferred at Berkeley.
Classes were held in North Hall until 1911,
when Boalt Hall, named in honor of Judge John
H. Boalt, was completed. In 1951, a new Boalt
Hall, at Bancroft Way and College Avenue, was
dedicated, and the old building was renamed
Durant Hall, in memory of President Durant.
The final addition to the Law School Complex
was completed late in 1967; it includes the
Earl Warren Legal Center and a seven-story
dormitory, Hiram Edward Manville Hall, and
provides classroom space for ultimate expan-
sion from 800 to 1,000 students.

On September 27, 1963, a distinguished audience, including seven
of the eight Associate Justices of the United States Supreme Court
and several members of the Supreme Court of California,
participated in the ground-breaking for the Earl Warren Legal
Center, the east wing of Boalt Hall. Chief Justice Warren himself
turned the first spadeful of earth and made a short address.
The center for legal research and conference is named for the
Chief Justice as the most distinguished alumnus of Boalt Hall.

A Freshman history class. Television sets lowered from the ceiling enable those in the back of the lecture room to see the lecturer as well as those in the front rows.

Edward Teller, associate director of Lawrence Radiation Laboratory since 1954 and a University professor-at-large, conducted an introductory undergraduate physics course on the Berkeley campus in the spring of 1962. Almost 1,400 students enrolled. Wheeler Auditorium was filled, and the lectures were relayed by closed-circuit television into nearby classrooms. Later than year, Teller became the third Berkeley faculty member to receive the Atomic Energy Commission's Fermi award; the first two were E. O. Lawrence in 1957 and Chancellor Seaborg in 1959.

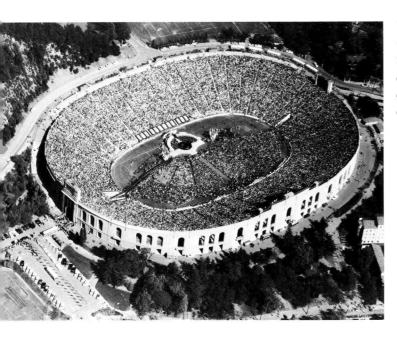

The celebration of Charter Day 1962 included the inauguration of Chancellor Edward W. Strong and the presentation of an honorary degree to John F. Kennedy, President of the United States and speaker of the day. The ceremonies, held in the California Memorial Stadium, were attended by eighty-eight thousand persons, reportedly the largest audience ever to hear President Kennedy in person.

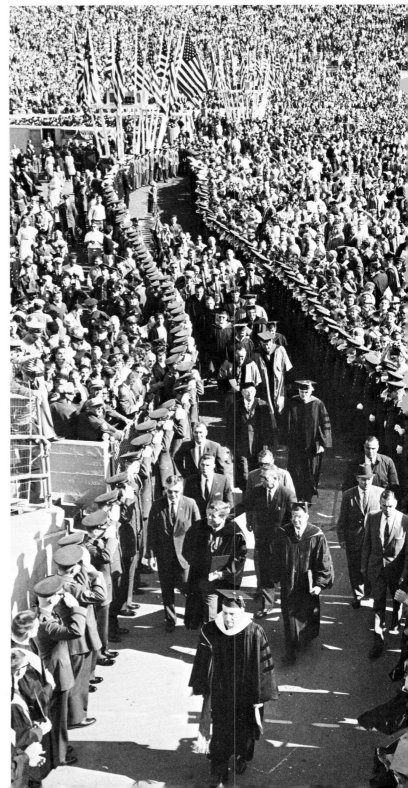

The academic procession leaving the California Memorial Stadium following President Kennedy's address. His opening remarks, "When I observe the men who surround me in Washington . . . I am forced to confront an uncomfortable truth . . . that the New Frontier may well owe as much to Berkeley as it does to Harvard," brought laughter and applause.

Adlai Stevenson, United States ambassador to the United Nations, was greeted by an overflow audience in the Greek Theatre at the ninety-sixth Charter Day ceremonies, in 1964.

Chancellor Strong adjusted the hood as U Thant, secretary-general of the United Nations, was awarded an honorary doctorate of laws at Charter Day exercises in 1964.

Students can find a shady place to study on the Wheeler Bench, a gift of the class of 1905 to commemorate the establishment of student government. Opposite the bench is the football statue, by Douglas Tilden, a noted California sculptor at the turn of the century. It was a trophy presented by Mayor James D. Phelan of San Francisco after the Bears won the Big Games of 1898 and 1899.

More than 1,500 Berkeley students actively engage each year in community projects. Thousands more donate time and money. Some ten to twelve major projects are sponsored each year by Stiles Hall, the campus YMCA; other major activities include Cal Camp, Big Brother, Amigos Anonymous, and several tutorial groups. And the volunteer work does not end with graduation. The Berkeley campus supplied close to one thousand Peace Corps volunteers between 1961 and the beginning of 1968—more than any other university campus in the country.

A School Resource Volunteer from Berkeley encourages elementary pupils in the neighboring town of Richmond.

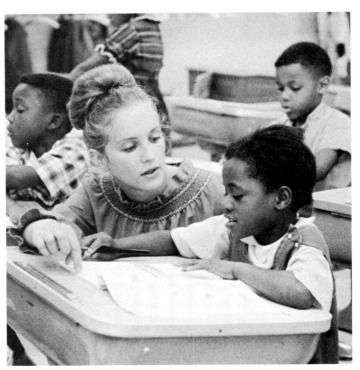

Student demonstrations erupted at Berkeley in the fall of 1964, when a non-student was arrested for trespassing near the steps of Sproul Hall in violation of University rules against the solicitation of funds for off-campus purposes. A large crowd immediately surrounded the police car in which he was placed; the crowd remained until the next day, preventing the car from leaving. The incident touched off continued agitation, in the form of protests, strikes, and demonstations, by students seeking a stronger voice in University affairs.

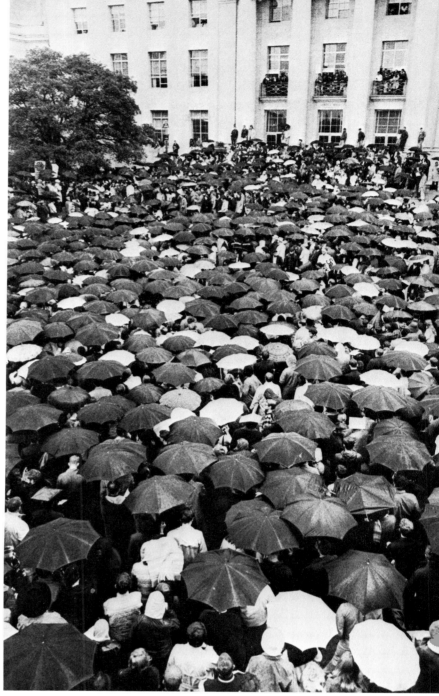

Mario Savio, a leader of the emerging Free Speech Movement, arguing the FSM cause from the roof of the entrapped police car.

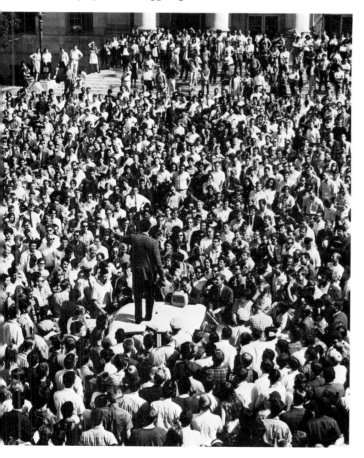

On November 30, 1966, a student demonstration to protest recruiting by the U. S. Navy in Sproul Plaza led to the arrest of nine students. The following day, despite a downpour, students gathered to listen to the call for a strike against the University through non-attendance at classes.

In 1965, Roger W. Heyns resigned a vice-presidency at the University of Michigan to become Berkeley's fifth chancellor.

Residence halls are named for donors or for members of the University "family" especially concerned with student housing. May L. Cheney Hall, named for the placement secretary of 1898–1938, towers beyond the curved roof of the dining hall.

Private gifts had built three residence halls—Bowles Hall for men (1929), International House (1930), and Stern Hall for women (1942)—before University funds were first used in residence-hall construction, in 1946. At that time seven three-story residences and a dining hall, known as the Fernwald-Smyth Halls, were erected on University property at the head of Dwight Way, to accommodate women students displaced from leased fraternity houses by the returning veterans of World War II. During the 1950's the Regents decided upon a residence-hall construction program, and in 1960 the first two units were completed and occupied. Each unit comprises four nine-story residences, two for men and two for women, housing 210 students each, and a general dining facility. A third unit was added in 1964.

With the expanse of ASUC activities following World War II, Stephens Union was outgrown. In 1961 a new four-story Student Union and attached Dining Commons were completed—the first buildings of a four-structure Student Center complex. The Clara Hellman Heller lounge (above) is a gift of her son, the late Regent Edward H. Heller '21. Other features of the Union include the Barbara M. Henry Pauley ballroom, a gift of her husband, Regent Edwin W. Pauley '23, and the Tilden Meditation room, given by Mr. and Mrs. Charles Lee Tilden in memory of their son.

Soon after the completion of the fountain between the new Student Union and the Dining Commons, in Sproul Plaza, a German short-haired pointer named Ludwig von Schwanenberg began appearing daily to play in the water. He became such a campus fixture that the Board of Regents in 1961, at the suggestion of the ASUC Executive Committee, recognized Ludwig's devotion by officially naming the fountain after him. Ludwig and his owners moved from Berkeley in 1965, but the fountain permanently bears his name.

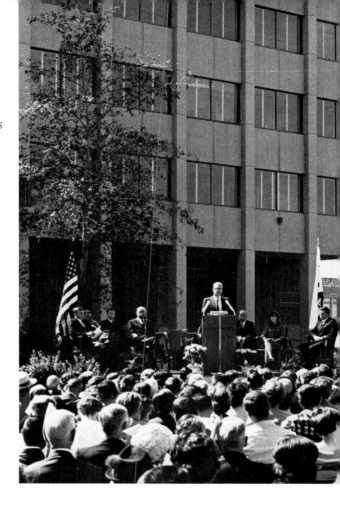

The dedication of the new Eshleman Hall, on September 18, 1965, was the first formal campus event at which Chancellor Heyns presided.

Some sixty student serial publications have appeared at one time or another on the campus, but only the four eventually sponsored by the ASUC, and one or two departmental publications, such as the Law Review, have survived.

Blue and Gold, the campus yearbook, has been published every year since 1874. It was a Junior-class publication until 1925, when it became an activity of the ASUC.

The campus newspaper also got its start in 1874, but its early career was more erratic. It began as the *Berkeleyan,* a monthly magazine merging the *University Echo* (formerly the *College Echo*), a publication since 1868 of the Durant Rhetorical Society, and the *Neolean Review,* which was begun by the Neolean Literary Society in 1873. The *Berkeleyan* failed in 1888, and was revived as a weekly in 1893. Its name was changed to the *Californian* early in 1897; in October 1897 it became the *Daily Californian.* Its shaky finances were taken over by the ASUC in January 1908, and the "*Cal*" has been in continuous publication ever since.

The *Occident* was started as a monthly literary magazine in 1881 and was maintained by private subscription until 1906. The English Club sponsored it from 1907 until 1926, when it became an ASUC activity. With the Depression, publication became sporadic, and was suspended between 1937 and 1945. The *Occident* is presently a semiannual publication.

The *Pelican,* a monthly humor magazine, was begun in 1903 by Earle C. Anthony, '03. It has been published continuously every since—by the Pelican Publishing Company until 1918, by the English Club from 1918 to 1926, and by the ASUC since 1926.

Student publications came into their own on November 14, 1931, with the dedication of Eshleman Hall for their exclusive use. Named in memory of John Morton Eshleman, '02, former president of the ASUC and lieutenant governor of the state at the time of his early death in 1916, this ASUC-owned building housed the offices of the *Daily Californian,* the *Blue and Gold,* and the *Occident.* In 1965, when the third building of the new Student Complex was completed, the name Eshleman Hall was transferred to it. The eight-story building, which forms the Bancroft Way boundary of the Student Union quadrangle, houses student publications (except the *Pelican,* which has its own building) as well as ASUC offices and intercollegiate athletics. (The original Eshleman Hall was renamed Bernard Moses Hall, after an early-day professor of history, and was remodeled for the Institute of Governmental Studies.)

The lack of a theater on the Berkeley campus has never daunted students interested in dramatic production. In fact, it may have been the stimulation of overcoming the confining conditions of the Wheeler Hall lecture platform that led to superior performance. From 1922 until 1941, the "little theater without a theater" was a highly successful activity of the ASUC. A newly established Department of Dramatic Art replaced the organized student activity in 1941, and the production of distinguished dramas was combined with the development of an academic program of significance.

A Wheeler Hall production of The Merchant of Venice, *in 1965.*

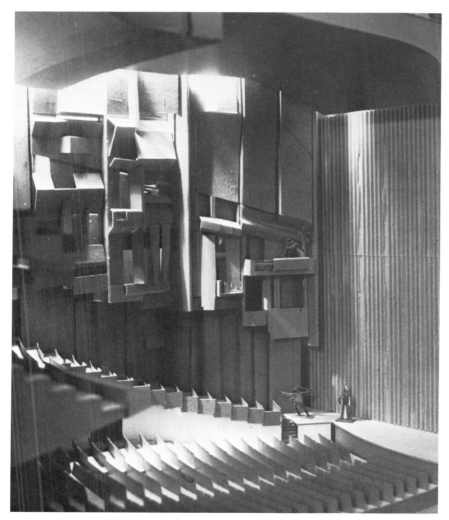

A model of Zellerbach Hall, the fourth and final building of the Student Center. The $6,800,000 structure, which is scheduled for completion during 1968, will provide a two-thousand seat auditorium that for the first time on campus can accommodate concerts, ballet, and opera, as well as a flexible, multiform theater seating about six hundred.

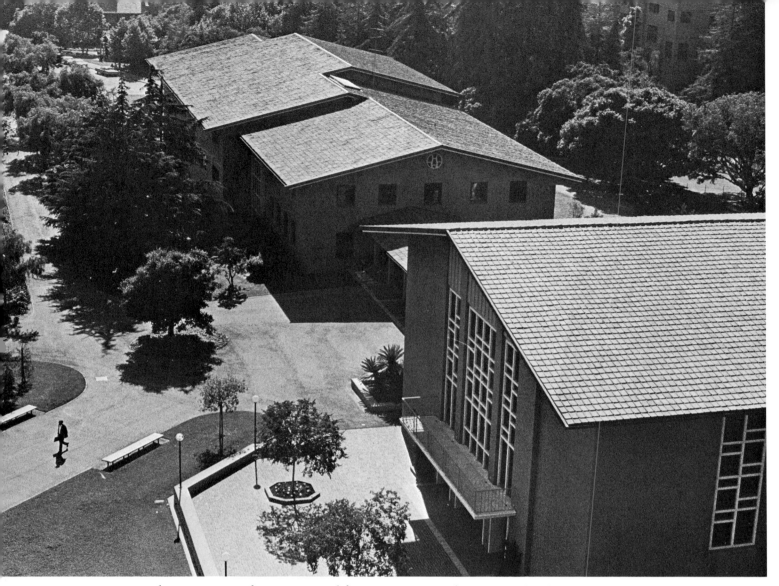

The Department of Music migrated from one temporary home to another for more than fifty years before Hertz and Morrison Halls were completed in the spring of 1958. A month-long festival of music accompanied the dedication. The Alfred Hertz Memorial Hall of Music (foreground), the bequest of a long-time conductor of the San Francisco Symphony Orchestra, provides a concert auditorium that seats 750 persons. Morrison Hall (background), was named in honor of Mrs. May Treat Morrison, '78, a generous benefactor of the University, and contains the Music Library, classrooms, and practice facilities.

The O'Neill Memorial Organ, in Hertz Hall, is a unique instrument designed and built by Walter Holtkamp. Lawrence H. Moe is the University Organist. Funds for the organ were left to the University by Professor Edmund O'Neill and his wife.

Art, in the form of freehand drawing, was an optional study in the College of Letters and a requirement in the College of Agriculture during the beginning years of the University. Courses given in the 1890's in decorative and industrial arts and instrumental and engineering design developed into a Department of Drawing and Art in 1913. In 1923, this in turn became the Department of Art, offering a balanced program in studio practice, theory and criticism, and the history of art.

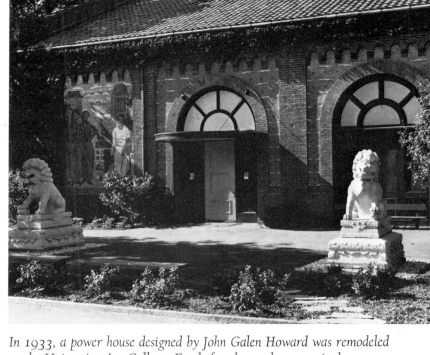

In 1933, a power house designed by John Galen Howard was remodeled as the University Art Gallery. Funds for the work were raised largely through the efforts of Albert W. Bender, a San Francisco philanthropist, and Perham H. Nahl, a professor of art. The wall mosaic and an accompanying one off the picture to the right, were completed as a project of the Depression-era Works Progress Administration. The matched Chinese dogs were given by Bender.

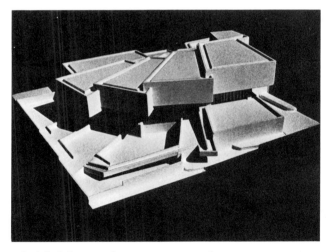

Wurster Hall, one of the largest, tallest, and most dramatic of the newer campus buildings, houses the College of Environmental Design, which brings together the former College of Architecture, the Departments of City and Regional Planning and of Landscape Architecture, and the Department of Design, which was formerly the Department of Decorative Art. Wurster Hall is named for William W. Wurster, professor of architecture and dean of the College of Environmental Design, and Catherine Bauer Wurster, a lecturer in city and regional planning.

Scheduled for completion in 1969 is this University Art Museum, a building marked by a series of gently rising terraces fanning out on two levels in a roughly semicircular pattern. It is located on the south side of Bancroft Way, across from Kroeber Hall with its Lowie Museum of Anthropology and Ryder Art Gallery. The new museum's seven galleries, will provide appropriate quarters and sufficient security for the highly valued traveling exhibitions that have been denied the campus in the past because of the lack of adequate facilities. The Art Museum will feature a collection of paintings of Hans Hofmann, "dean of abstract expressionists," who donated many of his works to the University and arranged to sell others to finance a gallery to house them.

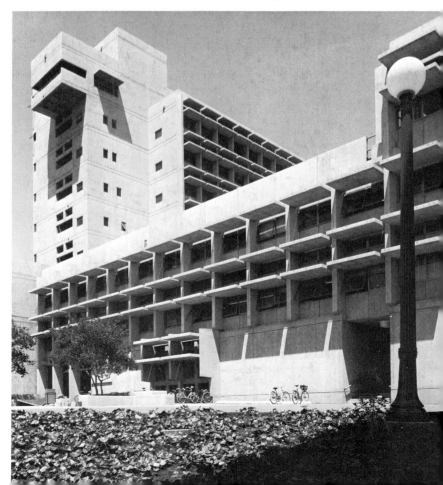

The first crystallization of the polio virus in pure form was made and photographed by an electron microscope at the Virus Laboratory in Berkeley in 1953. The laboratory, established in 1948 under the direction of Wendell M. Stanley, professor of biochemistry and molecular biology and Nobel laureate, cooperates with the Department of Molecular Biology, established in 1964, in research on the reproduction of viruses, the genetic code, and the nature of cancer.

In 1960 Berkeley had seven Nobel laureates: Owen Chamberlain (physics, 1959), Edwin M. McMillan (chemistry, 1951), William F. Giauque (chemistry, 1949), John H. Northrop (chemistry, 1946), Wendell M. Stanley (chemistry, 1946), Emilio G. Segré (physics, 1959) and Glenn T. Seaborg (chemistry, 1951).

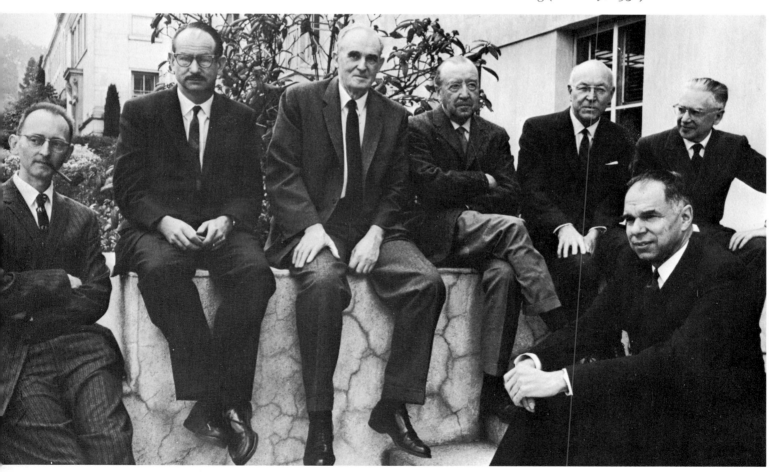

Donald A. Glaser received the 1960 Nobel Prize in physics for his invention of the bubble chamber while at the University of Michigan in 1952. He first came to Berkeley in 1959 as a visiting professor.

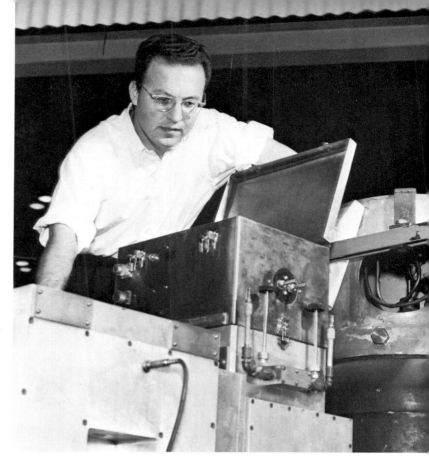

Melvin Calvin was awarded the Nobel Prize in chemistry in 1961 for his work on photosynthesis. During a visit to the campus of His Royal Highness Prince Philip, Duke of Edinburgh (left), in 1962, the two men discussed Calvin's research.

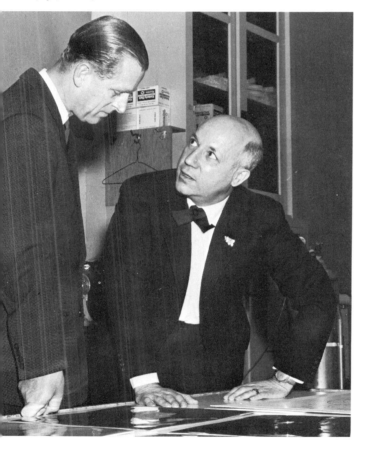

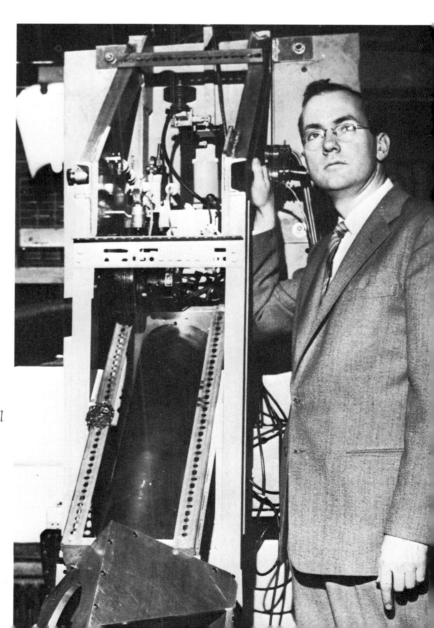

Professor-at-Large Charles H. Townes was awarded the Nobel Prize in physics in 1964 for his role in the invention of the maser and laser. He came to the University in 1967 and is based on the Berkeley campus in the Department of Physics.

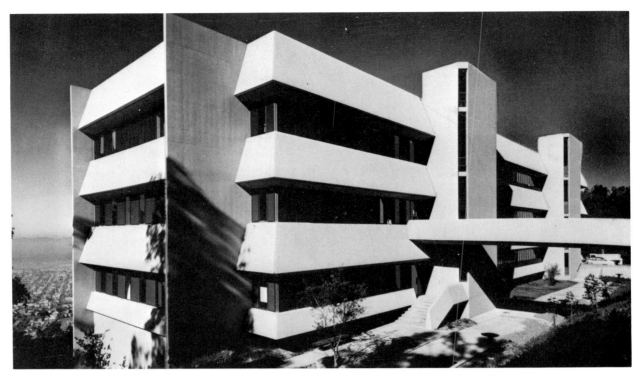

The new Space Sciences Laboratory, a two-million-dollar home for scientists and advanced students working in such fields as biophysics, atmospheric physics, cosmic-ray study, geomagnetics, and lunar and planetary explorations. The building, completed in 1966 with funds provided by the National Aeronautics and Space Administration, occupies a striking site in the hills overlooking the campus.

The Bevatron, built at the Lawrence Radiation Laboratory in 1954, was for several years the most powerful accelerator in the world. From the start of its operation it has been a world center for study in high-energy physics, as well as a major facility in Berkeley's program of graduate study in nuclear physics. Major modifications were made in the Bevatron shortly after this 1965 photograph was taken.

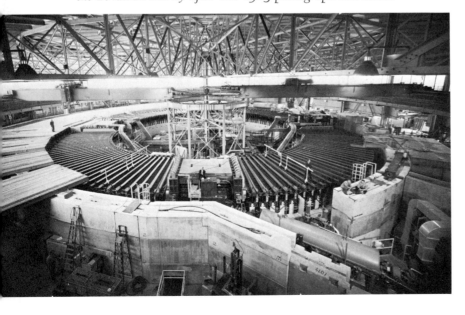

With such instruments as the Bevatron, the heavy-ion linear accelerator (HILAC), and the bubble chamber, Berkeley scientists have made many important discoveries: numerous new particles of matter including the antiproton and the antineutron; hundreds of artificial isotopes, among them carbon 14, whose uses include the study of photosynthesis and the dating of prehistoric material, and iodine 131, used in the detection and treatment of hyperthyroidism; vast new resources of nuclear energy; and thirteen of the fifteen synthetic elements.

The Donner Laboratory, although located on the lower portion of the Berkeley campus, is an integral part of the Lawrence Radiation Laboratory. It serves as the main center for the Radiation Laboratory's program in the uses of atomic energy in biology and medicine. The laboratory originated when research begun by Dr. John H. Lawrence, who came to visit his brother Ernest and remained in Berkeley to pioneer in the medical applications of atomic energy, attracted the attention of William H. Donner, whose son had died of cancer. Donner contributed funds to build the laboratory in 1941, and the Donner Foundation has made additional donations since his death.

The multiple-port in vivo counter, invented at the Donner Laboratory, is used in the diagnosis and investigation of obscure blood diseases. By means of radioactive iron, it can detect and photograph diseased cells throughout the body. Handling the machine are Dr. James Born, assistant director of the Donner Laboratory; Dr. John H. Lawrence, director; and a technician.

At the request of the Atomic Energy Commission, a separate component of the Radiation Laboratory was organized at Livermore in 1952. Its primary purpose is research and development of nuclear weapons, although it also explores uses of nuclear energy for peaceful purposes. The Plowshare program was developed in 1957 to explore the potential of nuclear explosives for large earth-moving projects that would otherwise be beyond man's reach, or that would be uneconomical by conventional means. Among the major Plowshare detonations was Project Sedan, an excavation demonstration in Nevada in 1962, in which a crater 1,200 feet in diameter and 320 feet deep was made. About 7,500,000 cubic yards of earth and rock were removed in one blast.

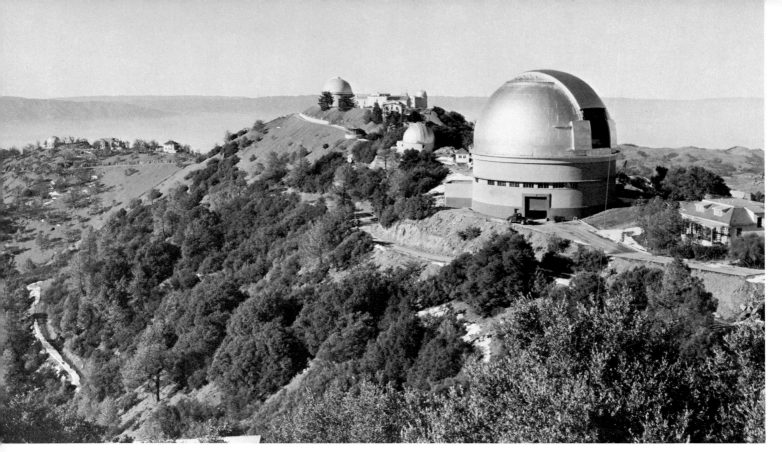

From the group of buildings completed on Mount Hamilton in 1888 to house the original 12-inch and 38-inch refractor telescopes, the Lick Observatory has spread along the summit ridge to include a campus of 3,300 acres, as were added the 36-inch Crossley reflector, the 22-inch Tauchman reflector, the 20-inch astrograph or star camera from the Carnegie Foundation, and the great 120-inch reflector telescope funded by the state legislature. In July 1965, some eight years after this photograph was taken, administrative responsibility for the Lick Observatory was transferred from the Berkeley campus to the Santa Cruz campus.

In 1958, the University's Radio Astronomy Laboratory was established in pine-circled Hat Creek Valley, twenty miles north of Lassen National Park. Supported in large part through a contract with the United States Office of Naval Research, the laboratory's thirty-three-foot and eighty-five-foot telescope dishes can detect radio waves from far beyond the limits of visual astronomy. The large telescope, pictured here, weighs some two hundred tons, stands 110 feet above the ground, and is considered one of the most accurate large radio telescopes ever constructed.

White Mountain Research Station, established in 1950, provides year-round laboratory facilities and living accommodations for faculty and students pursuing high-altitude research in a variety of disciplines. The station, located in Inyo County some 250 miles east of Berkeley, consists of four installations: headquarters and base laboratory at Bishop in the Owens Valley; the Crooked Creek Laboratory and living quarters at 10,500 feet (shown here, with a bristlecone pine in the foreground); the Barcroft Laboratory at 12,500 feet; and the Summit Laboratory at 14,250 feet—the highest permanent laboratory in North America.

Bodega Bay Marine Laboratory, opened in June 1966 on a 326-acre site in Sonoma County, serves the northern campuses in the study of marine coastal life. A grant from the National Science Foundation provided for construction of the laboratory building, which contains research space for forty investigators. Unlike the Scripps Institution at La Jolla, the laboratory is designed for study not of the ocean itself, but of life along the shore; the site provides a full range of marine environments, from open, rocky coast to sheltered sand beaches and mud flats.

University Extension does what it says—it extends the usefulness of the University to citizens of California who cannot attend regular University sessions. During the early 1890's, before University Extension began, off-campus lectures by faculty members attracted large audiences; in 1892, a course on Shakespeare's tragedies given by Professor Charles Mills Gayley in San Francisco had an enrollment of 170 persons. As a result, the Regents established a formal extension program in February 1893. Emphasizing its motto of "lifelong learning," originated by Leon J. Richardson, professor of Latin, who served as director of Extension from 1917 to 1938, the University Extension of today functions in all parts of the state in night classes and by correspondence, while by means of specialized workshops it keeps professional men abreast of the latest developments in their rapidly changing fields.

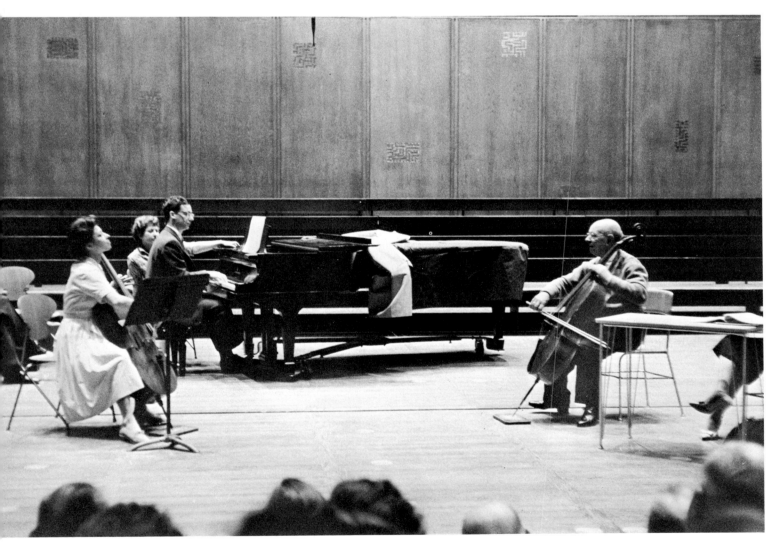

In Hertz Hall in the spring of 1960, world-acclaimed cellist Pablo Casals taught a University Extension master class for talented students.

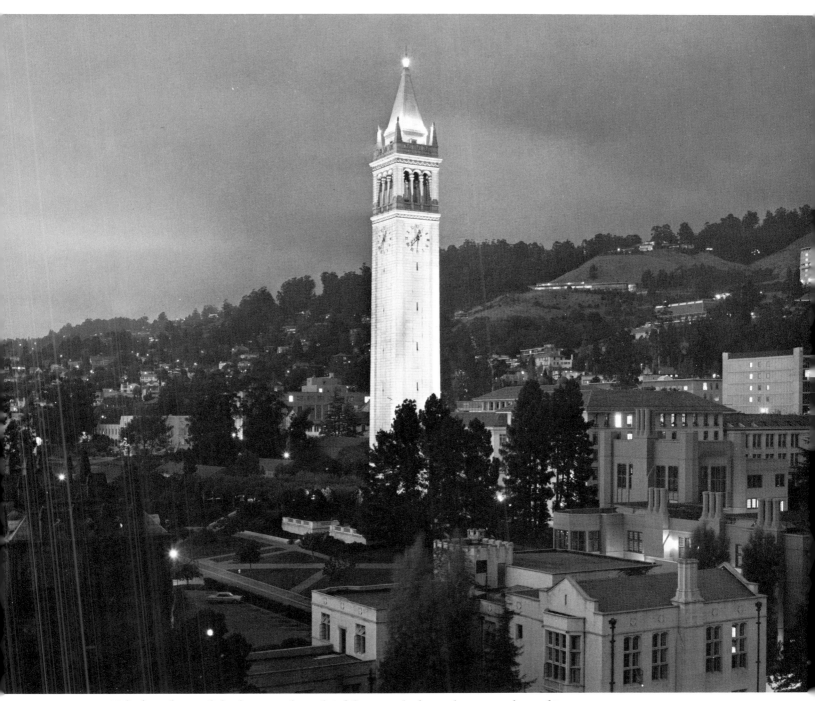

"The last glance of the future student of California as he leaves his native shore—his first returning glance as he welcomes home—shall fall on the spires of his own Alma Mater." This remark, made in 1858 by John B. Felton, a San Francisco lawyer who later served on the first Board of Regents, has proved prophetic, as the floodlit Campanile stands against the night.

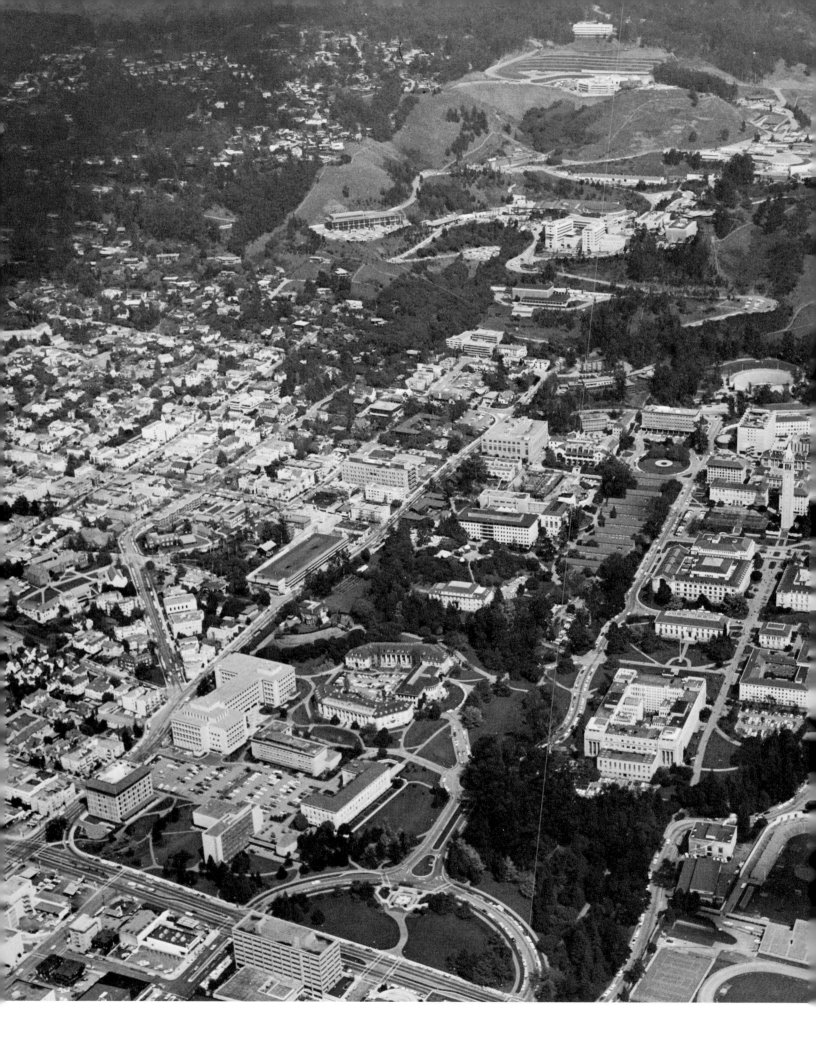

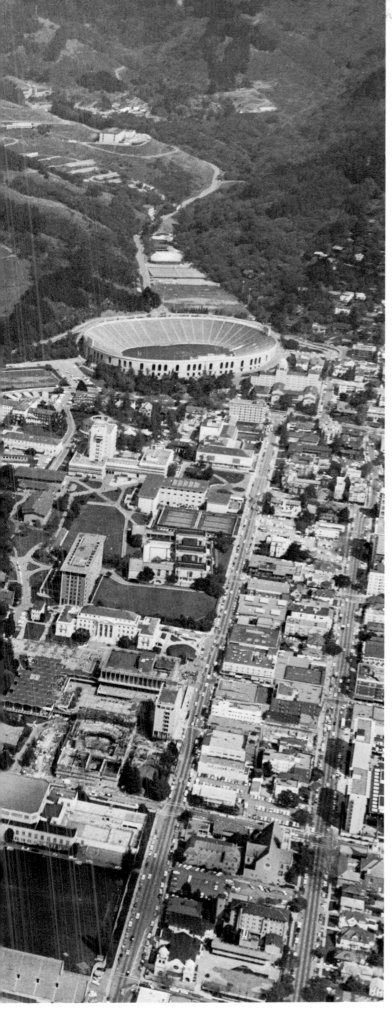

A campus aerial of 1967 clearly shows the original
160 acres included between the north and south
branches of Strawberry Creek (dark lines of trees
branching from left and right of the eucalyptus grove
in lower center) and rising from the grove to the
hills; the land purchased before 1873 to round out the
northwest corner of Oxford Street and Hearst
Avenue (lower left); the additional land purchased
since 1900 extending from Strawberry Creek to
Bancroft Way on the right; and, finally, the great
expansion after 1940 to 900 feet elevation in the hills
above, providing land for the Lawrence Radiation
Laboratory, Lawrence Hall of Science, and the
Space Sciences Laboratory at the top. The
campus divides into a southwest and central
student area (Edwards Fields, Harmon Gymnasium,
the Student Union complex with its auditorium-
theater under construction, and Hearst Gymnasium
and its playing fields) divided by Sproul Hall
(administration) with its white granite columns, and
Barrows Hall (classrooms and faculty offices). The
southeast corner (upper right), contains the fine arts,
anthropology and law, California Memorial Stadium,
and, immediately above the stadium, the Strawberry
Canyon Recreation Area. The central campus,
dominated by the Campanile, houses chemistry,
physics and mathematics, the General Library, the
humanities, and the life sciences. In the northwest
corner are public health and its allied sciences,
education and psychology, and agriculture. The
northeast area is devoted mainly to engineering, with
earth sciences, medical physics, and virus and
molecular biology on the periphery.

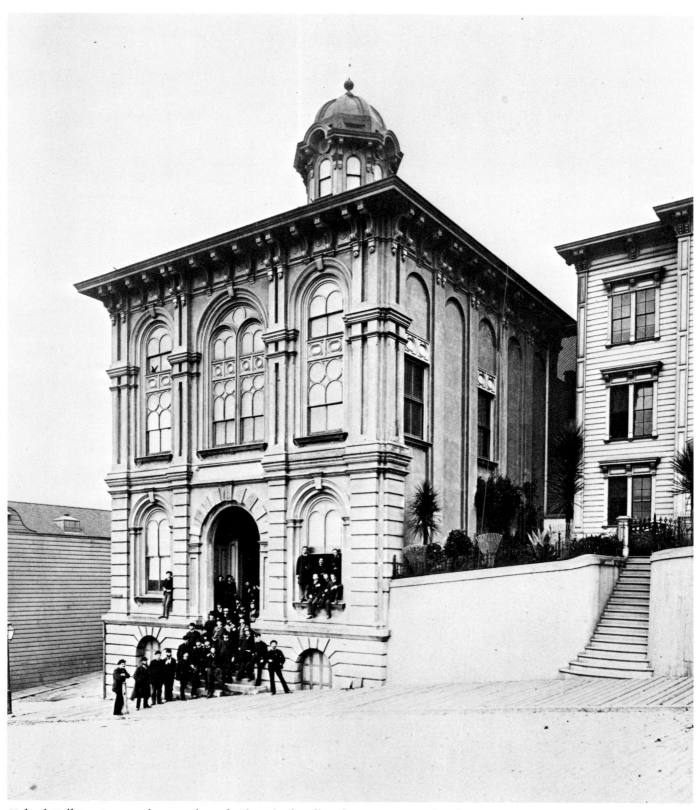

Toland Hall in 1873, at the time the Toland Medical College became associated with the university. The building's location at Stockton and Chestnut Streets, next to the Home for the Inebriates and opposite the San Francisco City Hospital, provided opportunities for clinical instruction.

San Francisco

The University of California San Francisco Medical Center dates back to 1864, when Dr. Hugh Huger Toland established a private medical college in the city. In 1873, Dr. Toland presented his college unconditionally to the young University of California. Also in 1873, the California School of Pharmacy became affiliated with the University. In 1881 the Regents established a College of Dentistry. A training school for nurses, established in 1907, became the School of Nursing in 1939.

Until the late 1890's, the Colleges of Medicine, Dentistry, and Pharmacy were in separate locations in downtown San Francisco. In March 1895, the Legislature appropriated $250,000 for buildings for the "Affiliated Colleges," a term that included medicine, dentistry, pharmacy, and the Hastings College of the Law, which was founded in 1878—although only pharmacy and Hastings were actually affiliated. Adolph Sutro, mayor of San Francisco, donated a site of thirteen acres on Parnassus Heights, then at the outermost western skirts of the city, and in October 1898, the three colleges of the health sciences came together on the new campus with its magnificent view over the city, the ocean, and the Golden Gate. The Hastings College of the Law decided to remain downtown.

Major growth and physical development into the San Francisco Medical Center began with the completion of the University Hospital in 1917 and a residence for nurses in 1919. Today, on an enlarged campus of 103 acres, the three original stone buildings have given way to eight fifteen- and sixteen-story modern buildings, including the 456-bed Herbert C. Moffitt Hospital, the largest and most comprehensive teaching hospital in the western United States. In addition to the Schools of Medicine, Dentistry, Nursing, and Pharmacy, there are teaching programs in a variety of paramedical specialties and biomedical fields. Graduate and post-doctoral training in the health sciences are increasingly emphasized, and organized research units are at work on a broad range of basic medical problems.

The North Beach area of San Francisco in the 1860's, from Black Point (the present Fort Mason). Toland Medical College, with its cupola, rises slightly to the right of center. The college's bulletin of 1881–82 described Toland Hall as "one of the most complete and stately in the country. . . . It is located near North Beach, overlooking Golden Gate, a locality favoring the health and industrious habits of the students."

The Regents of the University took the Toland College of Medicine into the University on a unique basis, designating it the Medical Department of the University and retaining the appointment of the faculty (who were accorded membership in the University's Academic Senate), but vesting authority in that faculty for the financial as well as the academic conduct of the department. This relationship continued until 1902, when, at the request of the medical faculty, the Board of Regents assumed the same financial responsibility and control over the Medical Department that it maintained over the other departments of the University.

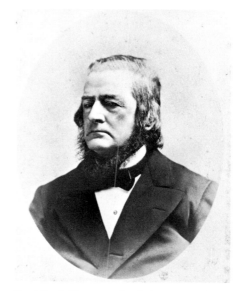

Dr. Hugh Huger Toland (1806–80).

The California College of Pharmacy, organized in 1872 by the California Pharmaceutical Society, opened its doors May 1, 1873. On May 15 the society received a proposal from President Gilman of the University of California to affiliate the college with the University. This was soon accomplished, and on July 8 the first lectures under University auspices were held, with President Gilman making the opening address. The terms of affiliation allowed the Board of Trustees of the California School of Pharmacy to continue to hold its own property, appoint the faculty, set fees, and establish the curriculum (although this last had to meet standards of instruction set by the University). The University granted the degree of Graduate in Pharmacy upon recommendation of the college's Board of Examiners and approval by a committee of the Regents. Affiliation continued until 1934, when the College of Pharmacy became an integral part of the University with a curriculum leading to a bachelor of science degree.

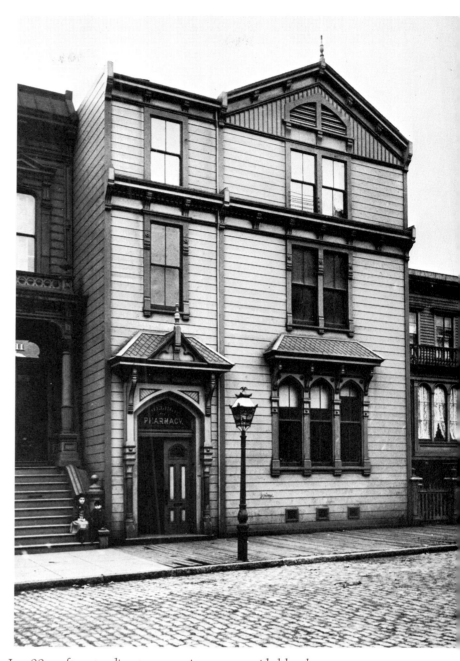

In 1883, after spending ten years in space provided by the California Academy of Sciences, the College of Pharmacy moved into its own building at 113 Fulton Street, a site now covered by the San Francisco City Hall. Funds for the new building were raised by private subscription.

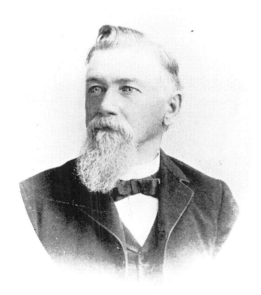

William T. Wenzell was president of the California Pharmaceutical Society and the California College of Pharmacy from 1872 to 1878, chairman of the Board of Trustees of the California College of Pharmacy from 1878 to 1880, and professor of chemistry at the college for many years.

In September 1881, the Regents established a College of Dentistry, acting upon a recommendation made by the medical faculty the previous May. This was the first dental school on the Pacific Coast. For the first ten years instruction was conducted in Toland Hall. In 1891, the college was moved to the two top floors of the Donohoe Building (shown here), on the corner of Market and Taylor Streets. After the new campus on Parnassus Heights opened, lectures and laboratory work in dentistry were transferred to the Dentistry-Pharmacy Building there, but a small infirmary remained in the Donohoe Building until the earthquake and fire of 1906.

Dr. Samuel W. Dennis, professor of operative dentistry and dental histology, organizer of the College of Dentistry, and its first dean (1881–85).

Adolph Sutro, mayor of San Francisco (1895–97) and
donor of the site of the Affiliated Colleges. A mining
engineer, born in Germany, Sutro came west during the
Gold Rush, planned the Sutro Tunnel in the Comstock Lode
of Nevada, and became a millionaire. He died in August
1898, aged sixty-nine, before completion of the Affiliated
Colleges' buildings.

The last official notice issued at Toland Hall,
October 18, 1898.

Rain and blowing sand accompanied the laying of
the cornerstone of the Affiliated Colleges, with
Masonic ritual, on March 27, 1897. San Francisco
seemed far distant from Parnassus Heights.
The following day, an editorial commented on
". . . the falling tears of Aesculapius, weeping
at the burial of a medical school amid the
sand dunes. . . ." San Francisco Mayor James
Phelan presided over the Saturday morning
ceremony, in the presence of former Mayor
Sutro and Dr. R. Beverly Cole, former dean of
the Medical Department, who was largely
responsible for bringing the Toland Medical
College and the University together. He also
was influential in the selection of "Sutro Heights"
as the new site for the Affiliated Colleges.

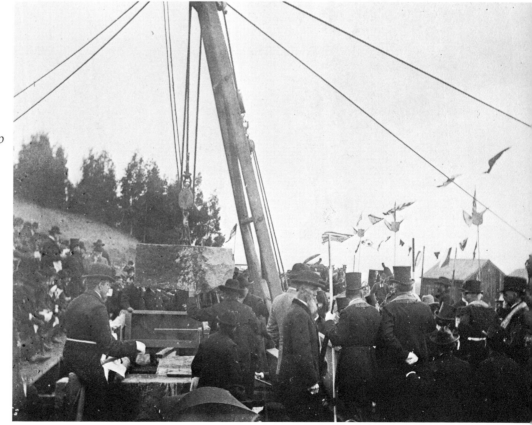

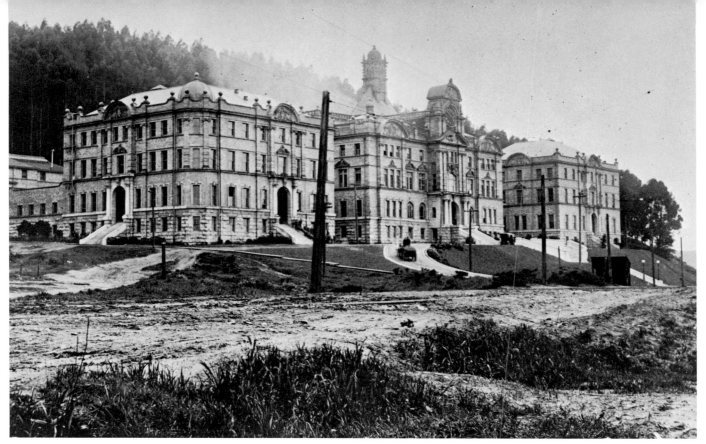

The Romanesque stone buildings of the Affiliated Colleges about 1904. The Colleges of Dentistry and Pharmacy occupied the building on the left, the College of Medicine that in the center. The third building was intended for the Hastings College of the Law, but the faculty considered it too far from the city's law courts and refused to move from Pioneer Hall, where the college was then located. Instead, the building became an anthropological museum and housed the growing Phoebe A. Hearst collections of archaeological specimens and art objects. The smaller building in the rear, built for the short-lived College of Veterinary Science, was remodeled in 1913 for the Hooper Foundation for Medical Research.

Plans that had begun in 1902 for acquiring a teaching hospital and a tr[e] school for nurses were crystallized by emergency conditions in San Fran[c] following the fire. To make room for this expansion, the first two years [of] medical instruction were transferred in 1907 to the Berkeley campus, w[ith] this former metallurgical laboratory was remodeled as the Anatomy Bui[lding].

The earthquake and fire of 1906 had a profound influence on the further development of the Parnassus Heights campus. Most of the hospitals of the city were destroyed, giving rise to a serious shortage of medical facilities. The Medical Department set up a number of emergency hospitals around the city, one of them in the Medical School Building—the beginning of the first University Hospital.

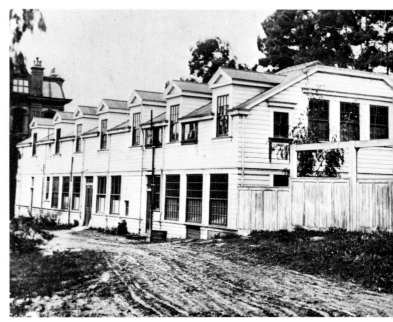

The museum building served for five years as the home of Ishi, lone survivor
in the Lassen foothills of the Yana Indian tribe—the "last wild Indian in
North America." Driven by hunger in 1911 from his ancestral haunts, Ishi
was brought to San Francisco by Berkeley anthropologists T. T. Waterman and
Alfred L. Kroeber, and at the museum they and Dr. Saxton Pope of the medical
faculty befriended and studied him for five years, obtaining a large fund of
information about the language, customs, myths, music, and arts of his people.
He built this summer shelter in the rear of the museum.
Ishi died in the University Hospital in 1916.

Miss Margaret Crawford, who organized the first
Training School for Nurses in 1907. The school's
white starched mortarboard cap and square blue-
enamel and gold pin were designed by Miss Crawford
and worn by the first graduates in 1909.

Dr. Robert A. McLean (right), professor of operative surgery and dean of the Medical Department from 1882–99, and Dr. George F. Shiels, associate professor of operative surgery, demonstrate their skill with block and tackle in 1894, in the operating theater of the old San Francisco City and County Hospital.

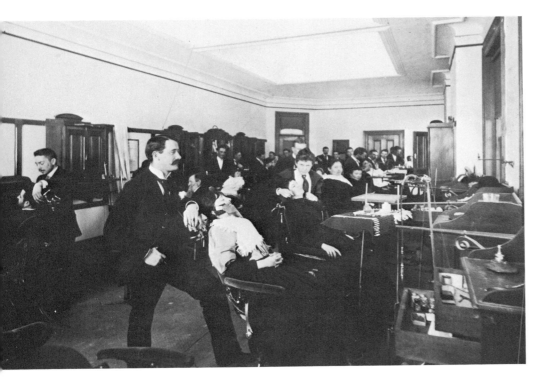

From the beginning, the College of Dentistry maintained a Dental Dispensary where, according to the annual report of the dean, "students have operated under the supervision of the Demonstrator of Operative Dentistry, and received instruction in treating, filling, and extracting teeth for indigent patients, who presented themselves in great numbers."
Dr. Benjamin M. Stich (foreground) checks the work of the students of 1894.

The dental class of 1905 in session—presumably looking a gift horse in the mouth.

The first staff of the Hooper Foundation included several men who have made great contributions to medical science: George H. Whipple (front center), first director of the foundation, later a Nobel laureate in medicine; Karl F. Meyer (front right), second director, described as "the most versatile microbe hunter since Pasteur"; Ernest Walker (front left), outstanding investigator of leprosy and tropical diseases; and Charles Hooper (rear left), the first to use liver extract in pernicious anemia

Intensive research began on the San Francisco campus in 1913, with the establishment of the George Williams Hooper Foundation, the first institute for medical research in the United States to be planned as an integral part of a University. The Hooper Foundation, with an endowment of over a million dollars from Mrs. Sophronia T. Hooper, widow of a San Francisco lumber merchant and philanthropist, early established its preeminence in the field of infectious diseases transmitted to man by animals. Through Hooper research, methods were devised for killing the organisms whose toxins cause botulism, making possible the growth of a safe canning industry in America.

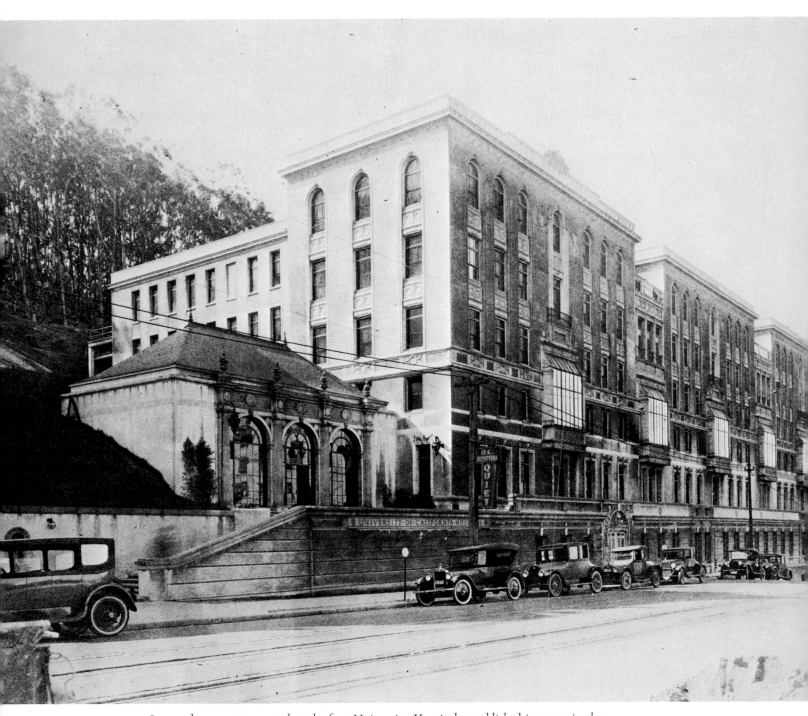

It soon became apparent that the first University Hospital, established in 1907 in the Medical School Building, was not large enough. The lack of clinical facilities was intensified by the distant location of San Francisco General Hospital, on Portrero Street. Dr. Herbert C. Moffitt, dean of the Medical Department (University of California Medical School after 1915), obtained private funds to construct this University of California Hospital, which opened its doors in 1917 and has played an important part in the development of medicine in California.

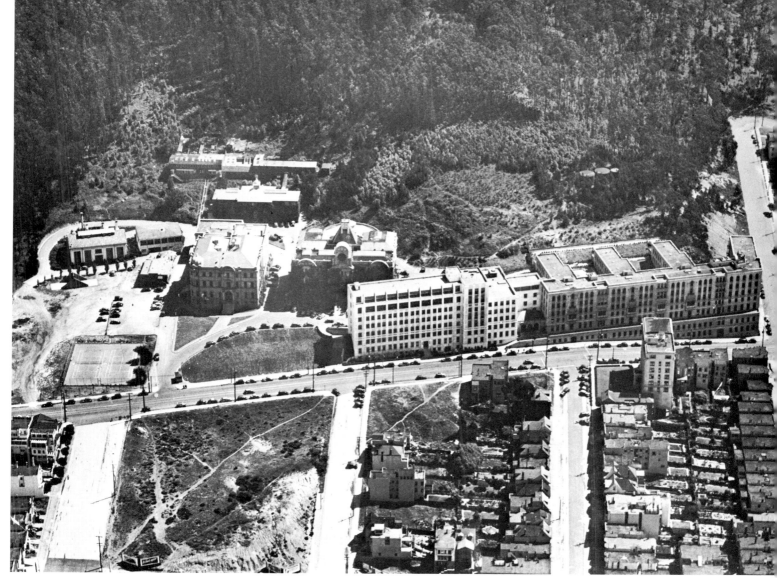

In 1934 the Museum of Archaeology and Anthropology was razed to make room for an out-patient clinics building (center), and the famous Hearst collection was put into storage in Berkeley. The Hooper Foundation occupied the building just behind Dentistry-Pharmacy.

In 1941 the Medical Center's facilities were further expanded when Dr. Robert Langley Porter, a former dean of the Medical School, persuaded the California State Department of Mental Health to affiliate with the University and construct a neuropsychiatric clinic near the campus. Participating in cornerstone-laying ceremonies in April 1941 were Dr. Langley Porter, Governor Culbert Olson, and President Sproul. The clinic (later renamed the Langley Porter Neuropsychiatric Institute) began operations in March 1943 with Dr. Karl L. Bowman as its first director. It occupied the site of the tennis courts seen in the preceding photograph.

Base Hospital Number 30 evacuating patients from a French railroad station during World War I. The unit was staffed by 35 officers, 65 nurses, and 150 enlisted men from the faculties and student body of the Medical School.

World War II saw the activation at the Medical Center of General Hospital Number 30, a unit composed of 28 officers, 70 nurses, and 325 enlisted men, which served in England and Belgium. Dr. Howard C. Naffziger (upper photograph, wearing civilian clothes), who visted the unit in England, was a member of the Medical School faculty from 1912 to 1950 and a Regent from 1952 to 1961. The modern era of surgical education at the Medical Center began in 1929, when Dr. Naffziger became chairman of the Department of Surgery. Under his leadership the center came to have one of the leading surgery departments in the country.

In 1917, a five-year curriculum leading to a baccalaureate degree in nursing was added to the diploma program initiated in 1907. In 1934, the diploma program was discontinued. The School of Nursing was created in 1939, and ten years later a program was authorized leading to the master of science degree in nursing. Since 1965 there has also been a program leading to the degree of doctor of nursing science, as well as new post-master's programs in clinical and functional areas.

Prior to 1954, the deans of the various schools reported directly to the president of the University. That year an administrative advisory committee composed of deans and administrative officials and chaired by the dean of the School of Medicine was appointed to conduct the affairs of the Medical Center. In 1958, to bring the Medical Center into administrative line with the other campuses, the position of chief campus officer was created, with the title of provost. This was changed to chancellor in 1964.

The Medical Center's first provost and first chancellor, Dr. John B. deC. M. Saunders (second from left), at his inauguration in 1958. Dr. Saunders, a fellow of the Royal College of Surgeons, Edinburgh, joined the University faculty in 1931, becoming dean of the School of Medicine in 1956. Dr. Saunders resigned as chancellor in 1966 to assume the newly created Regents' Chair of Medical History. He was succeeded by Dr. Willard C. Fleming (left), a member of the dentistry class of 1923. Dr. Fleming joined the faculty at San Francisco the year he graduated, became dean of the School of Dentistry in 1939, and served as vice-provost and then vice-chancellor from 1958 to 1965. On the right are President Kerr and Dr. Karl F. Meyer, distinguished pathologist and second director of the Hooper Foundation.

During the early years, the Medical Center offered few recreational facilities. The buildings were isolated, and there were no restaurants within blocks. "The campus then was a mill where the student entered, completed the required courses, and left with his degree—and little else," the student newspaper, *Synapse*, later commented. Such extracurricular activities as there were, usually were led by the dental students, the only group in full-time residence on the campus; medical students and nurses spent a great deal of their time at hospitals scattered around the city, and pharmacy students usually worked in drug stores during the afternoons.

The College of Dentistry's 1901 baseball team.

In the early 1920's, dental students with picks and shovels borrowed from the Market Street Railway cleared and leveled land for two tennis courts—the first recreational facilities on the new campus. The precedent set was followed throughout the rest of the 1920's and the early 1930's; once a year, classes were dismissed and students would work to improve the campus grounds.

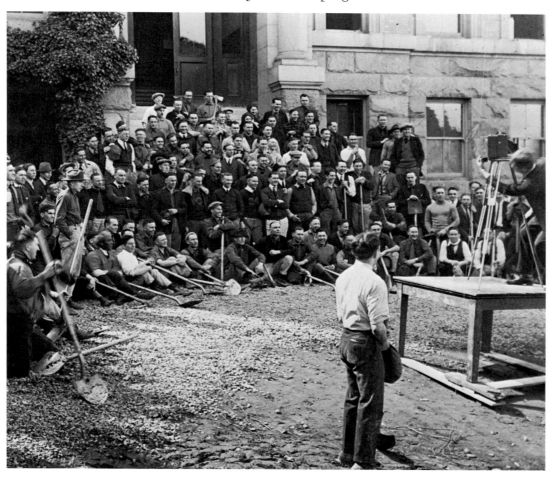

Beginning in 1921, the Associated Dental
Students, led by the group's president,
Willard C. Fleming, built a shack to use as a cafeteria.
Encouraged by Dean Guy S. Millberry, the
venture proved successful, and in 1925 it was
enlarged as the Dental Supply Store. The two
projects eventually came under the management
of Dr. George Steninger, class of 1925.

Dr. Steninger set up what amounted to a one-man drive to raise gifts from the faculty and alumni of
every school at the Medical Center. The funds he obtained, when matched by the Regents and added
to the cafeteria's profits, were sufficient to begin construction of the $3,500,000 Millberry Union,
which was completed in 1958. Included in the union complex, in addition to shops and a cafeteria,
are residence halls, a gymnasium-auditorium, and a swimming pool.

Gathered in the Millberry Union lounge at the time of the dedication of the union on September 19, 1958, were Dr. Steninger; Dr. Saunders; Marcia Rehfuss, president of the Associated Students; Dr. Fleming; and Robert Alexander, director of the union. The Smyth fireplace, with its mosaic tree, is dedicated to the memory of Dr. Francis Scott Smyth, a Medical School graduate of 1917, who was dean of the school from 1942 to 1954.

A strong intramural sports program is carried on in Millberry Union's athletic facilties.

Registration in the gymnasium-auditorium of Millberry Union in the early 1960's.

Synapse, *the school newspaper, was first published commercially in 1957, replacing an earlier mimeographed sheet,* Hy-Dent, *which was issued by the dental students. The newspaper today is a popular semiweekly, issued as a student activity.*

A "synapse" is defined as a point of contact between adjacent neurons, where nerve impulses are transmitted from one to another. Commented the yearbook, Medi-Cal, *on this* Synapse *staff of 1964: ". . . senior medical students from the schools of pharmacy, dentistry, nursing and dental hygiene, and a union staff member, who not only doubles in brass but occasionally eats brass when necessary, are the scintillating sentries of free speech through the campus newspaper."*

The Schools of Medicine, Nursing, and Pharmacy have developed traditional awards for their outstanding students. The oldest of these, the medical school's Gold-Headed Cane, was initiated in 1939 by Dr. William J. Kerr, chairman of the Department of Medicine. It is presented each year to the Senior medical student "who in his preparatory years has shown by signal devotion to the interests of his patients, that he will uphold the traditions of the true physician." The Florence Nightingale Award for excellence in clinical nursing was also suggested by Dr. Kerr, in 1944. A small gold guard with a miniature likeness of Miss Nightingale is attached to the school pin to symbolize the award. The School of Pharmacy's Bowl of Hygeia is awarded to the Senior student "best demonstrating the qualities of the ideal pharmacist."

The Gold-Headed Cane award carries forward a tradition of English medicine dating from 1689; the cane is derived from an original now resting in the Royal College of Physicians in London.

In 1967 the Gold-Headed Cane was awarded to two graduating students, since their classmates and members of the faculty found it impossible to choose between Lorne Eltherington (left) and Robert Handin (center). Honorable mention went to Lawrence Hill (right).

In the Gold-Headed Cane ceremonies, held the evening before commencement, graduating medical students receive their academic robes and take the Oath of Hippocrates.

THE OATH OF HIPPOCRATES
∴

I SWEAR BY APOLLO THE PHYSICIAN·
AND AESCULAPIUS·AND HEALTH·AND ALL-HEAL·AND ALL THE GODS AND GODDESSES · THAT · ACCORDING TO MY ABILITY AND JUDGMENT·I WILL KEEP THIS OATH AND THIS STIPULATION— TO RECKON HIM WHO TAUGHT ME THIS ART EQUALLY DEAR TO ME AS MY PARENTS·TO SHARE MY SUBSTANCE WITH HIM·& RELIEVE HIS NECESSITIES IF REQUIRED·TO LOOK UPON HIS OFFSPRING IN THE SAME FOOTING AS MY OWN BROTHERS·AND TO TEACH THEM THIS ART·IF THEY SHALL WISH TO LEARN IT·WITHOUT FEE OR STIPULATION·AND THAT BY PRECEPT·LECTURE·& EVERY OTHER MODE OF INSTRUCTION·I WILL IMPART A KNOWLEDGE OF THE ART TO MY OWN SONS·AND THOSE OF MY TEACHERS·AND TO DISCIPLES BOUND BY A STIPULATION AND OATH ACCORDING TO THE LAW OF MEDICINE·BUT TO NONE OTHERS◆I WILL FOLLOW THAT SYSTEM OF REGIMEN WHICH·ACCORDING TO MY ABILITY AND JUDGMENT·I CONSIDER FOR THE BENEFIT OF MY PATIENTS·AND ABSTAIN FROM WHATEVER IS DELETERIOUS AND MISCHIEVOUS◆I WILL GIVE NO DEADLY MEDICINE TO ANYONE IF ASKED·NOR SUGGEST ANY SUCH COUNSEL·AND IN LIKE MANNER I WILL NOT GIVE TO A WOMAN A PESSARY TO PRODUCE ABORTION◆WITH PURITY & WITH HOLINESS I WILL PASS MY LIFE & PRACTICE MY ART◆I WILL NOT CUT PERSONS LABORING UNDER THE STONE·BUT WILL LEAVE THIS TO BE DONE BY MEN WHO ARE PRACTITIONERS OF THIS WORK◆INTO WHAT- EVER HOUSES I ENTER·I WILL GO INTO THEM FOR THE BENEFIT OF THE SICK·AND WILL ABSTAIN FROM EVERY VOLUNTARY ACT OF MISCHIEF & CORRUPTION·AND·FURTHER·FROM THE SEDUCTION OF FEMALES OR MALES·OF FREEMEN AND SLAVES◆WHATEVER·IN CONNECTION WITH MY PROFESSIONAL PRACTICE·OR NOT IN CON- NECTION WITH IT·I SEE OR HEAR·IN THE LIFE OF MEN·WHICH OUGHT NOT TO BE SPOKEN OF ABROAD·I WILL NOT DIVULGE·AS RECKONING THAT ALL SUCH SHOULD BE KEPT SECRET◆WHILE I CONTINUE TO KEEP THIS OATH UNVIOLATED·MAY IT BE GRANTED TO ME TO ENJOY LIFE AND THE PRACTICE OF THE ART·RESPECTED BY ALL MEN·IN ALL TIMES·BUT SHOULD I TRESPASS AND VIOLATE THIS OATH·MAY THE REVERSE BE MY LOT

Dean Troy C. Daniels presenting the Bowl of
Hygeia to Richard B. Froh in 1966, the year
the award was initiated.

During the first commencement exercises held at the San Francisco Medical Center, the class of 1961
flung their mortarboards skyward in a traditional gesture. Previous graduates of the professional
schools in San Francisco had received their degrees at the Berkeley exercises.

To provide postgraduate training for practicing physicians, particularly those returning to private practice from the armed forces, Continuing Education in Medicine and the Health Sciences was officially established at the end of World War II. In the ensuing years, the department's activities have been expanded to serve nursing, dentistry, pharmacy, dietetics, physical therapy, X-ray technology, medical laboratory technology, and veterinary medicine. Between 1945 and 1967 the annual course offerings grew from less than a dozen to more than 140; total registration from less than five hundred to more than twenty thousand. The Continuing Education in Medicine program also has achieved worldwide recognition for its major symposia on paramedical issues of broad concern to both professionals and laymen.

To assist physicians of California and the West in maintaining the highest standards of health care, the Continuing Education program in 1964 began operating two-way radio conferences with more than seventy hospitals in California, Oregon, and Nevada. These Medical Radio Conferences were expanded in 1965 to include the fields of nursing, pharmacy, and postgraduate dentistry.

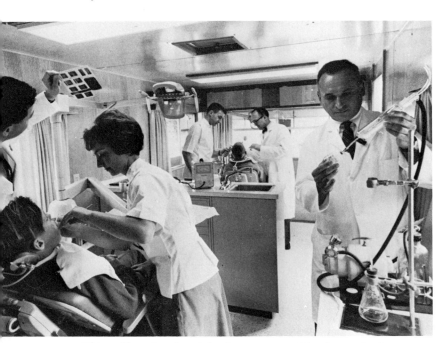

This well-equipped mobile clinic, operated by the Medical Center, provides rural areas of northern California with up-to-date medical facilities.

The mobile clinics also participate in "Project Head Start" programs, as well as providing general health education and services.

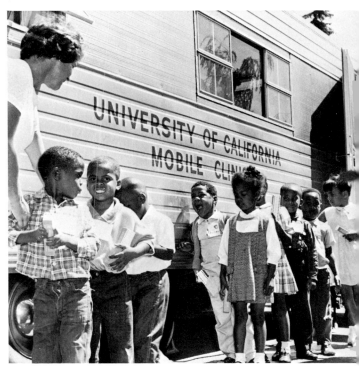

The Medical Center is inolved in several international programs and has made significant contributions to the advancement of medical education in developing countries. At the request of the Indonesian government, for example, the center has carried on a program at Airlingga University in Surabaya, to improve the quality of medical training and establish stronger clinical programs.

The intellectual horizons of the campus have often been expanded by bringing in outstanding physicians from other countries. At this medical-staff conference in December 1953, Sir James Learmonth of Edinburgh, at the podium, and Sir Charles Symonds of London (front row, third from the right), debate problems with students, faculty, and practicing physicians.

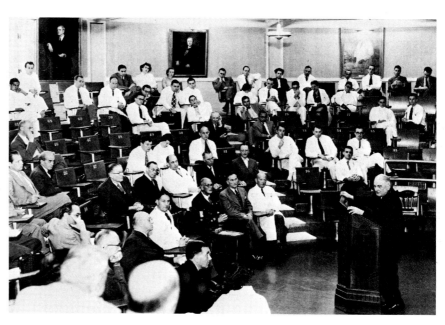

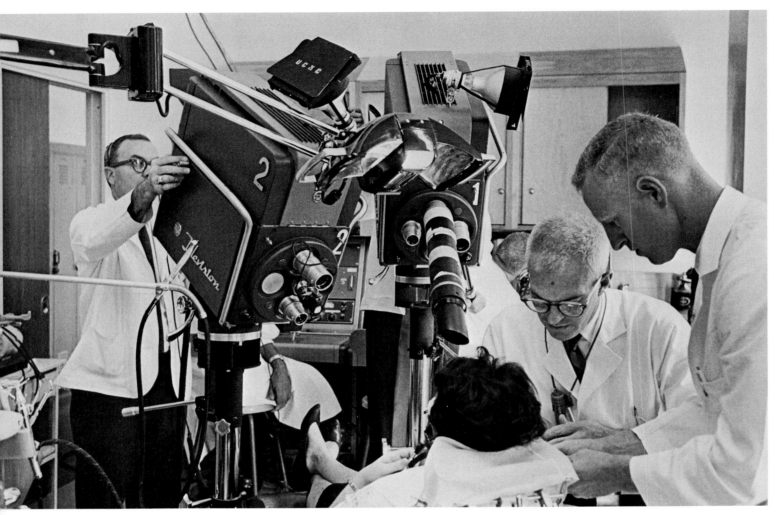

Television plays an important role in teaching and in projecting improved medical and dental techniques to other hospitals and institutions around the world. The San Francisco Medical Center was one of the first in the nation to establish a permanent unit dedicated to experimental research in the improvement of televised health-sciences instruction.

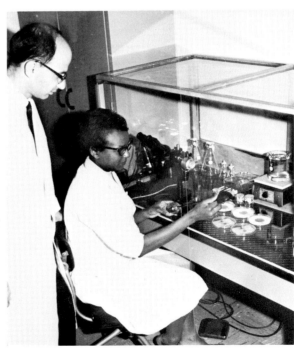

By 1961, study of the basic sciences had grown so large and so important that a separate Graduate Division was established to administer graduate degree programs in these sciences. Since the organization of the independent division, graduate student activities have acquired an increased identity among campus-wide activities, and graduate degree programs are offered in a score of subjects. Dr. Joel Elias is shown discussing organ culture techniques with a graduate student.

The Medical Center's record of contributions to knowledge in the health sciences is long and distinguished. Among the most outstanding of these are the discovery of the sterilization methods on which the modern canning industry is based; pioneering applications of chemicals and radioisotopes in controlling cancer; fundamental contributions to the understanding and control of plague and other animal-borne diseases; a series of recent advances in the definition and measurement of heart and lung functions; and the use of human growth hormones to treat several disorders of development.

Atomic research in 1920 and in 1960. The equipment above was used in 1920 in the extraction of radon, an element formed by the disintegration of radium. In the photograph at the right is the synchrotron installed by the Atomic Energy Commission and used in cancer research.

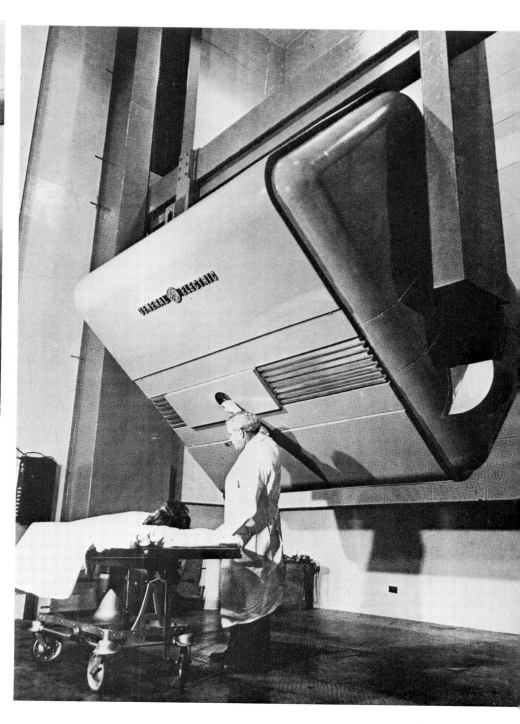

In 1944, two of the Medical Center's most distinguished researchers, Dr. Herbert M. Evans, '04, and Associate Professor Choh H. Li, Ph.D., '38, examined the first purified crystalline animal growth hormone. Dr. Evans, a professor of anatomy, Hertzstein Professor of Biology, and director of the Institute of Experimental Biology from 1930 to 1953, discovered the animal hormone. Professor Li, who became director of the Hormone Research Laboratory when it was organized in 1950, isolated the human growth hormone in 1956 and in 1966 reported the complete identification of its chemical structure. Such work with growth hormones is particularly useful because it helps provide an understanding of abnormal growth and thus is relevant to cancer research.

The first isolation of the virus of trachoma, the most widespread single cause of blindness in man, was accomplished at the Medical Center in 1959 by the staff of the Francis I. Proctor Foundation for Research in Ophthalmology. The foundation was established in 1947 through a gift from Mrs. Proctor in honor of her husband Francis, the noted ophthalmologist.

A medical student examines one of the more than 2,300 babies born each year in the Herbert C. Moffitt Hospital, which opened in 1955.

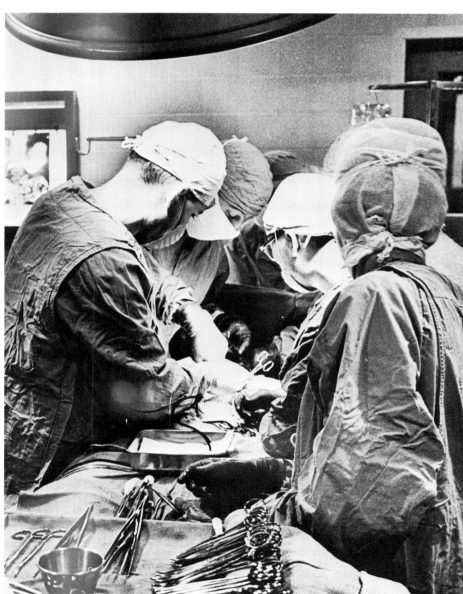

The "team" approach in surgery, with its union of surgeon, resident, graduate, nurse, medical technician, and undergraduates from diverse schools, has traditionally received great emphasis at the San Francisco Medical Center.

On June 2, 1958, distinguished members of the joint faculties assisted in moving the library into expanded new facilities in the Medical Sciences Building. There, for the first time, the collections of the several schools were brought together. The Pharmacy Library was integrated with the collections of the Schools of Medicine, Nursing, and Dentistry, which had been initiated earlier, and the unified Medical Center Library was established. It is one of the major health-science information centers in the United States, containing over 300,000 volumes, 5,000 periodicals, and 75,000 foreign medical theses.

Today the Medical Center's teaching staff numbers 1,700 members, many of whom donate their services. Some 12,000 dentists, nurses, pharmacists, physicians, and other professional and technical personnel have been graduated from the center. Teaching and research programs lead in turn to a substantial volume of health services to patients from all over California and other parts of the West. The center's hospitals record some 17,000 admissions a year. The part-pay medical and dental programs serve approximately 38,000 patients, for a total of some 208,000 visits a year.

Expansion required demolition in 1967 of the "Old Med School Building," as it was affectionately called. In the background is the Medical Sciences Building, completed in 1958, which contains most of the classrooms and teaching laboratories, the library, many offices, and some research activities.

124 SAN FRANCISCO

Seventy years and two months after it was put in place, the cornerstone of the medical building was opened—again in ceremonies conducted by the Masons, under whose ancient rites most cornerstones are laid.

Inside the copper box were copies of the city's six daily newspapers of March 26 and 27, 1897, the deed of land by Adolph Sutro, the legislative appropriation act of 1895, and this oldest photograph of the campus site, showing the leveling of the sand dunes by mule-drawn scoops in preparation for the construction of the first Parnassus Heights buildings.

SAN FRANCISCO 125

In this 1966 aerial view of the San Francisco Medical Center taken from the northwest, the structures are (clockwise from the left) the Langley Porter Neuropsychiatric Institute; Herbert C. Moffitt Hospital, with the Medical Sciences Building adjoining it on the west; the Health Sciences Instruction and Research East and West Towers (behind Moffitt-Medical Sciences); original Medical School Building of 1897 (razed in 1967 to prepare site for a plaza and an additional instruction and research building); Clinics Building; University of California Hospital; Parnassus Residences (for student nurses); and the Guy S. Millberry Union. Because of the critical need for people in all branches of medicine, the Medical Center is scheduled to expand rapidly, reaching a total enrollment of 7,500 by 1990. The Medical Center's Long Range Development Plan, approved in principle by the Regents, calls for eventually doubling the campus' two million square feet of building space. In order to conserve land, high-rise structures will form a multiple-level complex extending from Irving Street (left corner) to the upper slopes of Mount Sutro.

Two affiliates of the University—Hastings College of the Law and the San Francisco Art Institute—are also located in San Francisco.

Hastings College of the Law was founded by legislative act in 1878, with funds donated by Judge Serranus Clinton Hastings, first Chief Justice of the Supreme Court of California. The first school of its kind in the West, the college is affiliated with the University of California under the authority of the University's president and Board of Regents, who confer the degrees. The management of the school and selection of its faculty, however, are conducted by a self-perpetuating Board of Directors chosen from the membership of the Bar Association of San Francisco.

Pioneer Hall, at 808 Montgomery Street, was the first home of the Hastings College of the Law.

Hastings was to move fifteen times between 1879 and 1953, when it occupied this permanent site at Hyde and McAllister Streets, within easy walking distance of federal, state, and city buildings, with their several courts of law.

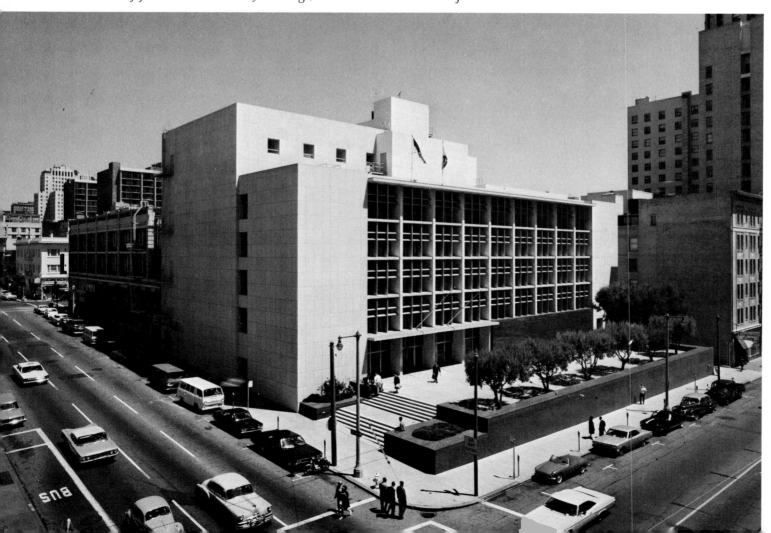

The San Francisco Art Institute was founded by the San Francisco Art Association in 1874 as the California School of Design. It became affiliated with the University of California in 1893, when Edward F. Searles gave the University his Nob Hill mansion, which had belonged to his late wife, formerly the widow of the railroad magnate Mark Hopkins. As an affiliated school, the institution was to be managed by the Art Association for instruction in and promotion of the fine arts, under the title of the Mark Hopkins Institute of Art. The mansion was destroyed in the great fire of 1906, and the Association rebuilt on the site, changing the name to the San Francisco Institute of Art and then, in 1916, to the California School of Fine Arts. In 1923, the Regents sold the land and used the proceeds to purchase the present site on Chestnut and Jones Streets. The name San Francisco Art Institute was adopted in 1961.

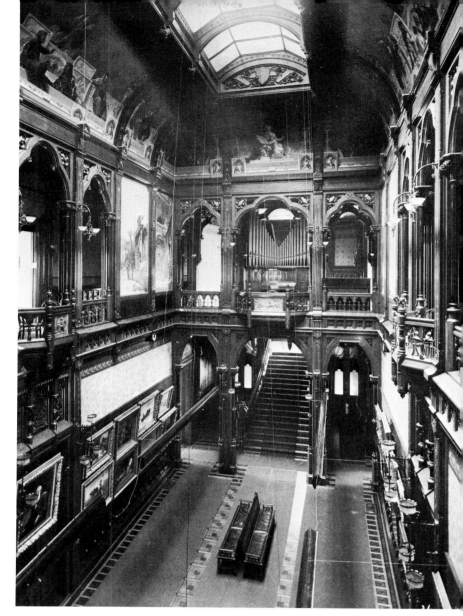

The Mark Hopkins Institute of Art about 1900.

The present location of the San Francisco Art Institute on the slopes of Russian Hill.

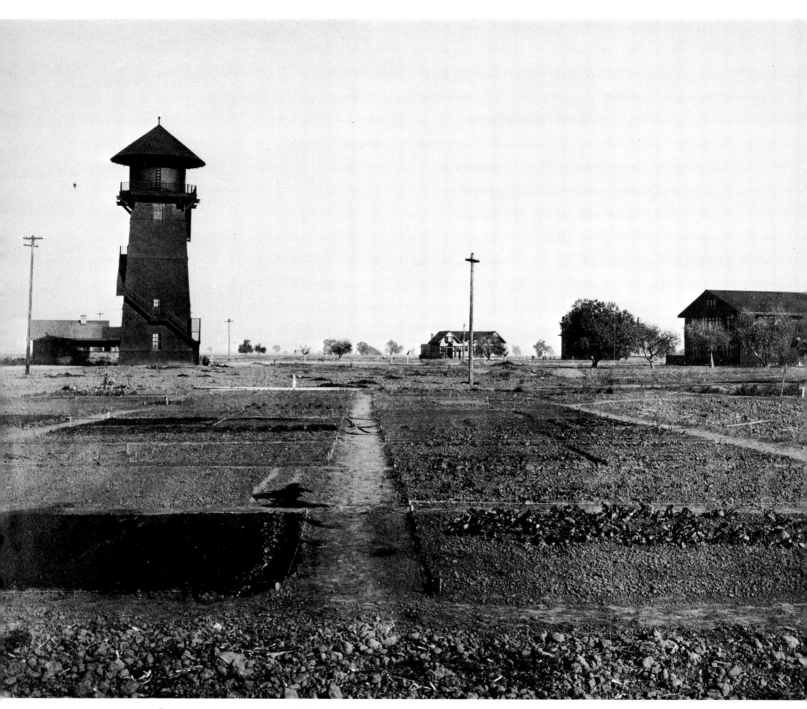

The University Farm around 1910.

Davis

During the 1880's, agricultural leaders throughout the state began urging that a University Farm be established. By 1899, these advocates included the secretary of the State Agricultural Society, Peter J. Shields, who had discovered that young men had to go to school in other states to learn to judge dairy products. Shields, who is often referred to as the "father of the Davis campus," drafted three bills calling for establishment of a University Farm. In 1905, the third one was passed. In 1906 the state purchased 773 acres of the Jerome C. Davis stock farm in Yolo County, and the first buildings were constructed in 1907. Formal instruction began in January 1909. In addition to supplementary courses for University students spending a semester on the Farm, a Farm School was established to provide a three-year program for grammar school graduates. The University Farm, later designated as a branch of the College of Agriculture, was administered by an assistant dean who reported to the dean of agriculture at Berkeley.

The academic mission of the campus began a gradual shift as early as 1922, when four-year degree work was initiated and the Farm School course was renamed the non-degree curriculum. Until then, students had had to take most of their degree work in Berkeley. Following World War II, academic work in non-agricultural disciplines was increased to help meet the needs of the state's growing population. In 1951 a College of Letters and Science was established, and seventy-six students enrolled, with majors in various subjects.

In 1959 Davis became a general campus of the University, with authority to add new major fields, schools, and colleges and to expand its graduate program. A College of Engineering was established in 1962 and a School of Law in 1966; a School of Medicine will accept its first students in the fall of 1968. By 1975, enrollment is expected to reach 18,500, with 3,500 of these in professional schools.

Even as a general campus, however, Davis remains the principal agricultural campus of the University. Most of its 3,700 acres are devoted to agricultural research, and in its sixty-year history the campus has made many significant contributions to agriculture. From the Davis campus and ten University field experiment stations located throughout the state has come a steady flow of new varieties of plants, better strains of livestock, mechanized labor-saving devices, more efficient production methods, and control measures against animal diseases and insect pests.

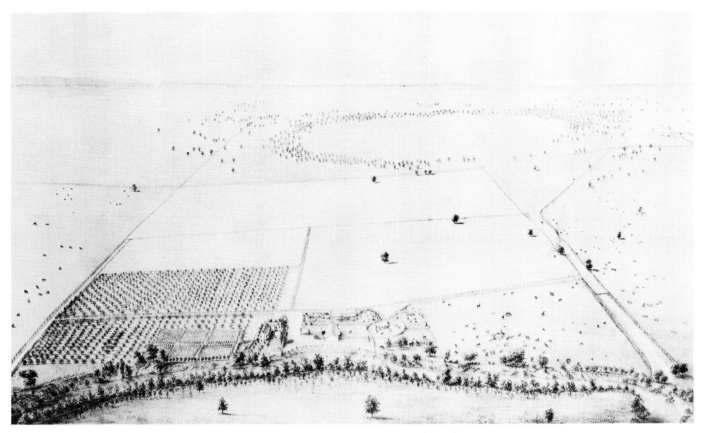

An 1858 lithograph of the Jerome C. Davis stock farm at the time it won a first-class rating from the State Agricultural Society. Local histories record that Davis received the land from his father-in-law, who came from Missouri to settle, but didn't like the water in Putah Creek and moved on to Napa County.

When the legislature was considering the bill authorizing purchase of a University Farm, Yolo County representatives added an amendment providing that in soil, location, climate, and general environment the place selected should be "typical" of the best agricultural conditions in the state. The object of the amendment was to make the bill fit Yolo County rather than Berkeley and add to the county's chances of obtaining the farm.

". . . a notable victory for Yolo county," reported the Woodland Mail *of April 6, 1906, upon selection of the Davisville site. In 1908 the name of the post office was officially changed from "Davisville" to "Davis," partly because of confusion with "Danville."*

The entrance to the University Farm in 1908, looking west along what is now Peter J. Shields Avenue. The road leads to the Stock Judging Pavilion and the Creamery.

A horticulture class of 1912.

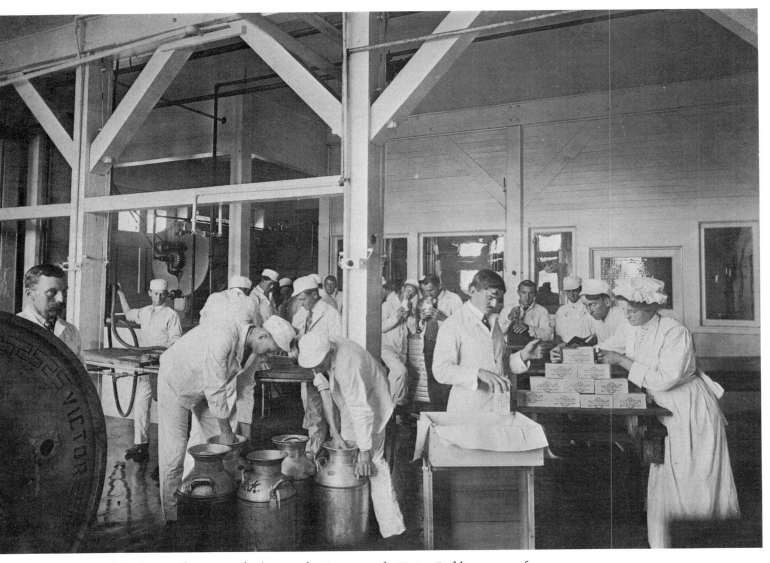

One of the busiest places in early days on the Farm was the Dairy Building, more often known as the Creamery. Manufacturing operations such as these were taught on the first floor; administration offices, a classroom, and a laboratory were located on the second.

Farmers' Institutes were inaugurated by the University in 1892 and held in California "wherever interest in agriculture was manifest." After the establishment of the Farm at Davis, a series of short courses, usually six weeks in length, were begun there. The courses were in demand from various segments of agriculture; in 1909–10, for example, some one hundred short courses, such as this one in animal husbandry, were held. Dr. Clarence M. Haring, Berkeley professor of veterinary science (far left), participated in the demonstration on throwing a bull.

A direct development of the Farmers' Institutes was demonstration trains—"cow, sow, and hen specials"
—which carried the results of agricultural and horticultural research throughout the state.
Arranged with the cooperation of the Southern Pacific and Santa Fe railroads, the trains carried faculty
and students from Davis and Berkeley, who conducted demonstrations and answered questions. The special
trains originated in 1908 and, with variations, were operated as late as 1928.

Students of the State Normal School at Chico
boarding one of the demonstration trains around 1910.

Before 1915, although there was a "summer road" to Sacramento, only a few adventurous souls attempted the passage across the marshy land. The most practical method of transportation to the state capital, thirteen miles away, was a single-track railway. But the arrival of the automobile and improved road conditions, including the building of the Yolo Causeway between Davis and Sacramento, helped break the isolation of the Farm.

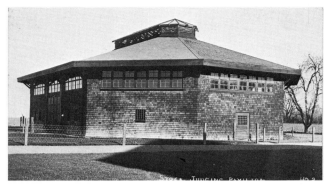

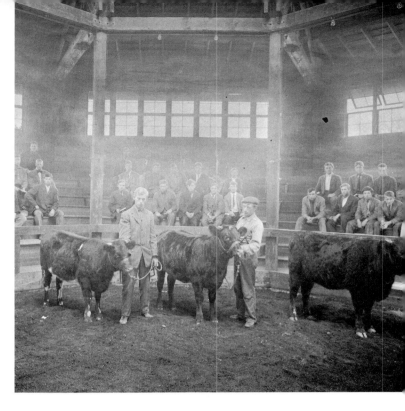

The Stock Judging Pavilion, one of the original Farm
buildings, was also used as an all-purpose meeting place.
After being moved twice, it was converted in 1964
to a two-hundred-seat Elizabethan theater,
the Wyatt Pavilion Theater.

The residence of the farm manager was another of the original structures. More recently it has housed
various academic departments, the Faculty Club, and administrative offices including the Chancellor's.

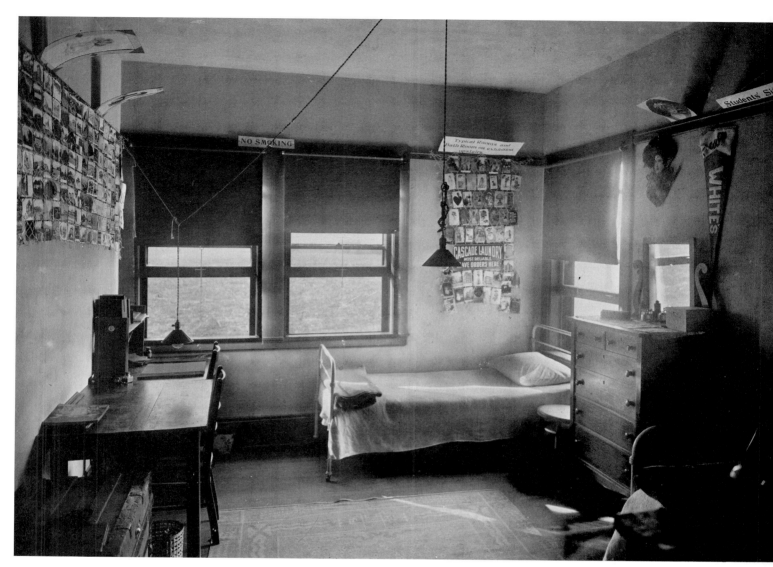

A student room in North Dormitory (later North Hall), which
was also among the first structures completed on the Farm.
The dormitory accommodated sixty-seven male students.

The dedication of North Dormitory, on May 22,
1909, was the occasion for a "Basket Picnic,"
out of which has grown the annual Picnic Day,
a major tradition on the Davis campus.

UNIVERSITY OF CALIFORNIA
COLLEGE OF AGRICULTURE

———

Dedication of the Dormitory and Basket Picnic

University Farm, Davis, California

Saturday, May 22, 1909

Beginning at eleven o'clock, in the Pavilion

———

Guests who arrive at the Farm before 10:45 are requested to
visit the Dormitory before the exercises in the Pavilion, which begin
promptly at 11 o'clock and which will conclude at 12:30.

Trains leave Davis in the afternoon as follows:

To Sacramento, 3:45; to San Francisco, 3:58; to Woodland
and Red Bluff, 5:35; to Marysville and Oroville, 6:30.

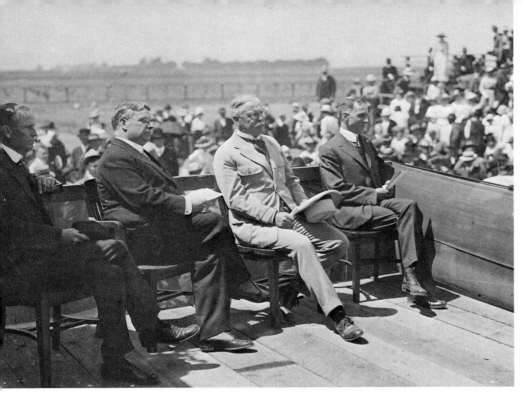

Seated on the speakers' platform for Picnic Day 1914 were Regent John M. Perry, president of the State Board of Agriculture; Governor Hiram Johnson; President Benjamin Ide Wheeler; and Hubert E. Van Norman, who served as Vice-Director of the Agricultural Experiment Station and dean of the University Farm School.

The 1918 Picnic Day parade.

Food shortages during World War I provided the theme for this float.

As early as 1920, Picnic Day parking was a problem.

The first women to enroll at Davis were three coeds from the College of Agriculture in Berkeley, who spent a term on the Farm in 1914 to add practical experience to their education in agriculture; others soon followed them.

The Farm in 1920. The main buildings were clustered around an alfalfa field (left), which later became the greensward of the Quadrangle.

All the early buildings on the Farm were wood, mostly shingle. The first two more permanent buildings—Dairy Industry and Horticulture—were completed in 1922. Among those gathered for the dedication of the Horticulture Building were Walter Howard (far left, front row), who was to serve as director from 1925 to 1937, and Leroy Anderson (fourth from the left, front row), who became superintendent of the University Farm School in 1910.

The Quad was producing hay as late as 1927. On the left is West Hall, completed in 1914 as a dormitory for sixty-seven men and razed in 1951 to clear the site for the Memorial Union. On the right is East Hall, built in 1909 to serve as a dining hall and infirmary. Relocated in 1951, it continues to be used as temporary quarters for various activities.

As an outgrowth of the many Farmers' Institutes
and short courses held on the Farm and throughout
the state, an Agricultural Extension was created
by the University in 1912. Bertram H. Crocheron
(left) organized the service and headed it from
1913 until his death in 1948.

A tractor repair school under way in a Kern County farmyard in the early 1920's.
Almost from the time of the first tractors, farm advisors of the Agricultural Extension
Service aided California farmers in maintaining their vehicles.

A 4-H convention held on the Davis campus in 1922. This group is from Sonoma County, source of the grapes one boy is relishing.

When Agricultural Extension was first inaugurated, there were farm advisors in only four counties—Humboldt, San Diego, Yolo, and San Joaquin. Today there are 532 farm and home advisors and specialists, working in fifty general fields and conducting training and educational programs for youths and adults. This 1951 field day for sheep men is typical of countless programs held thoroughout the state by Agricultural Extension Service farm advisors.

Freshman-Sophomore class rivalry at Davis began in 1914 with the "tank rush," from which emerged in the 1920's the "Frosh-Soph Brawl."

Boxing became a popular sport as early as 1913, and varsity teams engaged regularly in intercollegiate competition until 1956. The Farm's first athletic teams went under the name "California University Farm," and the letters "C.U.F." appeared on their uniforms. The name "Cal Aggie" became official in 1922.

Folk dancing has long been a favorite pastime on the Davis campus.

The marching band dates from 1929, when J. Price Gittinger became supervisor of musical activities. During early years the band was composed of students, faculty, and townspeople. A five-hundred-dollar appropriation by the Associated Students in 1935 was not enough to purchase complete uniforms, and for three years bandsmen provided their own trousers. But in 1938 the Associated Students voted to provide the new uniforms shown here.

From 1937 to 1952, the administration of the Davis campus was the responsibility of Assistant Dean Knowles Ryerson, a student at Davis in 1916 and later an official of the United States Department of Agriculture. In 1952 he transferred to Berkeley as dean of the College of Agriculture, replacing Claude B. Hutchison, who had served since 1931. He was succeeded by Stanley B. Freeborn, a member of the University faculty at Berkeley and Davis since 1914, who was given the title of provost. Also in 1952 a separate College of Agriculture was established at Davis, with Fred N. Briggs as its first dean, and a University-wide Division of Agricultural Sciences, under the direction of Vice-President Harry R. Wellman, was created to coordinate teaching and research on the four campuses offering agricultural programs.

During World War II, although a great deal of agricultural research continued, academic instruction was suspended and the campus was taken over by the Army Signal Corps. Dormitories became barracks, Putah Creek an infiltration course, and the chemistry building a training hall for communications specialists—with entry possible only after proper identification.

In October 1944, the Army returned the keys to the campus to Ira Smith, campus business manager. Classes were resumed in 1945.

The pre-World War II enrollment of about one thousand students nearly doubled in the first years following the war, grew slowly during the 1950's, then soared again in the early 1960's, as the "war babies" reached college age. By 1967 enrollment was over 10,000.

Graduate instruction began about 1925 with twelve students enrolled in various departments of the College of Agriculture in cooperation with corresponding departments or group majors on the Berkeley campus. From 1925 to 1952 graduate studies at Davis were administered by the dean of the Graduate Division, Northern Section. The first graduate degrees awarded at Davis were given at the commencement of 1949. Graduate enrollment, which at that time totaled 237, rose rapidly, reaching almost 2,500 by the fall of 1967.

The first commencement at Davis was held in 1948; previously, students completing their work were awarded degrees in Berkeley. These 1949 ceremonies were held in the Sunken Garden, scene of the exercises until 1957, when the area became too small.

Attending the dedication in 1949 of Haring Hall, the veterinary-medicine building and largest structure on the campus, were Claude B. Hutchison, dean of the College of Agriculture and vice-president of the University; George H. Hart, dean of the School of Veterinary Medicine; John Watson, a prominent dairyman who later became president of the State Board of Agriculture and a Regent; President Robert Gordon Sproul; and Dean Emeritus Clarence M. Haring, for whom the building was named. Haring was appointed to the veterinary-science faculty at Berkeley in 1904; he served as director of the University's Agricultural Experiment Station, then became the first dean of the School of Veterinary Medicine at Davis, an office he held until his retirement in 1948.

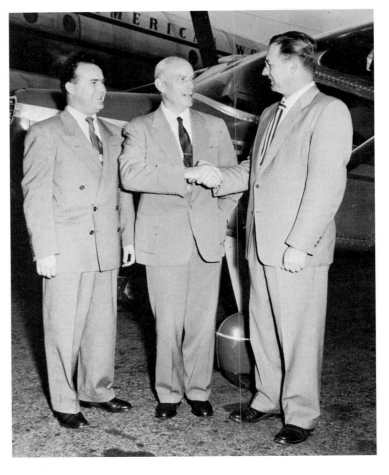

Dean Ryerson played a prominent role in international agricultural affairs, serving on several occasions as an advisor to the government of Thailand and as a member of the South Pacific Commission. Upon his return from Thailand in 1951, Dean Ryerson (center) was met at the San Francisco airport by John C. Patterson, manager of the University airport at Davis, and J. Price Gittinger, assistant to the dean.

Provost Freeborn became chancellor in 1958 and served until 1959. At commencement that year he was given an honorary degree in recognition of his forty-five years' service as a teacher and administrator.

Chancellor Freeborn's successor was Emil M. Mrak, who had joined the Berkeley faculty in 1936, becoming chairman of the Department of Food Science and Technology in 1948. He and most of the department transferred to Davis in 1951, where he continued as department chairman until he was named chancellor in 1959. At the opening social event of the year, the president's reception for students, are (from right) Chancellor and Mrs. Mrak, President and Mrs. Clark Kerr, and Acting Vice-Chancellor Vernon I. Cheadle.

On the University's Charter Day in 1962, Davis honored the one-hundredth birthday of Judge Peter
J. Shields, who drafted the bill establishing the University Farm, by dedicating twelve acres
of the University Arboretum as Shields Grove. A plaque presented by Dean Emeritus Ryerson cited
Judge Shields as the "founder of the Davis campus, patron of all agriculture, benefactor to
students, eminent jurist, husbandman, admirer of trees, friend to man."

Arbor Day ceremonies in 1964 honored Edwin C.
Voorhies (right), who for many years was a
professor of agricultural economics at Berkeley
and Davis and served as dean of students at
Berkeley from 1941 to 1946. A cork oak was
planted just north of Voorhies Hall, an academic
office building dedicated in his honor in 1959.

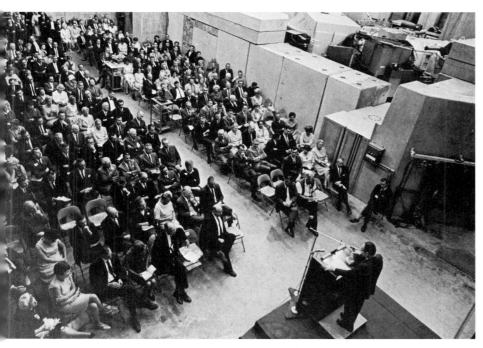

Edwin McMillan, director of the Lawrence Radiation Laboratory at Berkeley, was a principal speaker at the dedication in 1966 of the seventy-six-inch cyclotron at the Crocker Nuclear Laboratory. The instrument was designed to incorporate the pioneer Crocker cyclotron's sixty-inch magnet, which was moved from Berkeley to Davis in 1962.

Picnic Day, held in April, today draws as many as sixty thousand visitors to the campus. Elephant trains, with students serving as tour guides, were initiated in the late 1940's to provide transportation for the crowds.

Sheep-dog trials, such as this one in the 1940's, attract a great many Picnic Day visitors.

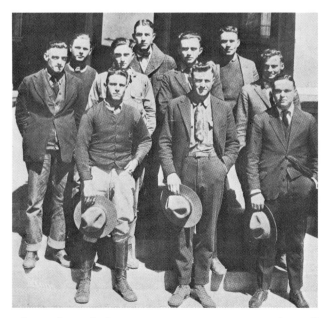

Almost from the beginning, Picnic Day was a student affair, with students in full control of planning and staging the event. The Picnic Day Board of 1920 is above; the Picnic Day Committee of 1966 is at the right.

The Cal Aggie sixty-man marching band leads the Picnic Day parade—even in the rain.

Homecoming weekend, held each fall, begins on Friday evening with the Pajamarino Rally, a tradition since 1916.

In the traditional Frosh-Soph Brawl, held during the first month of classes, students compete in such events as a tug-of-war, an obstacle race, and a hay-stacking contest. If the Freshmen win they are permitted to discard their Freshmen caps, known as dinks; otherwise, they must wear them until the Pajamarino Rally later in the fall.

The Cal Aggies had one of their best football seasons in the fall of 1966, when they tied for the Far Western Conference title. Number 22 is Dick South, holder of ten UCD records in football and twice all-conference halfback, in action against Nevada. The game was played on Toomey Field, named for the long-time director of athletics at Davis, Irving F. "Crip" Toomey.

Joseph Schildkraut and his wife, Leonore, during a rehearsal of Peer Gynt, which Schildkraut directed while serving as a Regents' Lecturer at Davis in 1963.

For the formal opening in 1962 of the assembly hall, Freeborn Hall, Darius Milhaud was commissioned to compose a symphony. Examining the score are Jerome W. Rosen, professor of music; J. Richard Blanchard, librarian; Chancellor Mrak; and Herman J. Phaff, professor of food technology.

Exhibits during the annual Festival of the Arts, a student-sponsored event, reflect a growing interest and achievement. Although the Department of Art was part of the Department of Philosophy and Fine Arts until 1958, it is today regarded as one of the best and liveliest on the West Coast. Among the department's undertakings is a Laboratory for Research in Fine Arts and Museology, established in 1953, which offers graduate work in the conservation and restoration of works of art—a rare field in American universities.

The value of agricultural research to the state's $3.5 billion in annual cash income for farmers is reflected in a recent estimate that the "real economic returns to the state each year from the University research findings [in all fields] surpass all of the monetary expenditures this state has provided for research in all the nearly one hundred years since the University's founding." Agriculture shows the effects of research efforts perhaps more than any other field.

Irrigation was one of the first fields of study on the Davis campus; the University Farm began teaching it in 1909. Over the years irrigation research at Davis has contributed substantially to efficient development and utilization of water in the state. Jaime Amorocho, professor of water science and engineering, inspects a model that was used to study friction along the gigantic canal of the California Water Plan.

Agricultural engineers have developed machines that harvest asparagus and lettuce, pick melons, shake peaches out of trees, and even plant seeds in holes bored precisely eight inches apart. The U.C.-Blackwelder mechanical tomato harvester has eliminated much of the hand labor previously needed in tomato fields.

To make the tomato harvester practical, plant scientists had to breed a new kind of tomato—the odd-shaped one on top. It is smaller and hardier, and it ripens simultaneously with its mates so the machine can sweep through a field and gather the entire crop at one time.

These hogs are having dinner standing up to test an idea that they might thus put a bigger proportion of their weight into their highly marketable hams. The experiment was successful— but not enough to be commercially significant.

A veterinary student cares for a patient in the school's large-animal clinic.

About two hundred beagles are part of the Radiobiology Project, established in 1951 under the auspices of the Atomic Energy Commission. In addition to the project's basic purpose of studying the effects of irradiation, the lifetime study of the beagles has revealed much basic information on dog behavior and care.

Leon H. Schmidt, director of the National Center for Primate Biology, with the first of the subhuman primates to arrive, in 1963, at this unique facility. Completed in 1965, the center presently has some three thousand primates under study, and eventually will house twenty-five thousand primates of fifty species. The United States Public Health Service built the center and finances its operation.

Late in the nineteenth century, the California grape and wine industry found itself in great difficulties due to overexpansion in grape plantings, lack of information regarding production practices, and root-louse invasion. The growers turned to the University for help. Largely as a result of Dean Eugene W. Hilgard's efforts, the legislature passed a bill calling on the Regents to provide instruction "in the arts and sciences pertaining to viticulture and the theory and practice of fermentation, distillation and rectification, and the management of cellars. . . ."

In 1935 the Department of Viticulture and Enology was transferred from Berkeley to Davis, although course work and research in viticulture began in the early days of the Davis campus. Recent research at Davis has produced both new varieties of grapes and new wine-producing techniques.

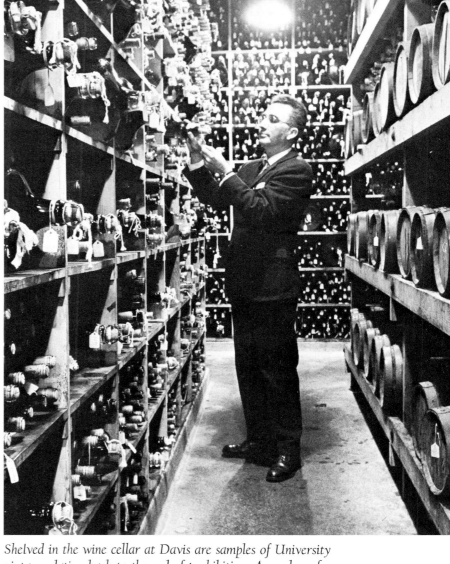

Shelved in the wine cellar at Davis are samples of University vintages dating back to the end of prohibition. A number of California's finest wines were created by the Department of Viticulture and Enology and tested in this cellar. A. Dinsmoor Webb, professor of viticulture and enology, examines a bottle.

Plant scientists at Davis developed this hybrid gerbera, called "Spectacular Daisy," by patiently transferring pollen from male to female flower parts with a small paint brush, then carefully selecting the plants seeded from these crosses.

The Frederick L. Griffin Lounge in the Memorial Union, shortly after the union's completion in 1955. Above the fireplace are the names of the men to whom the union is dedicated—the Davis students who died in World Wars I and II. Frederick L. Griffin was chairman of the Department of Agricultural Education at Berkeley and Davis during the 1920's.

Blocks of concrete in front of the library contain time capsules from the graduating classes, beginning in 1915. Even-numbered years are on the west walk, odd-numbered on the east.

The Memorial Union.

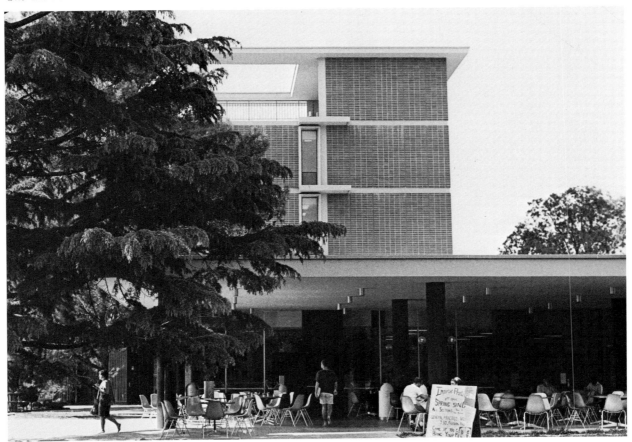

The plane-tree court of the 550,000-volume library offers a spacious outdoor reading room and retreat as well as a showplace for sculpture by students and faculty members.

Architect's model of the building for the School of Law, which began instruction in temporary quarters in 1966 with a class of eighty students. Ground-breaking ceremonies were held in June 1967. The building is scheduled for occupancy in 1968.

The University of California at Davis in 1967. Just above and to the right of center is the open, tree-lined Quadrangle. At the south side of the Quadrangle is the Library (center); at the north side is the Memorial Union. Social sciences and humanities buildings are located northeast to south of the Quadrangle, engineering and physical sciences to the southwest, biological sciences to the west, and agricultural sciences mainly to the northwest. At the center left is the five-story Administration Building. The area in the upper left is devoted to agricultural research. The Gymnasium and Toomey Field are at the upper right, and beyond them is part of the city of Davis.

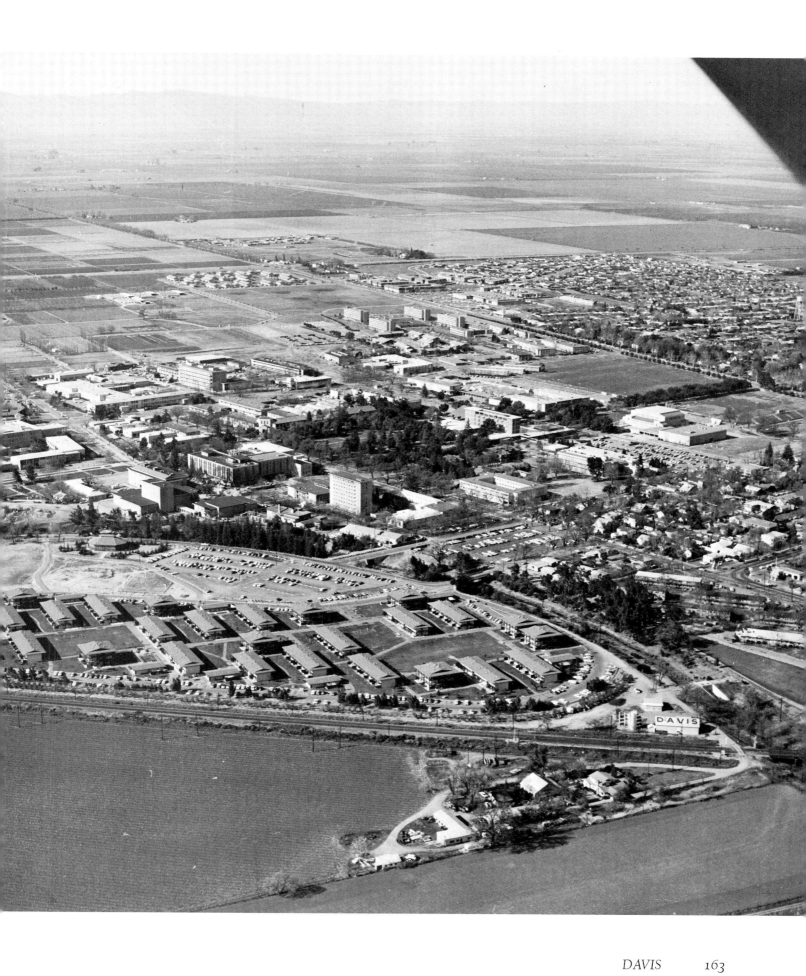

The Citrus Experiment Station at Mount Rubidoux in 1907, the year it was established.
The two-man staff conducted primarily fertilizer experiments.

Riverside

In 1905, in response to a request of southern California citrus growers for scientific assistance, the state legislature authorized the University to establish in one of the seven southern counties a pathological laboratory and an experiment station. A board of commissioners empowered to select the sites recommended locating the Southern California Pathological Laboratory at Whittier and the Citrus Experiment Station on a twenty-three-acre site on the slopes of Mount Rubidoux, near Riverside. The station remained at this location until 1917, when it was considerably expanded and relocated on the slopes of the Box Springs Mountains, about four miles east of the original site. In 1961, to reflect its extensive program, the name was changed to Citrus Research Center and Agricultural Experiment Station. It has become one of the world's leading centers for agricultural research.

In the meantime, President Sproul had advanced the idea that the University should have as one of its units a small college of liberal arts, similar in purpose and quality to the best private institutions in the East. In 1949, Gordon S. Watkins, former dean of the College of Letters and Science at UCLA, undertook the organization of such a college on an enlarged campus at Riverside. The new college opened in February 1954, with 130 students, including 3 continuing graduate students from the Citrus Experiment Station. The college, planned for a maximum of 1,500 undergraduates, aroused widespread interest, and its academic program achieved early success.

In 1959, as a result of increased demands on the state's system of higher education, the Regents decided to make Riverside a general campus, with a greatly increased enrollment and a large and diversified graduate program. New schools of engineering and administration have recently been approved, and long-range plans call for the establishment of several other professional schools. Further development and expansion of Riverside's graduate programs to include the doctorate in all basic fields of the arts, letters, and sciences is being given high priority.

The academic community has grown from a few hundred, when Riverside became a general campus in 1959, to more than four thousand students and approximately three hundred teaching faculty. A new enrollment ceiling has not been set, but Riverside is expected eventually to reach the 25,000–27,500 enrollment planned for the other general campuses.

By around 1912, many citrus growers drove automobiles—some from considerable distances—to meetings at the Mount Rubidoux station. The road on the right is Fourteenth Street; the center of downtown Riverside lies to the left. The station headquarters is off the picture to the right.

In the summer of 1913, a class held at the station traveled as far afield as the Roeding home in Fresno, to visit orchards on the Roedings' large ranch there.

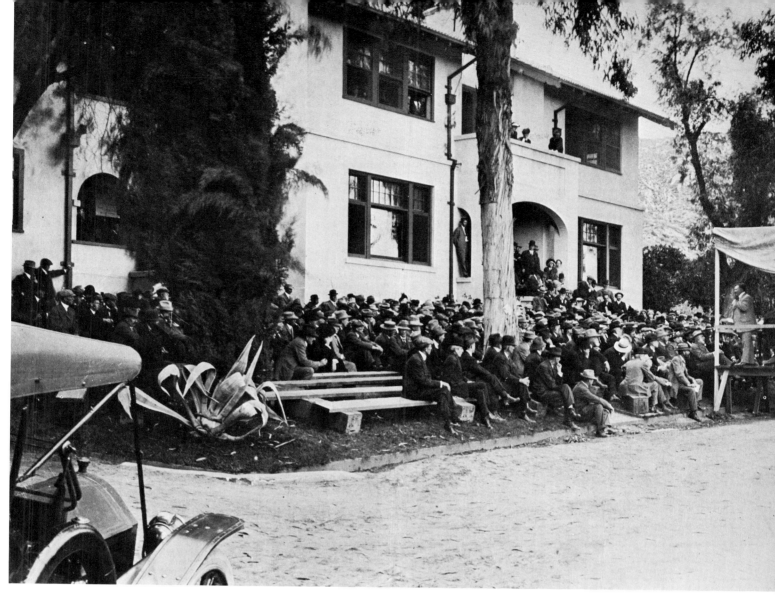

Citrus growers gathered at the Mount Rubidoux Laboratory, probably around 1915, for a lecture by one of the station's researchers.

By 1914 the Citrus Experiment Station had a staff of eighteen and an annual budget of $60,000. Its eleven research men were busy turning out information on a wide variety of problems facing citrus growers, especially nematodes, the parasitic soil worms that had just been found in almost every section of the state.

Following the big freeze of 1913, citrus growers began a campaign for an enlarged experiment station. As a result, the legislature appropriated $185,000 to provide land and facilities for combining the pathological laboratory at Whittier and the Citrus Experiment Station at Rubidoux. Several communities contended for the station.

On December 23, 1914, *the Regents decided to locate the new station in Riverside. The* Riverside Daily Press *reported that the news was heralded by "a 15-minute blast from the big steam whistle at the city electric light plant. Instantly the city was 'electrified,' and the rejoicing was most hilarious."*

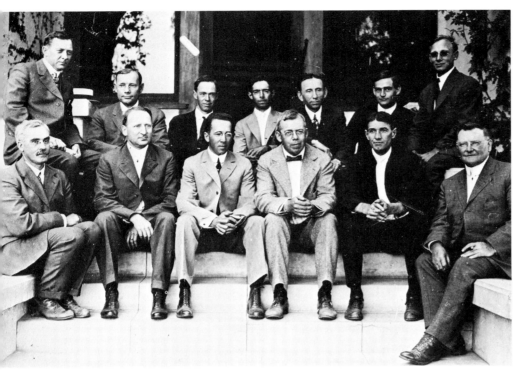

Staff members of the Citrus Experiment Station in 1916, on the steps of the Mount Rubidoux laboratory. Herbert John Webber, seated on the lower right, came from Cornell in 1913 to become first director of the Citrus Experiment Station and dean of the Graduate School of Tropical Agriculture. Leon B. Batchelor, who later became the second director, is third from the left in the front row.

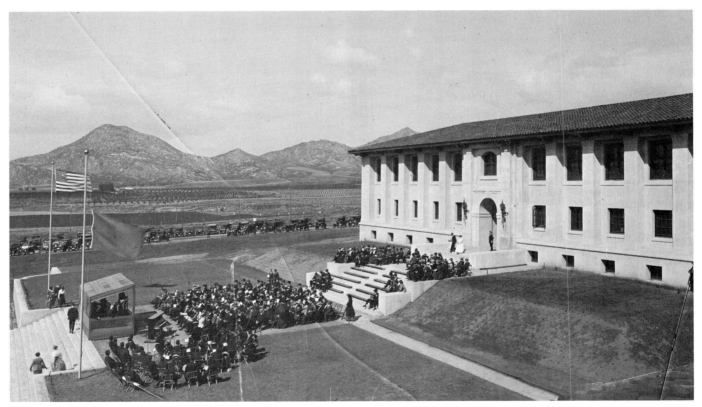

On March 27, 1918, citrus growers, scientists, and civic leaders met to dedicate the new Citrus Experiment Station and Graduate School of Tropical Agriculture. The site was a 471-acre tract on the western slopes of the Box Springs Mountains. The new laboratory building, the architects reported, was in the so-called mission style, "in so far as this type of architecture lends itself to laboratory construction." The only available photograph of the event was printed from a broken glass-plate negative.

Dean Webber observed at the time of the dedi-
cation that it was "particularly fitting that
Riverside, the home of the first Washington
navel-orange trees, which were received by
Mrs. L. C. Tibbets from the Department of
Agriculture in 1873, should become the site of
the first citrus experiment station." One of the
trees died in the 1920's, but the other is still
alive at the intersection of Magnolia and
Arlington Avenues.

The Magnolia Avenue orange tree in 1910.

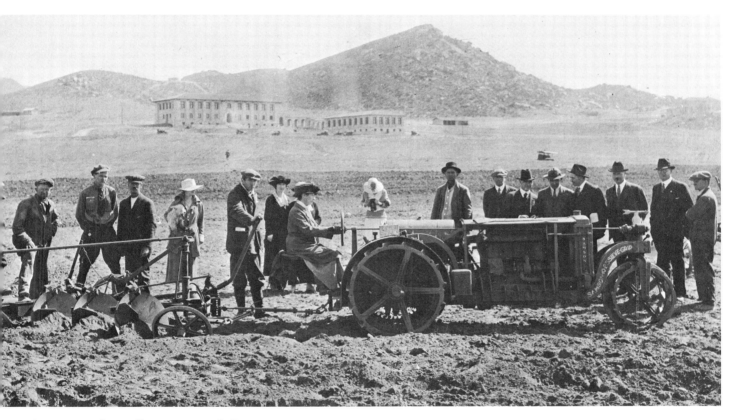

*Experimental as well as ornamental planting was
soon begun on the new site. About the time of
the dedication, this unidentified woman—
perhaps a feminist wanting to dramatize her
cause—took control of a tractor.*

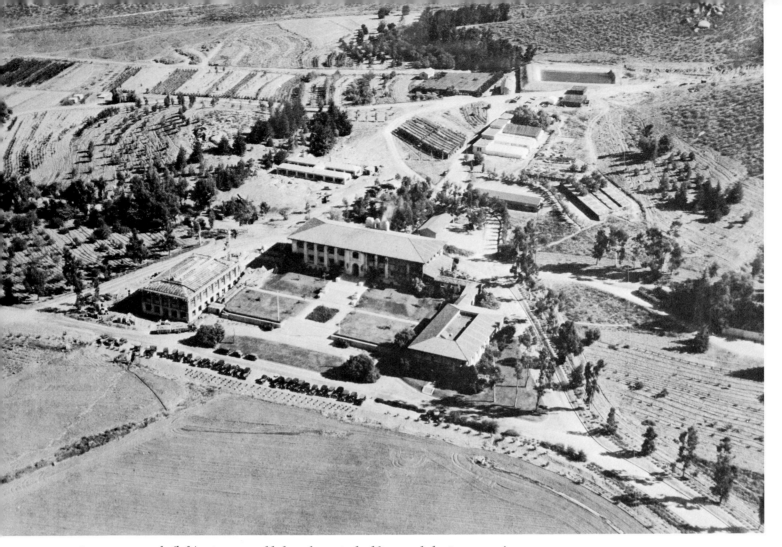

In 1931 a north (left) wing was added to the main building, and the Insectary (top center), considered one of the finest of its type, was constructed. The Entomology Building, just west of the Insectary, was built the following year.

The Citrus Experiment Station continued to expand, reflecting the rapid growth of California agriculture, until the Depression and World War II temporarily postponed further construction. The twentieth anniversary of the station was observed by the Synapsis Club, a scientific discussion group, on June 5, 1933; Herbert Webber, who had been succeeded as director by Leon B. Batchelor in 1929, planted a tangelo (a tangerine-grapefruit hybrid).

Soon after the end of World War II, President Sproul proposed to the Regents that the University of California should have another small college of liberal arts. The idea was approved, and in April 1948, Governor Earl Warren signed a bill appropriating funds to create a four-year liberal-arts branch of the University at Riverside.

The Citrus Experiment Station (top center, facing west) in 1948. The new college was to utilize the area occupied by the walnut orchard and oval-shaped alfalfa field in the upper left (north of the station).

In 1949 Gordon S. Watkins, who had been an outstanding member of the UCLA economics faculty since 1925, assumed the task of developing the expanded University campus at Riverside. The Korean conflict, which broke out shortly after he became provost, caused serious difficulties and delays, for the government severely restricted building materials. But Provost Watkins persevered, and in February 1954 the Riverside campus admitted its first group of 127 students. "Few institutions represent so fully the Emersonian concept of 'lengthened shadow of one man'," the Riverside *Press-Enterprise* commented. "If Dr. Watkins' determination had ever flagged, if he had taken the easy way out and gone back to his library at Westwood, there might never have been a new college here."

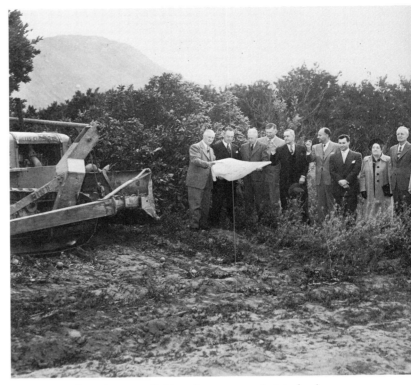

Provost Watkins (extreme left) and campus and civic leaders observed the new campus ground-breaking early in 1951.

The Riverside campus in 1953, just before completion of the original five buildings.

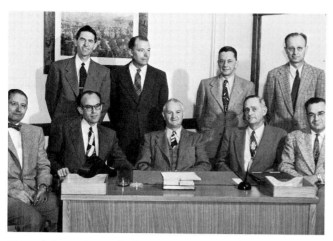

One of the major tasks facing Provost Watkins was the recruitment of a faculty. For the original sixty-five positions he considered more than two thousand scholars. Here the administrative heads of the new college gather for the first faculty meeting with Provost Watkins.

Provost Watkins, who with President Sproul, was instrumental in the creation of the College of Letters and Science at Riverside, at the time the campus opened. (As president emeritus and provost emeritus these two men later became the first persons to receive more than one honorary degree from the University of California— Sproul at Berkeley and Los Angeles in 1958, Watkins at Los Angeles in 1957 and Riverside in 1963.)

The student body and faculty of the new college held their first general assembly on February 8, 1954, in the lecture hall of the Social Science and Humanities Building (now Watkins Hall).

After a legislative study committee had recommended in 1947 the establishment of a four-year college adjoining the Citrus Experiment Station, a Riverside Citizens' University Committee was formed to work toward this goal. Since then the committee has greatly expanded its membership and program. Its general purpose today is to assist in developing the campus as an integral part of the Riverside community. The Committee has contributed directly to the success of a number of projects affecting the campus, such as the acquisition of additional land and provision of an annual scholarship fund.

The distinction of teaching the first class—on February 15— went to James B. Parsons of the history department.

Dedication ceremonies, on October 22, 1954, brought the campus its first academic procession. O. Paul Staubinger, faculty marshal, led the procession. Following him were President Sproul; Governor Goodwin J. Knight; Provost Watkins; Edward A. Dickson, chairman of the Board of Regents; and President Deane W. Malott of Cornell University, the dedication speaker. Behind the President's party were 400 robed participants, including Regents, University faculty, and 150 representatives of other colleges and universities.

The opening semester saw much controversy over a campus symbol to match the Bruins of UCLA and the Bears of Berkeley. In an election in November 1954, none of six proposed mascots received a majority, and a runoff was scheduled. Observing there was no enthusiasm for any of the proposed names, several students, including members of the basketball team, began a write-in campaign for the "Hylanders," a name suggested by a Freshman coed, Donna Lewis. The idea seemed appropriate to the location of the campus, in the highlands above the city of Riverside, and after the spelling was changed to "Highlanders" it won easily. In recognition of her contribution to campus traditions, Miss Lewis received a lifetime pass to all athletic events from Charles Young, student-body president (who later became vice-chancellor at UCLA).

The mascot combined the bear totem of the University and the Scottish theme of the campus.

PRESIDENT SPROUL HERE FEB. 23

No newspaper can appear without a masthead. Consequently, "UCR CUB" has been selected temporarily as the title, pending the selection and adoption of a more permanent name by an organized student body.

The UCR Cub

Vol. 1 February 18, 1954 No. 1

Reception To Be Held in PE Bldg. Next Tuesday

President Robert Gordon Sproul of the University of California will personally greet students on the Riverside campus at a reception February 23 in the new Physical Education building.

The reception will be held in the social activities and dancing room of the PE building. Following that, a dance will be held in the gymnasium.

Married students are invited to bring their wives, even though this is to be essentially a non-date affair. Dress will be informal.

With President Sproul in the receiving line will be Mrs. Sproul, Vice-President and Mrs. Harry R. Wellman, and Provost and Mrs. Gordon S. Watkins.

Faculty members of the new College of Letters and Science, as well as Science and academic staff members of the Citrus Experiment Station will also attend the event, traditionally held each semester on the five university campuses which offer undergraduate instruction.

PROVOST OPENS COLLEGE

Experimental Education Is UCR Keynote

"It is our hope that here we shall for a long time be free to challenge educational methods with a view to the discovery of better ways and means of attaining educational ends and purposes," said Provost Gordon S. Watkins at the convocation last Monday morning.

Complete Text of the Speech Follows:
"The University of California has accorded me a great privilege in giving me the responsibility of extending to the first student body of the College of Letters and Science on the Riverside Campus a word of cordial welcome. I know I speak for President Robert G. Sproul and all my associates in the University's official family when I say that we are delighted to see you. We hope your sojourn on this campus will be a pleasant and a profitable one.

"In a very real sense this is an historic occasion, not only in the life of the world-famous University of California but also in the lives of the faculty and student body of the University of California at Riverside. Seldom do students and faculty share the opportunities presented on this campus. On this young campus teachers and taught will share creatively in an old heritage and help make a new one. Let me dwell a moment on the integral elements of both types of heritage.

"The University of California at Riverside is an important part of a great State University, whose claim to greatness is, unquestioned by anyone who is at all familiar with institutions of higher learning. Faculty and students on this campus share this heritage of academic renown. Together we shall participate in creating here an institution of higher education worthy of this priceless heritage of greatness.

"A second element in the old heritage is the element of quality both as to admission to the University of California at Riverside and to standards of performance. Education, we
(Continued on Page 2)

President Sproul's Welcome Message

It is always a pleasure to welcome new students to the University of California. You would not be here unless your past record indicated some ability and willingness to benefit by the opportunities which the University of California has to offer you on the Riverside campus.

The University assumes not only that you can do college work, but also that you want to do it as well as you are able. Unlike the proverbial horse who can be led to water but can't be made to drink, you have not been led but have come of your own volition, and presumably you either have a thirst for knowledge or you are not adverse to developing one.

With the above assumption in mind, I would like to point out that a thirst for knowledge is one of the best stimulants to a reasonably happy life. It is one thirst that should be cultivated rather than quenched. Students who come to a university like camels expecting to make what they drink last a lifetime are not much better off than those who like the balky horse, refuse to perform at all.

You should not look on the Riverside campus, therefore, as simply a place where you live but rather as a place where you learn to live. This means taking part in every kind of curricular and extra-curricular activity for which you can reasonably find time. Thus you may make your stay here a part of your life, and not a haphazard prologue.

ROBERT G. SPROUL

Robert Gordon Sproul
President of the University

Reminder . . .

All students are reminded that study-list books are to be filed today and tomorrow between the hours of 8:30 and 4:30. There will be a two-dollar penalty for late filing.

Applications for scholarships are also currently available in the registrar's office for the 1954-55 season.

BUS SCHEDULE

Students needing transportation to and from Riverside may use the Fontana Bus Lines. Buses leave the Greyhound Depot on Market street near seventh street on the hour from 6 a.m. to 1 a.m. On the return trip from March Field, they can be flagged at the Canyon Crest entrance to the campus at about 20 minutes to the hour. Fare is 15 cents a single trip or 10 tickets for $1.40.

Philosophy Prof Also A Writer of New Book

A distinguished member of UCR's first faculty is Dr. Phillip Wheelwright, visiting professor from Dartmouth College. Dr. Wheelwright taught this Fall at Pomona College and is teaching philosophy this semester at UCR.

Dr. Wheelwright took his undergraduate and graduate work at Princeton University, and has been a member of the Princeton, New York University, and Dartmouth philosophy departments and a member of Phi Beta Kappa.

He is noted for his work on literary criticism and the philosophy of religion, and is the author of many articles and books. Among the books are the *Way of Philosophy*, published last Monday by the Odyssey Press and *A Study in Symbolism*, which will be published by Indiana University Press later this year.

UCR is proud to welcome Dr. Wheelwright as its first visiting professor.

A student newspaper was established on February 18, 1954, with the temporary title UCR Cub. The name was changed on October 10, 1955, to the Highlander, "to provide," the paper said, "the complete cycle of the Scottish theme."

A contest to select a name for these Highland dancers, who formed a women's spirit organization, resulted in the selection of "Highland Lassies." The group performs authentic dances at athletic events and other occasions.

"Scots-on-the-Rocks" weekend, held each year in late April or early May, features athletic competition, a carnival, queen and beard-growing contests, a dance, and a Freshman-Sophomore tug-of-war and mud fight. The traditional Scottish event of tossing the caber is a major event. Proceeds are used to support Uni-Camp, a summer program held each year for underprivileged children. At the second annual "Scots-on-the-Rocks" celebration in 1956, Highland Lassie Norma Andrews poses with five beard-growing Scots.

The first dramatic production on the campus was "1480 and All That," a faculty-written play that included both students and faculty in the cast; it was presented in May 1954.

In the spring of 1954 the 127 members of the charter class inscribed their signatures in this cement walk adjoining the gymnasium. Howard Cook, public information manager, dusted the walk in preparation for Charter Week activities in 1957. Because subsequent generations of students developed the habit of dragging their feet when using the walk, it was moved in the spring of 1967 to a less traveled area behind the main lounge of the University Commons.

Doug Mumma, the Freshman student who suggested the idea, helps one of the first coeds sign the walk.

Riverside's first commencement was held June 20, 1954, on the athletic field (the present intramural field). President Sproul spoke and gave a degree to each of the twenty students who had enrolled as Seniors in February of that year.

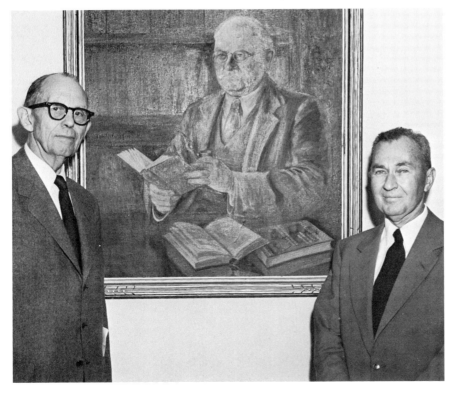

Webber Hall, one of the five original structures of the College of Letters and Science, was dedicated in 1954. Hanging in Webber Hall is this portrait of Herbert John Webber, first director of the Citrus Experiment Station, for whom the building was named. The portrait, done by Webber's daughter, Fera Webber Shear, was unveiled at the time of the dedication. On the left is Ralph P. Merritt, '07, who was comptroller of the University at the time Webber became director of the CES; on the right is Alfred M. Boyce, who succeeded Dean Batchelor as director in 1952.

In the early 1930's, Provost Watkins had taken part in the formation of an off-campus religious center at UCLA. Its success led him to suggest a similar undertaking at Riverside. Participating in the ground-breaking ceremonies of the University Religious Center, on February 21, 1955, are student-body President Charles Young; Edwin T. Coman, librarian and member of the building committee; M. H. Lerner, chairman of the building committee; Provost Watkins; and Philip L. Boyd, chairman of the Citizens' University Committee, who later became a Regent.

Provost and Mrs. Watkins in the partially constructed University Religious Center. The building, later named Watkins House in honor of Provost Watkins and his wife, serves as a religious and social center for many University activities. Watkins House receives half its support from Riverside churches and half from private contributions. Some eleven major denominations carry on programs of religious education there.

In the fall of 1955, the old Citrus Experiment Station Barn, built in 1916, was converted into a coffee shop. The horse stalls became booths, and the original equipment was used as decoration.

These autographed mugs represent a bygone tradition: Students kept them at the Barn, leaving them there after graduation to be used on visits to the campus.

The Associated Men Students, who originated the autographed-mug tradition, made Provost Watkins an honorary member of AMS Kaffee Klatsch in 19 At far right is George Beatty, who later became president of the Riverside Alumni Association.

Construction of the Big C was completed in the fall of 1957, after nearly two years' planning and work. Measuring 132 by 70 feet, the Big C is believed to be the world's largest concrete block letter. A Berkeley alumnus, E. L. "Jack" Yeager, contributed the materials; his workmen, together with students and staff, completed the project just before classes opened. Freshmen gave the Big C its first forty-gallon coat of paint, and succeeding Freshman classes have had the responsibility of painting the letter and keeping it clean.

Members of the Physics Club used walkie-talkies to assist from the ground in lining up the Big C. The Highlander commented: "The result was a 'C' that looked all square and straight from the campus, but rather cockeyed from above. This, however, is a problem of birds and helicopter pilots. UCR at least has a good-looking 'C'."

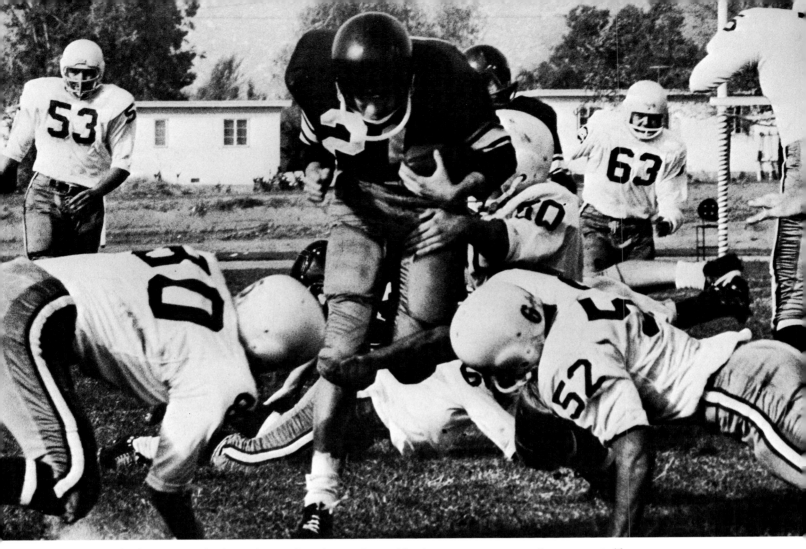

Quarterback Pete Kettela drives for yardage during the Highlander's 1960 win over Claremont-Mudd, which gave UCR its first undefeated football season (seven wins, one tie). That year, Kettela was named UCR's Athlete of the Year and received honorable mention for the Little All-American team. He returned to Riverside as football coach in 1965, to lead the Highlanders to the second-best record in the school's history (six wins and two losses).

The first tree planted on the new college campus, during Arbor Week of 1953, was dedicated—in the tradition of Berkeley's Wheeler and LeConte Oaks—to Provost Watkins (third from the left). Handling the shovel is Professor John T. Middleton of the Department of Plant Pathology; holding the tree is A. T. Shamel, a distinguished member of the Riverside community, who as a botanist with the United States Department of Agriculture developed many ornamental shade trees. Unfortunately, the tree soon met with a construction accident. A second Watkins Oak, planted in June 1956 by the Citizens' University Committee, still stands on the edge of the commons near Watkins Hall.

Herman T. Spieth succeeded Provost Watkins in 1956. Less than three years later, his title was changed to chancellor, and the college was designated a general campus of the University. The conversion to a general campus required several changes in the long-range academic plan, including establishment in 1960 of a graduate division. The first graduate degrees—six M.A. degrees—were awarded in 1962. The first Ph.D., in physics, was awarded in 1963.

Upon his retirement in June 1956, Provost Watkins, who had announced that he planned to visit his native country of Wales, was given a miner's cap as a farewell gift from the Associated Students. Watkins, the thirteenth son of a Welsh coal miner, had come to the United States on thirty-five dollars that he earned working in the coal mines.

Chancellor Spieth and T. L. Broadbent, dean of students, participate in ground-breaking ceremonies in April 1958 for the first residence-hall units.

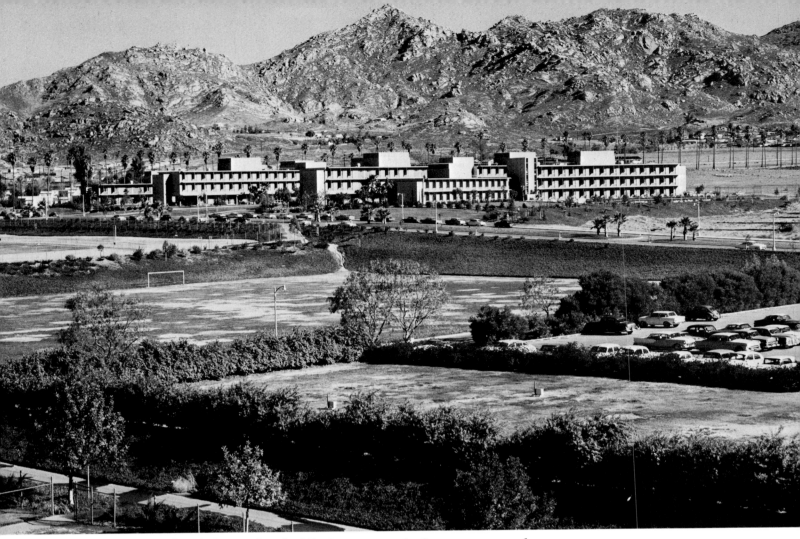

Aberdeen-Inverness Halls, which opened in the fall of 1959, were the first on-campus student residences. (Canyon Crest, an off-campus housing development purchased by the Regents, began housing married couples and some single students in 1955.) Together with Lothian Hall, a third on-campus unit, which was completed in 1963, they can accommodate a total of 1,700 students on campus.

Within the residence halls, language houses for students interested in Spanish, German, or French have been established. Each house is equipped with record players, tape recorders, magazines, books, and newspapers in a foreign language. The students in a house eat together and share appropriately decorated lounges.

The Citrus Experiment Station observed its fiftieth anniversary with an open house and symposium in February 1957. At the anniversary banquet Mr. T. Allen Lombard, chairman of the citrus-industry advisory committee, praised the station for its worldwide influence and accomplishments, which, he said, "have frequently been the difference between life and death for certain of our agricultural industries."

Old-timers of the Experiment Station gathered for a fiftieth-anniversary reunion. Second from the left is Leon D. Batchelor, who became director in 1929 and served twenty-two years in that capacity. During his thirty-eight years on the staff (1915–53), Batchelor saw the station's land area grow from thirty acres to almost one thousand and its staff from 18 to 265.

Lawrence Clark Powell (second from the right), University librarian at Los Angeles, examining a first edition of Samuel Johnson's Dictionary. *Powell came to Riverside to present the first Library Lecture in February 1955. Riverside's librarian, Edwin T. Coman, is fourth from the left.*

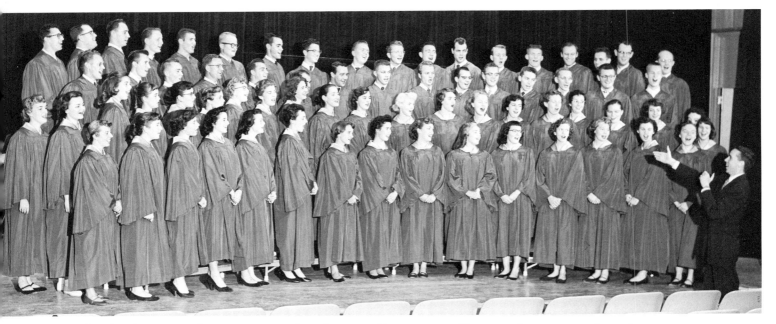

The Choral Society with its organizer and conductor, William H. Reynolds. Musical groups were formed early and have developed as prominent student activities on the Riverside campus. The Choral Society was organized in 1954, and made its first appearance at the dedication of the college in the fall of 1954. The twelve-voiced Madrigal Singers, the UCR Orchestra, the Collegium Musicum, and the Concert Band also provide regular concerts during the academic year.

Studio courses in art have been offered at Riverside since 1957.

Of the forty-nine faculty members that joined the college in February 1954, thirty-one remained ten years later. Many of the original faculty assembled for a tenth anniversary dinner sponsored by the Citizens' University Committee.

In 1961 the name of the Citrus Experiment Station was changed to Citrus Research Center and Agricultural Experiment Station, a college of agriculture was developed, undergraduate instruction was initiated, and graduate instruction was expanded.

Also in 1961 the University-wide Air Pollution Research Center was established at Riverside, under the chairmanship of John T. Middleton. The center grew out of studies begun by Middleton in 1944, when he received a complaint about the yellowing of spinach, an important southern California crop. Since then, smog has become an increasingly serious problem; crop damage due to air pollution now totals more than one hundred million dollars a year in California.

In January 1967, Middleton was appointed national chief of smog-control activities of the United States Health Service. He was succeeded at Riverside by Seymour Calvert, who will also serve as dean of the school of engineering which is scheduled to open at Riverside in 1969.

Middleton (left) during early experimental work, in 1952.

For studies of air pollution as it affects agriculture, Riverside is indisputably the nation's research headquarters. These plastic enclosures in a lemon orchard are part of a one-million-dollar industry-supported research project to determine the effects of air pollutants on the growth and production of citrus trees.

The Riverside campus also boasts the nation's first Department of Biological Control. This department, established in 1923 as the Division of Beneficial Insect Investigations, is engaged in research on methods of controlling harmful insects by importing or encouraging their natural enemies. Among the pests that have been brought under control are the spotted alfalfa aphid, the walnut aphid, and the green pea aphid. There are also indications that red scale—a pest that once cost citrus growers ten million dollars a year—has succumbed to a combination of chemicals and wasps imported from Asia.

This giant vacuum sweeper was developed by the Department of Biological Control to collect natural enemies of the spotted alfalfa aphid, one of the worst pests of California's largest forage crops.

Three-fourths of California's citrus growers use weed killers developed on the Riverside campus. The tests shown here were made in 1962 by the UCR Weed Control Research Group, a project undertaken at the request of citrus growers and the California Walnut Growers' Association.

Scientific research conducted at Riverside is estimated to save more than twenty-five million dollars worth of citrus and agriculture crops each year in California alone. The staff of the Citrus Research Center and Agricultural Experiment Station today is at work on approximately two hundred formal projects, utilizing some 500 acres of agricultural land on the campus and the 848 acres of the Moreno ranch, about ten miles from campus.

As citrus production moved northward into the San Joaquin Valley, a field station in that area became necessary to supplement the work being done at Riverside. To fill this need, the Lindcove Station, near Visalia, was established in 1959. It is one of ten field stations established by the University's Agricultural Experiment Station, of which the Citrus Experiment Station at Riverside was the first off-campus branch. Attending the dedication of the Lindcove Field Station were Roy McLane, chairman of the local sponsoring committee; Chairman Walter Reuther and Professor William P. Bitters of Riverside's Department of Horticultural Sciences; and Director Boyce of the Citrus Research Center and Agricultural Experiment Station.

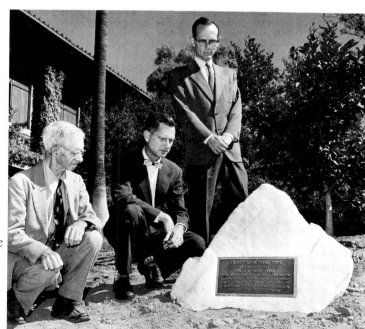

In 1958, a plaque and citrus tree were dedicated to Howard B. Frost (left), who was active at the Citrus Experiment Station in studies of citrus breeding and genetics for more than forty years.

The laboratory and living quarters at the Boyd Desert Research Center. Located in Deep Canyon, fifteen miles south of Palm Springs, it was the gift in 1959 of Regent Philip L. Boyd. It encompasses 3,500 acres of University-owned land and 6,500 acres operated under an agreement with the United States Bureau of Land Management. The 10,000-acre preserve of virgin desert land serves as a "living laboratory" for the study of desert plants and animals.

The noted California photographer, Ansel Adams, on a visit to the Boyd Desert Research Center.

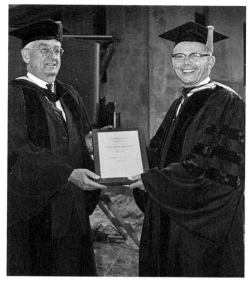

President Emeritus Sproul and Chancellor Hinderaker at the dedication of Sproul Hall, June 8, 1966.

This large classroom and office building was named in honor of President Emeritus Robert Gordon Sproul.

The University Commons opened in February 1967 and rapidly became a focal point of student life on the campus. The construction of the $2,500,000 building was financed by the students themselves and by private contributions. Since 1959, when two-thirds of the student body voted to assess themselves to build the Commons, every student has paid fifteen dollars a year toward the cost of constrctuion.

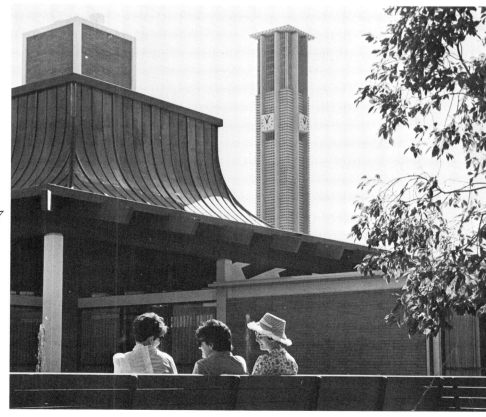

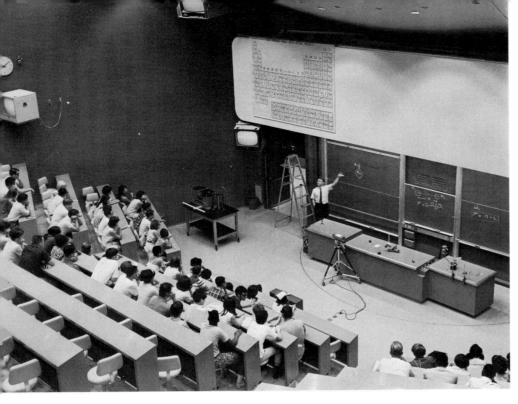

A revolving stage in the Physical Sciences Lecture Hall permits two lecture demonstrations to be set up at the same time. The room seats three hundred and is equipped for closed-circuit television.

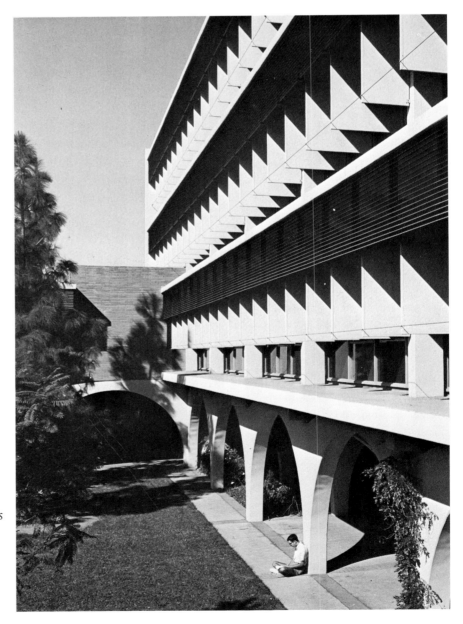

The Humanities Building contains classrooms and offices, a language laboratory, an art gallery, and a five-hundred-seat theater.

The Humanties Court between classes.

Looking across the Humanities Court toward Mount Cucamonga, in the distance; Watkins Hall is in the center.

The 400,000 volume library, with the Big C visible on the mountains in the background. The original building, at the left, was completed in December 1953; the five-story addition, in the center, was completed in February 1964.

Commencement of June 1965, with the unfinished Carillon Tower in the background.

A major event in the history of the Riverside campus was the dedication, on October 2, 1966, of the Carillon Tower, a gift of anonymous donors through the Citizens' University Committee. The thirty-thousand pound carillon was cast in Annecy-le-Vieux, France, from specifications developed by William H. Reynolds, a professor of music at Riverside.

In June 1966, a large crowd gathered to watch as the forty-eight bells of the carillon stood ready for the crane that was to lift them into the tower, through an opening in the top.

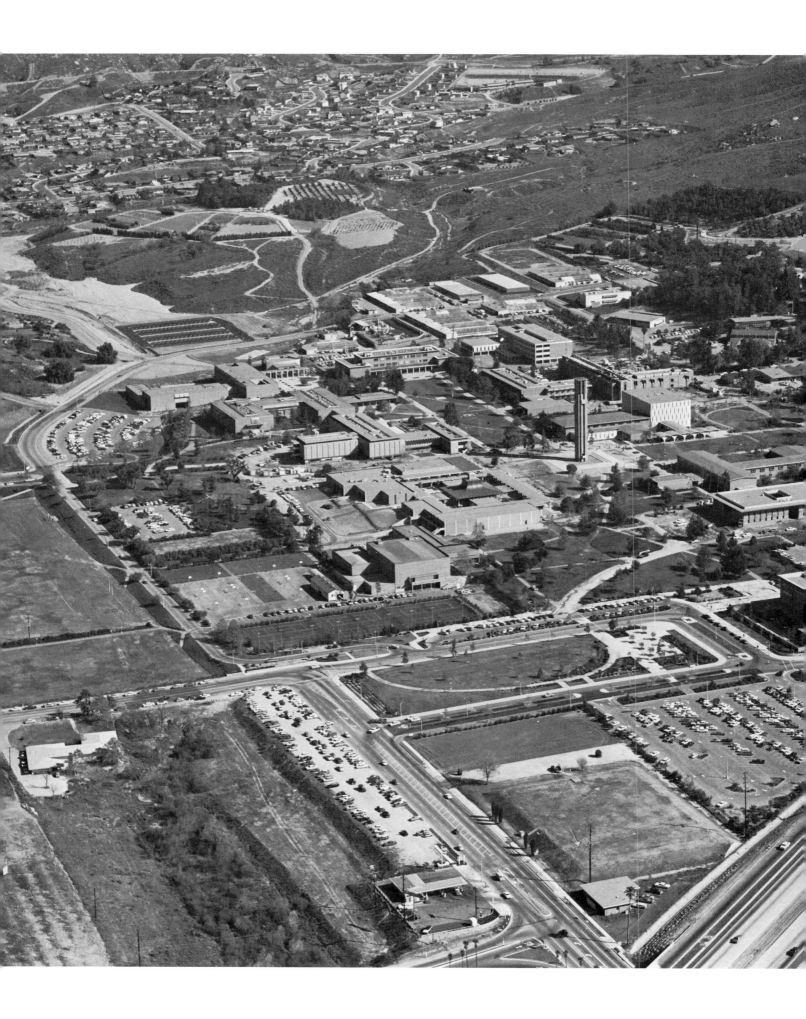

Situated equidistant from the ocean, the mountains, and the desert, and only an hour's drive from Los Angeles, the Riverside campus, building upon the remarkable achievements of the small liberal-arts college established in 1954, is expected to grow steadily in size and distinction. The Carillon Tower (center), seen from the west, dominates the campus. Clockwise from the tower, the main buildings are Physical Education (lower left), the University Commons (with the pagoda-like roof, in the center), Chemistry, Geology, Physics, Webber Hall, Batchelor Hall, Life Sciences, Library (white facade), Humanities (center right), Watkins Hall, Sproul Hall, and Administration.

In the spring of 1905, citizens of La Jolla contributed $992 to construct this small wooden laboratory at Alligator Head in La Jolla Cove Park for a group of Berkeley biologists.

San Diego

The San Diego campus of the University of California had its origin in 1892, when zoologists from Berkeley began searching for a marine-laboratory site for summer research. In 1903, during the first year the scientists worked in the San Diego area, citizens of the city formed the Marine Biological Association to provide financial assistance for the laboratory. In July 1912, this association transferred its property to the University of California—a possibility that had been anticipated in the association's articles of incorporation. The University honored the Scripps family, who were generous benefactors of the laboratory, by naming it the Scripps Institution of Biological Research. The name was changed to the Scripps Institution of Oceanography in 1925.

In 1957, the Regents decided to develop the La Jolla institution into a general campus of the University. The idea had received strong support in local elections, with citizens of San Diego voting to donate to the University 450 acres of city-owned land on the Torrey Pines Mesa above the Scripps Institution. The United States government assured the grant of an additional 418 acres from the adjacent Camp Matthews, and turned over the land in 1964. Plans were made to build a campus of twelve interrelated colleges, having a total enrollment of 27,500 students by 1995. The first step was the establishment of a graduate Institute of Technology and Engineering on the Scripps grounds, in 1958. Renamed the School of Science and Engineering, it registered its first graduate students in 1960. In 1964, with another new name—First College—and a widely expanded curriculum, it moved into new buildings on the Torrey Pines Mesa and enrolled its first undergraduates. In 1965, to honor Roger Revelle, the former director of the Scripps Institution who had planned much of this development, First College became Revelle College. A second college, named for California naturalist John Muir, admitted its first students in 1967. The School of Medicine is scheduled to accept its first class in 1968.

Enrollment at San Diego in the fall of 1967 was 3,079. Growth plans call for the campus to add around 800 students a year, with a new college to be opened every three years. The opportunity to work in small academic units with a distinguished faculty, the advantages of a major university, and the resources of an internationally renowned marine laboratory has drawn many students to the University of California, San Diego, to find a stimulating and significant education.

While honeymooning in San Diego in 1891, William
Emerson Ritter, head of the University's newly
established Department of Zoology, became
impressed with the wealth of material available
for biological study in the San Diego area.
More than ten years passed, however, before a
marine laboratory was actually set up there.
In 1903, this group from the Berkeley campus
moved into the small boathouse of the Coronado
Hotel. Ritter stands third from the left;
Charles A. Kofoid, associate director of the
new station, stands second from the right.

The boathouse-laboratory at Coronado.

Dr. Fred Baker, a San Diego physician, was largely responsible for the establishment in San Diego of the marine laboratory. In 1901, Dr. Baker heard Kofoid address the Tuesday Club, a group of leading business and professional men. Joined by Chamber of Commerce leaders, he began urging Ritter to bring his biological investigations to the San Diego area. In 1903, by offering Ritter a laboratory and funds to operate it for more than one season, he succeeded.

Among those from whom Dr. Baker received funds to support the biological station were E. W. Scripps, newspaper publisher, and his elder sister Ellen—who, as the jars in her office indicate, had an active interest in biological research.

Miss Ellen Scripps.

E. W. Scripps at his home at Miramar, a large ranch northeast of San Diego—a site he had chosen on a visit in 1892 to San Diego, which he described as a "busted, broken-down boom town, more difficult of access than any other spot in the whole country."

The interior of the first La Jolla laboratory.

Living conditions in the dusty village of La Jolla were sometimes a problem. The Berkeley researchers were advised that it would not be possible to live in La Jolla for less than six dollars a week. It was suggested they bring sleeping bags, and a mess tent was provided for them.

In September 1903, to insure the success of the laboratory, the Marine Biological Association of San Diego was formed. Homer Peters, a San Diego businessman, was named president, and E. W. and Ellen Scripps served on the board of directors. Each of these three agreed to provide $1,500 a year for a three-year period. For the first time Ritter was assured of an annual budget, and the itinerant band of summer researchers could now devote their time to the development of a major scientific survey.

The boathouse at Coronado proved unsatisfactory as a laboratory, however; because it was built over the water on piles, it was not

The researchers became something of a local attraction during the summer months. On weekends San Diegans went to La Jolla on the San Diego and Pacific Beach Railway to picnic at the cove, visit the sea caves there, and view the fishes in bottles at "the Biological."

Scripps improved and outfitted his powered schooner, the "Loma," and loaned it to the researchers. In the summer of 1906, however, the "Loma" ran aground near the lighthouse on Point Loma and was a complete loss. Dr. Baker, on the deck at the left, was among those who helped salvage the equipment on board.

steady enough for microscope work, and it lacked running seawater. By 1905 Ritter and his colleagues had found a new and better site, at La Jolla. In the spring of that year, the association received from the village and its citizens the land and money for a new station. By summer the "little green laboratory" at La Jolla Cove was finished.

In the second summer at La Jolla, sewage problems threatened the existence of the station. Miss Scripps acted swiftly. She quietly provided fifty thousand dollars so that it could be announced that funds were available for a permanent station at La Jolla if the local sewer problems could be settled and the site legally cleared for a building.

The "Loma" was replaced in 1907 by the eighty-five-foot "Alexander Agassiz"—named after the eminent Harvard biolog[ist] who visited San Diego in 1905 and gave valuable books and scientific apparatus to the station. The ship, with a crew of five, cost twenty-two dollars a day to operate, but the collecting results were declared to be worth such large expenditures. In 1917, however, Ritter concluded that the vessel was too large and expensive to operate for the particular marine investigations then being conducted, and it was sold.

The Marine Biological Association, disturbed by the inevitable growth of the village and the "rush and enforced environments" at La Jolla Cove, began to look for a new location. The most suitable land available in the vicinity was determined to be a tract about two miles north. E. W. Scripps and the association persuaded the city of San Diego to sell them the 170-acre tract at a public auction in August 1907. The only bid offered for the land, estimated at the time to be worth thirty to fifty thousand dollars, was that of the association —one thousand dollars. One condition of the sale was fulfilled by Miss Ellen Scripps' promise to provide ten thousand dollars for a road from La Jolla through the tract to Torrey Pines near Del Mar.

Looking northward on the 170 acres purchased for one thousand dollars and a promise to build a road.

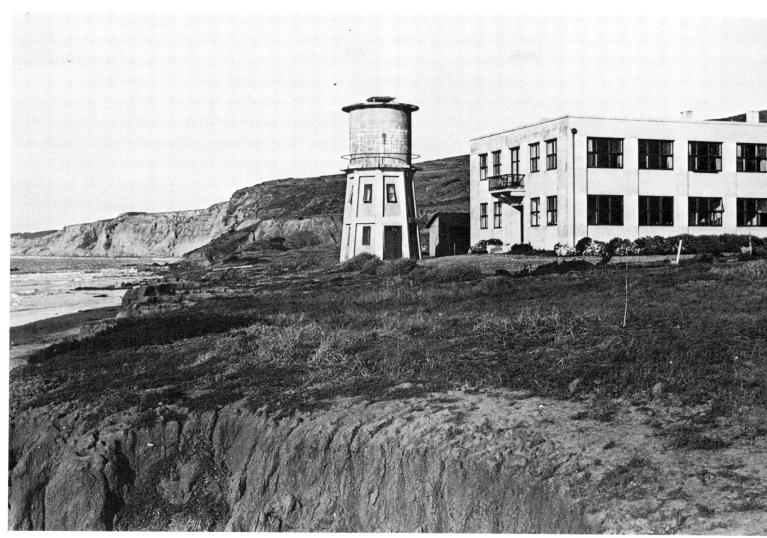

The first building constructed on the new site was a two-story cement structure containing three laboratories, a small library, and a public aquarium-museum. Along with the seawater tank next to it, the building was completed in 1910. It was called the George H. Scripps Building, in memory of Miss Scripps' deceased brother. Even before these first buildings were completed, Dr. Ritter's wife oversaw the planting of thousands of eucalyptus seedlings. Many died in the dry winter of 1909, but enough survived to form the basis of the substantial groves of these trees that now shade the campus.

At the time the Scripps Building was completed, all of the station's scientific work could be contained on the ground floor, leaving the second floor free for use as a temporary director's residence. Ritter also maintained his library and office there.

It had long been contemplated that eventually the biological station might become part of the University of California. Close relationships had existed over the years. Ritter continued to give lectures at Berkeley after he took up full time residence at La Jolla, and Kofoid, who had replaced Ritter as chairman of the zoology department at Berkeley, also continued to serve as associate director of the station.

In 1912, the Regents finally were persuaded to accept the station, and the Marine Biological Association deeded its property to them on July 12. The station was officially designated the Scripps Institution for Biological Research of the University of California.

In 1914 a small wooden public aquarium was constructed just north of the laboratory building. Nineteen cement tanks with plate-glass fronts were provided for displays. Although it was intended as a temporary structure, it served effectively for thirty-six years. Also in 1914, a separate residence for the director was completed, allowing more laboratories to be installed on the upper floor of the Scripps Building.

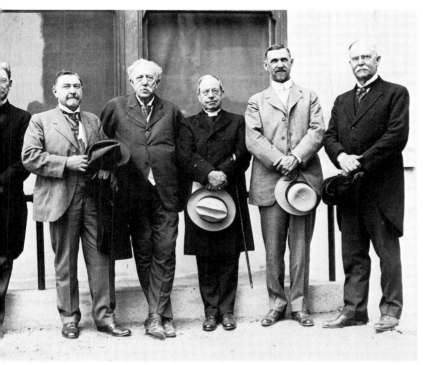

With the end of World War I came increased recognition of the need for greater knowledge of the ocean and wiser utilization of its resources. As Ritter expressed it, the United States, bordered by two great oceans, could no longer afford to regard these vast bodies of water as merely "a world highway and fighting arena."

In August 1916, a new library building was dedicated. Among the distinguished scientists and educators who participated were Director Ritter; D. T. McDougal of the Carnegie Institute; David Starr Jordan, chancellor of Stanford University; Bishop Joseph H. Johnson; G. H. Parker, professor of zoology at Harvard University; and President Benjamin Ide Wheeler.

The institution as it appeared in the early 1920's. The large building in the center is the library. The thousand-foot pier was completed in 1916, with funds from a new gift of one hundred thousand dollars from Miss Scripps. Because the need for staff housing was critical, a number of small cottages were built. Mrs. Ritter's observation that the cottages were "truly masculine in their planning and lack of conveniences" was no doubt justified by the furnishings, which included iron beds (costing $5.75 each) and burlap curtains.

The Scripps Institution in 1929. The small building in the upper right was the Scripps "community center"; it is now occupied by the Institute of Geophysics and Planetary Physics.

Upon Dr. Ritter's retirement in 1923, T. Wayland Vaughan, then with the Department of the Interior, became director. Two years afterward, the new field of marine geology was added to the established studies of marine biology, physics, and chemistry, and the name was officially changed to the Scripps Institution of Oceanography. In 1927, Vaughan escorted President William Campbell (left) through the Scripps museum.

Vaughan was succeeded in 1936 by Harald U. Sverdrup, famed Norwegian scientist and Arctic explorer. Sverdrup has been described as "the man who sent the Scripps Institution to sea."

In 1937 Director Sverdrup obtained from Robert P. Scripps, a son of E. W. Scripps (who died in 1926), an agreement to purchase and refit a ship specifically for oceangoing scientific research. The ship, a 104-foot auxiliary schooner rechristened the "E. W. Scripps," was formally presented to the institution on December 17, 1937. Sverdrup participated for short periods in many of the cruises of the "E. W. Scripps." She served the institution until 1955.

In 1939 Scripps scientists undertook the first complete oceanographic survey of the Gulf of California. It was the first long expedition of the "E. W. Scripps"—and of the institution.

In 1946, half the institution's staff went to Bikini Atoll to participate in the atom-bomb tests there. The oceanographers arrived ahead of most of the task force, set up research tents, and made a systematic survey of the physical, biological, and geographical features of the lagoon. As soon as possible after the bomb was exploded they returned to note its effects.

By 1940 the institution's fleet had grown from one vessel to four major ships, as well as a number of launches and buoy boats and a pair of amphibious trucks. During the war, the institution was largely engaged in research for the National Research Defense Council. Among other projects, Scripps scientists investigated methods of submarine detection and carried on basic research concerning all aspects of the ocean in relation to submarine warfare; for example, they were able to detect the source of a mysterious interference that had plagued sonar operations. The institution's research on waves greatly facilitated many amphibious landings, particularly on islands in the Pacific. Some of the institution's charts on Pacific currents were printed on pocket handkerchiefs for use in air-sea rescue work. And some two hundred Navy and Army officers completed special courses in sea, swell, and surf forecasting.

Since World War II, the institution's vessels have explored the Pacific's most remote areas and even ventured beyond its boundaries. In 1952, Scripps scientists engaged in a two-ship expedition, "Capricorn," that logged 21,218 miles in the central Pacific. When the "Horizon," a former seagoing tug, crossed the equator, the traditional initiation was held.

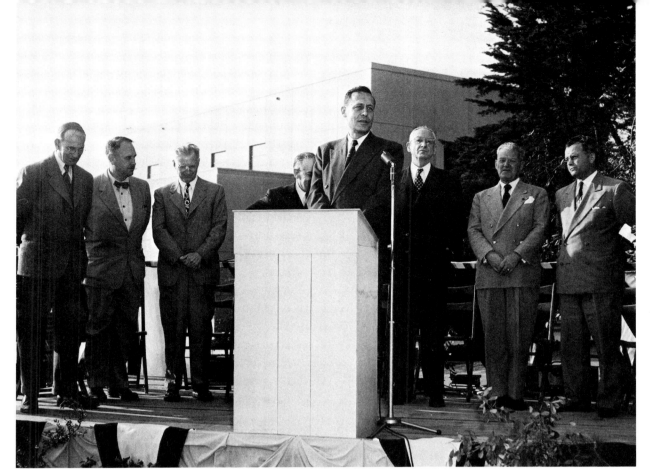

Sverdrup resigned in 1947 to become director of the Norwegian Polar Institute, in order to assist his country in its postwar efforts to rebuild. Carl Eckart, the head of the University's Marine Physical Laboratory, succeeded Sverdrup, and Roger Revelle filled the newly created post of associate director. In 1950, Eckart resigned to devote his full time to research, and Revelle was named director in 1951— exactly twenty years after he had first arrived from Berkeley as a graduate student. In March 1951, Revelle presided at the dedication of the Thomas Wayland Vaughan Aquarium-Museum.

After the dedication of the aquarium-museum, guests went aboard the "Horizon."

During World War II, the Navy and other governmental agencies had recognized the value of oceanographic information. After the war, increased federal funds became available and continued support of research seemed assured.

California's disappearing sardines also provided a postwar impetus to biological research. The state in 1947 levied a special tax on the sardine catch to provide funds for intensive research into causes of the drastic decline in the yearly sardine catch, and for other studies of value to the fishing industry. (The institution found that the heavy harvesting of sardines had caused their replacement by anchovies, which compete with sardines for food and living space.)

The end of the war also brought an increased demand for trained oceanographers, and Scripps was still the only institution in the country offering a degree in the field. Limitations on space, however, restricted enrollment in 1947 to forty-one graduate students.

The Scripps Institution of Oceanography in 1953.

In 1959, the San Diego City Council offered the University more than four hundred acres of choice land above La Jolla, and the Regents chose the area to become a general campus of the University. Governor Edmund G. Brown spoke in May 1961 at exercises marking the beginning of construction on the School of Science and Engineering.

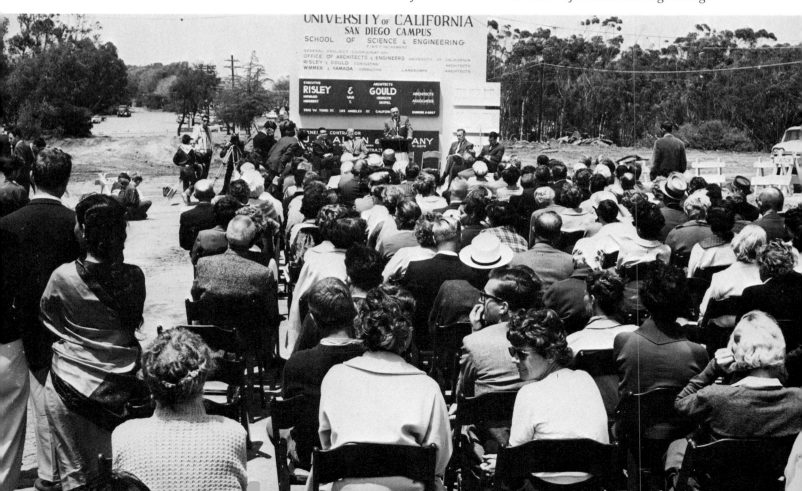

Herbert York, a former Berkeley and Livermore physicist who served as Director of
Defense and Engineering under President Eisenhower, became first chancellor at UCSD
in July 1961. In May 1962 he attended (safety hat in hand) the "topping off" ceremonies
of Building B (later Urey Hall) of the School of Science and Engineering.

Change of command ceremonies for the Camp Matthews land were held
October 6, 1964. The area became an integral part of the campus in 1965,
serving as administrative headquarters as well as providing space for
the new academic colleges while their buildings were being completed.

The Camp Matthews Marine Corps Rifle Range, adjoining the
campus site. In 1964, the deactivated camp was transferred
by an act of Congress to the University.

John S. Galbraith was inaugurated as chancellor on November 5, 1965. Galbraith, a former chairman
of the UCLA Department of History, was named chancellor after York asked to be relieved because of
ill health. At the formal inaugural ceremonies, held in the plaza east of Urey Hall, the main speaker
was Fred H. Harrington, president of the University of Wisconsin, who observed that
"now when it is barely started . . . this campus of this University is already great."

Greeting Chancellor Galbraith after his inauguration were
Frederick R. Huber, president of Palomar Community
College, and two UCSD faculty members,
William Prager and Roy Harvey Pearce.

Chancellor Galbraith accepted one of the first scholarship
checks provided by the Honorary Alumni of the University of
California, San Diego. Taking part in the presentation were
Tom Ham (center), one of the founders of the group, and
Charles Catlin, one of its first presidents. The Honorary Alumni
are an important source of scholarship funds and
other support for the new campus.

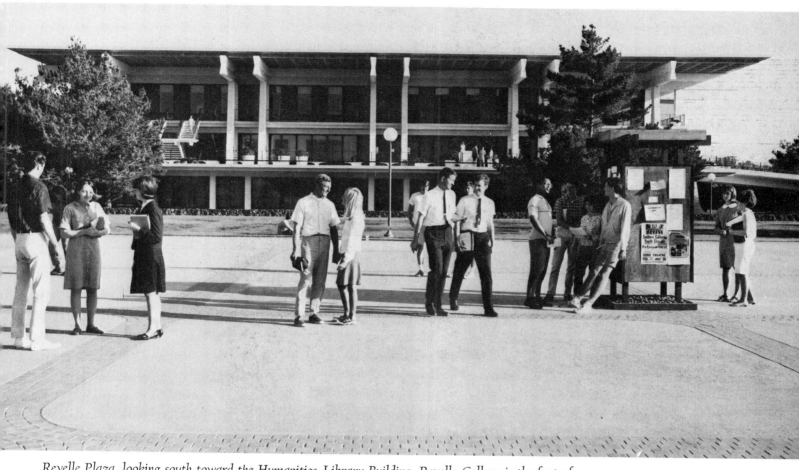

Revelle Plaza, looking south toward the Humanities-Library Building. Revelle College is the first of
twelve colleges planned for the San Diego campus. Each is to have independent residence and dining halls,
distinctive architecture, and different academic requirements and curricula. The colleges will be
interrelated and will provide a wide variety of both undergraduate and graduate programs. Their arrangement,
in three four-college clusters, will give students and faculty the intimate academic atmosphere
of relatively small units combined with the facilities and expertise of a large university.

Following the formal dedication of Revelle College
on October 1, 1965, Roger Revelle was transported
by jeep to a street party in his honor on Ellentown
Road, near the campus. Revelle's wife Ellen
(right) is a great-niece of Miss Ellen Scripps.

At a "big sister–little sister tea" in the sunken plaza of Revelle College during orientation week of 1965, women undergraduates posed on the breezeway between Bonner Hall and the Physics-Chemistry Building.

A view of Revelle College, with Urey Hall on the left, Bonner Hall on the right.

The four-story Undergraduate Sciences Building is located on the central plaza of Revelle College. Built at a cost of four million dollars, it houses laboratories, classrooms, and offices.

The watermelon drop is held after finals in the spring. A watermelon queen chosen by the students drops a large watermelon from the seventh floor of Urey Hall to see how far it will splatter; the object is to beat the marks set in previous years.

San Diego's original Freshman class, 181 strong, entered the University in the fall of 1964. To mark this historic event, the pioneering students gathered a year later to sign their names in the wet cement of the nearly completed Revelle Plaza. The names remain as a lasting memento.

The UCSD Carnival, held annually in the early spring, offers games of chance, clowns, and concessions. It is set up on the Revelle College campus next to the student dormitories.

Frosh beanies are distributed at the Welcome Day picnic, held each fall on the Sunday before registration. The tradition started with the first Freshman class in 1964. All undergraduates are invited to the picnic, hosted by the Honorary Alumni in honor of the entering Freshmen and their parents.

Miss Jane Schmidt, a member of the original Freshman class, fits a Frosh beanie onto the head of Lieutenant Alan L. Bean, a Navy astronaut, following his talk at the first Welcome Day picnic.

The first degree earned in the Scripps Institution was a Ph.D. in oceanography awarded in 1930 to Ancel B. Keyes. Others soon followed, but the degrees actually were conferred by the Berkeley or Los Angeles campuses and presented there. After San Diego was established as a general campus, it began awarding degrees on its own authority. As of June 1967, a total of 266 graduate degrees had been awarded by the San Diego campus.

The first undergraduate commencement exercises were held in the spring of 1967, when eighteen students who had entered with advanced standing received their degrees. The first four-year class graduated in 1968.

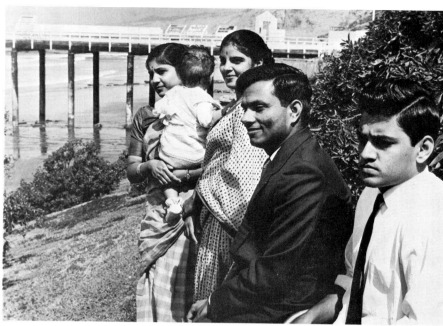

A familiar Scripps landmark, the pier, is seen behind two students and two student wives from India. The worldwide fame of the Scripps Institution brings many applications from foreign students. The first foreign student to enroll at Scripps was Walter Munk, from Austria, who received a Ph.D. in 1947. In 1960 Munk became director of the La Jolla laboratories of the University-wide Institute of Geophysics and Planetary Physics. Of the 161 graduate students currently enrolled at Scripps, 32 are from foreign countries.

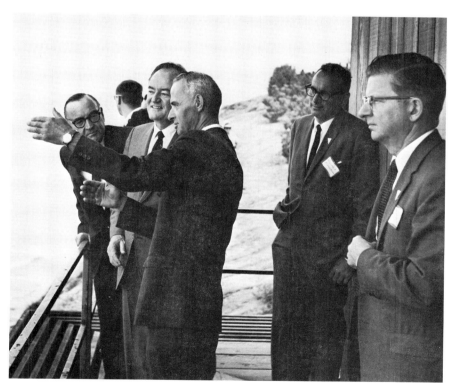

On September 27, 1966, Vice-President Hubert Humphrey made the Scripps campus his first stop on a nationwide tour of marine institutions. Admiring the ocean view from the balcony of the Institute of Geophysics and Planetary Physics are Governor Edmund G. Brown; Vice-President Humphrey; Jeffrey D. Frautschy, assistant director of the Scripps Institution; William A. Nierenberg, director; and Charles J. Hitch, then University vice-president for administration.

Ritter Hall, on the Scripps campus, houses this radiocarbon dating laboratory, in which the age of plant material and shells up to forty thousand years old can be determined.

The first art classes on the campus were conducted in remodeled Quonset huts in the Camp Matthews area.

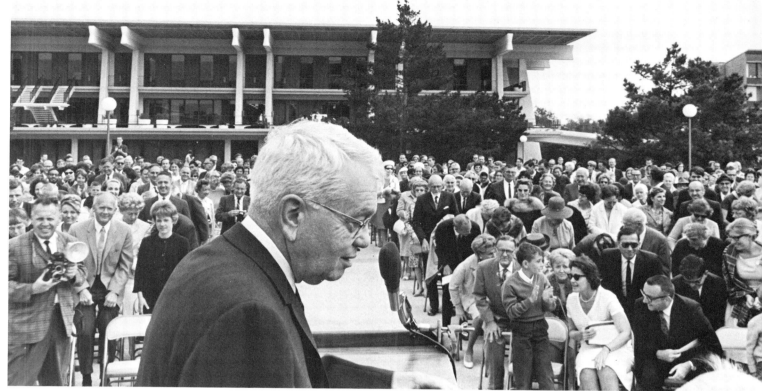

Harold C. Urey, a Nobel laureate in chemistry, spoke in May 1966 in Revelle Plaza at the dedication of Harold and Frieda Urey Hall. The seven-story classroom-office-laboratory building, located in Revelle College, was named in honor of Urey and his wife for their contributions to education and to the University of California. Urey, a University professor-at-large, is based on the San Diego campus.

The San Diego campus boasts another Nobel Prize winner in Maria Goeppert Mayer, the only woman besides Marie Curie to win the Nobel Prize for physics. Mrs. Mayer was cited for work in 1948 on the shell model for atomic nuclei. In this photograph, taken in December, 1963 in Stockholm, Mrs. Mayer approaches the King of Sweden to receive her Nobel medal.

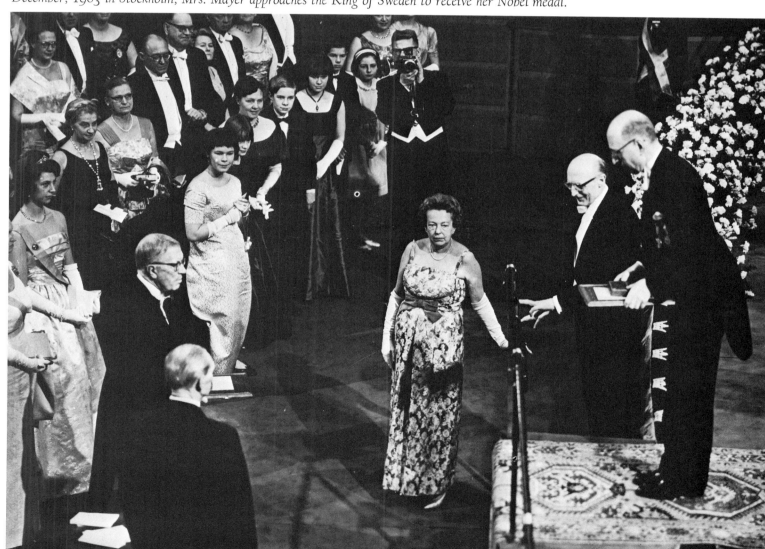

The Scripps Institution of Oceanography, which William Ritter once described as a "baby elephant," has grown from a small pioneering group of marine biologists into one of the nation's major centers of research. Its academic staff and faculty have increased from 16 in 1948 to 132 in 1968. The institution currently operates eight oceangoing research vessels and a number of smaller craft.

Each year more than two hundred major scientific papers and books are published by the Scripps staff, representing a great variety and complexity of scientific work. And there is no foreseeable end to the growth and diversification of the research program as the institution continues its efforts to add to man's knowledge of the world's oceans.

Home base for the eight oceangoing ships is the million-dollar Nimitz Marine Facility, located on the San Diego Bay side of Point Loma on six acres of gro leased from the Navy. From left to right are the "Ellen B. Scripps," "Argo," "Thomas Washington," "Horizon" (in rear), and "Alpha Helix." Si 1950, Scripps vessels have sailed more than nine hundred thousand miles in long expeditions alone, and their research activities currently log about two hundred thousand miles a year in all. In 1962–63 the "Argo" established a world's record for distance traveled in a single expedition, when she logged eighty-six thousand miles in a fifteen-month trip to the Indian Ocean.

In March 1966 the Scripps fleet acquired its newest research vessel, the "Alpha Helix"—a name derived from the spiral structure of some of the proteins and genetic materials that are among the most basic components of life. Donated by the National Science Foundation, the 133-foot oceangoing laboratory provides a modern, fully equipped biological station for work in any part of the world. The "Alpha Helix" recently participated in her second expedition—a trip to the upper Amazon.

Members of an expedition aboard one of the institution's research vessels use a meter net, which is washed down with seawater to concentrate marine organisms for study.

FLIP (for Floating Instrument Platform) is an oceangoing craft of unique design built by the Scripps Institution under a contract with the Office of Naval Research. After her ballast tanks are flooded, the 355-foot vessel can "flip" from a horizontal position to a vertical one, where she affords scientists an extremely stable position from which to conduct experiments and studies. When in the vertical position, three hundred feet of the vessel are submerged. Since FLIP has no motive power of her own, she is towed to the research position.

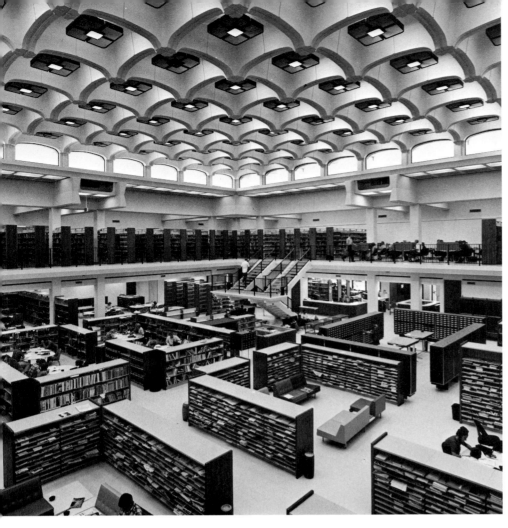

The present main library was started in 1962 with seventy-five thousand basic undergraduate books. In the fall of 1967 the library had well over four hundred thousand volumes. Approximately eighty thousand volumes are expected to be added each year. The University Library at San Diego was one of the first in the country to install successfully an "automated serials computer operation," in which a record of some fourteen thousand periodicals is kept up-to-date and immediately accessible. With the purchase of the Don Cameron Allen Renaissance Library in 1967, through a gift of San Diegan Ernest W. Mandeville, the UCSD Library was equipped to become one of the world's major Renaissance research centers.

Architect's model of the graduate research library, scheduled for completion in 1970. It is designed to house 650,000 volumes.

Architect's model of John Muir College, which is to be occupied in 1969–70. It is located directly north of Revelle College, with playing fields and a gymnasium (foreground) in between. The buildings of Muir College have been designed to encourage the integration of diverse activities and groups; for example, small classrooms, faculty offices, and lounges for off-campus students will be placed in the residence halls.

In 1966, ground was broken in the Camp Matthews area for a School of Medicine. The school is scheduled to accept its first class of thirty-two entering medical students in the fall of 1968, expanding to the full class of ninety-six students by 1970. It will draw upon the scientific faculty of the general campus in much of its work, and it will cooperate closely with the nearby Salk Institute for Biological Studies. Three hospitals will be centers of work and study: the 600-bed San Diego County University Hospital, a 1,040-bed Veterans Administration hospital to be built adjoining the campus, and a special 350-bed hospital to be built on campus for clinical research.

In an agreement made in 1965 with the San Diego County board of supervisors, the University accepted full responsibility for operation of the county hospital, now known as the San Diego County University Hospital, which will be used for teaching in the area of community medicine, comprehensive- and continuing-care programs, and supervised work under actual operating conditions. The hospital is in San Diego, thirteen miles from the campus.

The San Diego campus is situated on nearly one thousand acres spreading
from the seafront, where the Scripps Institution is located, across
a large portion of the adjacent Torrey Pines Mesa high above the Pacific.
Much of the land is wooded with eucalyptus; to the east and north lie
mountains, to the west the sea. In the center of this 1966 photograph
is Revelle College. Below Revelle is the Camp Matthews area. The site
of John Muir College is directly north of Revelle (across the road to
the right). On the coast just above Revelle is the pier that marks the
Scripps Institution.

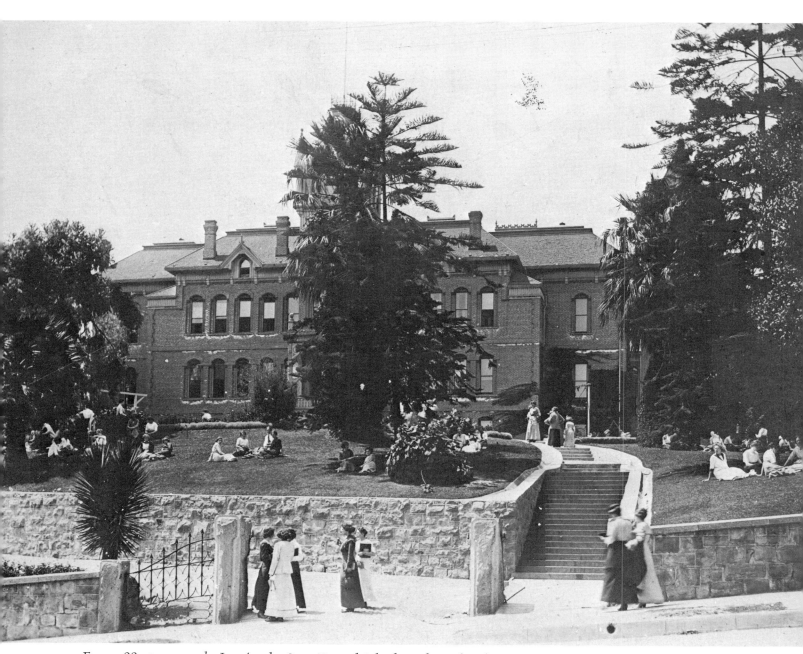

From 1882 to 1914, the Los Angeles State Normal School was located in downtown Los Angeles, where the public library now stands. The site, originally a five-acre orange orchard, was purchased by two hundred citizens for eight thousand dollars and presented to the state.

Los Angeles

UCLA's origins date back to 1881, when a normal school, the second in the state, was established in Los Angeles. In 1919, to provide public-supported university education to the rapidly growing southern portion of the state, the University of California experimented with the incorporation of the Los Angeles Normal School into a "Southern Branch" giving the first two years of college instruction. The experiment proved highly successful, and by 1924 two upper-division years had been added. The name "University of California at Los Angeles" was assigned by the Regents in 1927, and a graduate division, established in 1933, brought full university status to the young institution only fourteen years after its opening date. By 1925 it was evident that the 25-acre campus on Vermont Avenue, inherited from the normal school, was being outgrown, and interested citizens of the surrounding communities combined to secure and donate a splendid 383-acre site in the Santa Monica hills. A state bond issue provided three million dollars for buildings, and in September 1929 UCLA moved to its present site.

The young campus continued to grow in both size and quality for several reasons: It met the needs of a rapidly expanding community; it inherited a rich academic tradition from Berkeley; and it attracted outstanding young teachers, scholars, and scientists. Also, it received the generous support of a number of affiliated groups embracing the campus and the community.

UCLA, second largest of the nine campuses of the University of California, stands as an educational wonder. In less than half a century it has grown from a small normal school to one of the nation's leading institutions of higher education. Since the end of World War II the number of buildings on the campus has quadrupled. And its enrollment of twenty-nine thousand students in the fall of 1967 makes it the fastest-growing major university in the United States. In its remarkable growth, UCLA has been especially responsive to its setting in one of the world's great urban population centers, with vigorous literary and artistic communities and a heavy concentration of science-based industry nearby.

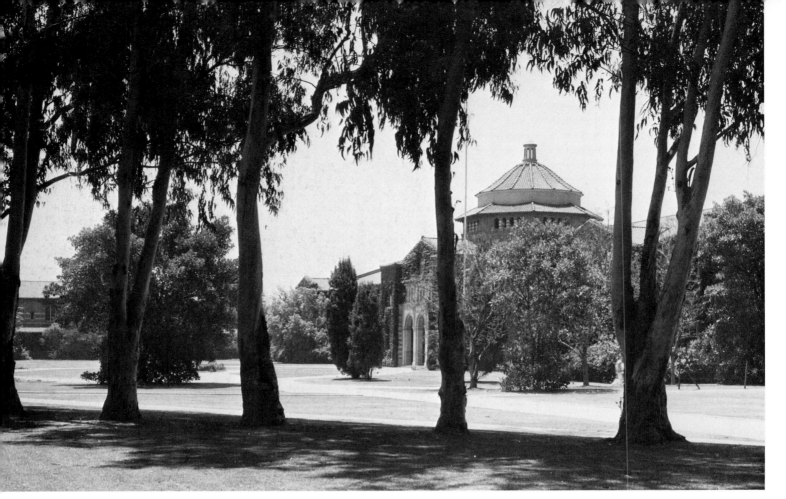

When the legislature in 1881 authorized the Normal School, the population of Los Angeles was 11,000. By 1911 it was 350,000. The school's location in the heart of such an expanding metropolis was no longer practical, and the legislature appropriated one hundred thousand dollars for purchase of a new site. After inspecting some seventeen proposed sites, a committee of the trustees selected a North Vermont Avenue location, and in 1914 the school settled here. A part of the new Quadrangle is shown, with Millspaugh Hall in the center.

The library, consisting of some 128,000 volumes, was one of the Normal School's major assets. The main reading room is shown.

Ernest Carroll Moore was called from Harvard University in 1917 to become president of the Normal School, succeeding Jesse F. Millspaugh, who had served in that position since 1904. In 1919, Moore and Edward A. Dickson, a Los Angeles newspaper editor and the only Regent from southern California, persuaded the Board of Regents to accept transfer of the Normal School to the University. At the Regents' request, the legislature gave unanimous approval to the establishment of a "Southern Branch," and on May 23, 1919, Governor William D. Stephens signed legislation transferring the buildings, grounds, and records of the Los Angeles Normal School to the University.

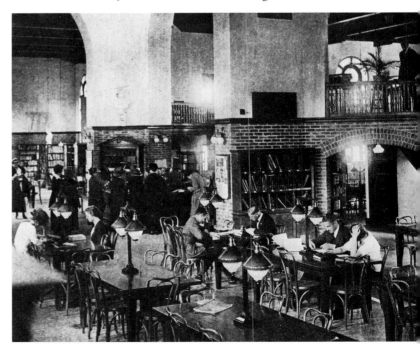

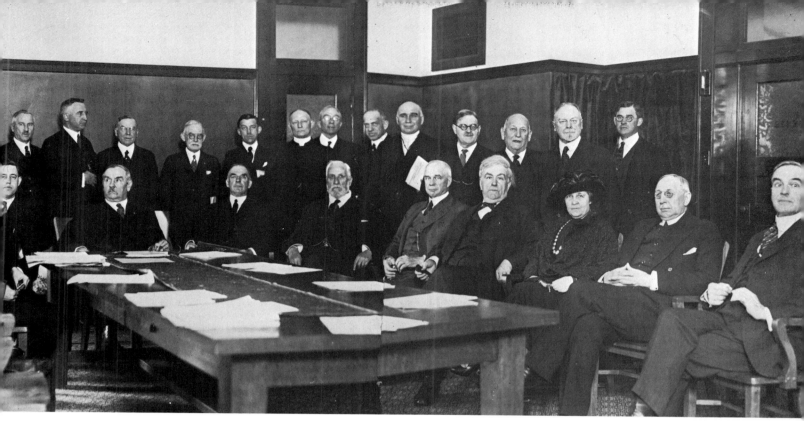

At their meeting of February 13, 1923, in accordance with a proposal by Regent Dickson, the Regents approved the addition of a third year to the College of Letters and Science. Standing are George I. Cochran, James Mills, President David P. Barrows, Allen Anderson, John A. Britton, Edward A. Dickson, Rev. Charles A. Ramm, James K. Moffitt, Mortimer Fleishhacker, Frank E. Merriam (speaker of the assembly), Byron Mauzy (president of the Mechanics' Institute), Henry A. Jastro (president of the State Agricultural Society), William H. Crocker, and Clinton C. Miller (president of the California Alumni Association). Seated are Robert G. Sproul (comptroller and secretary of the Regents), C. John Struble (assistant comptroller and assistant secretary of the Regents), Governor Friend Richardson, President-Elect William W. Campbell, Arthur W. Foster, Guy C. Earl, Garret W. McEnerney, Mrs. Margaret Sartori, John R. Haynes, and Charles S. Wheeler. A year later, the Regents added a fourth year and authorized the school to grant the bachelor's degree.

One of the student leaders on the Vermont Avenue campus was Ralph Bunche, who was later to receive the Nobel Peace Prize and serve as undersecretary of the United Nations. Both scholar and athlete, Bunche was valedictorian of his class of 1927 and a member of the first UCLA basketball team to defeat Stanford twice in one season.

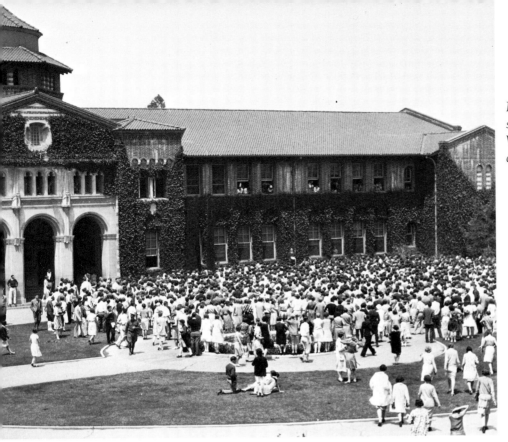

On a walk through the hills of western Los Angeles in the spring of 1923, Regent Dickson and a fellow Berkeley alumnus, Irwin J. Muma, came upon a large expanse of pasture land. As they reached the high point of the area they had a splendid view of the Santa Monica Bay before them, with the green hills of Bel-Air behind. Both men were impressed with the area's striking similarity to the Berkeley campus with its view of San Francisco Bay from the sloping Berkeley hills. Acutely aware of the growth problems on the Vermont Avenue campus, which then had some five thousand students crowded onto a campus designed for half that number, they decided to promote the site as a new and permanent home for the University in Los Angeles.

In 1924 the Regents authorized President Campbell to appoint a committee of seventeen citizens from Los Angeles and vicinity to select a new site for the Southern Branch. The committee, after studying seventeen proposed locations, recommended four for consideration by the Regents: Burbank, Fullerton, Palos Verdes, and the Westwood site promoted by

Regent Dickson.

On March 21, 1925, the Regents met in San Francisco to decide. A tense, anxious crowd waited outside the conference room. Finally Robert G. Sproul, vice-president and comptroller, appeared and announced the decision to select Westwood. Within two hours all Los Angeles newspapers were on the street with extra editions. The following day, a Sunday, thousands of people visited the Southern Branch's new site.

Owners of the 383-acre tract were Edwin and Harold Janss, who controlled 200 acres, and Alphonzo Bell, who held the remainder. They offered to sell the land for one million dollars, although its value for subdivision purposes was considerably higher. Citizens' committees in Los Angeles and the surrounding communities conducted intensive, highly organized bond campaigns to raise the necessary funds. Los Angeles provided $700,000; Santa Monica $120,000; Beverly Hills $100,000; and Venice $50,000. Later, the city council of Los Angeles augmented the fund by an appropriation of $100,000.

The Westwood site before construction began.

The new site was part of the Wolfskill ranch, which had once been part of the old Spanish land grant Rancho San Jose de Buenos Ayres. In 1884 John Wolfskill, a forty-niner, bought the 4,400-acre tract for ten dollars an acre. His ranch house apparently stood near what is now the site of the Mormon temple.

The dedication of the new site, on October 25, 1926, took place at Founders' Rock. This seventy-five ton boulder of granite had been brought from Perris Valley, near Hemet, earlier in the year. It was placed in the general area where Regent Dickson and Mr. Muma were believed to have stood three years before, when they strolled to the top of a chaparral-covered hillside and resolved that the area should become the new site for the Los Angeles campus of the University. As the campus grew, however, Founders' Rock became a traffic hazard and was moved from the circle in front of the Administration Building, first to the Hilgard Avenue entrance, later to Dickson Court, where it now rests.

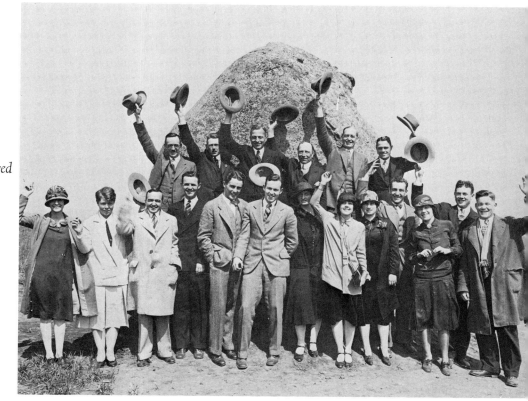

Some people argued that the Westwood site was too small. One group held that at least 1,000 acres should be obtained, to accommodate the inevitable population growth that would occur in southern California, but they were dismissed as "typical California boosters." A Regents' committee, pointing out that the average size of nine leading American campuses was 156 acres, reported that "a campus of 300 acres should be sufficient for all future needs." (When the Regents undertook development of three new campuses following World War II, the criteria for campus sites specified a minimum of 1,000 acres.)

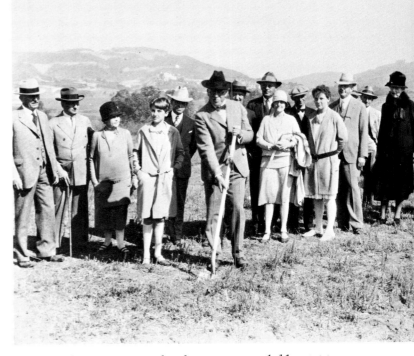

On September 21, 1927, a brief ceremony was held to initiate construction activities on the Westwood site. In the presence of a small group of University officials, faculty, alumni, and Regents, Director Ernest Carroll Moore turned the first spadeful of earth for the new library building. Among those looking on were Charles H. Rieber (dean of the College of Letters and Science), James R. Martin, Regent Margaret R. Sartori, Virginia Janss, Regent Edward A. Dickson, Harold Janss, Dr. Edwin Janss, Mrs. Harold Janss, Betty Janss, John E. Goodwin (librarian), Mrs. J. E. Goodwin, Robert M. Underhill (assistant comptroller and assistant secretary of the Regents), and George Kingdon.

A month later, on October 22, Governor Clement C. Young cut the ribbon to mark the opening of the arroyo bridge, the first structure to be completed on the new campus. Among those at the ceremony were ASUCLA President Thomas J. Cunningham (wearing a "Senior Sombrero"), Regent Edward A. Dickson (behind the Governor's right hand), Howard McCollister, Judge Russ Avery, Regent Margaret Sartori (hidden by the Governor's left hand), Professor Earle R. Hedrick, Dean of Women Helen M. Laughlin, Professor Waldemar Westergaard, Dr. Edwin Janss, Dean Charles Rieber, and Kenwood Rohrer.

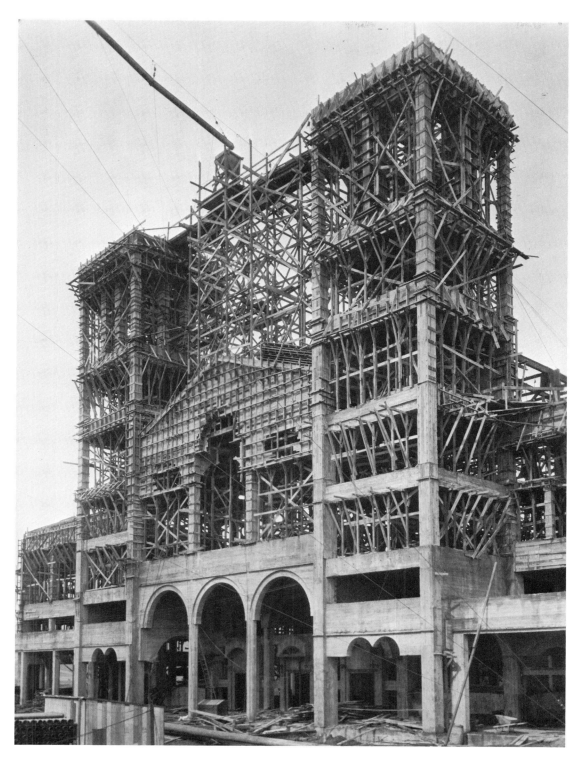

The rolling terrain of the campus, with the Santa Monica Mountains in the background and the blue Pacific in the distance, suggested northern Italy to the architects, who adopted a red-brick Romanesque style. They patterned Royce Hall, an auditiorium and classroom building (shown under construction in this 1928 photograph), after the Church of San Ambrogio in Milan. Royce Hall, which provides the campus with more floor space than all the Vermont Avenue structures combined, is named after the California-born Harvard philosopher Josiah Royce, a graduate of Berkeley with the class of 1875 and an early-day instructor in English there.

The new campus was surveyed under the supervision of University Engineer Herbert B. Foster, '07. Since names for the projected streets surrounding the campus were not written on the maps provided Foster, he wrote them in himself. In his own words: "I took my hydraulic course in the University from 'Little Joe' LeConte. I worked for Dean Eugene W. Hilgard on some of his books for publication, and I took the Great Books course from Gayley . . . I put them down on the map." Thus, the streets bordering the Westwood campus came to be named after distinguished members of the Berkeley faculty.

Moving day was May 31, 1929. A half-holiday was declared, and students played an important role in the proceedings. As Director Moore recorded the event in his journal: "The first loads of moveables were at the head of a column and a long line of student automobiles followed them. I had taken Professors Haines and Graham and Mrs. Graham to lunch at Bel-Air and was waiting at the end of the bridge to receive the procession. It was a thrilling sight to see two thousand young people pour themselves among the buildings and into them. The ROTC band played vigorously from the steps of Royce Hall and again from the Library. There was no speaking, just taking possession of the new University plant."

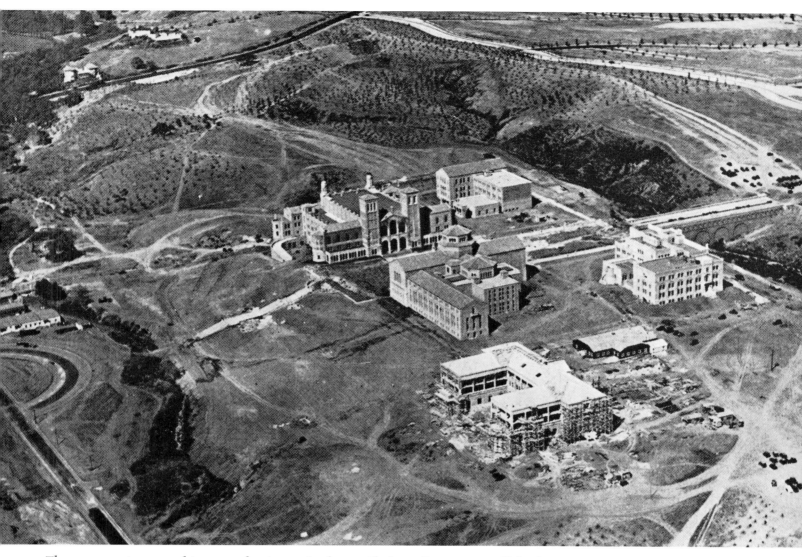

The campus as it appeared in 1929 when instruction began. Clockwise from Royce Hall (with its twin towers) are the Chemistry Building (now Haines Hall); the Physics-Biology Building (now Kinsey Hall); a temporary structure serving as a student store; the Education Building (now Moore Hall); and the College Library. Enrollment that fall totaled 6,175.

Director Moore posed in front of Royce Hall with Kenny Piper, last student-body president on the Vermont Avenue campus; Robert Keith, first student-body president at Westwood; and Lowell Stanley, assistant graduate manager of ASUCLA. Keith was the first speaker at the first assembly in the auditorium; his opening words were "UCLA looks forward to a glorious future."

Kenny Piper made good a campaign pledge to get uniforms and a director for the UCLA band (shown welcoming John Philip Sousa to town in 1929).

The new campus was formally dedicated on March 28, 1930. "Never before," according to one commentator, "was there a more distinguished group of scholars gathered in southern California." Delegates came from universities all over the world, including some of the oldest European schools. UCLA awarded its first honorary degrees—to Arthur Holly Compton of the University of Chicago, Nobel laureate in physics; John Dewey of Columbia University, psychologist and educator; Adam Blythe Webster, dean of the University of St. Andrews, Scotland; and Sir John Arthur Thomson, professor of natural history at Aberdeen University.

At Dedication of University of California at Los Angeles March 28, 1930.

(left to right) – Regent William H Crocker; Regent George I Cochran; Dr Arthur H Compton (winner of the Nobel Prize for Physics); Regent John R Haynes; Dr George E Vincent, president of Rockefeller Institute; J Arthur Thompson y Aberdeen University, Scotland, distinguished scientist; President-elect Robert Gordon Sproul; President W W Campbell; Dean Blythe Webster, St Andrews University, Scotland; Regent Mortimer Fleishhacker; Regent Edward A Dickson; Regent Guy C Earl.

This photograph of dignitaries assembled for the dedication ceremonies, captioned in Regent Dickson's handwriting, is among the "Dickson Papers," housed in the archives of the UCLA Library. Dickson gave the library his lifetime collection of items on early printing, Lincolniana, and materials on state and national politics and on the foundation and early years of UCLA, as well as his correspondence.

Among the University officials participating in the dedication ceremonies were retiring President William Wallace Campbell and Vice-President (President-Elect) Robert Gordon Sproul. "So, in the sight of all the world," to quote from the latter, "with the blessings of distinguished scholars from our own and other lands, the new campus and buildings of the University of California at Los Angeles were dedicated to their task of long, long years."

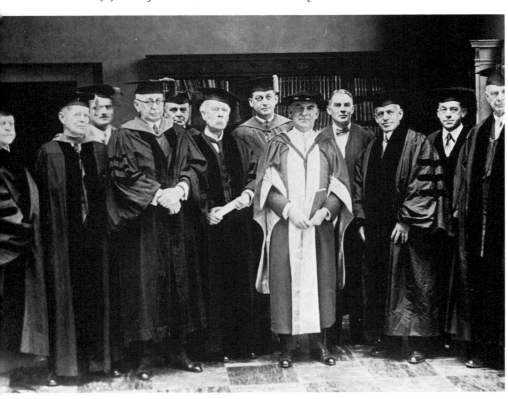

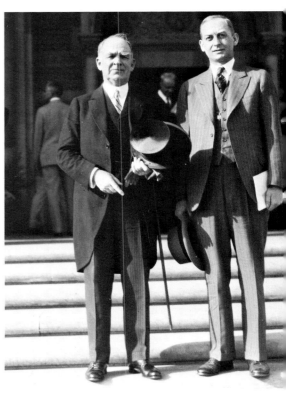

The first four buildings were placed on the slightly elevated ground of the eastern half of the site,
allowing the gymnasiums and athletic fields to be located to the west on a broad
meadow, through which meandered a sycamore-bordered creek. To provide ready access between these two
levels of the campus and to create a striking approach to the buildings from the west, Edwin and
Harold Janss provided funds for the construction of red brick steps—eighty-seven separate steps in
three flights and two landings, each landing flanked by terra-cotta balustrades.

The Janss Steps were dedicated in the summer
of 1931. Assembled for the occasion were many
of the men who were prominent in the development
of the new campus. The Janss brothers are in
the first row—Edwin at the left, Harold
fourth from the left.

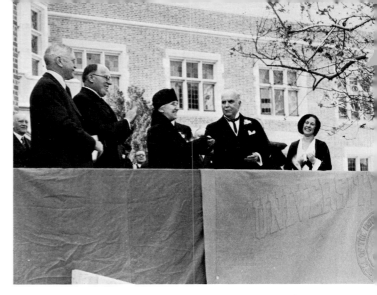

Until the early years of World War II, the Associated Women Students' annual party—the Hi-Jinks—was one of the highlights of campus activity. Skits were held for women-only crowds in Royce Hall, with women "cops" acting as guards to keep out inquisitive men and to see that all women were in costume. During the 1929 program, two men in women's clothing unsuccessfully attempted to crash the gate. The "cops" escorted them to the stage, presented them to the crowd in the glare of spotlights, then ejected them from the building.

Kerckhoff Hall, the student union, was one of several new buildings added to the cluster around the main quadrangle during the 1930's; the others were the Education Building, the Men's Gymnasium, Mira Hersey Hall, and the Administration Building. Director Moore, who felt keenly the need for a student union building, was instrumental in persuading Mrs. William G. Kerckhoff to build such a structure in memory of her late husband. The dedication of Kerckhoff Hall, modeled after Edward VII's Chapel at Westminster, was held on January 20, 193 Shown here are: Allan C. Balch, Kerckhoff's business partner; Director Moore; Mrs. Kerckhoff; Governor James Rolph; and Lucy Guild and Earl Swingle, vice-president and president, respectively, of the ASUCLA.

On the morning of January 15, 1932, to the amazement of everyone, the campus was blanketed with snow, the first to fall on the hills of Westwood in fifty years. Faculty and students alike joined in making snowmen and snowballs. One result was fourteen smashed windows, several of which were credited by some reports to the inexpert aim of certain professors.

In August 1933, largely at the urging of the southern alumni, the Regents authorized graduate study for the degrees of master of arts and master of science, specifying a graduate enrollment of 150. The first dean of the graduate school was Vern O. Knudsen, chairman of the Department of Physics and a distinguished acoustical physicist, who had joined the faculty in 1922. The first master's degrees were awarded at commencement in June 1934. Two years later the Regents extended the graduate program to include the degree of doctor of philosophy in the fields of English, history, mathematics, and political science. The first Ph.D. was awarded in June 1938, to Kenneth Bailey, a student of history.

Establishment of graduate work was one of UCLA's "big leaps" in the transition from a teachers' college to a great university. When Knudsen retired as chancellor in 1960, he described the development of the graduate division as UCLA's greatest single accomplishment.

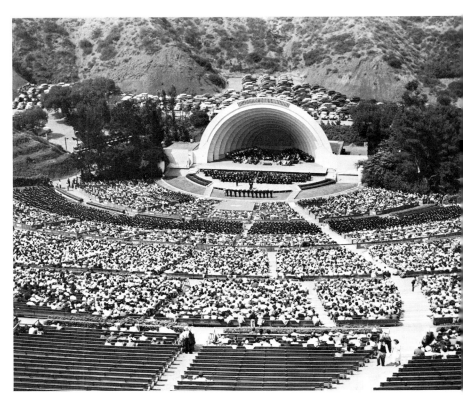

From 1928 to 1940, UCLA commencement exercises were held in the Hollywood Bowl (above), and from 1941 to 1949 in the Outdoor Theater on the campus (below). Permanent work was never begun on the Outdoor Theater, however, and it was abandoned after World War II to provide space for a medical center.

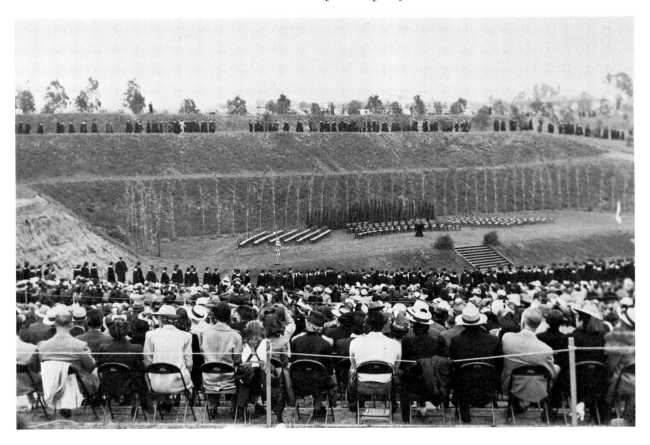

Westwood Village began in 1922 as a quiet residential area around the intersection of Pico and Sepulveda Boulevards; but the coming of the University soon brought change. Here is the Westwood Village of April 1936. An alumni publication of the times observed: "The atmosphere of Westwood is one of gracious living, and the smartness and beauty of the Village itself have done much to make it so."

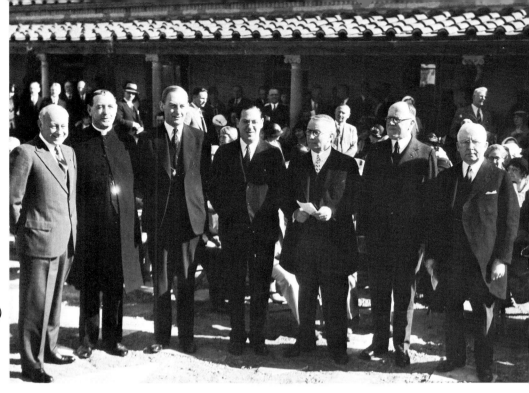

University, civic, and religious leaders joined in the 1932 dedication of the first University Religious Conference building, adjoining the campus. Among those attending the ceremony honoring the interdenominational organization for university students were Cecil B. DeMille, chairman of the building committee; Bishop Cantwell of the Roman Catholic Diocese of Los Angeles and San Diego; President Robert G. Sproul; Rabbi Edgar Magnin, representing the Jewish faith; Rev. James B. Fox, secretary of the Baptist City Mission Society and first president of the Conference; Provost (as of 1931) Ernest Carroll Moore; and Rev. J. Lewis Gillies, district superintendent of the Methodist Episcopal Church and first vice-president of the Conference. In 1951 the property was acquired by UCLA for the new School of Medicine, and the Conference built a new home on Hilgard Avenue.

In 1936, Provost Moore, director of the University in Los Angeles from its inception, announced his intention to retire from administrative work. His last official duty was to preside over commencement exercises that year, after which he served another five years as professor of education and philosophy. When he died in 1955, at the age of eighty-three, services were held in Royce Hall. Among the speakers was Edwin A. Lee, dean of the School of Education. "Above all," he said, "the significance of Dr. Moore's accomplishments in teaching and administration was enhanced by the characteristic, vouchsafed to so few men, which he possessed in such ample measure—the capacity to envision. Furthermore, he possessed what most dreamers lack—the ability and the tenacity to see his visions through to reality. UCLA is the visible embodiment of his imagination and his purpose, a monument to his farseeing wisdom and his indomitable spirit."

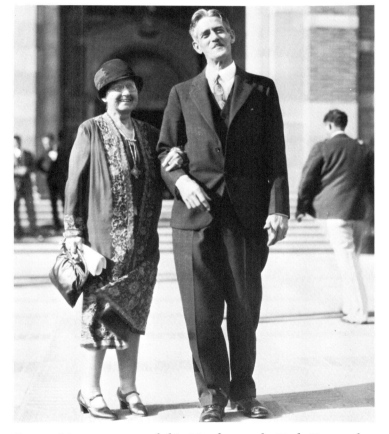

Provost Moore was succeeded in March 1937 by Earle Raymond Hedrick, head of UCLA's mathematics department, who served as vice-president and provost until his death in 1942. He appears here with Mrs. Hedrick at the time of the campus dedication in 1930. By the fourth year of Provost Hedrick's administration, the student body had grown to more than ten thousand, making UCLA the eleventh largest university in the United States and second in California only to Berkeley.

After Provost Hedrick's death no successor was named, and for three years President Sproul placed administrative responsibility for the campus in a committee of three deans—Bennett M. Allen, Gordon S. Watkins, and J. Harold Williams. During 1942–43 President Sproul himself took up residence on the Westwood campus, directing the affairs of the entire University from there.

World War II brought marked changes to the campus. Air-raid drills were held. The Red Cross Blood Bank was a regular feature of campus life. The University plowed the areas west of the track and north of the Women's Gymnasium, and victory gardeners cultivated small plots.

During the war enrollment shrank, but the campus became important to the war effort by providing instruction in engineering, medi-

cine, languages, and meteorology, officer training to armed-forces groups, and defense training classes for industry. By September 1943, one out of every three students on the campus was in uniform.

The Sigma Nu fraternity house was one of several that served as quarters for Navy V-12 students enrolled in an officer training program. The fraternity crest above the door was covered, for the duration, by a wooden box. At the left is Buck Hendrick, custodian of the house.

A rifle marksmanship class, part of the Army Specialized Training Program for basic engineering work.

Because of the shortage of men at the war's end, coeds pitched in to unearth the big cement "C," which had been covered by military authorities as a defense measure.

At the Regents' meeting of October 1944, the position of provost was offered to Clarence A. Dykstra, then president of the University of Wisconsin, who had served as a professor of political science at UCLA from 1926 to 1930. He assumed the position of vice-president and provost in February 1945, serving until his death in May 1950.

Provost Dykstra was succeeded in 1952 by Dr. Raymond B. Allen, the first chief executive to hold the title of chancellor. He served until 1959.

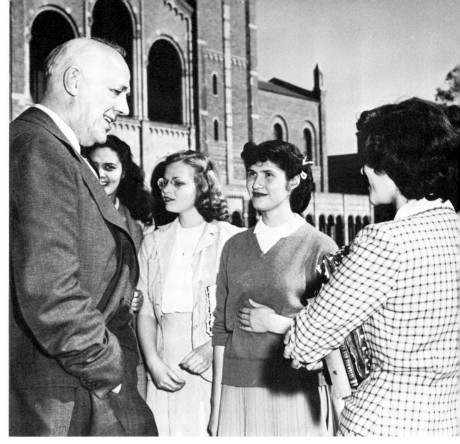

Provost Dykstra talking with students in 1945.

Bequeathed to UCLA in 1934 by William Andrews Clark, Jr., as a memorial to his father, the Montana senator and copper king, the William Andrews Clark Memorial Library is housed in a Renaissance-style building completed in 1926. It is in Los Angeles, about ten miles from the campus, surrounded by four acres of gardens and lawns. In developing the library, the University decided not to compete with or duplicate the holdings of other research libraries in the area but to continue the library's concentration on two widely separated periods of English culture—the age of Dryden and that of Oscar Wilde. The Dryden and Wilde collections are now the most complete in the world.

The fifth annual Founder's Day celebration, held in 1948 at the Clark Library, drew an enthusiastic crowd of thirteen hundred— including Lawrence Clark Powell, UCLA librarian and director of the Clark Library; Paul Dodd, dean of the College of Letters and Science; Vern O. Knudsen, dean of the Graduate Division; Mrs. Dodd; and Mrs. Knudsen.

Mardi Gras began in 1949 as a bazaar to raise money for the school's foreign students. Today, it has grown into a full-scale carnival. Funds go to support Uni-Camp, held each summer in the San Bernardino Mountains, under the sponsorship of the University Religious Conference, for one thousand underprivileged children of the Los Angeles area.

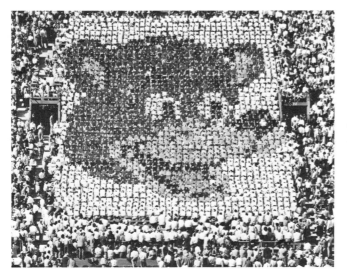

In 1924, the Grizzly Bear was chosen as the official UCLA mascot; however, this had to be changed when UCLA joined the Pacific Coast Conference in 1929, because the athletic teams of another PCC member, the University of Montana, were already known as "Grizzlies." Berkeley's teams had long been known as "Bears;" UCLA's, therefore, became "Bruins." In the days when students brought live bears to football games, they were usually called "Joe" or "Josephine" Bruin. Joe Bruin is still in attendance at every UCLA athletic event, but live bears have been supplanted by students dressed in costumes. A portrait of Joe Bruin is a favorite card stunt of UCLA rooters at football games.

Among the songs closely identified with UCLA is "Strike Up the Band," by George and Ira Gershwin. It was renamed "Strike Up the Band for UCLA" and presented to the school in April 1937. Here a group of coeds sings as George Gershwin plays the song at his home.

Raising the Victory Flag on the Monday after a major athletic victory has been a tradition since 1935. In 1949, upon the death of A. J. "Sturzy" Sturzenegger, assistant graduate manager of the ASUCLA and assistant football coach, students decided to replace the weather-beaten flag with a new banner dedicated to "Sturzy." To raise the necessary funds, the old flag was placed on the lawn of the Quad and students tossed in coins.

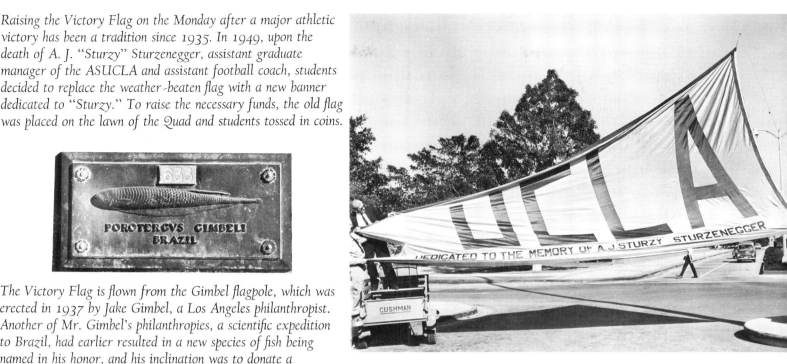

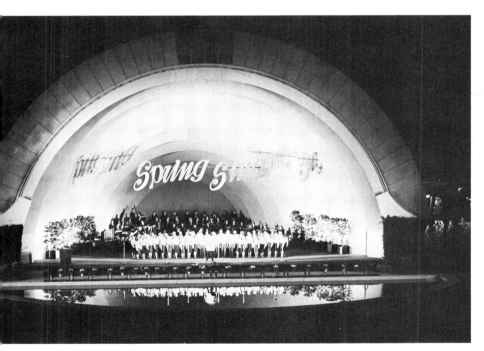

The Victory Flag is flown from the Gimbel flagpole, which was erected in 1937 by Jake Gimbel, a Los Angeles philanthropist. Another of Mr. Gimbel's philanthropies, a scientific expedition to Brazil, had earlier resulted in a new species of fish being named in his honor, and his inclination was to donate a fountain in which this fish, the Porotergus gimbeli, would be exhibited. But a new flagpole was needed, and he compromised by donating one—with a bronze plaque at the base showing the fish that bears his name.

Many stars of film and stage have participated in campus rallies and other student events— including Ronald Reagan, who served as master of ceremonies for the 1955 Spring Sing.

Spring Sing originated in 1946, when the claim of Phi Kappa Psi as champion serenaders of fraternity row was challenged. The first formal competition, in Royce Hall, was so well attended that the following year the Sing moved into the Outdoor Theater. In 1950, construction activities for the Medical Center forced the event to move to the Hollywood Bowl.

UCLA has traditionally celebrated a gridiron victory over their crosstown rival, the University of Southern California, with a student parade through Westwood Village led by the Victory Bell, a 295-pound silvered locomotive bell. The bell was presented to the ASUCLA by the Alumni Association in 1939. In 1941 it was stolen by "bogus" rooters during a football game, and an intensive but fruitless search ensued. USC rooters returned it the following year, after an agreement that the Trojans would buy a half interest. Since then the bell has been the official trophy of Bruin-Trojan football rivalry— won twelve times by UCLA, fifteen times by USC.

The Noble Order of Kelps, a men's spirit organization, was formed in 1947. Members are selected on the basis of their service to the University and their capabilities as "rooter rousers." In 1954, they followed the Bruin basketball team to Madison Square Garden for the Holiday Tournament. Clad in Bermuda shorts, the Kelps delighted the crowd by throwing oranges into the stands and exhibiting an artificial palm that bore a sign reading "Los Angeles City Limits."

The bonfire of 1941 was a memorable one. Student guards detected a bomb and removed it just in time to prevent premature lighting of the thirty-foot pyre.

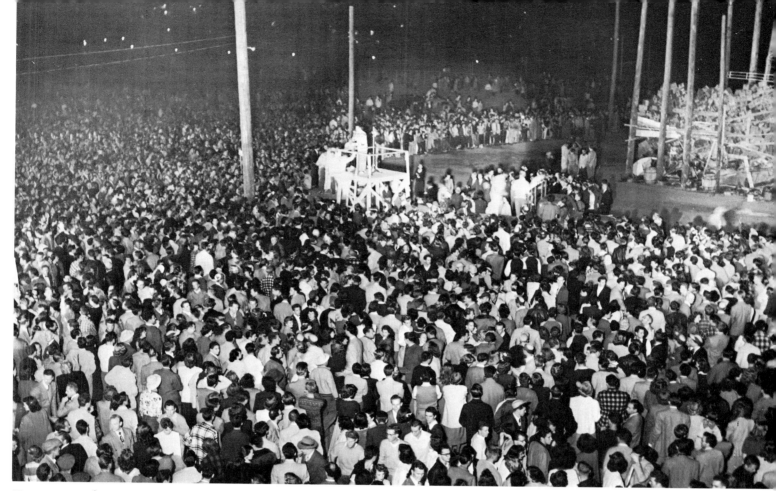

Homecoming of 1949 is regarded by campus authorities on such affairs as the "greatest in history." A crowd estimated at one hundred thousand—Westwood's largest assemblage—witnessed the bonfire and parade.

Since 1927, Homecoming has been a major event on the UCLA campus, featuring bonfires, rallies, and—since 1933—a float parade. UCLA bonfires are especially distinctive in one respect: Discarded movie sets have sometimes been available to add to the pile of logs, telephone poles, railroad ties, crates, and the like. In 1964 the parade was temporarily eliminated, the floats became stationary, and the bonfire was replaced by an olio show, a barbecue, and a television rally with USC. Large television screens were set up on each campus and students watched each other's rallies on closed-circuit television. The parade and bonfire were reinstituted in 1965.

Kenny Washington, halfback from 1937 to 1939 and an All-American player in 1939—the first of seventeen Bruins to receive this honor. One of the all-time greats of UCLA football, Washington remains the number-one ball carrier in Bruin history. In 1937 against USC with UCLA behind 0–19 in the last quarter, Washington pitched two touchdown passes in twenty-six seconds and just missed another as time ran out.

Although card stunts at football games possibly originated on the Berkeley campus, UCLA was the first school to develop *lighted* stunts. In the 1930's UCLA played many of its football games at night and decided to try something unique with card stunts. Each student was given four light bulbs, each of a different color, and various stunts were performed in the darkened stadium by plugging in the appropriate bulbs. However, the four different light bulbs and miles of wire involved were expensive and difficult to handle. They were abandoned in 1953, when an ingenious student developed a card that was similar to those used in ordinary card stunts but had eight colored light filters placed in a circle. Students then could use flashlights, shining them through the various filters as directed. Night games are less frequent now, but stunts with lights continue to be a trademark of the UCLA rooting section.

An early stunt, using light bulbs.

One of the later stunts, created by 1,665 students shining flashlights through the special cards.

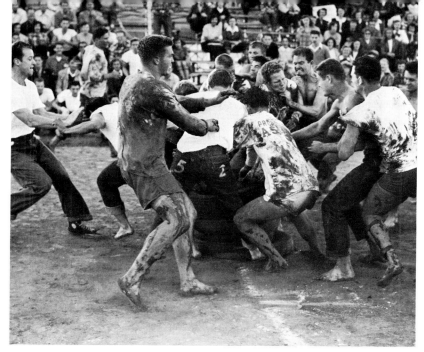

Mud brawls, pie-eating contests, egg fights, "slave" selling—these and more mark the forty-year tradition of Men's Week and Greek Week. Men's Week began in 1928 on the Vermont Avenue campus and featured a Frosh-Soph mud brawl, which marked the end of the sporadic and unorganized hazing of Freshmen by upperclassmen and ushered in an era of traditional rivalry and antics by lowerclassmen. This mud brawl, which took place in 1957, was one of the last strictly masculine affairs. In 1960, Men's Week was transformed into Greek Week, and sororities were invited to participate in some of the contests. In recent years Greek Week has become less boisterous, the contests being limited strictly to pie-eating, sack races, chariot races, selling pledges as slaves, and the like. Proceeds go to student charities.

In 1952, a group of UCLA students affiliated with the University Religious Conference became concerned with the need for better understanding of America by college students in India. The result was "Project India." Each year since that time, two groups of seven students have visited college campuses throughout India, meeting students and participating in service projects. One Project India group joined students from Calcutta College in building a community center.

One rainy morning, pranksters rolled a fellow student's car up the steps onto Royce Hall's covered porch as their answer to the parking problem.

There has never been a time, apparently, when parking was not a problem on the Westwood campus. From the beginning, with little or no public transportation, students were largely commuters. In October 1929, soon after the campus opened, an advertising fraternity reported that the UCLA student body drove more automobiles than any other in the country. By actual count, they said, some 2,384 cars were parked on the campus and adjoining streets.

Today, parking structures and lots on campus accommodate 15,760 vehicles, and more facilities are planned. But many of the students and faculty still would agree with Dick Goldstone's poetic lament in the Daily Bruin *of November 13, 1929.*

Though you get here at dawning,
At daylight or dark,
Be it ever so humble,
There's no place to park.
No corner or crevice,
No cranny or crack,
No niche for bestowing
The travel-worn hack.
Though you search every alley,
Each field freshly plowed,
You are met with the notice—
"No parking allowed."
So arrive with the sunbeam
That heralds the day—
And park out on Wilshire,
Miles away.
Bring blankets and breakfast
And boots, if you like,
A compass and sextant
Prepared for a hike—
But no matter how early
You get here, alas
You can ne'er park in time
For an eight o'clock class!

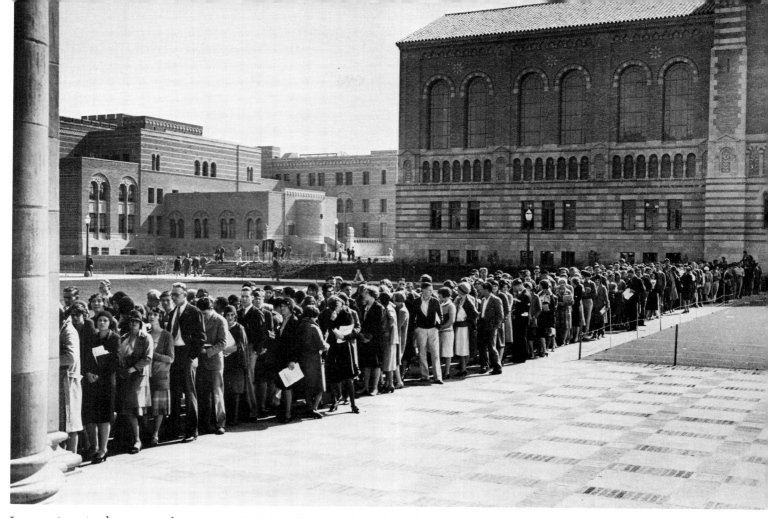

Long registration lines are nothing new at UCLA, as this scene from the early 1930's indicates.

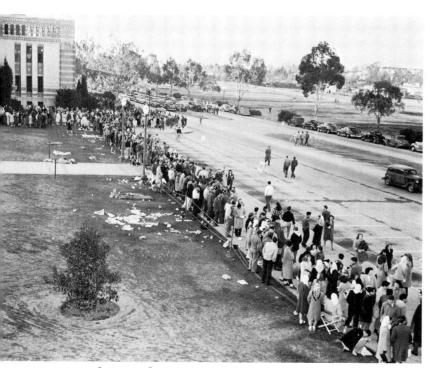

By 1947 the "reg" lines weren't any shorter. Yearbook captions under such photographs as this read, for example: "Gotta wait for good things . . . $29 . . . ding . . . you're in."

But some new gimmicks had been added: The ASUCLA photographers were proud of this contraption, which took thirty student ID photos a minute.

The Faculty Center (left) was completed in 1958, filling a long-expressed need. Located just south of the Administration Building, the Center was financed by contributions and loans secured by faculty members. Previously, small faculty groups had gathered in various places on campus for lunches and other informal meetings. A group that met in Kerckhoff Hall (right) often included Professor Fredric P. Woellner, of the Department of Education, who retired in 1956 after thirty-three years of inspired teaching to an estimated thirty-five thousand students.

In July 1960, as UCLA entered its forty-second year, Dr. Franklin D. Murphy, forty-four-year-old Kansas physician and educator, became UCLA's third chancellor and sixth chief executive. At the age of thirty-five Dr. Murphy had been promoted from dean of the medical school to chancellor of the University of Kansas and had established a reputation for getting things done. Almost from the day he arrived at the Los Angeles International Airport, to be greeted by Regent William Forbes and ASUCLA Director William C. Ackerman and their wives, Chancellor Murphy was labeled "UCLA's man on the go."

In his inaugural address September 23, Chancellor Murphy set forth his objective: to lead UCLA to "major scholarly distinction in world-wide terms." "If the richest nation in the world," Dr. Murphy said, "cannot find adequate funds to support the highest quality and breadth of education and research, our national values have become so eroded and perverted that the future for us would appear very dim indeed."

Retiring Chancellor Vern O. Knudsen introduced Dr. Murphy to the campus. One of the "greats" of the UCLA faculty, Knudsen served as vice-chancellor from 1956 to 1959 and as chancellor from 1959 to 1960.

University of California students are privileged to see and hear many world-famous personages who visit the state.

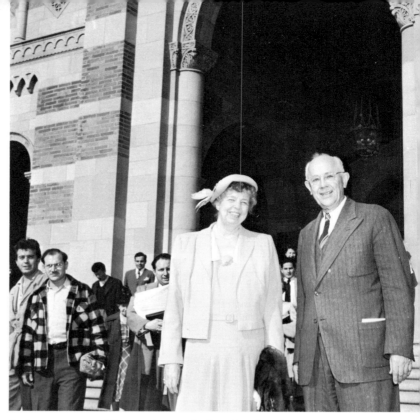

In January 1950, Eleanor Roosevelt (standing beside Provost Dykstra) addressed an overflow crowd in Royce Hall on the United States' responsibilities to the United Nations.

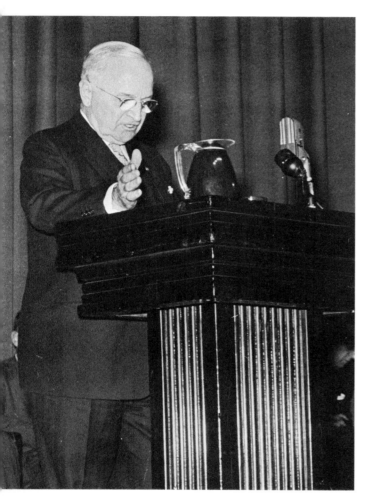

Former President of the United States Harry Truman also filled Royce Hall when he spoke in April 1959, in a program commemorating the fiftieth anniversary of the founding of Sigma Delta Chi, the national professional journalism society.

The eminent poet and Lincoln biographer Carl Sandburg responds to a request for his autograph just before an appearance in Royce Hall on March 13, 1961. A few days later, he was awarded an honorary doctor of fine arts degree at Charter Day ceremonies.

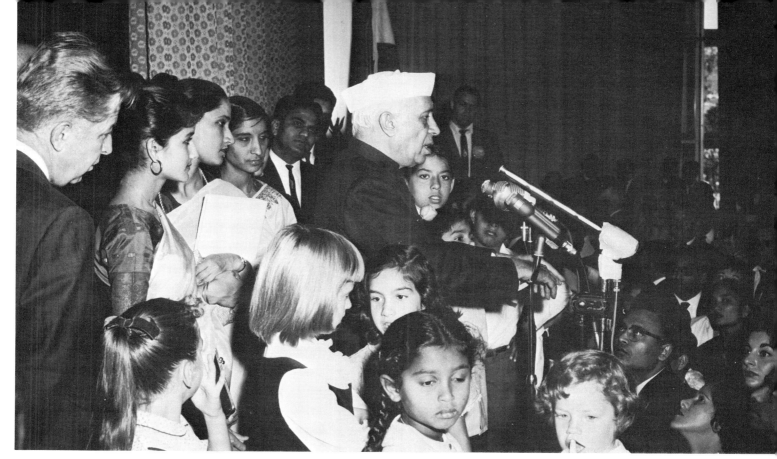

Jawaharlal Nehru, prime minister of India, observed his seventy-second birthday on November 14, 1962, at UCLA. As he mounted the steps of the Student Union, a gathering of students sang "Happy Birthday" to him before he spoke at a reception given by the India Club and attended by representatives of Indian students at eleven other California colleges and universities.

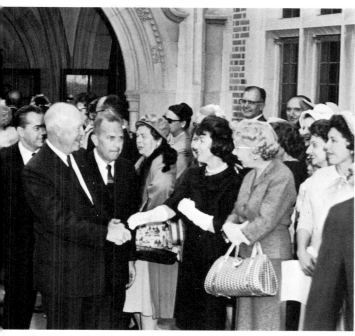

e principal speaker at Charter Day exercises on April 2, 1963, rmer President Dwight D. Eisenhower, told an audience of twelve usand on the Art Parterre, "America's first line of defense s through her University campuses." Later, the General ended a reception given by the UCLA Alumni Association.

His Royal Highness Prince Philip, Duke of Edinburgh, spoke at 1966 Charter Day ceremonies, held in Pauley Pavilion, on the role of leisure in contemporary society. From left to right are Chancellor Murphy, Prince Philip, President Clark Kerr, and Chairman of the Regents Edward W. Carter.

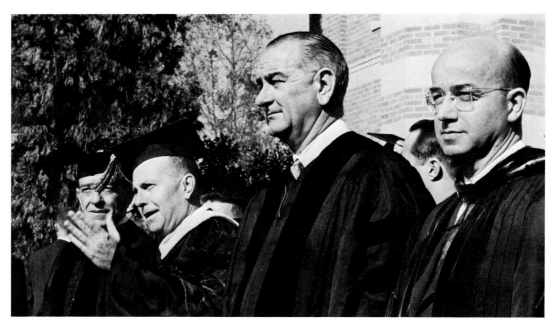

The athletic field across from the Women's Gymnasium was the scene of
one of UCLA's most memorable Charter Days—February 21, 1964. Before a
crowd of thirty-four thousand, the presidents of Mexico and
the United States spoke and received UCLA's highest honors.
Left to right are President Adolfo López Mateos, Chancellor Murphy,
President Lyndon B. Johnson, and Clark Kerr, president of the University.

"UCLA's grandest Charter Day," the alumni magazine wrote. "It was a
day which nature had invested with appropriate colors, golden and
intense blue; a light breeze ruffled the graceful fronds of eucalyptus
fringing the canopied stage. The University concert band set to music
the mood of the morning, with ringing brass and percussion converting
mere expectancy into excitement. Now, from the sky, like giant birds,
dipping and cornering around Sproul [Hall] and the bright banners,
whirred a procession of helicopters, flying over the crowd and landing
on the running track. The two presidents emerged, almost as if
modern-day dei ex machina,—though these were not "gods from machines"
bringing pat solutions to the world's turbulent problems, but mortal
men charged with almost superhuman responsibilities."

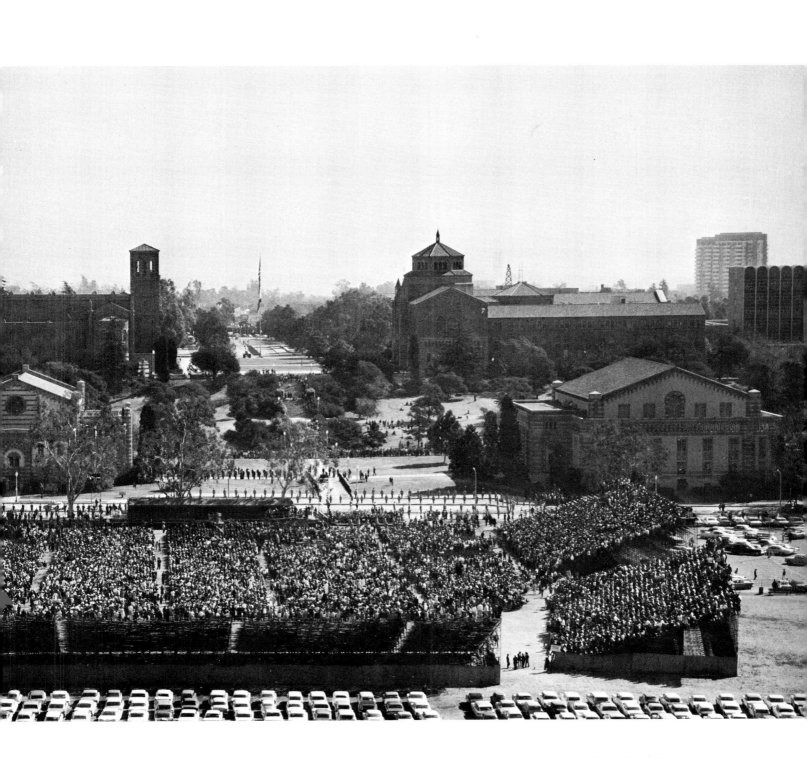

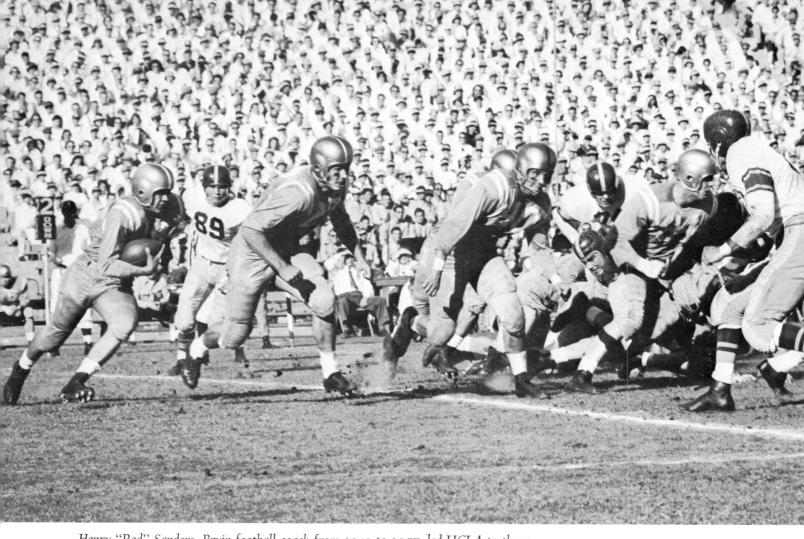

Henry "Red" Sanders, Bruin football coach from 1949 to 1957, led UCLA to three straight Pacific Coast Conference titles and to gridiron prominence. The 1954 team's power, which earned it the Grantland Rice award, is demonstrated against USC.

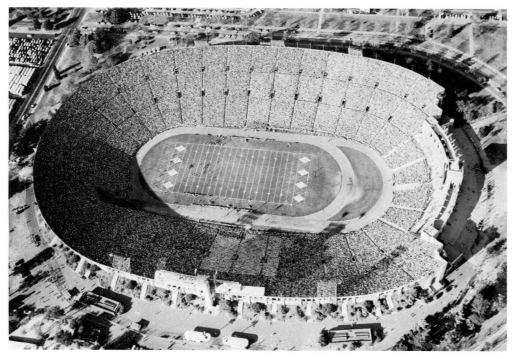

The year: 1954.
The crowd: 102,548.
The score: UCLA 34, USC 0.

Joe E. Brown and UCLA moved to Westwood about the same time, and for many years Joe appeared at the opening rally of every year. He has often been called "UCLA's number-one rooter."

The song girls' faces reflect the emotions that swept the crowd of nearly ninety thousand in critical moments as the Bruins upset USC 10 to 3 in 1959.

In the Rose Bowl in 1965, Coach Tommy Prothro's underdog Bruins turned back the Michigan State Spartans 14–12, earning UCLA its first New Year's Day victory. Hero of the game was Sophomore quarterback Gary Beban—named Heisman Trophy winner in 1967.

UCLA's 144-piece marching band at half time. The band originated in 1928 as a 42-piece ROTC unit and remained a military band until 1934.

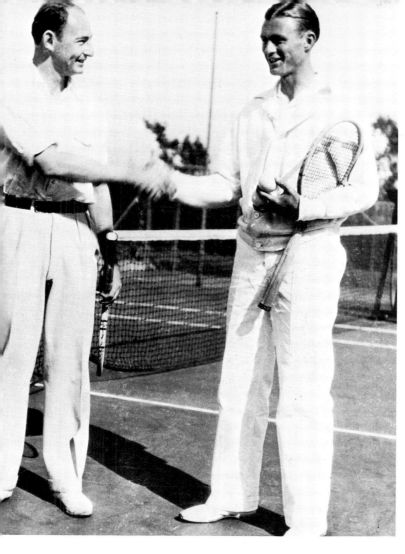

William C. Ackerman coached Bruin varsity and Freshman tennis teams for thirty years—from his student days in 1921 to 1950. In 1950 his Bruins won the National Collegiate Athletic Association (NCAA) team championship, the first national collegiate title won by UCLA in any sport. Bill Ackerman is frequently referred to as "Mr. UCLA" because of his long service to the campus as a student leader, tennis and baseball athlete, head yell leader, intramural athletic director, physical education instructor, graduate manager, tennis coach, and—from 1933 to 1967 —executive director of the Associated Students. His opponent in a 1928 tennis tournament was Harry Coffin (left).

The NCAA tennis title won in 1950 was the first of many that were to come to UCLA, as the Bruins piled up an amazing record of eight NCAA team championships in tennis in sixteen years. In 1951 Ackerman was succeeded as coach by J. D. Morgan, who has also been UCLA's director of athletics since 1963. Morgan stands with the 1965 NCAA championship team— Ian Crookenden and Dave Sanderlin on the left, Dave Reed and Arthur Ashe on the right.

In 1952, UCLA javelin thrower Cy Young brought the Bruins their first Olympic gold medal in track and field, winning the javelin event at Helsinki with a new Olympic record of 242 feet 3/4 inch. Young was the first American ever to win this Olympic event.

For a time UCLA almost seemed to have a monopoly on decathlon athletes. In the 1960 Olympics, held in Rome, Rafer Johnson and C. K. Yang finished first and second, with the two highest decathlon scores in history. On the campus, Elvin C. "Ducky" Drake, UCLA track coach from 1947 to 1964, stands between the

The 1966 track and field team hoist Coach Jim Bush (who succeeded Drake) on their shoulders after a decisive 86–59 dual meet win over crosstown rival USC, on their way to winning UCLA's second national championship in track and field. (The first was in 1956). In the background is Assistant Coach Ken Shannon.

The Bruins captured their first NCAA basketball title in 1964 (upper picture), their second in 1965, and their third in 1967 (lower picture). Coach John Wooden (foreground of upper picture, right rear of lower picture), who has not had a losing season since he came to UCLA in 1949, thus became the first college basketball coach ever to guide his teams to perfect title-winning seasons twice—first with the diminutive 1964 team, again in 1967 with a giant of a player, Lew Alcindor (near center rear of lower photo), who made his presence known like no other Sophomore in the annals of college basketball.

UCLA Captain Mike Warren performs the traditional ceremony of cutting down the net after the Bruins' final victory in 1967.

*Seven o'clock in the evening arrives and the campus lights up and becomes jammed
with cars as classes in the continuing adult-education programs get under way.*

University Extension has been immensely successful, and nowhere in the state more than in Los Angeles. In 1967, there were more than fifty thousand registrations for its many programs on the UCLA campus.

In 1916, after twenty-five years at Berkeley, the Regents approved the establishment of a southern headquarters for University Extension. The first office was located in the Union League Building at the corner of Hill and Second Streets. It was a modest beginning, but one described by Regent Dickson as the "first visible appearance of the University of California in the southland." In 1922, University Extension leased a new Hill Street building at the corner of Eighth Street.

Soon there were fourteen University Extension centers in as many different communities of southern California. Since 1958, when Paul Sheats, professor of education at UCLA, was appointed University-wide dean of University Extension, its headquarters has been in Los Angeles. The growth of University Extension in both the number and the variety of its programs has been extraordinary, and today it is considered the largest educational organization of its kind. In 1967, there were 234,000 registrations for extension programs on the nine campuses and in 250 different communities around the state.

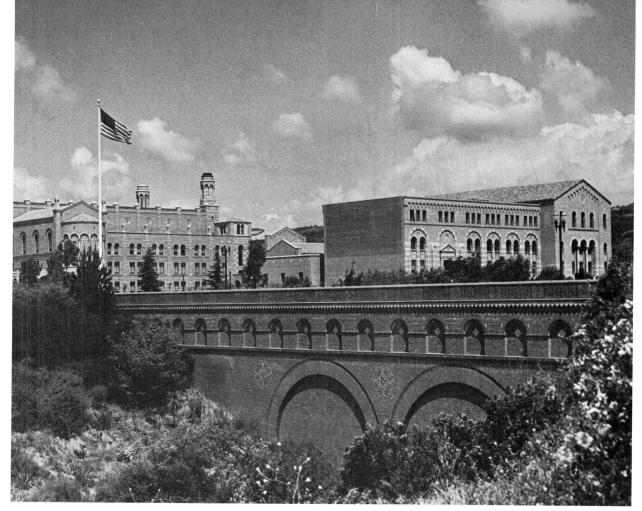

The arroyo bridge was the first project completed on the new campus after construction got under way in 1927; it was badly needed to transport materials and machinery across a ravine to the building sites. The bridge was a campus landmark for many years.

In 1947, land was in great demand for UCLA's vast postwar building program, and the arroyo north and south of the bridge was filled with four hundred thousand cubic yards of earth. The alumni magazine reported that "poets wept when the lovely brick span across the arroyo was shored up to take the weight of the earth which would hide the bridge forever."

In the years immediately following World War II, UCLA embarked upon an extensive construction program; between 1946 and 1951 some ten major new buildings or annexes were completed. Within a single month in 1951, two important ceremonies were held. On November 2, the cornerstone was laid for a new $16,500,000 medical school—the largest single building project in UCLA history. Eight days later, a new building for the School of Law was dedicated in impressive ceremonies featuring Roscoe Pound, dean emeritus of Harvard Law School and visiting professor of law at UCLA.

Two Warrens participated in the cornerstone ceremonies for the new medical school. Governor Earl Warren was introduced by President Sproul as "the man who, more than any individual, is responsible for the appropriations which assure the realization of this great humanitarian dream"; Dr. Stafford L. Warren, who was in charge of the medical activities of the Manhattan Project, was named first dean of the medical school.

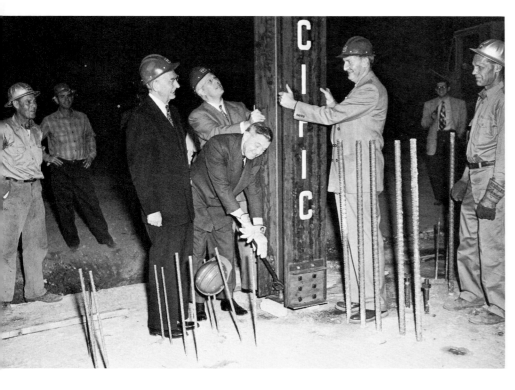

Inaugurating building activity at the medical school, Chairman of the Regents Edward A. Dickson helped bolt a thirty-foot steel column to a special face plate, with President Sproul, Governor Warren, and Dean Warren assisting.

The first class of 28 medical students was accepted in 1951 in temporary quarters. In 1954, the School of Medicine moved into its permanent buildings and upon completion of present construction program will enroll 128 students in each of four classes. The entire UCLA Center for Health Sciences now has more than 2,000 students. In addition to the School of Medicine, it includes Schools of Dentistry, Nursing, and Public Health, the University Hospital and Clinics, and many research facilities. Among these research facilities are the Jules Stein Eye Institute; the internationally recognized Brain Research Institute, which has pioneered in an interdisciplinary approach from which has come new knowledge of the brain mechanisms controlling wakefulness, sleep, and behavior in general; and the laboratory of Nuclear Medicine and Radiation Biology, which has channeled much of the atom's mighty potential into peaceful uses. These uses include many precise and rapid new diagnostic tests for medical problems of the thyroid gland, liver, kidneys, lungs, and brain.

The comprehensive research program carried on under the direction of the medical school's faculty has achieved many major advances, including the application of computers to the health sciences.

A fisheye photograph shows the patient's view of an operation at the Jules Stein Eye Institute. The surgeons often wear magnifying eyeglasses when greater magnification from an operating microscope is not needed.

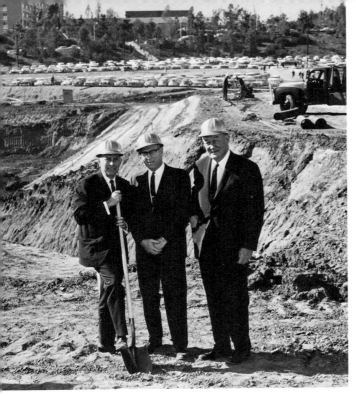

Ground-breaking ceremonies for the Memorial Activities Center were held in 1964. Taking part were Chancellor Murphy; John Wooden, basketball coach; and Regent Edwin W. Pauley, whose gift of one million dollars, to be matched by alumni contributions, made the center possible.

The thirteen-thousand-seat Pauley Pavilion, part of the Memorial Activities Center, was completed in 1966 as a basketball stadium and an auditorium.

First ceremony to be held in the MAC complex was commencement of June 1965, at which time the central Pauley Pavilion was dedicated and named for the principal donor. To complete the Center, plans call for construction of a second satellite building for indoor sports, a major student-activities plaza, and two intramural playing and practice fields.

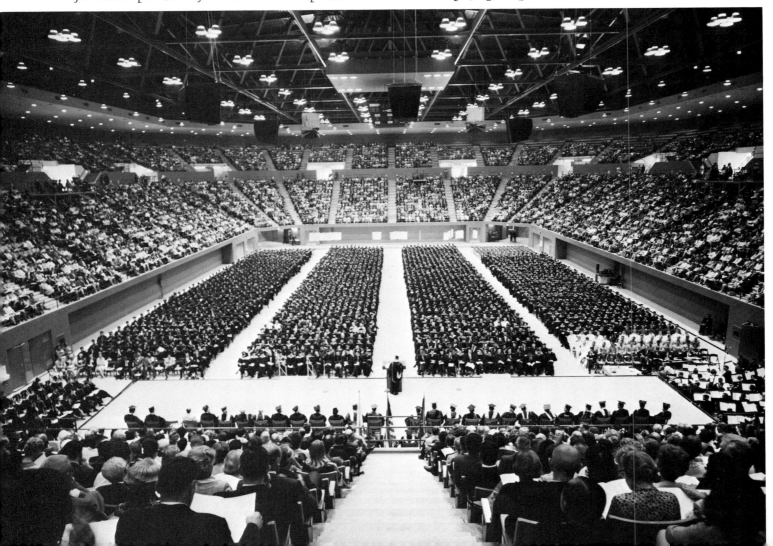

The early 1960's became the "age of dormitories" on UC campuses, as steps were taken to carry out a substantial part of the Regents' decision that twenty-five percent of each student body be housed on campus, in order to bring the students a better balanced academic and human experience. Ground-breaking ceremonies for Dykstra Hall, the first dormitory constructed as part of the Regents' program, were held March 26, 1958. Participating were Regent Edwin W. Pauley; David Gorton, ASUCLA president; President Sproul; Chancellor Allen; and Earl J. Miller, dean of students.

Now dotting the western campus skyline are the campus residence halls—Dykstra, Rieber, Sproul, and Hedrick.

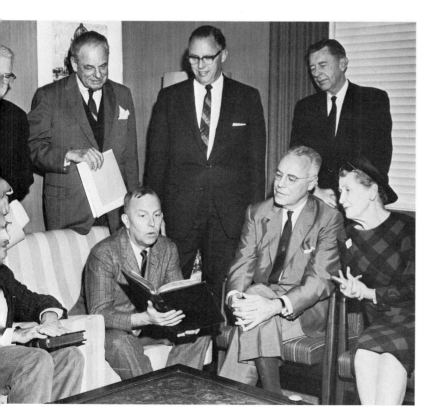

The 128,000-volume library transferred to Westwood in 1929 now numbers more than 2,500,000 volumes. During the early 1960's, UCLA ranked first in rate of growth among the libraries of twenty leading American universities, and in 1966 the American Council of Education rated it fourth in the nation, surpassed only by Harvard, Berkeley, and Yale. In 1964 the library acquired its two-millionth volume: an edition of the complete works of Plato, published in 1513 by the Aldine press and regarded as one of its most handsome and important issues. Shown with the two-volume work are (seated, from left) librarian Robert Vosper, Chancellor Murphy, Regent Edward W. Carter, Mrs. Elmer Belt, and (standing) Dr. Elmer Belt, Professor Majl Ewing, Alumni Association President W. Thomas Davis, and Professor C. D. O'Malley.

The eleven-story Social Sciences Building was occupied in February 1964, amid a tumult of strongly expressed opinions, both pro and con. The small black square windows led to the building's almost universal (though inaccurate) nickname of "Welton's Waffle." (The architect was actually Maynard Lyndon; Welton Becket is chief supervising architect for campus planning.)

The building program in which UCLA engaged between 1960 and 1966 was the largest ever undertaken by an educational institution anywhere in the nation. The problem of erecting numerous buildings on UCLA's 411 acres while also providing sizable landscaped courts and recreational areas required much of the building to be upward rather than outward. Some new structures on the campus rise as high as twelve stories.

A modern mural depicting various fields of physics decorates the southern facade of Knudsen Hall, UCLA's new physics building. The structure contains such special facilities as an anechoic (echo-free) room supported on air springs and a fifteen-thousand-gallon water tank for underwater acoustical research.

The Dickson Art Center, commemorating Regent Edward A. Dickson's special interest in the arts, provides an area in which the aesthetic interests of the University and the community are focused. Galleries adjoin an eight-story building housing the Department of Art and a 416-seat auditorium for special lectures and other public events. The new North Campus Quadrangle (a portion of which is shown here) contains the UCLA Sculpture Court, with its twenty-six donated works by modern sculptors, including Matisse, Lipchitz, Rodin, Henry Moore, Laurens, Archipenko, Calder, and David Smith.

A focal point of the Sculpture Court is the heroic Jacques Lipchitz bronze "Song of the Vowels," a gift of the UCLA Art Council and Regent Norton Simon. The artist examined the sculpture with Mrs. Herman Weiner, president of the Council, shortly after a crane lifted it into place.

The Department of Theater Arts at UCLA combines drama, motion pictures, television, and radio under a concept introduced when Kenneth Macgowan established the integrated department in 1947. William Melnitz, who later became the first dean of the College of Fine Arts, joined the department in the same year and helped foster a tradition of widely acclaimed productions of modern and classic works, such as this 1961 production of Shakespeare's Richard II.

The theater-arts department's motion-picture division provides a unique school for filmmakers. Student films have been consistent winners at Venice, London, and Edinburgh festivals.

Roger Wagner, founder and conductor of the famed Roger Wagner Chorale, also conducts one of UCLA's numerous student musical groups, the A Capella Choir. Other groups include the University Chorus, the Madrigal Singers, the Men's Glee Club, the Women's Choral Society, the University Orchestra, the Symphonic Band, the Marching and Varsity Bands, and the Opera Workshop.

The hokora (family shrine) in the UCLA Japanese Gardens in Bel-Air, a gift in 1965 from Regent Edward W. Carter. The gardens, only a few minutes drive from the campus, are used for instruction in landscape design and horticulture, for conferences, and for meetings of campus departments and University-affiliated groups. Originally owned by Gordon Guiberson, the gardens are authentic in design and construction, having been built in 1963 by a Japanese landscape architect who brought skilled craftsmen and native materials from Japan.

The Museum and Laboratories of Ethnic Arts and Technology offer excellent facilities for ethnological studies. Enriched by the gift of the Wellcome Collection in 1966, the Museum holds the largest collection of primitive art of any United States educational institution. At the Institute of Ethnomusicology, students can study and perform the traditional music of fifteen or more cultures. Mantle Hood, director of the Institute and an authority on the music of Indonesia, performs with his students on the Javanese gamelan.

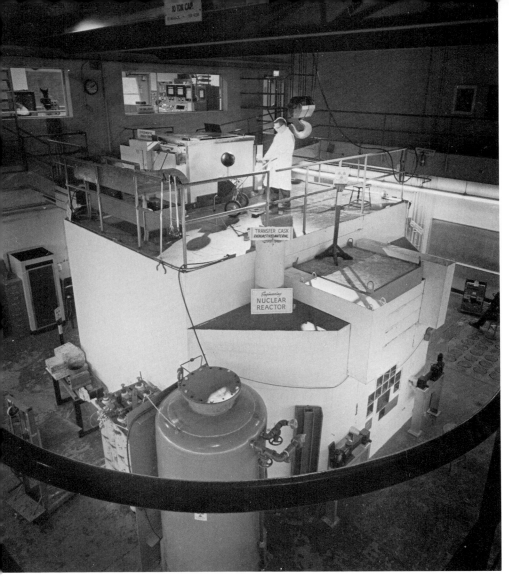

UCLA's hundred-kilowatt Argonaut nuclear reactor is operated by the Department of Engineering as a laboratory tool in undergraduate instruction and as a service facility for other University departments. Originally installed in 1960 as a ten-kilowatt instrument, its power was increased in 1964 and its use increased to a two-shift operation. It is one of many such pieces of special equipment at UCLA; others include a fifty-million-electron-volt spiral-ridge cyclotron, a medical linear accelerator and cobalt unit, and a radiocarbon laboratory for dating organic remains.

One of the most widely known of the University's distinguished scholars, scientists, and teachers is Willard F. Libby, who was awarded the Nobel Prize in Chemistry in 1960 for development of the "atomic time clock"—a method of determining the age of fossils by measuring their radioactivity. Libby, a graduate of the Berkeley campus, served five years on the Atomic Energy Commission before joining the UCLA faculty in 1959. He now directs the University-wide Institute of Geophysics and Planetary Physics, which includes the Space Science Center and whose research projects range from the core of the earth and the bottom of the ocean to the outermost reaches of the solar system. At the UCLA Isotope Laboratory, Libby holds pieces of Peruvian rope whose age he has fixed at 2,630 years (plus or minus 300 years) by means of his "atomic time clock." He stands in front of the laboratory's gas combustion and purification system, in which a small sample is burned and the carbon dioxide is collected and purified.

Since the earliest days of high-speed computers, UCLA has kept pace with their use in academic fields. In addition to the Western Data Processing Center, established in 1956, two other computing facilities serve research in engineering and its related fields and in the health sciences. The $3,300,000 Health Sciences Computing Facility was dedicated in 1963. Among those attending the dedication were Dr. Sherman N. Mellinkoff, dean of the School of Medicine; Vice-Chancellor Foster Sherwood; and Dr. Wilfred J. Dixon, director of the facility.

Joseph Kaplan, a long-time professor of physics at UCLA, is another of its best-known scientific figures. He has been president of the International Union of Geodesy and Geophysics and chairman of the United States Committee for the International Geophysical Year; in recognition of his efforts in the IGY, the U. S. Board of Geographical Names christened a snowclad Antarctic peak Mount Kaplan. A pioneer in upper atmosphere research, he has received the coveted Hodgkins Prize of the Smithsonian Institution, as well as various other awards. Kaplan belies the assertion that prominent researchers have little interest in teaching, for he still conducts general physics courses for undergraduates.

The Institute of Transportation and Traffic Engineering (ITTE), established in 1947 by an act of the California legislature, has facilities at the Richmond Field Station and the Berkeley campus as well as the Los Angeles campus. The study of controlled automobile collisions conducted by the Institute is of special value. Out of such research projects has come a host of scientific recommendations to cut death and injury on the state's roads and highways. The ITTE, whose work has been described by professional magazines as "the country's most comprehensive highway safety research program," is only one of many organizations operating within the University to conduct research and provide graduate and continuing-education programs and public-service advisory work.

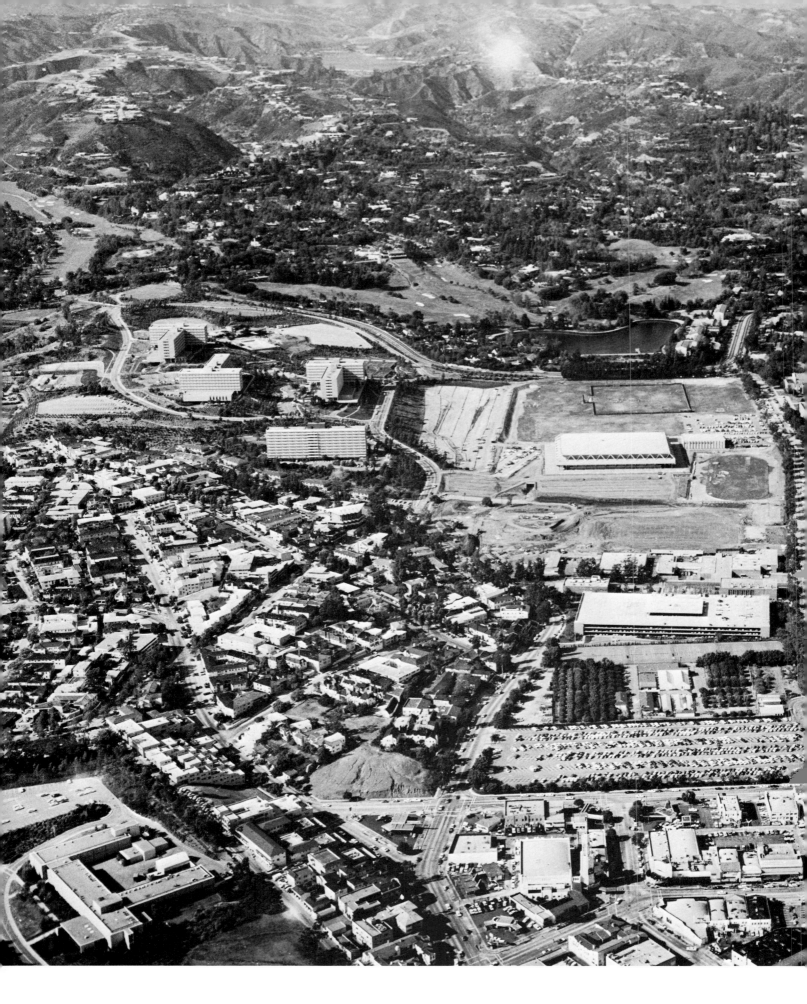

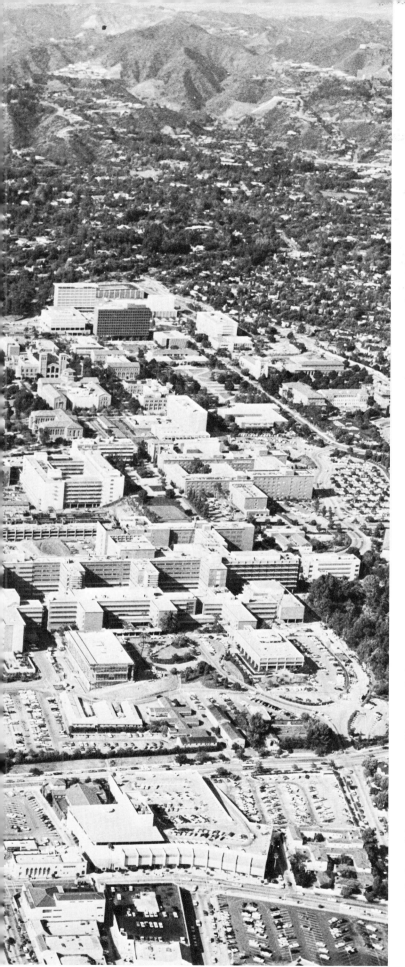

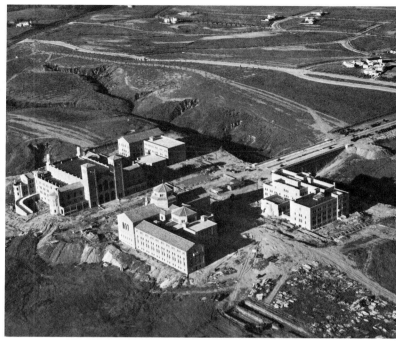

The face of the campus at Westwood has changed radically in thirty-eight years. The 1967 aerial photograph (left) shows the amazing progress that has come about since 1929 (above). In 1929, the Daily Bruin commented editorially: "Rampant now on the campus is the steam shovel competition. Professors raise their voices; they shout; and then they give up in despair. But the steam shovel goes on, puffed up over its own importance. . . ." Today construction activity is beginning to slow down. By 1970, the building program is expected to be virtually completed. Seen from the air, UCLA forms a butterfly-like pattern on the gently rolling slopes at the feet of the Santa Monica Mountains. At the tip of the left wing (left center) are four large residence halls; in the center is the Pauley Pavilion. Below the Pavilion is one of the large parking structures, and lower yet, one of the surface parking lots that dot the campus. The street below the large parking lot is LeConte Avenue, which separates the campus from Westwood Village. On the upper part of the right wing are the concentrated buildings of the central campus, dominated at the upper tip by the high-rise Dickson Art Center and the Social Sciences Building. On the lower part, just above LeConte Avenue, is the interlocking complex of the Center for the Health Sciences, the largest building in Los Angeles County. Above the campus is the residential district of Bel-Air. The San Fernando Valley may be dimly glimpsed over the tops of the mountains.

*In 1892, this unused Congregational church building at Santa Barbara and Ortega
Streets became the second home of the Anna S. C. Blake Manual Training School, first
antecedent of the University of California at Santa Barbara.*

Santa Barbara

The Santa Barbara College of the University of California opened for instruction July 1, 1944, more than half a century after its inception in 1891 as a manual-training school for girls. That first school, established by Anna S. C. Blake, was merged into the city school system in 1899 as a specialized school of manual arts and home economics. In 1909, with the addition of teacher-training courses, the institution became a state normal school. During the next twenty-five years, it passed through various expansions and changes of title, emerging in 1935 as the Santa Barbara State College, which was incorporated into the University by legislative action in 1943.

When acquired by the University, the college occupied two campuses, both within the city of Santa Barbara. In 1954, the college acquired a new campus of 414 acres on the coast near Goleta, ten miles to the west. The new campus provided a private beach, a gentle climate, and spectacular views of both the Santa Ynez Mountains and the ocean. By the end of 1967 the campus had gained another 436 acres, from the Storke Ranch and the Devereux School.

The initial master plan for Santa Barbara College was to develop it as a liberal arts college of high quality, with a maximum enrollment of 2,500. In 1958, the Regents revised the academic plan, increasing the capacity to 10,000; renamed the institution the University of California, Santa Barbara; and directed that it be developed as a general campus of the University. In 1960 the planned maximum was increased once more, this time to 15,000. In February 1967, yet another revision in the academic plan provided for a new enrollment ceiling of 25,000, to be reached in the mid-1980's.

The major academic components of UCSB are the College of Letters and Science, established in 1961, the College of Engineering, the Graduate School of Education, and the Graduate Division, all established in 1962, and the College of Creative Studies, opened in the fall of 1967. The long-range academic plan adopted in 1967 provides for five additional professional schools and a new academic college.

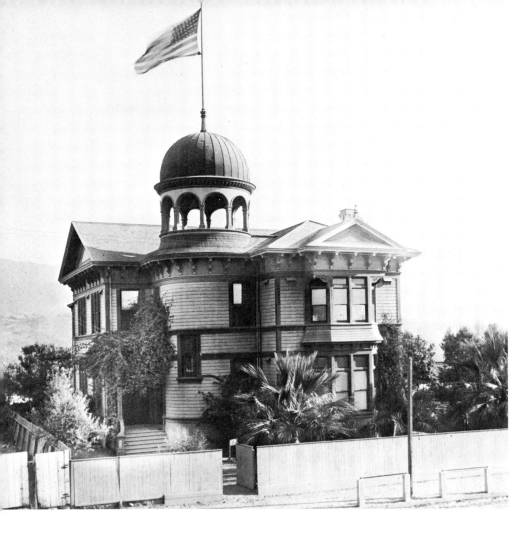

In 1893, the Blake School moved into a new building on Santa Barbara Street near De la Guerra Street.

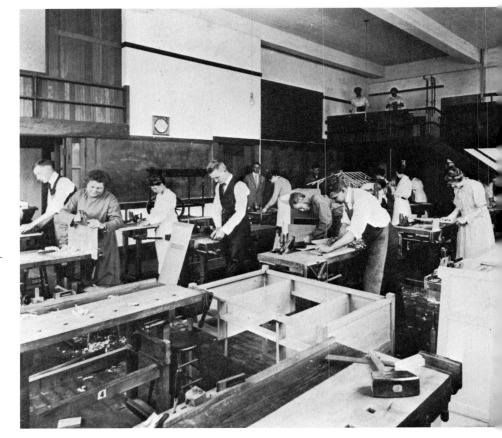

Local histories record that Santa Barbara was the first community on the Pacific Coast to include in its school curriculum the subjects of cooking, sewing, and sloyd— a system of manual training developed in Sweden. Held after regular school hours in the Blake School building, the classes were approved by the Santa Barbara school board but were entirely supported by Miss Blake until her death in 1899. She deeded the school building to the city shortly before her death, and citizens of Santa Barbara voted a special tax to support the school.

Under the leadership of Miss Ednah A. Rich, who served as principal and then president from 1892 to 1916, the school evolved into a city normal school and then, in 1909, into a state-supported institution called the Santa Barbara State Manual Training School—the only state institution in the country devoted exclusively to teacher training in manual arts and home economics. From 1909 to 1913 the school occupied this building at Victoria and Chapala Streets in downtown Santa Barbara. The building later served as offices for the Santa Barbara school board until it was razed in 1967.

In 1913 the school was relocated in downtown Santa Barbara near the old mission, on a fourteen-acre site that came to be known as the Riviera campus. The Santa Barbara and Suburban Railway completed an extension from the mission to the campus that year, and Miss Rich drove a final golden spike.

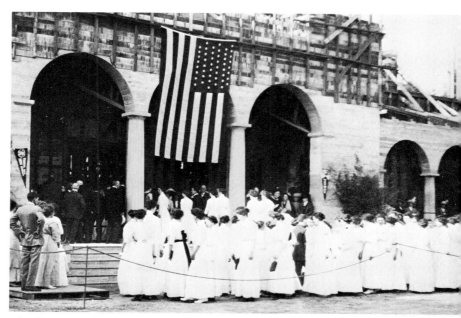

The first commencement on the Riviera campus was held in May 1913, in front of the unfinished quad building. Although the school had become coeducational by this time, women still were clearly in the majority.

Frank Ball, Miss Rich's successor, served from 1916 to 1918, when he was succeeded by Clarence L. Phelps. Under President Phelps' direction the school became the Santa Barbara State Normal School in 1919, the Santa Barbara State Teachers College in 1921, and in 1935, after an increase in the liberal arts curriculum and the development of academic majors leading to the bachelor of arts degree, the Santa Barbara State College.

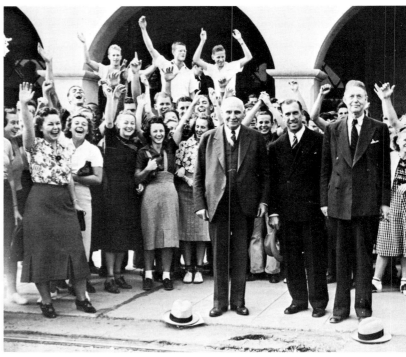

A rally at the Southern Pacific Depot in 1936 provided a send-off for the football team upon their departure for Denver. The three posed in front are, from the left, Governor Frank F. Merriam, Coach Theodore Harder, and President Phelps. The center student of the three standing high in the background is Eugene Burdick, later to become a prominent author and professor of political science on the Berkeley campus.

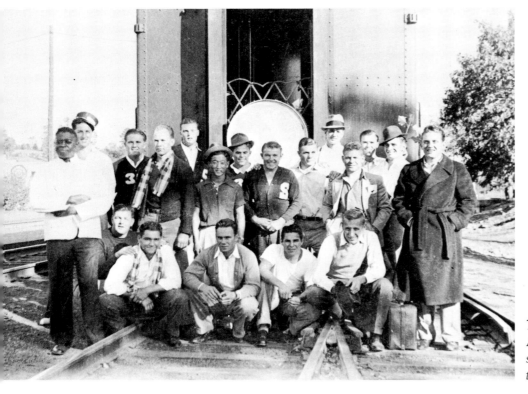

The 1936 football team en route to Flagstaff, Arizona. The Gauchos that year ended the season with a 9–1 win-loss record, the best in the school's history.

EL GAUCHO

STUDENTS CHANGE SCHOOL EMBLEM

Registrar's Total Show Big Increase Over Previous Year

Payment of Fees Deferred Under New Method Designed to Eliminate Confusion of Changes

Many Books Are Purchased by Miss K. Ball

'34 Grads Get Jobs Teaching

S. B. PRESIDENT

College Registrar Places Students in Schools

Many Employed Here

Report Compiled by Miss Menken, Secretary

BAND PLAYS FOR FIRST FOOTBALL GAME OF SEASON

COLLEGE HEAD

College Votes on New Name; Selects El Gaucho Symbol

Yell and Song Leaders Elected at Meet in College Auditorium; Lambourne Conducts First Assembly

766 Students Given Health Examination

YEARBOOK EDITOR LETS CONTRACT FOR LA CUMBRE

Except for a brief period in 1962 when it appeared as the University Post, the school newspaper has always been named for the school symbol. From 1921 to 1930 it was The Eagle; from 1930 to 1934 The Roadrunner (above), and from 1934 to the present—because of the community's Spanish heritage—El Gaucho.

This group of administrative and faculty representatives gathered in 1944 for the transfer ceremonies. In the back row are Assemblyman Robertson; Ednah Rich Morse, first president of the normal school; Provost Clarence L. Phelps; UC President Sproul; and Vice-Presidents Monroe Deutsch and James H. Corley. In the front row, fourth from left, is Jane Miller Abraham, who began work with the school in 1911 as Miss Rich's secretary and served until 1946 in various capacities, mostly as registrar and later alumni secretary. Next to her is Helen Sweet Keener, for many years Dean of Women.

As early as 1935, publisher Thomas M. Storke and other leading citizens had advocated a University campus at Santa Barbara, maintaining that the cultural background of the city provided an asset that few communities in the West could match. Major credit for the long but ultimately successful battle is given to Storke; to Pearl Chase, a Santa Barbara civic leader; and to two Santa Barbara legislators, Assemblyman A. W. "Bobbie" Robertson and Senator Clarence Ward. In 1943, after several previous bills had failed, Assemblyman Robertson succeeded in getting legislation adopted authorizing the transfer of the Santa Barbara State College to the University. Governor Warren signed the measure on June 8, 1943, and on July 1, 1944, the transfer was officially made.

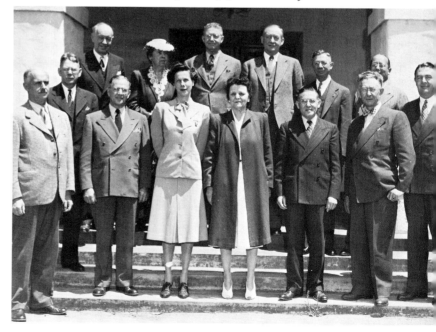

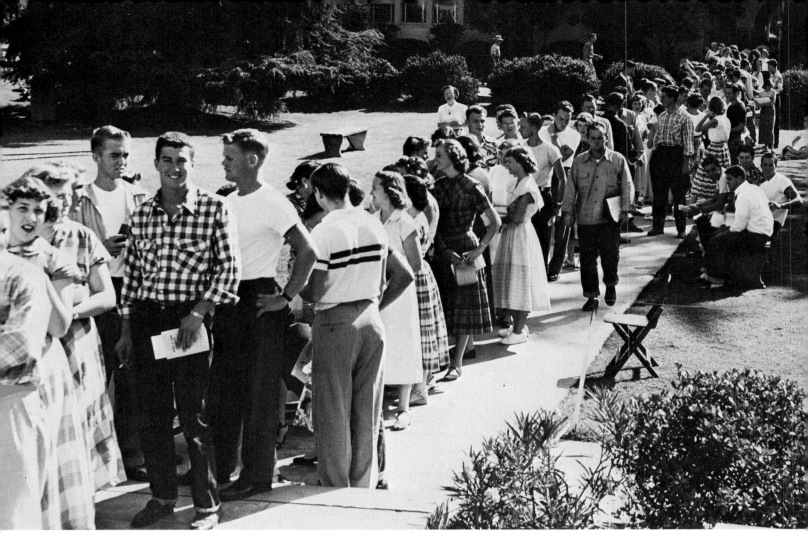

Fall-semester enrollment during the first year of University operation was 1,464; by 1947 it had nearly doubled. And the registration lines grew with the enrollment.

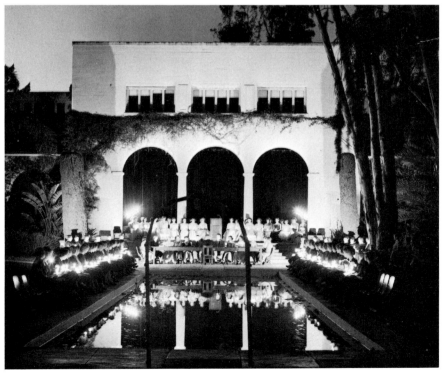

The Quad, with its reflecting pool mirroring the colonnades and graceful eucalyptus trees, was a center of student life during the forty-year history of the Riviera campus. A traditional event on the Quad for many years (shown here in 1953) was the Candlelight Recessional, sponsored by Crown and Scepter, a Senior-women's organization.

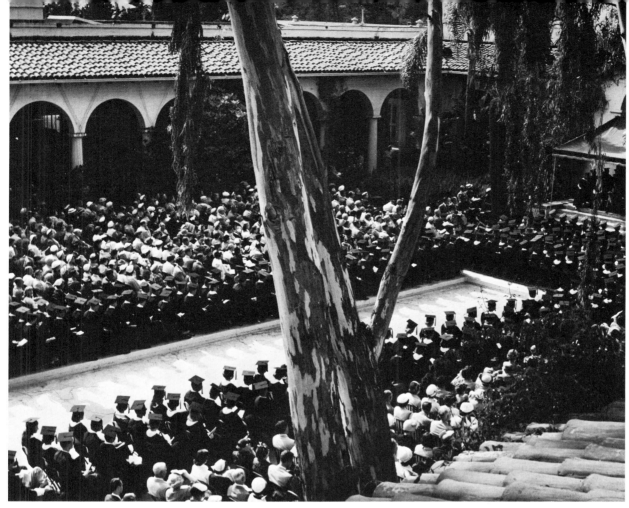

The Quad—also known as the College Court—was the scene of many commencement ceremonies on the Riviera campus. The last was held in 1954.

"To the Quad Pool" became a familiar punishment handed down by a traditional tribunal to erring Freshmen students.

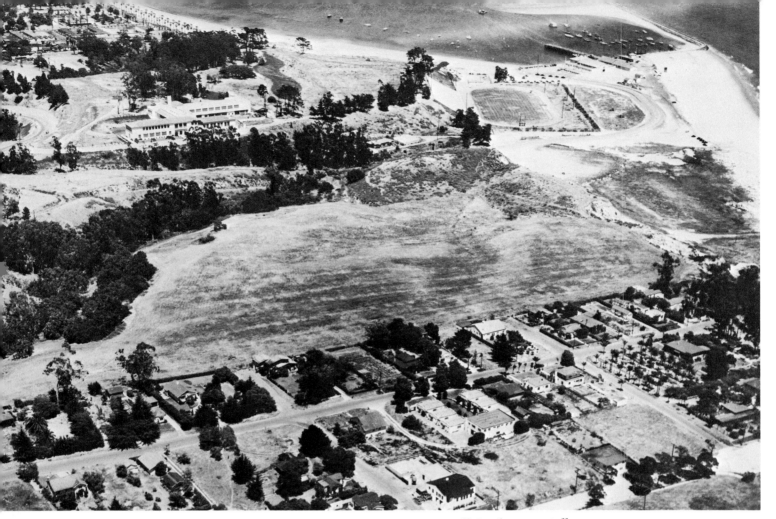

By 1941 it was apparent that the Riviera campus was becoming too small for the State College and its steadily increasing enrollment. In that year the eighty-eight-acre Mesa campus, known locally as Leadbetter Hill, was acquired and an option taken on adjoining land to the west; however, plans for developing the area as a campus were frustrated by World War II. Only one building, occupied by the Industrial Arts Department, was actually completed.

The two existing campuses—Riviera and the crosstown Mesa site—were inadequate, without additional land, to accommodate the inevitable postwar expansion. To develop the Mesa campus, as originally planned, would have required condemnation of expensive adjoining lands, and the future, as T. M. Storke relates it, "was not encouraging."

To use his words, "once again Santa Barbara's 'guardian angel' came to our aid." A Marine Corps air station at Goleta, some ten miles west of Santa Barbara, was declared war surplus, and the proposal was advanced to utilize this site.

In February 1948, an advisory committee composed of Russell Buchanan, professor of history; Theodore Harder, chairman of the physical education department; and Duane Muncy, campus business manager, recommended the Goleta site to President Sproul. This representative faculty group then visited the site at Sproul's request and confirmed the recommendation.

In October 1948, for the sum of ten dollars, the War Assets Administration handed over the keys to this 414-acre tract, located on a seacoast mesa with approximately a mile of shoreline.

Pictured on the Riviera campus shortly before the move to Goleta are three men who served at various times as chief campus officer; J. Harold Williams, provost from 1946 to 1955; John C. Snidecor, acting provost in 1956; and Elmer R. Noble, acting provost from 1956 to 1959.

Ground-breaking for the University Library took place in 1952; participating in the ceremony were Assemblyman Stanley Tomlinson, Regents Victor R. Hansen and Edward A. Dickson, President Sproul, and Provost J. Harold Williams. The library was one of two permanent buildings completed when the Goleta campus opened in September 1954; the other was the physical-sciences building.

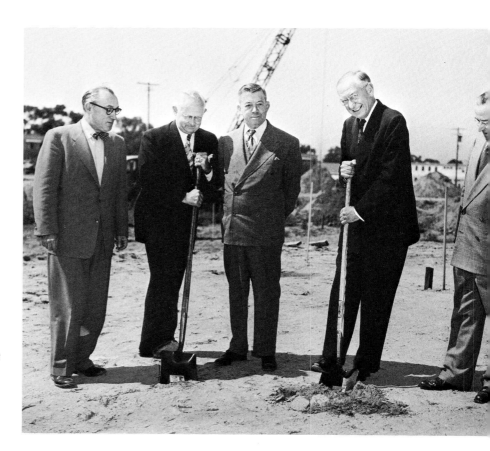

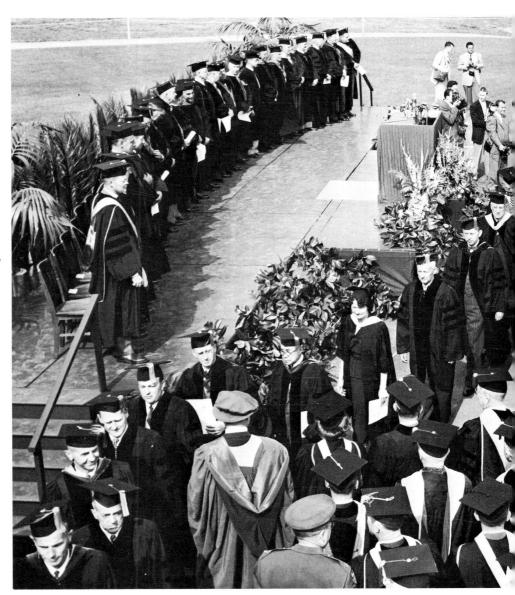

The dedication of the new campus and installation of Clark G. Kuebler as provost was held in March 1955. Delegates from many colleges and universities throughout the country participated in the colorful academic procession.

Samuel R. Gould, one of the most articulate leaders in American higher education, was inaugurated as Santa Barbara's first chancellor in September 1959. He served until 1962.

Frosh Camp, a two-day event held in the fall before registration begins, affords new students an opportunity to become acquainted with classmates—and with UCSB traditions. Lectures, discussions, picnics, talent shows, and beach games are among the two days' activities.

The Frosh-Soph mud brawl was a registration-week tradition in the 1950's. Here the girls battle in the mud brawl of 1958.

The annual Greek Week, in the spring, includes activities ranging from essay contests to paddleboard relays to cleaning up the city's parks. In 1955 the city's baseball grandstand received a new coat of paint.

A feature of Homecoming Week, which is held each year in late October or early November, is the float parade. Living groups create elaborate and colorful entries for the parade down Santa Barbara's State Street, and the UCSB marching band and other community bands and marching units participate. Part of the 1961 parade is shown.

Spring Sing began in 1949 as the Greek Sing and was soon expanded to include all living groups. These are the 1957 women's division winners on the steps of the county courthouse's sunken garden.

Coach Rick Rowland, Assistant Coach Bob Gray, and the 1967 Gaucho swimming champions, with UCSB's first National Collegiate Athletic Association college-division trophy.

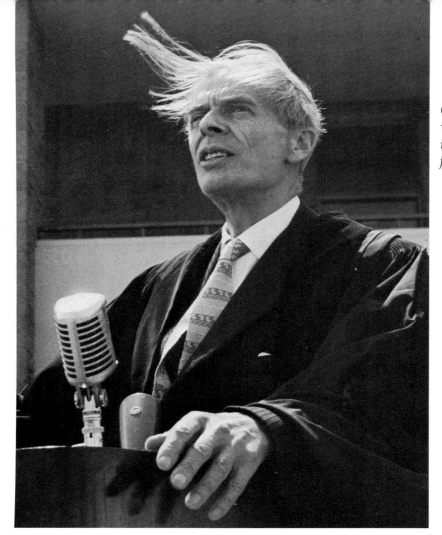

On a windy Charter Day in 1959, Aldous Huxley, visiting professor-at-large, spoke at ceremonies in Storke Plaza and received Santa Barbara's first honorary degree.

Charter Day ceremonies in 1960 honored Thomas M. Storke with a doctor of laws degree that cited him as a "California editor, publisher, and author, energetic in the service of his city, his state, and his nation." From the left are President Kerr, Storke, and Regent McLaughlin.

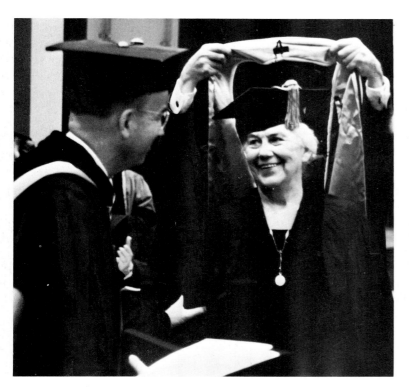

At the inauguration of Chancellor Gould, in 1959, an honorary doctor of humane letters degree was awarded to Miss Pearl Chase for leadership in social and civic volunteer work.

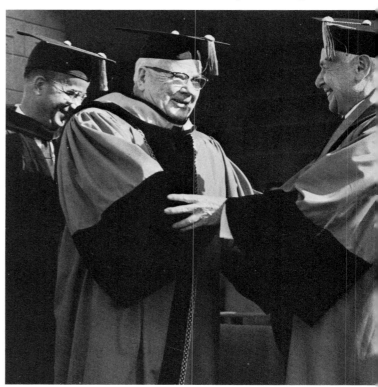

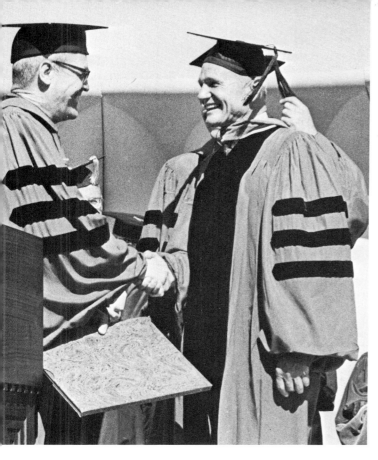

At Charter Day ceremonies in 1967, Chancellor Vernon I. Cheadle presented Francis Minturn Sedgwick with an honorary doctor of fine arts degree. The citation commended his "exceptional skill in portraiture," his distinction as a sculptor and writer, and his "support and encouragement to the development of the arts."

When the University moved to the Goleta campus in 1954, Marine Corps bachelor officers' quarters, given the name "Las Casitas," provided the only on-campus housing. The first permanent University residence hall, Santa Rosa, was completed in 1955. By 1965 there were five University residence halls, accommodating over two thousand men and women, and by 1967 construction was under way on San Rafael Hall, the sixth.

The first dining commons was a wooden frame building that had served as an officers' mess. It had a seating capacity of 346 and only one serving line. In January 1959 the Ortega dining commons was opened, followed by De la Guerra in 1961; the two facilities provided seating for more than twelve hundred.

The first three residence halls to be constructed on campus were Santa Rosa, in the foreground, Anacapa, at the far left; and Santa Cruz, to the right, behind De la Guerra Commons.

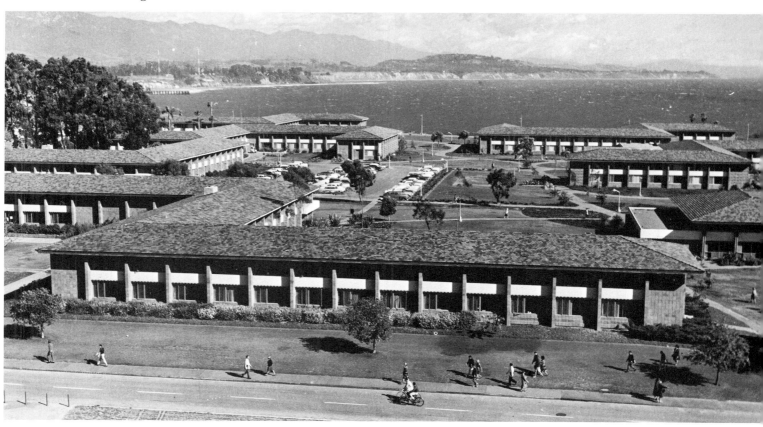

Chancellor Cheadle arrived at Santa Barbara just as the campus was beginning an unprecedented growth. The 1961 enrollment of four thousand had tripled by the fall of 1967. Graduate study, which was authorized in 1953, has also grown rapidly. The first master's degree was awarded in 1955; the first two doctorates in 1963. By 1967 the number had risen to 248 master's degrees and 24 doctorates.

Vernon I. Cheadle became chancellor in 1962. He came to Santa Barbara from the Davis campus, where he had served ten years as professor of botany and one year as acting vice-chancellor. Pictured with Chancellor Cheadle at his inauguration ceremonies are Lieutenant Governor Glenn M. Anderson, President Kerr, and Regent Edwin W. Pauley.

The 1964 commencement was the last of many held in Storke Plaza. As more room was needed, the ceremonies were moved first to the library mall, then to the athletic field, and finally, in 1967, to the new stadium.

The Santa Barbara campus serves as headquarters for the University's Education Abroad Program, which has centers at fifteen foreign universities on three continents and permits Juniors and Seniors to spend a full academic year studying in a host country. The pioneer center in the program was opened at the University of Bordeaux, France, in 1962. President Kerr, Bordeaux Rector Jean Babin, and Chancellor Cheadle are shown at ceremonies opening the Bordeaux center.

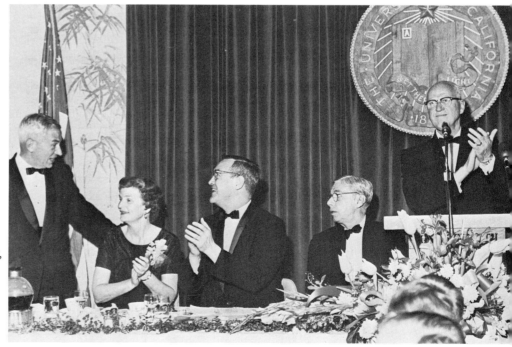

"Excellence in Education" was the subject of a major symposium held in conjunction with Charter Week of 1963; it was one of a series of campus conferences discussing various aspects of "California and the Challenge of Growth." President Lee Dubridge of the California Institute of Technology and James B. Conant, former president of Harvard University, were the principal speakers. Here at a concluding dinner session are President Dubridge, Mrs. Kerr, Chancellor Cheadle, President Conant, and Rueben Irvin, chairman of University Affiliates, sponsor of the dinner.

In October 1966, a capacity crowd of twelve thousand witnessed the first football game in the new athletic stadium. Since 1938, the Gaucho teams had been using La Playa Stadium in Santa Barbara.

 The Schubertians, a group of specially trained singers drawn from the Men's Glee Club, perform regularly at Santa Barbara and on tour, specializing in music for small male chorus and in the works of Franz Schubert.

The campus beach is convenient and attractive for sunbathing, nature walks, and picnics, such as this 1963 beach barbecue sponsored by the Associated Students.

Since 1960, the Residence Halls Association has sponsored annual pushcart races. Various student living groups compete, with men pushing and women steering. The carts, constructed by the men, are decorated for a parade preceding the race and then stripped of decorations for the competition.

At this Chumashan burial grounds, archaeology students excavated remains and artifacts of a southern California hunting people who lived about four thousand years ago.

The Department of Religious Studies, created in 1964, had as its first visiting professor the distinguished theologian Paul Tillich.

Whale watching—a sometime faculty pastime on the promontory overlooking the Pacific Ocean. In late March, during their northbound migration, as many as twenty-one California grey whales have been sighted within an hour.

When the Santa Barbara Normal School moved to the Riviera campus in 1913, its library possessed less than 3,500 volumes. Manual-arts, home-economics, and teacher-training materials predominated, reflecting the normal school's curriculum. When the state college became a campus of the University in 1944, the library held some 40,000 books and pamphlets. Not until the move to Goleta in 1954 did the library have its own building. Library space was doubled in 1962, then again in 1967 when this eight-story addition was completed. Holdings in the fall of 1967 totaled over 450,000.

Jay Monaghan, a noted Lincoln scholar and author, has served as a consultant on the William Wyles Collection of Lincolniana and Western Americana since 1953. Beside him is a replica of a bust of Lincoln by the sculptor Leonard Volk. One of the country's leading collections on Lincoln, the Civil War, and the period of westward expansion, the Wyles Collection was donated in 1928, together with a trust fund, by the Santa Barbara businessman William Wyles. Through steady growth it now numbers eighteen thousand volumes as well as many manuscripts. An extensive collection of Confederate Civil War photographs, manuscripts, letters, books, prints, and official rosters and documents was added in 1965.

"The Miracles of St. Nicholas of Tolentino," attributed to a fifteenth-century Italian artist, is one of twenty rare oil paintings by masters of the fifteenth, sixteenth, and seventeenth centuries. The collection was the gift, in 1960, of Francis Minturn Sedgwick, a Santa Ynez Valley rancher and sculptor.

The Morgenroth Collection of Renaissance Medals and Plaquettes, purchased in 1963, is one of the world's three major collections of its kind. It consists of over four hundred rare medals and plaquettes commemorating important events and personalities of the fifteenth to the eighteenth century. Among the medals is this fifteenth-century bronze portrait of Issotta Degli Atti of Rimini, wife of Sigismondo Malatesta, Lord of Rimini. On the reverse side is an elephant, symbol of the Malatesta family.

The first research institute at Santa Barbara—the Institute of Environmental Stress—was established in 1965. Dr. Manubu Yoshimura, a Japanese physician, is engaged in research at the Institute on the effects of a warm climate on the heart.

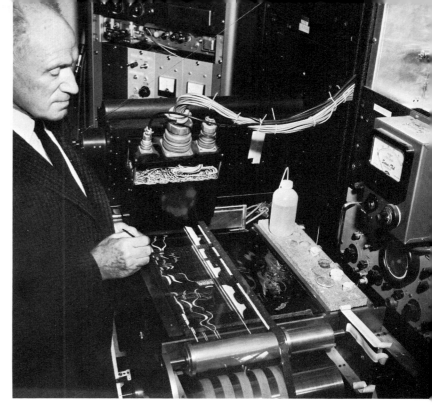

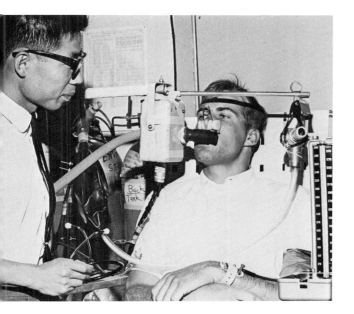

Santa Barbara has pioneered in speech-synthesis research and the development of speech simulators—work designed to aid in language teaching and speech correction. Here Pierre Delattre, professor of French and director of the UCSB Speech Synthesis Project, paints a speech pattern on a cellophane loop to isolate and thereby vary at will one of the acoustic cues by which speech is identified.

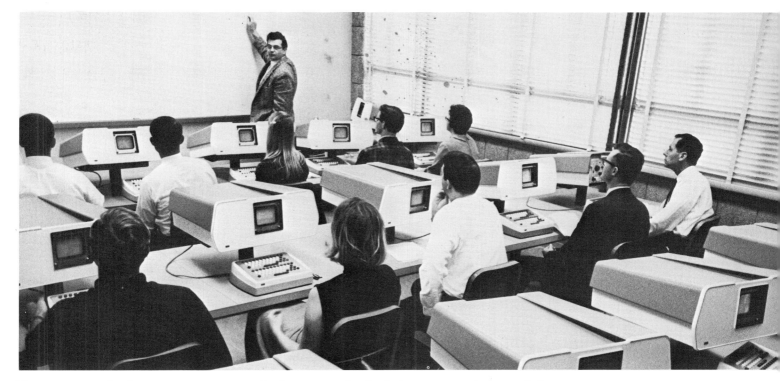

The most recent developments in computer technology are used in both the Computer Center and the new Electrical Engineering Building. Here Glen J. Culler, director of the Center, explains a computing system that enables the operator to "talk" directly with the digital computer, observe the results immediately on a display tube, and, if necessary, modify his program.

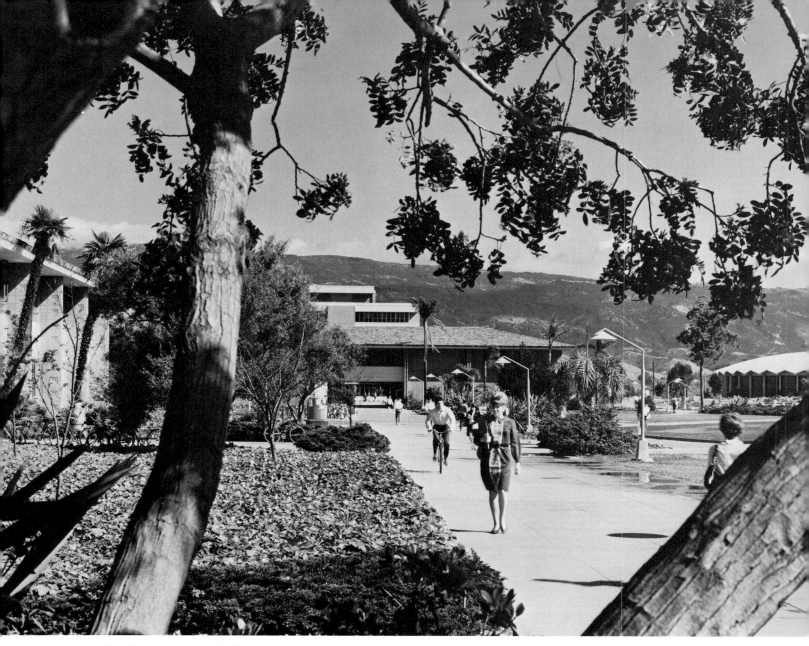

Broad walkways are typical of the Santa Barbara campus. The Santa Ynez Mountains form a backdrop here for North Hall, the Administration Building, and Campbell Hall.

The new five-story chemistry building had to be enlarged before it was finished, symbolizing the rapid growth in recent years of the Santa Barbara campus. Standing in front of the building is Bernard R. Baker, professor of chemistry and an authority on the synthesis of natural products.

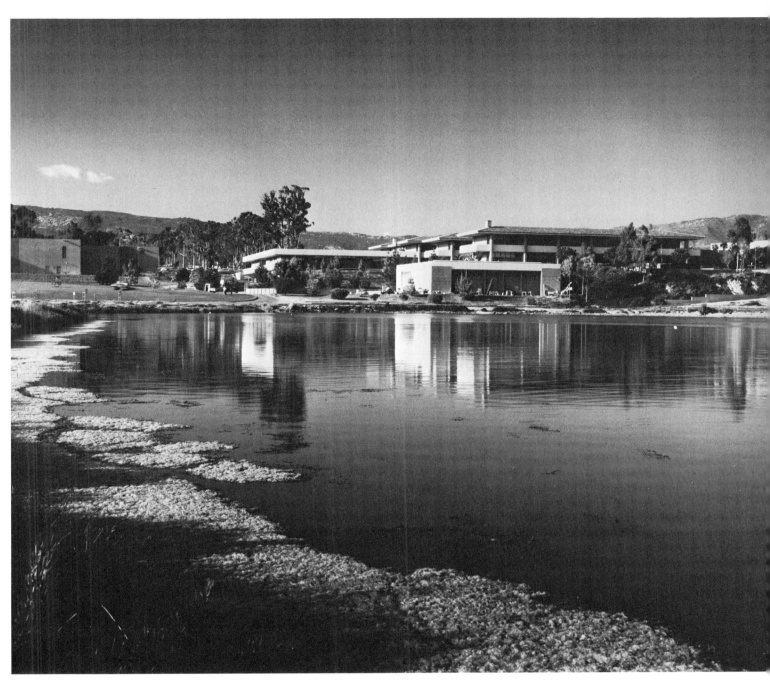

The Arts Building is reflected in the campus lagoon, with part of the Speech and Dramatic Arts Building to the left.

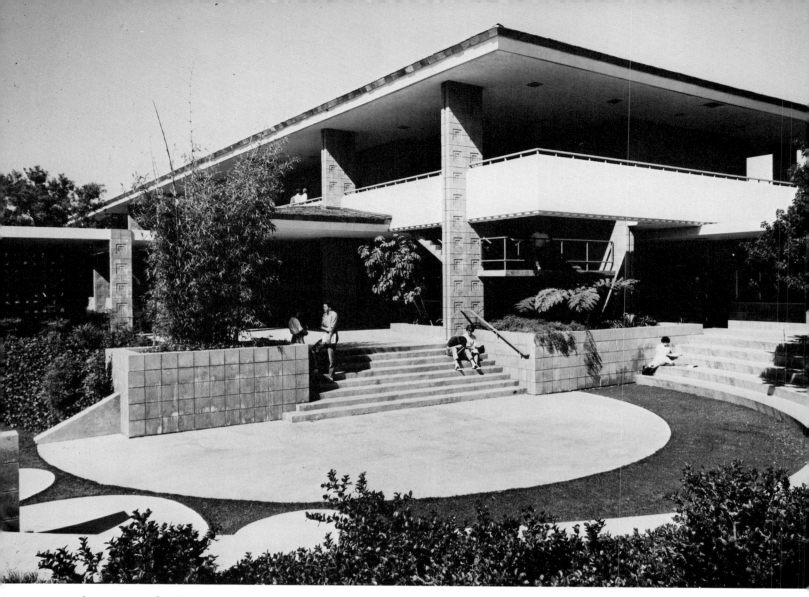

The Music Bowl, adjacent to the Music Building, is the scene of many concerts and recitals.

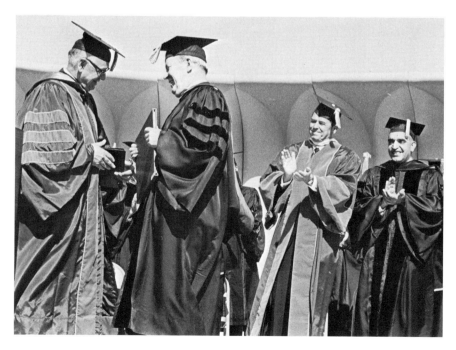

Charter Day ceremonies in 1967 brought to the Santa Barbara campus prime ministers from opposite sides of the globe. The Honorable Lester Bowles Pearson, prime minister of Canada, received an honorary degree from Acting President Harry R. Wellman. On the right are Governor Ronald Reagan and the Honorable Muhammad Hashem Maiwandwal, Afghanistan prime minister, who also received an honorary degree.

As Faculty Club charter members looked on from the Speech and Dramatic Arts Building, Chancellor Cheadle broke ground for the new Faculty Club in May 1967. With him is Dr. Steven Horvath, director of the Institute of Environmental Stress and first president of the club.

The University Center, which opened in 1966, supplies services and programs touching almost every phase of the students' extracurricular life. For the first time there are permanent facilities for the Associated Students' activities, including a coffee shop, a bookstore, offices, meeting rooms, and recreation facilities.

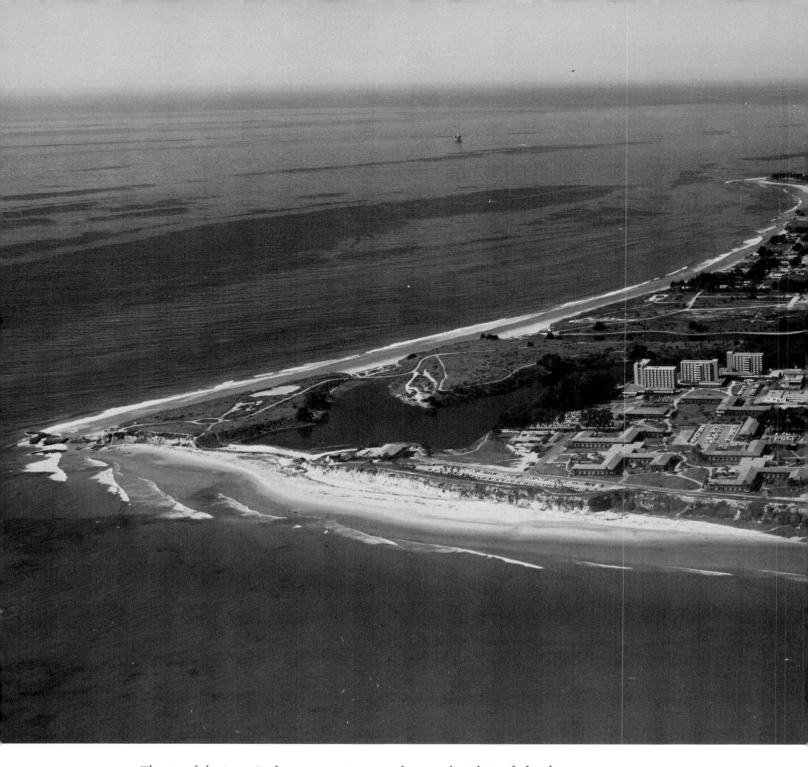

The site of the Santa Barbara campus is spectacular, awash with Pacific breakers on two sides. Goleta Point juts into the sea on the left, sheltering the Campus Lagoon. The Santa Ynez Mountains stretch along the coast at the top. Facilities on the Goleta campus have been rapidly expanded as the campus has advanced toward its objective: a rich undergraduate liberal arts program in a residential setting, together with first-rate graduate and professional training. Soaring enrollment has made some multistoried structures inevitable, as this February 1967 photograph shows; the major ones, from the left, are the San Nicolas and San Miguel residence halls, the University Library (center of campus), Electrical Engineering (foreground), Chemistry, East Hall, and (behind East Hall) the Administration Building. The round building between East Hall and Administration is Campbell Hall. Ward Memorial Boulevard enters the campus from the lower right.

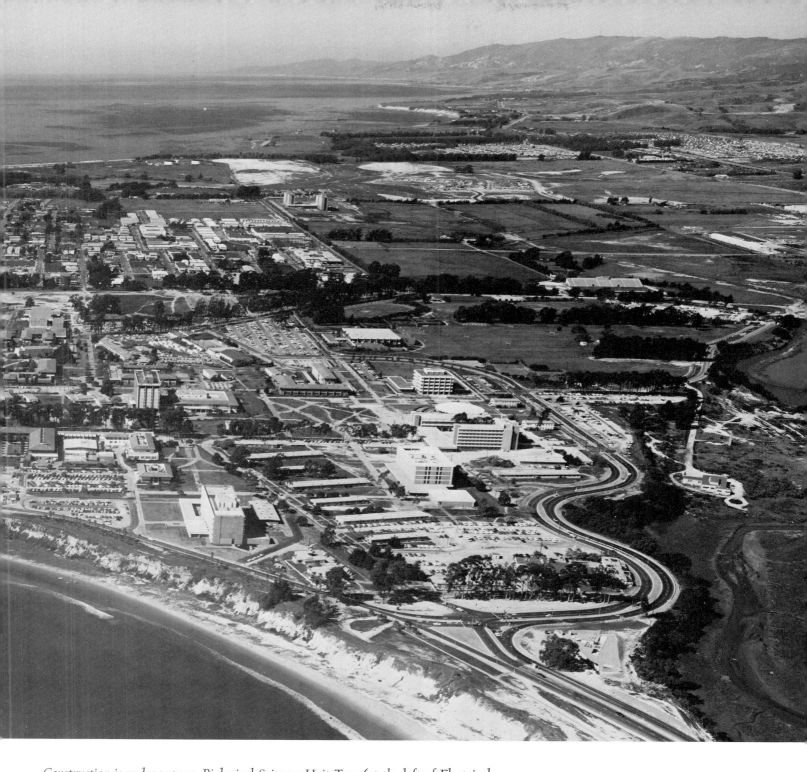

Construction is under way on Biological Sciences Unit Two (at the left of Electrical Engineering). Soon after this photograph was taken, ground was broken for three other academic buildings—Physics, Classroom and Office Number Four, and Music Unit Two. The Faculty Club and the San Rafael residence hall are also being built. But despite all this construction, forty-two of the ninety-nine original Marine Corps buildings were still in use in 1967. The built-up area beyond the campus is Isla Vista, where many of the students live, often in privately owned and operated residence halls. One such hall is the double ten-story structure in the distance, north of Isla Vista. Except for a few small houses, Isla Vista was entirely vacant when the University moved to the Goleta campus in 1954. Beyond Isla Vista is the Devereux School, from which the campus acquired over two hundred acres in 1967.

The eighty-eight-thousand-acre Irvine Ranch stretches from the Santa Ana Mountains to the Pacific Ocean. Devoted originally to sheep and cattle grazing, the ranch evolved, under its founder, James Irvine, and his successors, to field-crop farming and citrus production.

Irvine

Early in the 1950's, the Regents concluded from University-wide enrollment projections that by 1970 the University should have in operation three new campuses—one of them in the eastern Los Angeles–Orange County area. Twenty-three locations were considered before the tentative selection, in March 1959, of the Irvine Ranch. Located a few miles inland from Newport Beach, on gently rolling land overlooking the Santa Ana Basin, the site seemed amply to fulfill the criteria of "nobility" and "sense of place," which were among those set for the new campus. And because the 88,000 acres of almost undeveloped land that surrounded the prospective campus were under the control of a single owner, the site offered great potential for the development of a carefully planned and integrated campus and community. (The 44,000-acre coastal region of the Irvine Ranch is now being developed by the Irvine Company, its present owner, as a vast complex of homes, schools, industries, shopping centers, hotels, parks, cultural centers, and recreation areas.) In July 1960 the Irvine Company offered 1000 acres as a gift, and the deed was recorded on January 29, 1961. In January 1964 the Regents purchased an additional 510 acres adjacent to the original site.

Daniel G. Aldrich, Jr., Irvine's first chancellor, anticipates that the campus will meet the needs of a new era with an emphasis on public service, in the spirit of the land-grant colleges. Chancellor Aldrich, a soil scientist with the University for twenty years, was University dean of agriculture at the time of his appointment.

The Irvine campus is expected to grow rapidly, both in size and in the extent of its academic programs, with its enrollment reaching 27,500 by 1990. In addition to the College of Arts, Letters, and Sciences, the School of Engineering, and the Graduate School of Administration, the California College of Medicine, a Los Angeles institution, became affiliated with the University there in 1965.

The chain of title of the Irvine land deeded to the University.

Chancellor Aldrich, William L. Pereira, master planner of the campus, and Charles S. Thomas, president of the Irvine Company, are shown with the long-range campus development plan—approved by the Regents in June 1963. It features a large central park, with plazas for each academic discipline radiating from an inner circle of buildings. An administrative plaza will link the campus to the adjacent town center, to be developed on the Irvine Company's property.

Dedication ceremonies were held June 20, 1964, in conjunction with the first meeting of the Regents on the Irvine campus. President Lyndon B. Johnson was the principal speaker; Governor Edmund G. Brown and President Clark Kerr also spoke. Chancellor Aldrich is shown welcoming the large crowd that assembled at Gateway Plaza for the occasion.

"California is not just talking about education—you are doing something about it," President Johnson told the crowd of fifteen thousand.

Students decorated the campus Library-Administration Building in honor of Chancellor Aldrich's inauguration. Inaugural ceremonies were held in Campus Hall May 20, 1966, with delegates from major colleges throughout the nation participating. Francis Keppel, assistant secretary for education of the U. S. Department of Health, Education, and Welfare, delivered the major address and received Irvine's first honorary degree

Members of the charter class seemed spontaneously to adopt the yell "ZOT" each time the highly successful water-polo team made a goal. The yell was attributed to the anteater in the popular newspaper cartoon strip "B.C.," whose tongue made such a sound when it hit an ant. In an election held on November 30, 1965, the anteater forces won out, making their candidate (more properly known as the ant bear) Irvine's official mascot.

The first day of classes—October 4, 1965. The Fine Arts Building is on the left; Humanities–Social Sciences is on the right. Enrollment on that first day totaled 1,589—a little more than half the fall 1967 enrollment of 2,835.

The class of '66, first to earn degrees at UCI, numbered fourteen. At a commencement dinner June 25 in the Commons, Professor Bernard R. Gelbaum of UCI (extreme left) told the graduates: "In your memorable year at Irvine you have been one of a group of adventurers brave enough to forego the comfortable paths to success, daring enough to gamble with a set of untried ideas, and eager enough to cause a quiet revolution in University outlook. You were endowed with great resources, excellent counsel, a desire to succeed, and the crucial ingredient of courage." Members of the class here gather at Gateway Plaza, where two years earlier the dedication ceremonies had been held.

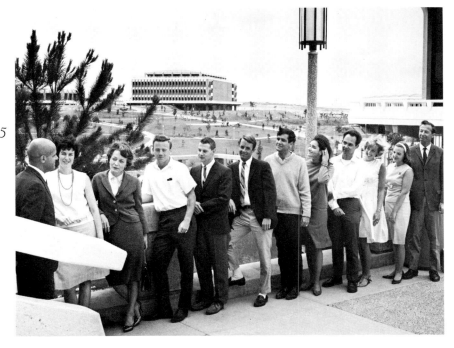

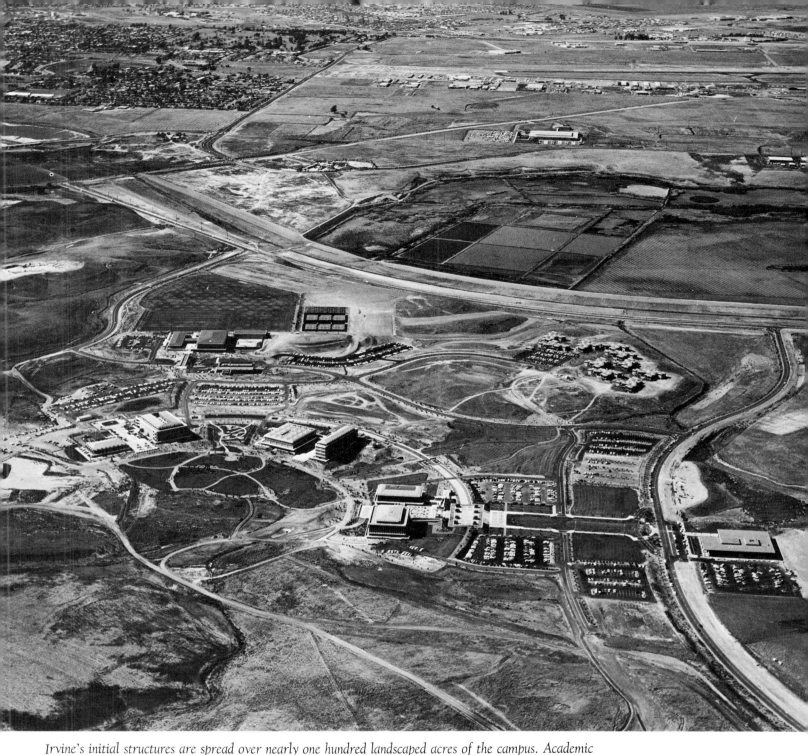

Irvine's initial structures are spread over nearly one hundred landscaped acres of the campus. Academic
buildings partly ring the central park; from the left, they are the Science Lecture Hall, the Natural
Science Building, the Fine Arts Building, the Humanities–Social Sciences Building, the Commons, and
the Library-Administration Building. Above, left center, are the playing fields and Campus Hall
(including a gymnasium-auditorium and an outdoor pool). Right of center are the Mesa Court residences,
accommodating eight hundred students. Gateway Plaza faces northeast toward the future town
center, across Campus Drive at the far right. At the left of the Science Lecture Hall, construction is
underway on a nine-million-dollar Physical Science Building, scheduled for completion in 1969. The
School of Engineering and the Social Science Building will complete the ring. Also in the planning stage
are the Fine Arts Village (to be located near Mesa Court), an addition to the library, and a Student
Health Center. Upper Newport Beach and the Orange County Airport are in the background.

Henry Cowell migrated from Massachusetts to California around 1849, to become one of the state's land barons and a leading supplier of building materials. Among his landholdings was a ten-thousand-acre ranch in Santa Cruz County. It served as the family's home for a number of years and as the original headquarters of his lime and cement business; lime from the Cowell Ranch was widely used in the rebuilding of San Francisco following the earthquake and fire of 1906.

Santa Cruz

In 1957 the Regents announced plans to develop a general campus of the University in the South Central Coast area. During the four-year search that ensued, a list of more than seventy proposed locations was narrowed to fifteen, then to two, and finally, in March 1961, to one: the Cowell Ranch. Situated in the meadow-to-forest transition zone of the Santa Cruz mountains, it overlooks Monterey Bay and the city of Santa Cruz, two miles to the south. The following July, Dean E. McHenry, UCLA political scientist and University-wide dean of academic planning, was named chancellor. The two-thousand-acre site was purchased from the S. H. Cowell Foundation for approximately $2,000,000, and the Foundation later contributed $925,000 toward construction of the first college, Cowell.

In its development, Santa Cruz has departed from the usual American campus design. Plans are to construct a series of twenty to twenty-five semiautonomous residential colleges, each enrolling four hundred to eight hundred undergraduates. Each will have a distinctive academic orientation and be headed by a provost who will live in the college. At the core of the campus will be the main library, the science laboratories, and other large, specialized instructional facilities, as well as the central administrative units. The Santa Cruz concept of a "collegiate" university is largely the work of Chancellor McHenry, who has sought to synthesize the best of a small college and the best of a large university, all within the framework and strength of a great state university system.

When it opened in 1965, the University of California, Santa Cruz consisted of a single liberal arts coeducational college. In the early years, emphasis will be on developing the undergraduate colleges. Graduate work began in 1966, and doctoral degrees were offered in five fields during the 1967–68 academic year. By 1995 the campus is scheduled to have at least twenty-five thousand students, adding one college almost every year.

Chancellor McHenry made his first official public appearance in October 1961, when he posed for newspaper photographers on the new campus and then addressed the local Rotary Club. While awaiting campus buildings, he actually had offices at nearby Cabrillo College.

Rosettes of leased trailers—dubbed "Mobile Home Estates" by the students—housed Cowell and Stevenson College students during the first year. Field House, on the left, served as a dining hall, assembly room, and recreation facility. Shown under construction at the top of this 1965 photograph are Cowell College on the left, Stevenson College on the right.

Each of the UCSC colleges will be a liberal arts college, but each will approach the liberal arts from a different perspective. The first college, Cowell, which began instruction in 1965 with 654 students, has a humanistic perspective. Adlai E. Stevenson College, which opened in the fall of 1966 with 700 students, has a special concern for the social sciences. Crown College (named after the Crown Zellerbach Foundation), which began in the fall of 1967 with 525 students, emphasizes the natural sciences. College Four will open in 1968 and stress international and comparative studies, including languages and linguistics. The Regents have approved plans for College Five, which is scheduled to start in the fall of 1969, its curriculum to emphasize fine arts and literature.

*Buildings at Santa Cruz have been designed to maintain the natural beauty
of their setting, as the plaza of Cowell College evidences.*

At Chancellor McHenry's inauguration, on Charter Day in 1966, an honorary degree was awarded to Max
Thelen, president of the trustees of the S. H. Cowell Foundation, a Berkeley graduate of 1904, and
a practicing attorney in San Francisco for over sixty years. With Mr. Thelen are President Clark
Kerr and Provost Page Smith of Cowell College.

Under the watchful eye of A. E. Whitford,
director of the UCSC Lick Observatory, some
sixty-seven tons of laboratory equipment and
materials were moved from Mount Hamilton to
the Santa Cruz campus in November 1966,
marking the end of the seventy-eight-year-old
community of resident astronomers on the
world's first mountaintop observatory.
Graduate students and faculty still use the
great telescopes remaining at Lick's Observing
Station on Mount Hamilton, but they return
to the Santa Cruz campus to use the complex
analytical devices and computer facilities
demanded by modern astronomical research.

The UCSC Tutorial Project, planned and administered by students, has attracted a very high level of participation. During the past academic year, as many as 125 students, selected from some 250 applicants, spent their Saturday mornings helping enrich the lives of Santa Cruz elementary school children on a one-to-one tutor-pupil basis. During the summer, thirteen students served as tutor-counselors in a series of three-week camp sessions organized by the Tutorial Project.

The first commencement ceremonies at UCSC, on June 11, 1967, saw eighty-six undergraduate, three graduate, and four honorary degrees conferred. The scene was the Upper Quarry. Here, the faculty and graduating seniors of Stevenson College march behind the new Stevenson College banner.

Most of the original Cowell Ranch structures, such as the cookhouse
and carriage house, have been preserved for campus use.

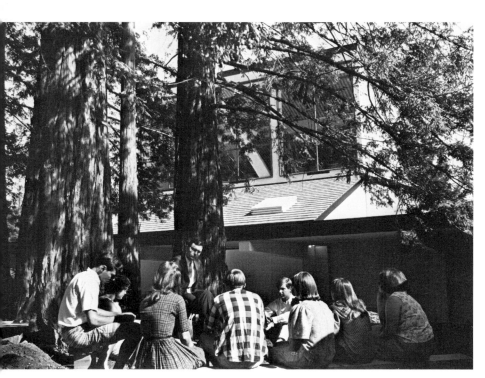

Outdoor seminars, such as this one
at Stevenson College, are popular.

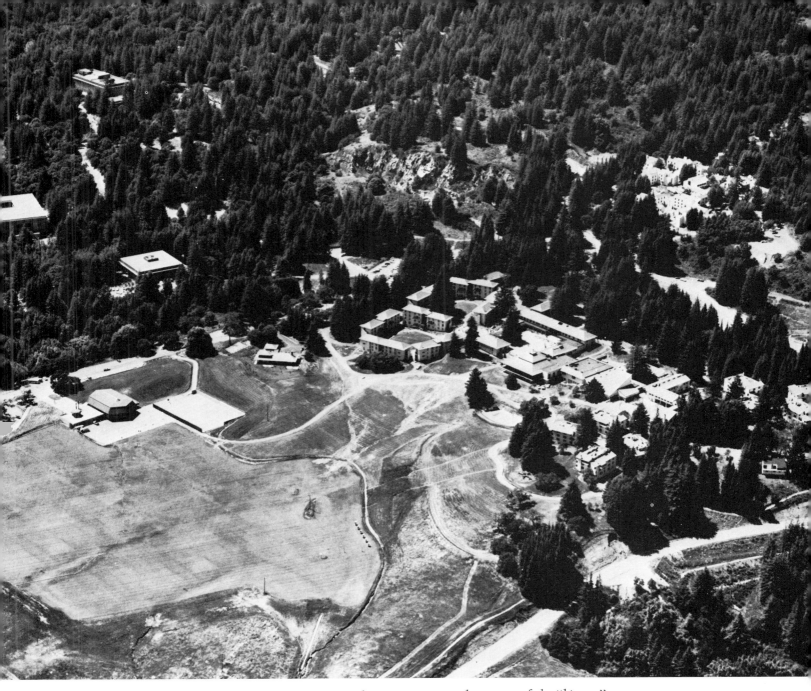

The University of California, Santa Cruz—an exciting and promising approach to some of the "bigness" problems of higher education. Here among the rolling foothills of the Santa Cruz mountains, seventy-five miles south of San Francisco, are the sites of the first four colleges. This aerial view, taken in September 1967, depicts only about one-tenth of the two-thousand-acre campus. Above Field House (center left) are the central services (administration) building, the University Library, and the natural-sciences building. The new health center will be located above the Upper Quarry (top center), which serves as an amphitheater. Cowell College is in the center, Stevenson College at the lower right. Crown College is above and to the right of Cowell. College Four will be located just to the right of Crown.

Acknowledgments

The editors are indebted to the following individuals for assistance and counsel in the preparation of this volume: James deT. Abajian and Lee Burtis, California Historical Society; Richard Fogel, Arthur Hakel, and Leonard H. Verbarg, *Oakland Tribune*; Tom Patterson, *Riverside Press-Enterprise*; Larry Booth, San Diego Title Insurance and Trust Company; Gordon Pates and the late Joan Bell, *San Francisco Chronicle*; Larry Lieurance, Stuart Rasmussen, *San Francisco Examiner*; Paul Veblen, *Santa Barbara News-Press*; Rev. Walter Bond Davis, First Congregational Church, Santa Barbara. And on the Berkeley campus: Ray Colvig, Mrs. Emily G. Elliott, Walter Frederick, Richard P. Hafner, Professor James D. Hart, Professor John D. Hicks, Dean C. Johnson, Robert S. Johnson, James R. K. Kantor, Mrs. Elizabeth L. Karsten, Don Palmer, Miss Agnes Robb, Robert A. Steiner, James Uno, Daniel M. Wilkes. On the Davis campus: Robert Bynum, Donald Kunitz. On the San Diego campus: Gay Crawford, W. Greaves, Sam Hinton, Mrs. Helen Raitt, Paul West, Marston Sargent. On the Riverside campus: Mrs. Kathryn Forrest, R. Ted Hendrixson, Charles Luce, John J. Maxwell, Professor Robert A. Nisbet. On the San Francisco campus: Thomas D. Harris, Dr. Berthal J. Hartman, Dr. Ian W. Monie, Jerry Norris, Dr. J. B. deC. M. Saunders. On the Los Angeles campus: Andrew J. Hamilton, Chandler Harris, John B. Jackson, James V. Mink, Nancy Naylor, Ann Sumner. On the Irvine campus: H. B. Atwood. On the Santa Cruz campus: Gurden Mooser, Joan Ward. On the Santa Barbara campus: Professor Ernest L. Bickerdike, Christian M. Brun, George Obern, Professor Wilton Wilton.

In addition to the photo credits given below, the University archives, information offices and alumni associations on the various campuses can be credited for many of the pictures included in this collection. All picture credits are keyed by page number and letter. The letter gives the location of the picture on the page (A–B–C–D) left to right and top to bottom.

Page	Photographer and location of picture
6	David Freund (C)
7	Glasheen Graphics (A); Jerry Stoll (C); Stu Shaffer (D); Vester Dick (E)
11	Paul Bishop (A); Don W. Jones (B)
17	California Historical Society (A)
19	California Historical Society (A)
21	California Historical Society (A,B)
23	O. V. Lange (A)
32	Jon Brenneis (C)
43	California Historical Society (A)
49	Thelner Hoover (A); G. E. Russell (B)
50	*Oakland Tribune* (B)
52	Wide World Photo (B)
56	C. Abell (B)
57	*Oakland Tribune* (A, B)

Page	Photographer and location of picture
59	Ralph Crane—*Life Magazine* (A)
60	Lawrence Radiation Laboratory (A,B)
61	Lawrence Radiation Laboratory (B)
63	*Oakland Tribune* (A)
64	Jon Brenneis (A); Ed Kirwan (B)
65	Ed Kirwan (C)
67	Ed Kirwan (B)
68	Ed Kirwan (A,B)
69	Ben Jacopetti (B)
70	Ed Kirwan (B)
71	Ed Kirwan (A,B); Dennis Galloway (C)
72	Ed Kirwan (B); Lonnie Wilson—*Oakland Tribune* (C)
73	Ed Kirwan (A,B)
74	Ed Kirwan (A,B)

Page	Photographer and location of picture	Page	Photographer and location of picture
76	Ted Streshinsky (A)	184	Ken Middleham (A,B)
77	Harry Wade (A); Ted Streshinsky (B)	185	*Riverside Press-Enterprise* (A)
78	Bob Campbell—*San Francisco Chronicle* (B)	186	Ken Middleham (A); *Riverside Press-Enterprise* (B)
79	Dennis Galloway (A); Ed Kirwan (B)	188	Ken Middleham (A)
80	Jerry Stoll (A); Helen Nestor (B)	189	Ken Middleham (B)
81	Jerry Telfer—*San Francisco Chronicle* (A); Lonnie Wilson—*Oakland Tribune* (B)	190	Life Sciences—UCR (A,B)
82	Lee Johnson—*Life Magazine* (A); Bill Young—*San Francisco Chronicle* (B)	191	Ken Middleham (A,B)
		192	Ken Middleham (A,B)
83	Jim Marshall (A); Donald Kechely (B)	193	Herb Quick (A)
86	Betty Strong (A); Roger Sturtevant (B)	194	Ken Middleham (A,B)
87	Ed Kirwan (A,C); Dennis Galloway (B)	195	*Riverside Press-Enterprise* (A); Wistaria Linton (C)
88	Jon Brenneis (A,B)	196–197	Ken Middleham
89	Lawrence Radiation Laboratory (A,B); Massachusetts Institute of Technology (C)	201	Historical Collection—Title Insurance and Trust Company (B,C)
90	Lawrence Radiation Laboratory (B)	202	Historical Collection—Title Insurance and Trust Company (A,B)
91	Lawrence Radiation Laboratory (A,B)	207	Historical Collection—Title Insurance and Trust Company (A,B)
92	Alver J. Olson (B)	208	Historical Collection—Title Insurance and Trust Company (A)
93	Dennis Galloway (B)		
95	Dennis Galloway (A)	211	United States Navy Electronics Laboratory (B)
96–97	Lawrence Radiation Laboratory	212	Historical Collection—Title Insurance and Trust Company (A)
105	Robert H. Lowie Museum of Anthropology (A)	213	San Diego-Union Tribune Publishing Company (A); United States Marine Corps Photo (B); Glasheen Graphics (C)
113	Joshua Freiwald (B)		
117	Peter Breinig—*San Francisco Chronicle* (B)	214	Glasheen Graphics (A,B,C)
120	Howard Fox—from: Schindler, Meyer; *The Thirtieth in Two World Wars*; San Francisco 1966. (A)	215	Harry Crosby (A); Glasheen Graphics (B)
123	Tom Walters—from: *The Thirtieth in Two World Wars* (A); Glasheen Graphics (B)	216	San Diego-Union Tribune Publishing Company (A); Glasheen Graphics (B)
		217	Glasheen Graphics (A,B)
128	Proctor Jones (B)	218	Glasheen Graphics (A,C,D); Harry Crosby (B)
133	Harold J. McCurry (B)	219	Glasheen Graphics (B)
136	Harold J. McCurry (B)	220	Harry Crosby (A,B)
140	Harold J. McCurry (A)	221	Glasheen Graphics (A); Stockholm—*Reportagebild* (B)
161	Gerald Ratto (B)		
169	Avery Edwin Field (A)	224	Tom F. Walters (A); Glasheen Graphics (B)
170	*Riverside Press-Enterprise* (A); Avery Edwin Field (B)	225	Glasheen Graphics (A); C. R. Learn (B)
172	*Riverside Press-Enterprise* (A)	230	Thelner Hoover (A)
173	*Riverside Press-Enterprise* (B,C)	232	Thelner Hoover (A)
174	Ken Middleham (B)	233	Historical Collection—Security First National Bank of Los Angeles (A); Stagg (C)
175	Ken Middleham (B)		
176	Marllyn Boswell (A); Ken Middleham (B,C)	234	Thelner Hoover (A)
177	Ken Middleham (A,B)	235	Thelner Hoover (A)
178	*Riverside Press-Enterprise* (A)	236	Thelner Hoover (A); M. L. Bailey (B)
180	Ken Middleham (A)	237	Thelner Hoover (B)
181	Ken Middleham (A,B)	238	Thelner Hoover (A,D)
182	*Riverside Press-Enterprise* (A)		
183	Marllyn Boswell (A); Ken Middleham (B)		

ACKNOWLEDGMENTS 325

Page	Photographer and location of picture	Page	Photographer and location of picture
239	Security First National Bank of Los Angeles (A); Arts Photo (B)		News-Press (B)
240	Thelner Hoover (A,B,C,D)	298	*Santa Barbara News-Press* (A)
242	Thelner Hoover (A)	300	Gilberts of Goleta (A,B,C)
243	*Los Angeles Times* (A)	301	Gilberts of Goleta (A)
	Thelner Hoover (B)	303	Gilberts of Goleta (A,B); Leigh Wiener —(IBM) (C)
244	Official United States Navy Photo (A)	304	David Muench (A)
245	Thelner Hoover (C)	305	David Muench (A)
246	Thelner Hoover (C)	306	Gilberts of Goleta (A); *Santa Barbara News-Press* (B)
248	Stan Troutman (A)		
249	Thelner Hoover (A)	307	Gilberts of Goleta (A); David Muench (B)
251	*Palo Alto Times* (B)		
253	Thelner Hoover (A)	308–309	Mark Hurd Aerial Surveys
267	Thelner Hoover (A)	312	Bertil Svensson (B)
269	Leigh Wiener (A)	313	Ted Streshinsky (A,B); Beth Koch (C)
276	Bob Schultz (A)	314	Clay Miller—*Santa Ana Register* (A); Wayne Clark (C)
277	Leigh Wiener (A)		
289	*Santa Barbara News-Press* (A)	315	Lloyd A. DeMers (A)
290	Jon Brenneis—Cal Pictures (A)	316	Jerry Stoll (A)
292	*Santa Barbara News-Press* (A,B)	318	Dick Vester (A,B)
293	*Santa Barbara News-Press* (A,B)	319	Al Lowry (A)
294	Robert M. Quittner (A)	320	Dick Vester (A); Jon Brenneis—Cal Pictures (B)
295	*Santa Barbara News-Press* (A); Karl Oberst (B)		
296	Gilberts of Goleta (A); Jerry Stoll (B)	321	Al Lowry (A); Dick Vester (B)
297	Gilberts of Goleta (A); *Santa Barbara*	322	Dick Vester (A); Al Lowry (B)
		323	Dick Vester (A)